Van Gogh Judy Sund

W9-BMU-896

ART&IDEAS

Φ

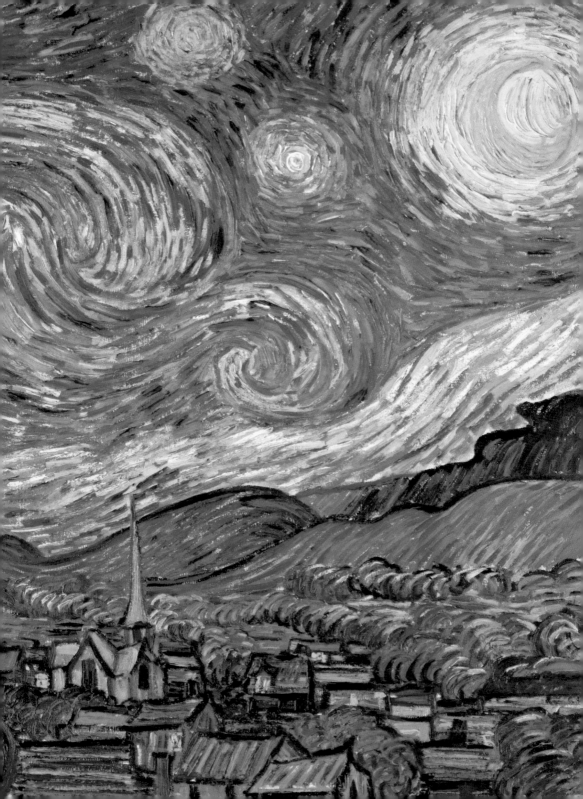

Van Gogh

Opposite
Starry Night
(detail of 165),
1889.
Oil on canvas;
73 x 92 cm,
28¾ x 36¼ in.
Museum of
Modern Art,
New York

A promising but little-known newcomer to the art world at the time of his suicide, Vincent van Gogh (1853–90), a self-styled 'stranger on earth', was to emerge in the following century as one of the first media-moulded personas to inhabit collective consciousness, a man on a first-name basis with the world. A posthumous construct of psychologists, film-makers and novelists, as well as biographers, art historians and artists, the legendary 'Vincent' is a man whose personal celebrity outstrips even the fame of his work. An impulsive, self-mutilating madman, whose eccentricities and manic energies are reflected in the animated brushwork, radical stylizations and high-keyed hues of his paintings, this legendary Vincent, tragically misunderstood in his own time, is lionized in ours.

Those who seek to ground the historic Van Gogh in the cultural landscape he inhabited must reckon both with the high value that Western culture places on the uniqueness and 'originality' epitomized by the mythologized Vincent, and with art history's continuing weakness for the notion of transcendent genius. Tethering the overblown persona of popular imagination to a set of actualities has been a primary project within Van Gogh studies since the 1980s, and it is an overarching goal of this book.

No one, in fact, was more intent than Van Gogh on (as he put it) 'belonging to one's time', or more ready to acknowledge debts owed to admired antecedents and peers. A former art dealer well versed in painting's histories, he viewed his own work as part of a continuum. Equally intrigued by contemporary currents, Van Gogh often combined modern approaches with traditionalist conceptions, a tendency exemplified by a Parisian self-portrait that is both a homage to Rembrandt van Rijn (1606–69) and a pledge of allegiance to recent trends (1). Taking his cue from a self-portrait in the Louvre (2), Van Gogh echoed Rembrandt's pose, confronting a canvas with

palette in hand, his expression mild, his demeanour workmanlike. Even as he glanced backwards, however, Van Gogh looked around: his picture's light ground, prismatic colour and considered brushwork show the Dutchman in Paris venturing beyond the long shadows cast by idolized forebears to engage with Impressionist and Neo-Impressionist practice.

His approach to picture-making was also (if less obviously) inflected by concepts Van Gogh gleaned from preachers, poets, philosophers, novelists and composers. Veiled references to these infuse his imagery with literary and musical associations, as well as art-historical asides. While his pictures' popular appeal resides in their seemingly emotion-fuelled spontaneity, they are in fact products of a reflective intellectual with a strong sense of purpose. As art historian Ronald Pickvance has observed, they rarely chart their maker's psychic state. Indeed, Van Gogh's pictures mask private concerns as often as they mirror them. The Parisian self-portrait, for instance, a study in stolidity, gives little indication of the disequilibrium Van Gogh felt at the time. Though 'seriously sick at heart' due to the dissolute life he led in the French capital, the artist played down the malaise hinted at by his pallor and red-rimmed eyes. Instead, he enacted the consummate professional, his rigid bearing complemented by firm contours and the measured rhythms of evenly spaced brushmarks.

Van Gogh's *oeuvre* might be compared to the canvas in the self-portrait's foreground. As a readily identifiable representation, it conveys certain information. Its placement, however, emphasizes the boundaries that separate artist from viewer, picture from 'reality'. Many of Van Gogh's pictures remain, on some level, as inaccessible as that turned-away canvas – arenas of processes at which we can only guess. At the same time, his drawings and paintings are cultural artefacts – products of particular times and places that become at once more complicated and more comprehensible when considered against the broad contours of European culture at the end of the nineteenth century – and, more particularly, in light of Victorian evangelism, Dutch

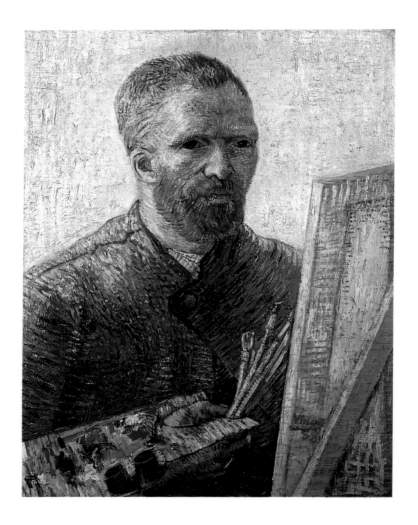

1
*Self-Portrait
before an Easel,*
1888.
Oil on canvas;
65 x 50·5 cm,
25⅝ x 19⅞ in.
Van Gogh Museum,
Amsterdam
(Vincent van Gogh
Foundation)

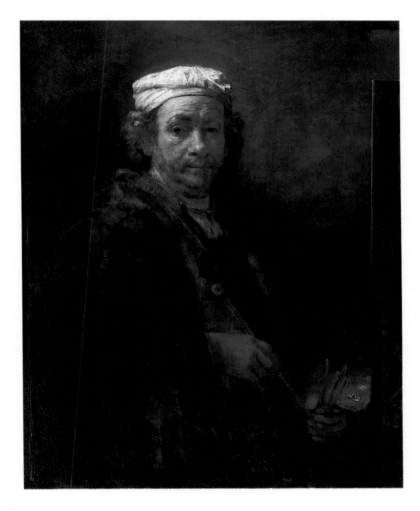

2
**Rembrandt
van Rijn**,
Self-Portrait,
1660.
Oil on canvas;
111 x 90 cm
43½ x 35½ in.
Musée du Louvre,
Paris

industrialization, French aesthetic debates, and the creative competitions that animated Van Gogh's interactions with his peers.

His artistic career, which spanned the 1880s, was born of Van Gogh's failed attempt to preach. Renouncing pulpit for pencil, he taught himself to draw, and honed his hard-won draughtsman's skills in his native Holland, where he recorded the country's modernization as well as his own nostalgia for the landscapes of his youth. Drawn to painting by the evocative possibilities of colour, Van Gogh also explored the expressive potential of texture in rough-hewn oil paintings of Dutch labourers, before lightening both his palette and his touch in Paris in the mid-1880s. A hotbed of art and ideas, the French capital at that time was the site of raging debate between naturalists – whose practice relied on direct observation of 'real world' motifs – and proponents of Symbolism, a movement spearheaded by literati who believed that art, a product of subjective experience, should reference immaterial realms. According to the poet-critic Gustave Kahn, Symbolists aimed 'to objectify the subjective', giving form to Ideas (with a capital I), whereas naturalists aimed to 'subjectify the objective (nature through a temperament)'. Van Gogh, an avid consumer of naturalist fiction and a painter who felt lost without models, was a wary witness to Symbolism's rise (he arrived in France in the year Kahn penned that pronouncement). Yet his best known pictures and stated intentions bear closer relation to Symbolist precepts than he himself seemed to realize.

The term 'Symbolist' usually designates the idea-bound art of *fin-de-siècle* painters such as Edvard Munch (1863–1944), Fernand Khnopff (1858–1921) and Jan Toorop (1858–1928), while Van Gogh is categorized as 'Post-Impressionist' – an unhappy label that identifies neither a concerted movement nor a consistent style. Devised by the English critic Roger Fry in the early twentieth century, the term 'Post-Impressionism' seeks to link artists as varied as Georges Seurat (1859–91), Paul Cézanne (1839–1906) and Paul Gauguin (1848–1903) by virtue of their relation to Impressionism. Like those near-contemporaries, Van Gogh adopted the prismatic

palette and visible brushmarks of Impressionism in the mid-1880s, but soon ventured from objectivity tinged by personal perception ('nature through a temperament') to a much more wilful subjectivity. 'Instead of trying to reproduce exactly what I have before my eyes,' he wrote, 'I use colour more arbitrarily, to express myself forcibly.' Such commitment to the artful manipulation of optical reality (as opposed to its replication) manifests itself variously but consistently in so-called Post-Impressionist art, and Van Gogh's best work testifies to the power of colour, line and space to generate meaning in and of themselves. The 'Symbolist' dimension of his *oeuvre* resulted from his quest to communicate verbal ideas in paintings that are allusive rather than anecdotal or allegorical, paintings in which unexpected and amplified hues combine with idiosyncratic linear and spatial effects to render mundane motifs strangely evocative.

The cultural contexts in which Van Gogh worked, and in which he himself placed his production, are vividly described in his collected correspondence. Comprising some nine hundred letters, his correspondence is a carefully crafted production in itself. Whether addressed to painter friends, his art-dealer brother Theo, or their youngest sister, Wil, Van Gogh's letters contain eloquent accounts of his picture-making, alongside musings on day-to-day concerns. No artist of any era left so extensive and revealing an account of his proclivities and dislikes, ambitions and accomplishments, trials and errors, and Van Gogh's letters (first published, piecemeal, in the 1890s) have had a profound impact on the way his paintings are 'read'. I quote them often in the pages that follow, not least to support my own interpretations of Van Gogh's intentions and his pictures' meanings. It should be remembered, therefore, that the letters themselves are highly mediated accounts of pictures, people and circumstances, and that writers on Van Gogh (myself included) cite them selectively.

My analyses also depend on memoirs and letters by Van Gogh's family and his associates; on careful examination of his production and that of artists and writers who shaped his vision; and on accounts of the

places and cultures in which he lived and the circles in which he moved. I have never believed in ascribing the idiosyncrasies of Van Gogh's style to posthumously diagnosed physical impairment, and instead relate most aspects of his work to conscious aesthetic choice.

I am profoundly indebted to the scholarly literature surrounding Van Gogh. Many colleagues are cited here, and others will surely find refractions of their own observations in my arguments. I have also dipped into the vast popular literature on Van Gogh – a discourse that favours the most sensational dimensions of the artist's life and presents 'Vincent' as a saintly outsider who martyred himself to art. Such excesses have induced me to maintain a respectful distance from biodrama. I remain convinced, however, that just as reasoned analysis of his methods and products points up aspects of Van Gogh's personality that popular chronicles underplay – confidence, cunning and gusto among them – familiarity with the charged incidents that punctuated his life illuminates the emotional currents that underlie the *oeuvre*'s blatant beauty.

The hyperbole surrounding Van Gogh became an object of study in its own right in the late twentieth century, of interest not only for what its says (and does not say) about the man who inspired it, but also for the role Van Gogh's myth played in the formation of cherished notions of artistic temperament, and of the criteria by which modern audiences define and evaluate art. I discuss the Vincent of song and screen in this book's final chapter.

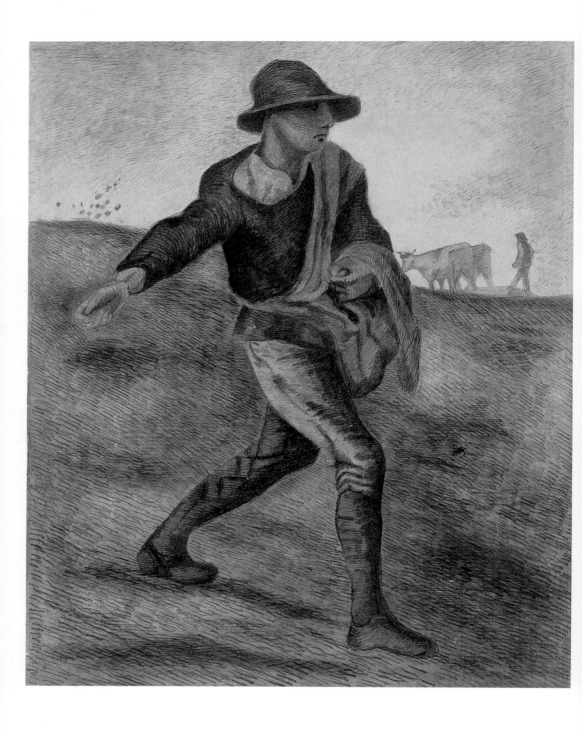

The painter who signed himself 'Vincent' – supposedly to save foreigners the trouble of mispronouncing Van Gogh (but perhaps also to distance himself from his relatives) – was one in a succession of family members given that name. Both his paternal grandfather and his father's favourite brother had been christened Vincent (the latter nicknamed Cent), as was his parents' firstborn, a brother still-born exactly one year before the artist's own birth on 30 March 1853. Still in mourning when their new son arrived, Van Gogh's parents perhaps named him Vincent in commemoration of their loss, but were doubtless also intent on honouring both the family patriarch and the prosperous and childless Cent.

3
*The Sower
(after Millet)*,
1881.
Pencil and ink
heightened
with green
and white;
48 x 36·5 cm,
19 x 14½ in.
Van Gogh
Museum,
Amsterdam
(Vincent
van Gogh
Foundation)

The future artist began life in a rural community in the southern Netherlands during an era of great commercial expansion and internal development. Van Gogh would witness the transformation of his native province, Brabant, by the Industrial Revolution, which took off in Holland in the 1860s. In his home town, Zundert, Vincent grew up as something of an outsider – in a family of middle-class Protestants living amid a majority of Roman Catholic labourers. Though the Netherlands was predominantly Protestant, rural Brabant was not. Less than 150 of Zundert's 6,000 inhabitants were members of the Dutch Reformed congregation, to which the Revd Theodorus van Gogh, Vincent's father, had been called in 1849.

Like his father before him, Vincent's father studied theology at the University of Leiden, but – like many Dutch Reformed ministers of his generation – he embraced the teachings of the Groningen School, an evangelical movement that promoted intensely emotive piety and Christian commitment to social causes. A lacklustre preacher, Theodorus passed his career in a string of provincial postings. His wife, born Anna Carbentus, the daughter of a respected bookbinder, had been raised in The Hague, a cultural centre of the

nineteenth-century Netherlands. Having tried her hand at flower painting in her youth, Anna encouraged her eldest son's early interest in art.

The Van Gogh children – who eventually numbered six – grew up in a cultivated atmosphere at odds with Zundert's prevailing rusticity. The parsonage was littered with books and hung with reproductions of popular paintings such as Paul Delaroche's *Mater Dolorosa* (4) and J J van der Maaten's *Funeral Procession through the Fields* (5).

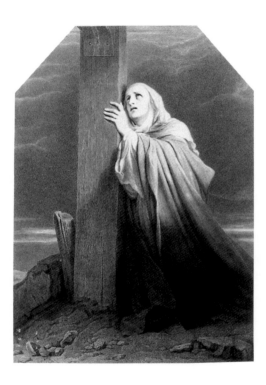

4
After Paul
Delaroche,
Mater Dolorosa,
1853.
Goupil print

5
After Jacob
Jan van der
Maaten,
*Funeral
Procession
through the
Fields*, 1863.
Lithograph,
annotated by
Van Gogh;
26·1 x 33·6 cm,
10¹⁄ x 13¹⁄ in.
Amsterdam
University
Library

Wary of the coarsening influence of local youngsters, Theodorus and Anna hired a governess to home-school their brood, and young Vincent spent most of his playtime in the company of his brother Theo, four years his junior. Despite their rather rarified existence, Vincent and Theo would always consider themselves 'Brabant boys' who shared vivid childhood memories. The year before his death, Vincent wrote wistfully of his ability to picture 'every path, every plant in the garden' at Zundert.

At the age of eleven, Vincent was packed off to boarding school. His parents took education seriously. Not only Vincent and his brothers, but their three sisters, too, were sent away for schooling, despite strain to family finances and the fact that many girls of the Dutch middle class were educated at home. After his first year away, Vincent qualified for admission to a newly founded secondary school, where instruction in linear and freehand drawing supplemented the academic curriculum (6). His drawing master, Constantijn Huysmans (1810–86), a Paris-trained Dutchman who specialized in Brabant landscapes and rustic interiors, was a proponent of art education for the masses and author of *The Landscape* (*Het Landschap*; 1840) – a primer on pencil-drawn vistas – and *Principles of Drawing* (*Grondbeginselen der Teekenkunst*, 1852; 7). Through Huysmans's

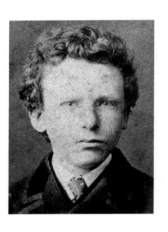

6
Vincent van Gogh aged 13, 1866. Vincent van Gogh Foundation, Amsterdam

7
Constantijn Huysmans, Illustration of hands from the *Principles of Drawing*, 1852

efforts, drawing had become a required part of Dutch secondary studies in 1863. An advocate of 'the diligent study and frequent copying' of prints and plaster casts after admired paintings and sculptures, Huysmans nonetheless felt an art teacher's first duty was 'to foster a keen power of observation, an acute awareness of the source of all beauty, God's glorious nature'. Van Gogh's later advocacy of copy-making and his concomitant commitment to an art grounded in the direct observation of nature echoed his earliest training.

Vincent entered young adulthood well-read, proficient in foreign languages and conversant in the visual arts – the last thanks especially to his uncle Cent, an art dealer and collector. Indeed,

three of Theodorus's four brothers were art dealers, and both Vincent and his brother Theo entered that trade with their uncles' help. The future painter (who later would struggle to sell just a few of his own paintings) began a career in picture-selling at the age of sixteen, apprenticing at the gallery Cent had built up from an art supplies store in The Hague, then sold to Parisian entrepreneur Adolphe Goupil in 1861. Goupil & Co (founded 1827) specialized in high-quality engraved and photo reproductions of popular French Salon paintings, and eventually had branches in London, New York, Berlin, The Hague and Brussels, as well as three in Paris. With his gallery's incorporation into this network, Cent became a principal in the business and began to spend much of his time in France, leaving management of Goupil's Hague branch to H G Teersteeg. In 1866, the Brussels gallery established by another of Theodorus's brothers, Hein, also became a Goupil franchise, and when the teenaged Vincent – Cent's presumed heir – joined the firm in 1869, he entered the orbit of his uncles (another of whom was an independent art dealer in Amsterdam) and seemed destined to become an art-world insider.

In his first years at Goupil, Vincent's knowledge of recent French art grew rapidly as he familiarized himself with portfolios of prints and photos of Salon favourites by Delaroche (1797–1856), William Bouguereau (1825–1905), Jules Breton (1827–1906) and Jean-Léon Gérôme (1824–1904). The Hague branch also did a brisk business in original works, specializing in landscapes and rustic scenes by Barbizon School painters (so called because they worked in the Forest of Fontainebleau near the village of Barbizon, south of Paris) and, increasingly, by Barbizon-influenced Dutch painters who began congregating in The Hague during Van Gogh's residence there, and who soon became known as The Hague School.

The city had much to offer artists. As Holland's long-established seat of government (the provincial representatives who formed its governing body, the States General, had been meeting there since the 1580s), The Hague provided ample art patronage by the government officials who maintained grand residences in the city's heart and country retreats in its environs. The municipal drawing

school, founded in 1839, offered classical training to four hundred students, and the artist-run Pulchri Studio, which opened in 1847, was a fulcrum of cultural life. In addition to life-drawing sessions, Pulchri provided opportunities for the display and discussion of members' portfolios, and organized musical and literary evenings where painters and collectors mingled. The Goupil Gallery often exhibited its wares there, giving the organization a five per cent commission on sales.

In addition to this lively arts scene, The Hague – situated amid verdant pastures, and the dunescape adjoining the North Sea and the fishing village of Scheveningen – offered proximity to picturesque locales. As the French vogue of *plein-air* painting (*ie* painting outdoors, directly from nature, rather than in the studio) gained steam in Holland, many Dutch enthusiasts took up residence in The Hague. Hendrik Mesdag (1831–1915), devoted to seascapes, settled there in 1869 (the year Van Gogh arrived). Anton Mauve (1838–88), a dedicated *plein-air* painter, and Jozef Israëls (1824–1911), who was drawn to rustic life, moved there in 1871, the same year that Hague native Jacob Maris (1837–99), the

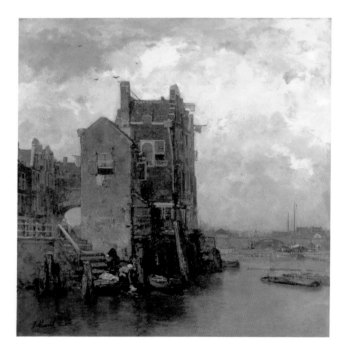

8
Jacob Maris,
View of Old Dordrecht,
1876.
Oil on canvas;
106·5 x 100 cm,
42 x 39⅓ in.
Gemeente-
museum,
The Hague

9
Jules Dupré,
Autumn, c.1865.
Oil on canvas;
106·5 x 93·5 cm,
41⅞ x 36¾ in.
Museum Mesdag,
The Hague

premier Dutch landscape painter of the late nineteenth century,
returned from Paris (8). Together with longtime resident (and
Pulchri founder) Willem Roelofs (1822–97) and several Hague-
born artists, including Bernard Blommers (1845–1914), Johannes
Bosboom (1817–91) and Jacob Maris's brother Willem (1844–
1910), recent arrivals took to the city's outskirts in pursuit of
unpretentious subjects. Their commitment to the direct observation
of nature ('naturalism') and their work's stylistic similarities – most
notable in textural brushwork and 'tonal' palettes (dominated by
closely related neutral shades) – led critic Jacob van Santen Kolff to
label them The Hague School in an essay of 1875. (Their penchant
for overcast skies and muted shades eventually earned them the
nickname 'The Grey School'.)

Though precedents for Hague School themes and style could be
found in French paintings of the sort Goupil sold – by Camille Corot

(1796–1875), Jules Dupré (1811–89; 9), Jean-François Millet (1814–75) and others – Van Santen Kolff rightly observed The Hague School's inherent Dutchness. Landscapes and scenes of daily life were rarely painted by European artists before the seventeenth century, when a number of artists in the newly founded Dutch Republic challenged prevailing norms. Elsewhere in Europe, the most ambitious artists painted exalted narratives (biblical, mythical, historical, allegorical) and portraits of society's élites. In the Dutch Republic, however, the prevailing Protestantism – which proscribed images of the divine – virtually eliminated the market for religious works, and, in the absence of a monarchy, painters lacked the kind of royal patronage that promoted the production of grandiose narrative pictures by their colleagues abroad. Instead, seventeenth-century Dutch artists pitched their paintings toward the prosperous entrepreneurs who steered Holland's thriving economy – members of a merchant class who sought medium-sized pictures for domestic ornament. While many painters continued to make portraits, others found commercial success with subjects long considered unworthy of representation: vistas of land and sea, scenes of everyday life (genre), animal paintings, arrangements of inanimate objects (still life).

10
Jacob van Ruisdael, *View of Haarlem from the Dunes at Overveen,* c.1670. Oil on canvas; 55·5 x 62 cm, 21⅞ x 24⅜ in. Mauritshuis, The Hague

Known as the 'Little Dutch Masters' because of the seeming insignificance of their subject matter, such artists changed the face of Western painting. The landscape modes established by Meindert Hobbema (1638–1709) and Jacob van Ruisdael (1628–82; 10), for instance, were much emulated in nineteenth-century France (by the Barbizon painters), England (most notably by John Constable; 1776–1837) and the United States (by the Hudson River School). The popularity of genre painting also rose steadily, linked to the rise of the middle class. By the end of the nineteenth century, grand narratives had lost favour with patrons and painters alike. Today the 'lesser genres' – landscape, still life and scenes of daily life – dominate representational art.

As Van Santen Kolff observed in the mid-1870s, it was the 'realism' of Hague School painting that made it quintessentially Dutch. Its verisimilitude also made it 'modern' within the broad spectrum

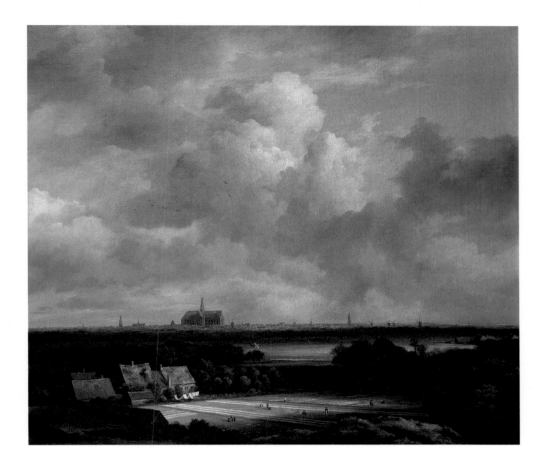

of European art, where classicism was still highly valued. Favoured and championed by his uncle Cent (who owed much of his financial success to French enthusiasm for contemporary Dutch *plein-air* painters), Barbizon and Hague School pictures were among the first paintings Van Gogh admired at close hand.

At the same time, the trainee dealer was intent upon learning about older art, particularly that of the Netherlands' 'Golden Age', the seventeenth century. Goupil's Hague establishment fronted on the Plaats, a seventeenth-century square in the town centre, as does the Mauritshuis, a state picture gallery established in 1822. Housed in a former aristocratic residence, the Mauritshuis displays several Rembrandts, including *The Anatomy Lesson of Dr Tulp*, Ruisdael's *View of Haarlem* (10) and Vermeer's (1632–75) famed *View of Delft*.

Van Gogh was a frequent visitor there, and also at the Trippenhuis in Amsterdam, a dimly lit mansion that served as the Rijksmuseum before that institution's present building was completed in 1885. Less than 50 kilometres (30 miles) from The Hague, Amsterdam was home to Vincent's uncle C M (Cor) van Gogh, who had a gallery on the Leidschestraat. On visits there, Vincent especially enjoyed the city's Rembrandts: *The Syndics of the Cloth Guild*, a group portrait he considered 'the most beautiful Rembrandt', hung at the Trippenhuis, and *The Jewish Bride*, which Van Gogh thought exemplified Rembrandt's 'poetic' side (as opposed to the 'truth' of *The Syndics*), could be seen in M A van der Hoop's private museum (now part of the Rijksmuseum). He probably took in the royal collections in Brussels when he went to see his uncle Hein.

Vincent's museum-going was likely directed to some extent by his uncles and by his boss, Teersteeg, who became a friend. His most influential guide, however, was the French critic Théophile Thoré (1807–69), whose *Les Musées de la Hollande* (1858–60; published under the pseudonym W Bürger) provided an overview of Dutch art and detailed commentaries on notable works in the Mauritshuis, Trippenhuis and Van der Hoop collections. Thoré was a French republican whose role in the revolution of 1848 and subsequent opposition to Napoleon III (r.1852–70) led to a decade-long exile (1849–59), some of which was spent in Holland gathering materials on Dutch painters. Thoré admired the Dutch Masters' focus on 'simple' subjects and their ability to find 'poetry' in the lowliest themes. His liberal leanings led him to stress the democratic character of seventeenth-century Dutch art, which he held to reflect the political, religious and social conditions of a republic that broke the strangleholds of Catholicism and monarchy.

Van Gogh tended to adopt as favourites those Dutch works Thoré particularly admired, convinced, he told Theo, that 'whatever Thoré says is true'. Vincent's comments on older Dutch art and on specific paintings echoed passages of *Les Musées de la Hollande* years after he read it. He also was an avid reader of art magazines, and particularly fond of the *Gazette des Beaux-Arts*, the journal

founded and edited by Thoré's fellow republican Charles Blanc (1813–82), director of fine arts under the more liberal of France's shifting governments. The *Gazette* published reviews of the annual government-sponsored arts exhibition known as the Salon, theoretical essays (including advance instalments of Blanc's *Grammaire des arts du dessin*; 1867), and profiles of artists, including monographs on seventeenth-century Dutch painters by Blanc and Thoré. When the fifteen-year-old Theo joined Goupil's Brussels gallery in 1873, Vincent advised him not only to visit museums but also to 'read about art, especially the art magazines, *Gazette des Beaux-Arts*, etc.', and offered to lend him Thoré's *Musées*.

The Van Gogh brothers began to correspond regularly after Theo joined Goupil, which Vincent thought a 'splendid' firm, noting, 'The longer you are in it, the more ambition it gives you.' His employers – especially his uncle Cent – were equally ambitious for him, and in spring 1873 announced Vincent's move to Goupil's London office. The new posting would broaden his knowledge of the firm's workings and help polish his English, as well as affording access to London's art scene and museums. Still, after almost four years in The Hague, Vincent left it with reluctance. In his last months he took up drawing again, doubtless prompted in part by the desire to create souvenirs of the town in which he had attained adulthood. One drawing of 1873 was made from the corner of the Plaats closest to Goupil's (11). Painstakingly rendered, it is nonetheless lent a casual air by its asymmetrical composition, the cut-off tree at left, and the fact that its most notable landmark, the Binnenhof (parliament building), is glimpsed through a tree.

In May, Van Gogh left The Hague (where Theo soon took up his position), and travelled to London via Paris. It was his first visit to the French capital, which was still rebuilding after its occupation during the Franco-Prussian War of 1870–1 and the destruction of monuments that attended the rise of the radical Parisian government known as the Commune, and the fierce street fighting surrounding the Commune's violent suppression by national guardsmen in May 1871. Paris nonetheless struck Van Gogh as beautiful. In addition to calling

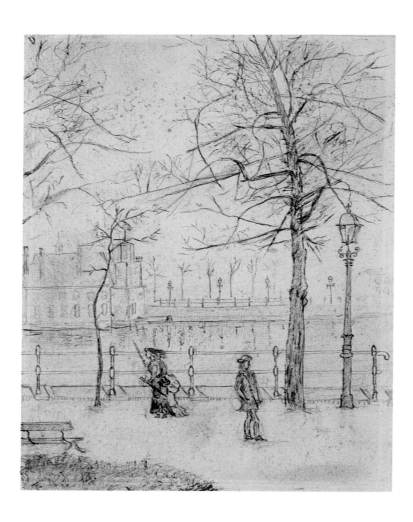

at Goupil's three offices there, he visited the Louvre, the Luxembourg Palace (a repository for state-owned contemporary art) and the Salon exhibition. The 1873 Salon featured paintings by Bouguereau, Breton, Corot and Charles-François Daubigny (1817–78); Israëls and the Maris brothers; and the avant-garde production of Édouard Manet (1832–83), who was represented by a portrait of his colleague and future sister-in-law, Berthe Morisot (1841–95), and by his crowd-pleasing portrayal of a rotund beer drinker, *Le Bon Bock* (*The Good Glass of Beer*). The picture that left the most lasting impression on Van Gogh, however, was Jules Goupil's *Young Citizen of the Year V*. In this half-length portrayal of a young survivor of the French Revolution of 1789, Goupil (1839–83), the son of gallery founder Adolphe, evokes the

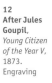

11
The Lange Vijverberg, 1873.
Pen and brown ink and pencil;
22 x 17 cm
8⅝ x 6¾ in.
Van Gogh Museum, Amsterdam (Vincent van Gogh Foundation)

12
After Jules Goupil,
Young Citizen of the Year V, 1873.
Engraving

youthful promise and poignant fragility of the first French republic, born of civil war and regicide. Van Gogh's interest in Thoré's writings may have sparked his appreciation of the painting's republican theme, and he certainly prized its sentiment. A print of the *Young Citizen* – 'indescribably beautiful and unforgettable' – hung in Van Gogh's London lodgings, and in several subsequent residences (12).

Once in England, Van Gogh found a room in Brixton, a then-fashionable south London suburb, from which he walked along the Thames to Goupil's office near the Strand. In the 1870s, England was a highly industrialized country and the heart of a far-flung empire that was

still expanding. Millions of English people lived in squalid poverty, however, and many of them were residents of the London Van Gogh traversed (13), more prosperous at the age of twenty than he ever would be again. Goupil paid him £90 a year, more than three times the average London workman's salary. He took to wearing a silk top hat, and described himself as 'gradually becoming a cosmopolite' in the British capital, 'neither Dutchman, nor Englishman, nor Frenchman, but simply a *man*'.

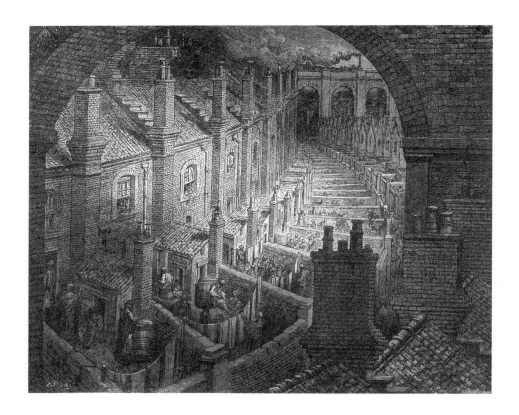

Goupil's English operation was quite different from that in The Hague. It mainly wholesaled prints to dealers, and had no gallery at the time of Van Gogh's transfer. An expansion was afoot, however, and the young dealer speculated, 'When the sale of paintings grows more important, I shall perhaps be of use.' In the meantime, he eagerly examined Dutch pictures in English collections (*eg* the Rembrandt etchings at the British Museum's print room), and, as at The Hague, set about acquainting himself with local

talents. At the Royal Academy's exhibition of 1873, Van Gogh saw pictures that ranged from 'uninteresting' to 'awful', but, as he told Theo, 'one must get used to it'. Soon he was writing appreciatively of recent pictures by John Everett Millais (1829–96), George Henry Boughton (1833–1905), and the French-born James Tissot (1836–1902), all of whom produced highly finished anecdotal works with middlebrow appeal. Millais and Boughton also did historical narratives, and both were adept at landscape, an aspect of each man's work that appealed to Van Gogh. Millais's *Chill October*, an unpeopled autumnal vista, was one of the English paintings Van Gogh believed he would always remember, and Boughton's *Bearers of the*

13
Gustave Doré,
Over London by Rail,
engraving
from *London: A Pilgrimage*,
London, 1872

14
After George Henry Boughton,
Bearers of the Burden, 1875.
Engraving;
16·6 x 24 cm,
6½ x 9½ in

Burden (14), depicting forlorn rural types arrayed along a rutted road in a scrubby landscape, would inspire both a drawing of 1881 and a sermon Van Gogh wrote for an English audience.

More gradually (and much less self-consciously), Van Gogh became a fan of English popular art, drawn especially to Social Realist depictions of London's working classes and their haunts. He regularly examined the shop windows of the rival weeklies *Illustrated London News* and *The Graphic*, where dramatic wood engravings were displayed (15). 'The impressions I got on the spot were so strong,' Van Gogh recalled some years later, 'that notwithstanding all that

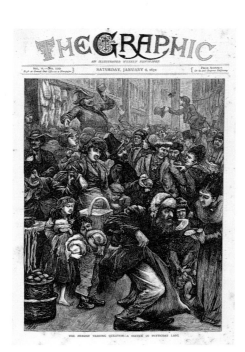

**15
Hubert von
Herkomer**,
*The Sunday
Trading Question
– A Sketch in
Petticoat Lane*,
front page of
The Graphic,
6 January 1872

has happened to me since, those drawings are clear in my mind.'
While Luke Fildes (1843–1927), Hubert von Herkomer (1849–1914)
and Frank Holl (1845–88) emerged as his favourites, Van Gogh
admired many draughtsmen working in London for their work's
'Monday-morning-like soberness and studied simplicity … solid and
strong'. He eventually collected more than a thousand English
illustrations, 'a sort of Bible for an artist'.

The example of the English illustrators, and of the French engraver
Gustave Doré (1832–83) – whose *London: A Pilgrimage* Vincent
recommended to Theo (see 13) – combined with the novelty of his
surroundings, perhaps spurred Van Gogh to take up drawing again
in 1874, though the pursuit, as he later recalled, 'came to nothing'.
Despite his former teacher Huysmans's emphasis on the solution
of perspectival problems, Van Gogh complained of his own inability
to surmount them: 'How often I stood drawing on the Thames
Embankment on my way home … If there had been somebody then
to tell me what perspective was, how much misery I would have
been spared.' He found it easier to make the sorts of copy drawings

Huysmans had encouraged, and made sketches after Boughton and Corot while in London.

Van Gogh's contact with the English art scene seems to have had less impact upon him than his growing awareness of English evangelicalism. In Victorian England, many Protestants were dissatisfied with the rationalist doctrines and ingrained rituals of the Church of England and sought emotive, experiential spirituality. While some English evangelicals remained dissenting members of the official Church (like their Dutch counterparts, the Groningers), many adhered to 'nonconformist' sects (eg Methodist, Baptist and Congregationalist) that rejected formulaic, clergy-led worship in favour of Bible reading, hymn singing and impassioned preaching that stressed salvation through personal rededication to Christ. As a member of the Dutch Reformed Church – which taught the authority of Scripture, the precedence of preaching over ritual, and the importance of personal piety – Van Gogh had been weaned on similar convictions. Moreover, Groningers such as his father emphasized heartfelt devotion to God and redemption through Christ-like good works.

In London's heady atmosphere of religious revivalism, the religiosity of Vincent's boyhood rekindled, and he was especially impressed by the 'home mission' movement's efforts to convert the urban poor to Christian fundamentalism. London missions had flourished since the passage of England's Religious Worship Act of 1855, which sanctioned preaching in secular spaces and open-air venues where people flocked to hear populist ministers such as Charles Haddon Spurgeon and the touring American Dwight Lyman Moody. Spurgeon's Metropolitan Tabernacle (which Van Gogh seems to have visited) packed in thousands, and the prominent, well-funded Christian Mission (which changed its name to the Salvation Army in 1878) ran several smaller 'preaching stations' in London.

Van Gogh's enthusiasm for English evangelicalism deepened under the influence of George Eliot's fiction. Eliot (the pen name of Marian Evans) had embraced evangelicalism briefly in her youth and continued to find its adherents compelling long after her intellectual rejection of its precepts. Evangelicals of various persuasions people

her work, to which Van Gogh was introduced by *Adam Bede* (1859). He responded to Eliot's pictorial prose, with its carefully contrived 'word paintings' (Van Gogh singled out her verbal rendering of a gloomy heath), and he doubtless appreciated the warm endorsement of Dutch pictures that appears as an authorial aside in *Adam Bede*. On another front, his budding ambition to proselytize was fed by Eliot's sympathetic portrait of an unschooled female preacher, 'speaking directly from her own emotions, under the inspiration of her own simple faith'.

Van Gogh's renewed interest in the state of his soul at this time was also due to the disappointment he suffered in his first affair of the heart. Smitten with the daughter of his Brixton landlady, he seems to have fallen in love with the very idea of love, reading and rereading Jules Michelet's *L'Amour* (*Love*; 1858). Atypical of Michelet, who is best known for his histories of France and the French Revolution, *L'Amour* is a treatise on the happy domesticity resulting from a man's successful courtship of a suitably submissive woman. The book struck Van Gogh as 'both a revelation and a Gospel', and he admired Michelet's imagistic prose ('word painting' was a vogue among English and Continental writers of the period). He was particularly fond of Michelet's rendering of an autumnal garden occupied by a woman in black, and the author's musings on the circumstances behind her air of melancholic reverie. *L'Amour* profoundly influenced Van Gogh's attitudes towards women, and its paeans to marriage – and perhaps more specifically Michelet's assertion that most Englishwomen were dreamy homebodies who made 'ideal spouses' – encouraged his aspiration to marry the landlady's daughter. The object of Vincent's affections, however, was secretly engaged to another. Her rejection derailed him.

The manager of Goupil's London branch soon found his once-able trainee inattentive, even sulky, but because Vincent was the nephew of a principal, he was transferred to the home office rather than dismissed. Van Gogh's relocation to Paris in July 1875 was a stopgap measure that failed: his uprooting embittered him, and the change of scene did nothing to improve his professional productivity. Taking a room in Montmartre, at the city's northern edge, he led a reclusive

life. His only friend was a young English colleague, Harry Gladwell, who spent many evenings reading the Bible with Van Gogh and sharing frugal meals in his quarters.

Declaring himself reborn in Christ, Van Gogh became a devotee of the *Imitatio Christi*. A favourite text of Groningen preachers, this medieval devotional handbook, attributed to Thomas à Kempis, encourages withdrawal from mundane pursuits and renunciation of earthly pleasures. Van Gogh embraced its asceticism, and, though he continued to read George Eliot, taking up *Scenes of Clerical Life* (1857), *Silas Marner* (1861) and *Felix Holt, the Radical* (1866) – all of which treat evangelical Christianity and the theme of redemption – he destroyed his copy of *L'Amour* and urged Theo to do likewise. He advised his brother that love for art and nature might fuel religious feeling but should never substitute for it. On his own, still frequent, visits to the Louvre and the Luxembourg, Vincent carefully attended to works that stirred his soul.

He took no interest in the sensational new painting that was generating controversy in Paris in the mid-1870s. Throughout his stay (May 1875 to March 1876), Van Gogh remained oblivious to the style that a critic had dubbed 'Impressionism' in response to the first group exhibition by Camille Pissarro (1830–1903), Claude Monet (1840–1926), Pierre-Auguste Renoir (1841–1919) and

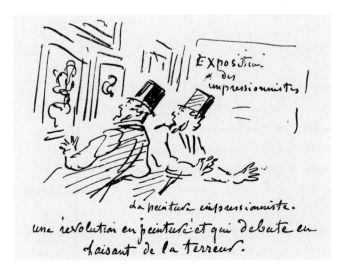

16
Cham
(Amédée-
Charles-Henry
de Noé),
A caricature
of the first
Impressionist
exhibition in
Paris, 1874.
Engraving.
The caption
translates: 'A
revolution in
painting, and
one that begins
by terrorizing.'

their associates in the spring of 1874 (16). The French painters he admired at this time were Jules Breton and the recently deceased Millet and Corot, and when Van Gogh visited the gallery of the Impressionists' dealer, Paul Durand-Ruel, it was to examine Barbizon School etchings. He was attuned to undercurrents of piety in those painters' depictions of rural life; at the sale occasioned by Millet's death in 1875, Van Gogh reported, 'I felt like saying, "Take off your shoes, for the place where you are standing is Holy Ground"'.

As his interest in the art business waned, dereliction of duty led to Van Gogh's dismissal in January 1876. When Adolphe Goupil's successor, Léon Boussod (who, in partnership with his son-in-law, eventually changed the firm's name to Boussod & Valadon), gave him three months' notice, Vincent reacted philosophically: 'When the apple is ripe,' he remarked to Theo, 'a soft breeze makes it fall.' He set his sights on a lay ministry in England; at twenty-three, he felt too old to commence studies for ordination, but he hoped that his command of foreign languages and 'experiences in different countries, of mixing with … poor and rich, religious and irreligious' might compensate for the incompleteness of his education. Eliot's description in *Silas Marner* of a community of factory workers who establish their own chapel had convinced him, he wrote, of the 'longing for religion' among 'labourers and the poor'. Intent on preaching among them, he took an unpaid job at an English boys' school as a foothold from which to pursue his goal.

Back in England, Van Gogh was disappointed to learn that he was considered too young for work in an urban mission. His job quest, however, led him to the Revd Thomas Slade-Jones, a Congregationalist minister with Methodist connections, who ran a chapel at Turnham Green outside London, and a boys' school at his home in Isleworth. Promised both a small salary and a chance to aid in Slade-Jones's ministry, Van Gogh jumped at an offer of employment at the school. Its students were 'boys from the London markets and streets' whom he taught history and languages, led in prayers and hymns, and read to from the Bible. He also taught Sunday school at the Turnham Green chapel and conducted prayer

17
A sketch of Petersham and Turnham Green churches, from a letter to Theo, 25 November 1876.
Van Gogh Museum, Amsterdam (Vincent van Gogh Foundation)

het kan licht gebeuren dat Gij ook nog eens te
Parijs komt. 's avonds half 11 was ik weer hier
terug, ik ging gedeeltelijk met de underground
railway terug. – Gelukkig had ik wat geld binnen
gekregen voor Mr Jones. Ben bezig aan Ps. 42:1
Mijne ziel dorst naar God, naar den levenden God
Te Petersham zei ik tot de gemeente dat zij slecht
Engelsch zouden hooren, maar dat als ik sprak
ik dacht aan den man in de gelijkenis die
zei „ heb geduld met mij en ik zal u alles
betalen" God helpe mij. – of liever schets
Bij Mr Obach zag ik het schilderij van
Boughton : the pelgrims progress. – Als Gij ooit
eens kunt krijgen Bunyan's Pilgrims pro-
gress het is zeer de moeite waard om dat
te lezen. Ik voor mij houd er ziels veel van.
Het is in den nacht ik zit nog wat te werken
voor de Gladwell's te Lewisham, een en ander over
te schrijven enz, men moet het ijzer smeden als
het heet is en het hart des menschen als het is
brandende in ons. – 's Morgen weer naar Londen
voor Mr Jones. Onder dat vers van The journey of life
en the three little chairs zou men nog moeten
schrijven: Om in de bedeeling van de volheid der
tijden wederom alles tot één te vergaderen in
Christus, beide dat in den Hemel is en dat op aarde
is . – Zoo zij het. – een handdruk in gedachten
groet de Hr en Mevr. Tersteeg voor mij en allen bij Roos
en Haanebeek en v Stockum en Mauve, à Dieu en
 geloof mij
 uw liefh. broer
 ♥s Vincent

Petersham Turnham Green

meetings and Bible study at two Methodist churches nearby (17).
With Slade-Jones's encouragement, in November 1876 Van Gogh
delivered his first full-fledged sermon.

He proudly sent the full text to Theo. Psalm 119:19 ('I am but a
stranger here on earth, hide not thy commandments from me')
was the point of departure for remarks that drew on Vincent's own
experiences of displacement to evoke the Christian's arduous
journey from birth to salvation. Recalling the pain of relinquishing
childhood's 'golden hours' to make his way in the world, he alluded
to the detour he had taken from a well-marked path. He compared
the journey of earthly life to both the disciples' stormy crossing on
the Sea of Galilee (John 6:17–21) and a wayfarer's hike toward a
mountain peak. Tipping his hat to John Bunyan's allegorical account
of his own conversion, Van Gogh declared 'Our life is a pilgrim's
progress', and he went on to paraphrase Christina Rossetti's poem
on Christian commitment, 'Up-hill'. He connected both texts to 'a
beautiful picture I once saw': a sunset view of an autumn landscape
cut by a roadway, where a black-clad woman (perhaps echoing
Michelet's) greets the traveller. Like the word-painted landscapes
of *L'Amour* and *Adam Bede*, Van Gogh's description is detailed,
colouristic and spatially precise. Remarks made to Theo suggest that
its primary inspiration was a Boughton painting titled *The Pilgrim's
Progress*, but this work has not been traced. It has been argued that
Van Gogh actually meant Boughton's *God Speed!* of 1874 – an image
of Canterbury pilgrims in springtime – but his description is closer
to *Bearers of the Burden* (see 14). Perhaps he conflated two or more
images in memory, possibly adding his recollections of a 'word
painting' to those of an actual picture. Whatever the case, his
decision to end his sermon with a visual image followed the practice
of the Dutch preachers Vincent most admired (including his father
and his uncle Johannes Stricker), who often vivified homilies with
edifying picture-based poetic commentaries (*bijschriften-poëzie*).

Having delivered his sermon, Vincent exulted to Theo, 'It is a delight-
ful thought that in the future wherever I go, I shall preach the Gospel;
to do that *well*, one must have the Gospel in one's heart.' He similarly

apprised his parents of his achievement and his aims. While
Theodorus and Anna cannot have opposed their eldest son's piety,
the fervour of Vincent's devotion worried them. Groninger or not, the
Revd Van Gogh was enough of a traditionalist to feel that preachers
should be properly trained and ordained. When Vincent returned
home for the Christmas holidays, his family prevailed on him to
remain in Holland. Recognizing the strength of his desire to preach,
Theodorus eventually agreed to support his studies for the ministry.

From May 1877 until July 1878 Vincent prepared for his university
entrance exams in Amsterdam. He lived with Theodorus's brother Jan
(commandant of the Amsterdam navy yard) while his studies were
monitored by the Revd Johannes Stricker, a noted theologian and
preacher who was married to one of Anna's sisters. Stricker found
a professor of classics to tutor Vincent in Latin and Greek, and a
mathematician to teach him algebra. The aspiring preacher, however,
doubted the necessity of mastering ancient tongues and higher
mathematics. Convinced that his knowledge of the Bible, the
Imitatio Christi and Bunyan's *Pilgrim's Progress* (1678) would stand
him in perfectly good stead, Vincent was impatient with the long
preparation for ordination. His interest in secular culture revived
as he discussed art with his uncle Cor, read Michelet's and Thomas
Carlyle's histories of the French Revolution, and Charles Dickens's
novelization of its dramatic events, *A Tale of Two Cities* (1859).
Vincent found that visual imagery often put him in mind of Scripture,
and covered the margins of the prints he owned with citations from
the Bible, the *Imitatio* and other devotional verse (see 5). Recanting
earlier admonitions, he advised Theo to 'have a good time, try to find
something in art and in books', and even asked his brother to send
him a copy of the page from Michelet describing the woman in black.

After more than a year's study for his exams, Vincent threw up his
hands in frustration. In an effort to salvage his future, Theodorus
arranged (with Slade-Jones's help) Vincent's provisional acceptance
at an evangelists' training school near Brussels. Its three-year course
allowed students to do fieldwork while working towards certificates,
and offered small stipends to promising candidates. Vincent failed to

distinguish himself, and after three months he was told he
could continue his coursework but must pay his own way. Already
exasperated by what seemed unnecessarily lengthy studies, he
convinced the Synodal Board to let him take up a mission instead, and
in December 1878 he settled in the Borinage, a Belgian coal-mining
district. There he would work as a minister's assistant and, as he later
remarked, 'take a free course at the great university of misery'.

The Borinage is in southern Belgium, some distance from its urban
centres, but by the time Van Gogh moved there, nature had been
overrun by industry (18). Its mineshafts were surrounded by 'poor
miners' huts, a few dead trees black from smoke, thorn hedges,
dunghills, ash dumps'. In the snow, Van Gogh observed, 'the effect

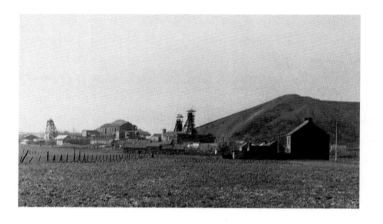

18
Photograph of
the Borinage,
c.1880

19
*Miners Going
to Work*,
1880.
Pencil;
44·5 x 56 cm,
17½ x 22 in.
Kröller-Müller
Museum, Otterlo

is like black characters on white paper – like pages of the Gospel.'
Though he regularly addressed the small flock that gathered in a local
meeting room, the actualities of the miners' situation challenged his
idealist notions. Sermonizing soon took a back seat to a hands-on
ministry that involved nursing the sick and injured. In an effort to
alleviate his neighbours' material want, Van Gogh gave away most
of his possessions. The Synodal Committee that evaluated his work
commended this 'spirit of self-sacrifice', but judging Van Gogh an
untalented speaker, dismissed him from his post.

When a new man took over in October 1879, Van Gogh abandoned
his calling to preach, but he remained in the Borinage – lonely,

demoralized and despairing of his future. He later recalled asking himself, 'How can I be of use in the world?' His attitude toward both evangelicalism and traditional religious institutions had soured, but Van Gogh retained his faith in God and love of Christ. He gradually forged a self-styled religious humanism that allied Christian convictions with ideas drawn from nineteenth-century novelists and philosophers. 'Homesick for the land of pictures', he had turned to literature instead, indulging a 'more or less

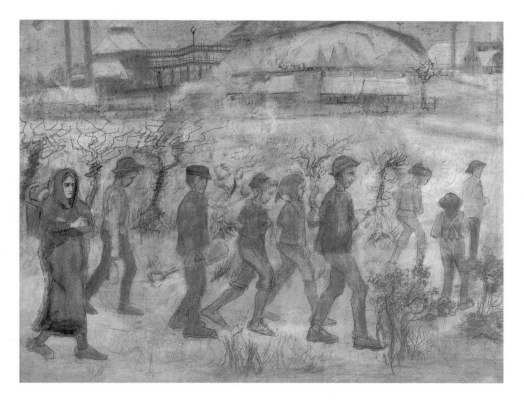

irresistible passion for books'. In the winter of 1879–80, Van Gogh read Michelet anew, took up Shakespeare, and devoured novels including Harriet Beecher Stowe's abolitionist saga *Uncle Tom's Cabin* (1852), Dickens's *Hard Times* (1854) – a rumination on the modern worker's plight – and Victor Hugo's scathing denunciation of the French penal system, *Le Dernier Jour d'un condamné* (*The Last Day of a Condemned Man*; 1829). He began to channel what remained of his zealotry toward social causes (though his concern with the

'welfare of the poor oppressed' would remain sentimental, classbound and more philosophical than active).

In this era of reflection, which he later characterized as a 'moulting time' from which he emerged renewed, Van Gogh came to see books by 'serious masters' as secular equivalents of Scripture and verbal equivalents of the pictures he loved. He told Theo that his discovery of 'something of Rembrandt in Shakespeare [prompted, perhaps by Blanc's comparison of the two in *Gazette des Beaux-Arts*], and of Correggio in Michelet, and of Delacroix in Victor Hugo' not only sustained him in his isolation from the art world but strengthened his belief that 'everything which is really good and beautiful … comes from God.' That conviction justified his renewed passion for products of secular culture, though Vincent wondered how 'to put those self-same passions to good use'. When the answer finally came to him, he recognized it as one he had often considered: 'I said to myself, in spite of everything I shall rise again: I will take up my pencil, which I have forsaken in my great discouragement, and I will go on with my drawing. From that moment everything has seemed transformed for me.' As early as 1880, Van Gogh described his work as a means of recovering 'mental balance', a process that 'somehow or other … will set me right'. He now saw the possibility of expressing convictions visually, and his art, idea-driven from the start, would continue to reflect spiritual yearnings.

20
Jean-François Millet,
The Sower,
1850.
Oil on canvas;
101·6 x 82·6 cm,
40 x 32½ in.
Museum of Fine Arts, Boston

Compelled to move beyond the sorts of topographical and architectural studies he had produced in The Hague and in England, Van Gogh was drawn to the human element of the Borinage, and worked hard at figure drawing. He wished to improve on his clumsy renderings of his neighbours and their environment, particularly one in which a large mine building and its spoil heap form the shadowy backdrop for scrawny figures whose attenuated limbs and ungainly silhouettes are echoed by the spindly branches and dark trunks of trees beyond them (19). Before pressing on with such compositions, however, Van Gogh decided he must study figural works by artists he admired. Probably recalling Huysmans's advice, he thought it 'much better to copy good things' than to continue on his own without firm grounding, so in

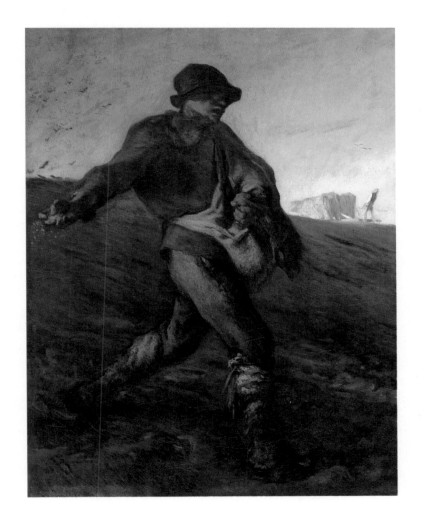

1880 he began making drawings based on prints after Millet's *Labours of the Fields* (1852), *Four Hours of the Day* (1858) and notorious *Sower* (1850).

When shown at the Paris Salon of 1850–1, Millet's *Sower* (20) struck many as anarchic, with its grimy, scowling protagonist casting metaphorical seeds of dissent. Some thirty years later, Van Gogh saw it differently, attracted to its Christian connotations. The Gospels of Matthew, Luke and Mark all record the parable in which Christ compared himself to a sower. As Matthew summarizes, 'The sower of the good seed is the Son of Man. The field is the world; the good seed stands for the children of the Kingdom, and weeds for the children of the evil one ... The harvest is the end of time. As the weeds are gathered and burned, so at the end of time ... the righteous will shine as brightly as the sun in the Kingdom of their father' (13: 37–40, 43). Van Gogh – who once described himself as an aspiring 'sower of God's word' – found Millet's image immensely compelling, and in September 1880 told Theo: 'I have already drawn "The Sower" five times ... and I am so completely absorbed in that figure that I will take it up again' (see 3). Indeed, the last of Van Gogh's variations upon Millet's striding seed-caster were made in spring 1890, just weeks before his death.

In addition to copying Millet, Van Gogh in the Borinage studied the popular drawing manuals of Charles Bargue, which were published by Goupil and sent to him by Teersteeg, his former manager in The Hague. In the autumn of 1880, Van Gogh made completion of Bargue's *Cours du dessin* (*Drawing Course*) a prerequisite for reworking his drawings of miners, in which he set himself the simple goal of achieving 'something human'. Awed by artists such as Millet, Breton and Israëls, whose images of the working class seemed to capture 'evangelically' the essence of 'that precious pearl, the human soul', Van Gogh scarcely dared dream of equalling them. Yet 'maybe someday', he told Theo, 'you will see that I too am an artist'.

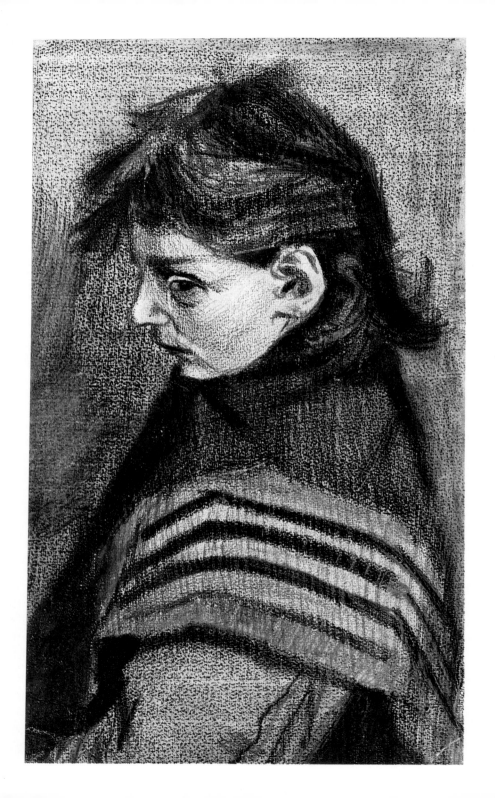

In the autumn of 1880, Van Gogh's longing for 'the land of pictures' prompted him to leave the Borinage for Brussels, a capital city with a rich artistic heritage and a varied contemporary art scene. While the city's arts academy continued to inculcate classicism, the French-influenced Société Libre des Beaux-Arts (established 1868) championed nature-based painting and freedom from academic conventions. Another artists' society, L'Essor (established 1876), was dedicated to the pursuit of realism. Apparently unbeknownst to Van Gogh, the Belgian capital was on the brink of becoming an international centre of the avant-garde: the journal *L'Art Moderne*, which began publication in 1881, was to become the official organ of Les Vingt ('the twenty'), a Brussels-based artists' group founded in 1884 to promote innovation through exhibitions of unconventional work from Belgium and abroad. Indeed, Van Gogh's first public notoriety would owe a great deal to his work's display at Les Vingt's exhibition of 1890.

That was still a long way off when he arrived in Brussels as a novice draughtsman, hoping 'to have good things to look at and see artists at work'. His move there commenced the series of shifts between country and city that marked Van Gogh's decade-long artistic career, throughout which he routinely felt torn between his inbred preference for rustic life and his desire for the stimulus of older art and the company of other painters.

Theo, too, had made a move in 1880: to Goupil's Paris organization. In contrast to his older brother, he quickly ingratiated himself with Goupil's new owners, Boussod and Valadon, who made him manager of their Montmartre gallery. A salary increase allowed Theo to relieve their father of most of the burden of Vincent's support. He also became his brother's chief adviser and confidant. His approbation became terribly important to the artist, who assured him, 'I will try

21
Girl with Shawl,
1883.
Black chalk
and pencil;
43.3 x 25 cm,
17 x 9⅞ in.
Kröller-Müller
Museum, Otterlo

hard not to disappoint you'. Their adult relationship (mainly letter-based) would always be complicated by the fact that, while Vincent depended on and expected his brother's financial and emotional support, he sometimes felt diminished by this and resentful of his benefactor.

In Brussels, eager to re-enter the art world, Vincent sought out contacts from his past, calling on his uncle Hein's successor at the Goupil Gallery, and visiting the Hague School artist Willem Roelofs, who had a studio there. Both counselled him to enrol at the academy, but Van Gogh characteristically preferred to go his own way. He spent the next six months feasting his eyes on pictures old and new, continuing his work from Bargue, and taking lessons from a painter who goes unnamed in his letters. He found a friend in Anthon van Rappard (1858–92), a Dutchman who had met Theo while working in the Paris studio of French academician Jean-Léon Gérôme. Vincent was initially suspicious of Van Rappard's wealth and status as a son of minor nobility, as well as his academic training, but he soon warmed to the younger man, who joined L'Essor in Brussels. Over the next five years, Van Rappard was his most trusted colleague.

22
Landscape with a Windmill, 1881.
Pencil and charcoal;
35·5 x 60 cm
14 x 23½ in.
Kröller-Müller Museum, Otterlo

When Van Rappard made plans to leave Belgium for the Dutch countryside in spring 1881, Van Gogh quickly followed suit. He was eager to cut expenses and put his improved drawing skills to work in the depiction of subjects dear to his heart – open vistas and agrarian labour. As he later told Van Rappard:

You and I can do no better than to work after nature in Holland (landscape and figures). There we are ourselves, there we feel at home, there we are in our element. The more we know about what's happening abroad, the better, but we must never forget that we have our roots in Dutch soil.

In the interests of economizing, Van Gogh moved into his parents' house. Theodorus and Anna were then settled in Etten, a Brabant village not unlike Zundert. In taking up residence there, Vincent returned not only to rural life but to the landscape of his childhood, albeit altered by industrialization and agricultural advances.

After years of casting about, he found reassuring affirmation of his rootedness in the area's familiar moors and marshland, windmills and thatched cottages (22). Though he continued to copy Millet and work from Bargue's *Exercises*, he was often on the heath, grappling with living nature, in which he found a formidable opponent:

Nature begins by resisting the artist, but he who really takes it seriously does not allow that resistance to put him off his stride; on the contrary, it is that much more of a stimulus to fight for victory, and at bottom nature and a true artist agree ... After one has struggled and wrestled with nature, she sometimes becomes more docile and yielding ...

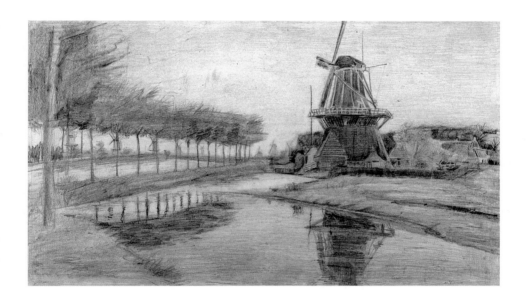

what Shakespeare calls 'the taming of the shrew' ... In many things, but especially in drawing, I think that holding tight is better than letting go.

Van Gogh's image of the artist as male combatant locked in battle with feminized nature was indebted to the French novelist and critic Émile Zola, who describes art-making in much the same way in *Mes Haines* (*My Hatreds*; 1866), an essay collection Van Gogh read in the Borinage. Now, as he struggled to render three-dimensional reality (a process Van Gogh found considerably more taxing than reproducing the two-dimensional images in his copybooks), he was buoyed by Zola's accounts of other artists' arduous efforts.

Though far from any art centre, he was not without professional camaraderie. Van Rappard occasionally worked with him in Etten, and in September Van Gogh visited The Hague. As in Brussels, he called at the Goupil gallery, where he showed his portfolio to Teersteeg. He also renewed his acquaintance with painters he knew from his days as a dealer – notably Anton Mauve, a principal of the Hague School who was now a relation by marriage, the husband of Vincent's cousin Jet Carbentus since 1874 (23). Van Gogh also visited Théophile de Bock (1851–1904), who took him to see the recently completed panorama depicting Scheveningen, a fishing community on the outskirts of The Hague (24).

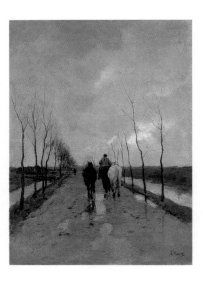

23
Anton Mauve,
A Dutch Road,
c.1880.
Oil on canvas;
50 x 37 cm,
19⅞ x 14½ in.
Toledo Museum
of Art, Ohio

24
**Hendrik
Willem
Mesdag**,
*Panorama of
Scheveningen*,
1881.
Oil on canvas;
14 x 120 m,
45 x 400 ft.
Panorama
Mesdag,
The Hague

Funded by a Belgian investment group and designed by the Hague School marine painter Hendrik Mesdag, the 360-degree view of Scheveningen was one of hundreds of panoramas made in the nineteenth century. First popularized in Britain, these large-scale vistas were mounted in round pavilions with centralized viewing spaces, and drew large paying audiences. Often taken on tour, panoramas could acquaint stay-at-homes with faraway sites and plunge modern audiences into epic events (from Christ's Crucifixion to the Battle of Gettysburg). Mesdag's was commissioned around the time that 'panoramania' (as the *Illustrated London News* called it) began to wane. Rather than undertaking a distant place or time,

Dear Reader, Books by Phaidon are recognised world-wide for their beauty, scholarship and elegance. We invite you to return this card with your name and e-mail address so that we can keep you informed of our new publications, special offers and events. Alternatively, visit us at **www.phaidon.com** to see our entire list of books, videos and stationery. Register on-line to be included on our regular e-newsletters.

Subjects in which I have a special interest

☐ Art ☐ Contemporary Art ☐ Architecture ☐ Design ☐ Photography

☐ Music ☐ Art Videos ☐ Fashion ☐ Decorative Arts ☐ *Please send me a complimentary catalogue*

	Mr/Miss/Ms Initial	Surname
Name	└─┴─┘	
No./Street	└─┴─┘	
City	└─┴─┘	
Post code/Zip code	└─┴─┴─┴─┴─┴─┴─┘ Country └─┴─┴─┴─┴─┴─┴─┴─┴─┴─┴─┴─┴─┴─┴─┴─┴─┴─┘	
E-mail	└─┴─┘	

This is not an order form. To order please contact Customer Services at the appropriate address overleaf.

Please delete address <u>not</u> required before mailing

Affix

stamp

here

PHAIDON PRESS INC

7195 Grayson Road

Harrisburg

PA 17111

PHAIDON PRESS LIMITED

Regent's Wharf

All Saints Street

London N1 9PA

Return address for USA and Canada only

Return address for UK and countries
outside the USA and Canada only

the Hague School *plein-air* artist chose to record a nearby locale at an everyday moment, sketching Scheveningen – a village that was fast becoming a bathing resort – from a dune that was soon to be levelled. To execute the panorama, he recruited a team of local talents: his wife, Sientje (1834–1909), De Bock, B J Blommers and G H Breitner (1857–1923). Measuring some 14 × 120 m (45 × 400 ft), the finished painting was made in less than four months.

Van Gogh, often hungry for collegial contact, was surely intrigued by the collaborative aspect of Mesdag's undertaking. The vision of artistic cooperation that became a preoccupation of his later life

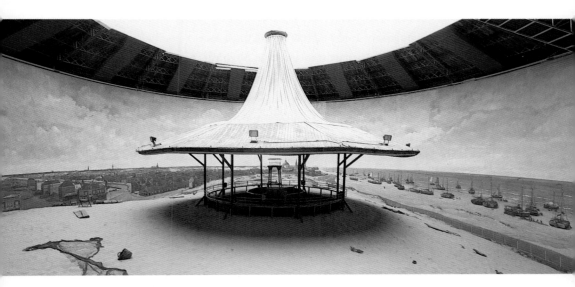

(and underlay Van Gogh's ambition to build a 'studio of the South' in Provence; see Chapter 5) perhaps owed something to the successful teamwork he saw manifested in the panorama. The populist dimension of this painting-cum-spectacle also appealed to Van Gogh, who was drawn to art intended for the many rather than the few (for example, English illustration). Finally, as he continued to wrestle with perspectival problems in his own work, Vincent doubtless found the panorama's masterful illusionism impressive. He told Theo that viewing it had reminded him of Thoré's remark on Rembrandt's *Anatomy Lesson*: 'This picture's only fault is that it has no fault.'

Invigorated by his visit to The Hague, Van Gogh pursued figural work with new resolve. Determined 'to observe and paint everything that belongs to country life', he paid Etten neighbours to pose rustic tasks. He considered the line drawings he now elaborated with sepia and watercolour a marked improvement over his earlier efforts, though most continued to betray his copybook apprenticeship. Bargue's manuals put a premium on linear description, privileging contour over the internal tonal gradations ('shading') by which artists impart illusions of volume. The figures resulting from Van Gogh's first efforts at life drawing are similarly dominated by contour, and reflect, too, his tendency to 'hold tight' rather than 'let go'. As he strove to translate living subjects into two-dimensional representations, Van Gogh compulsively drew and redrew the lines separating figure from ground and one body part from another. A typical result is *Worn Out* (25), with its relief-like figure hovering before a cottage interior rather than sitting within it. The man's shoulder may be seen to float free of the torso it is meant to adjoin, and his elbow does not so much rest upon his thigh as melt into it.

Compositionally and thematically, *Worn Out* recalls the work of Israëls (26), the Hague School painter Van Santen Kolff called 'master of pity *par excellence*'. Israëls's focus on the figure (mainly working-class people in dingy interiors) set him apart from his colleagues and won Van Gogh's admiration. The emphatic line and charged English-language title Van Gogh bestowed on *Worn Out* also link it firmly to the graphic art that had captivated him in London. A resemblance has been noted between the pose of *Worn Out*'s model and that of a figure in Arthur Boyd Houghton's frontispiece for the Household Edition of Dickens's *Hard Times* (27). The despondent posture of this man at the end of his tether was one Van Gogh would often reprise.

Ponderous contours of the sort seen in *Worn Out* exacerbate the stiff look of drawings of field labourers Van Gogh made in 1881, where lines collide at angular junctures. Their thickness contributes to the effect of inertia that Van Rappard remarked in a sketch that showed 'not a man who is sowing, but a man posing as a sower' (28). Van Gogh's difficulty in capturing the proportions of actual

25
Worn Out,
1881.
Pen and ink,
pencil and
watercolour;
23·4 x 31 cm,
9¼ x 12¼ in.
P and N de Boer
Foundation,
Amsterdam

26
Jozef Israëls,
Growing Old,
c.1878.
Oil on canvas;
160 x 101 cm,
63 x 39¼ in.
Gemeentemuseum,
The Hague

27
**Arthur Boyd
Houghton**,
frontispiece
to Charles
Dickens's
Hard Times,
London, 1866

28
The Sower,
sketch from a
letter to Anthon
van Rappard
dated 12 October
1881.
Pen and
brown ink;
11·5 x 7 cm,
4½ x 2¼ in.
Private collection

human bodies manifests itself in the way his figures' torsos often seem undersized in relation to their limbs. Well aware of these gaucheries, Van Gogh met criticism with equanimity, remarking that it might take years to gain his stride. In the meantime, he told Van Rappard, his courtship of 'Dame Nature' continued, 'though she is still resisting me cruelly, and does not want me yet, and often raps me over the knuckles when I dare to prematurely consider her mine'.

He was less jocular about parallel attempts to win the heart of his uncle Stricker's daughter, Kee, a 35-year-old widow who had lost her husband three years before. She and her young son spent a few weeks in Etten in 1881, and in his biography of Van Gogh, David Sweetman suggests that Kee, in her widow's garb, reminded Vincent of Michelet's description of the melancholic woman in black. She certainly stirred Van Gogh's tendency to romanticize damaged women (in 1878 he had declared that he would pass up a young beauty for a poor, ugly, old or 'somehow unhappy' woman, who 'through experience and sorrow, has gained a mind and a soul'). During her visit, he accompanied her on country walks, and fell passionately in love. When he declared himself, however, Kee's refusal was adamant (Vincent quoted her as saying, 'No, never, never') and her departure to Amsterdam swift.

For months, Vincent pleaded with Kee by letter, despite his parents' entreaties to desist. He took encouragement from *L'Amour* and its sequel, *La Femme* (*Woman*; 1859), openly declaring that he 'attached more value to Michelet's advice' than to his father's. As Theodorus derided his son's 'infection' by French ideas, Vincent insisted one could 'get more from rereading Michelet than from the Bible'. Urging Theo to enter the fray, Vincent remarked that lovesickness distracted him from work, pointedly adding, 'My work certainly concerns you … who have already given so much money to help me succeed'. Linking his hope of professional success to his successful pursuit of Kee, Vincent argued that 'to become an artist one needs *love*', and, in a less sentimental vein: 'A married artist with a wife spends less and is more productive than an unmarried one with a mistress.' Vincent asked Theo to fund travel to Amsterdam, where he hoped to confront Kee in person, and advised him to look on the expense as a necessary investment in his artistic future. When the money arrived, Vincent made a surprise call on the Strickers, and went so far as to hold his hand in a lamp flame to demonstrate his resolve to see Kee. Her parents adamantly refused further contact, and Vincent never saw her again.

The travel money served his professional enterprise nonetheless, for rather than returning immediately to Etten, the lovelorn artist stopped at The Hague, where he visited Teersteeg, De Bock and, most importantly, Mauve. The last saw both the promise and the flaws in the younger artist's work ('Mauve says the sun is rising for me, but is still behind the clouds') and offered useful criticism (suggesting, for instance, that Van Gogh's figures would be better proportioned if observed from farther away). A co-founder of the Dutch Watercolour Society (with Mesdag and Jacob Maris), Mauve was a great proponent of that medium and tutored Van Gogh in its usage, starting him on still life, then having him paint a Scheveningen woman from life (29).

Lack of funds soon forced Vincent's return to Etten, where (having found yet another father figure in Mauve) he was increasingly disrespectful of Theodorus. Grievances against his father and

29
Scheveningen Woman,
1881.
Watercolour;
23.5 x 9.5 cm,
9¼ x 3¾ in.
Van Gogh
Museum,
Amsterdam
(Vincent
van Gogh
Foundation)

Stricker stoked Vincent's resentment of clergymen in general, whom he condemned as hypocrites. His disdain for his father's calling, his church and his associates came to a head with Vincent's refusal to attend church on Christmas Day. After a heated exchange, Theodorus ordered him out of the house, and Vincent boarded a train to The Hague, where he would spend the next twenty months.

Between 1800 and 1850 The Hague's population had doubled. In 1881, at about 100,000 people, it was still rising, and cheap housing was scarce. Van Gogh took a room with an alcove in a house that stood amid the haphazard suburban sprawl that accompanied the mid-century development of Dutch railways. The surrounding meadowland was cut by train tracks, the horizon studded with factory chimneys. With borrowed money, he bought wood engravings from *The Graphic* and *Illustrated London News* to decorate his new lodgings.

Thanks to his connections, Van Gogh got off to a good start in The Hague. Mauve arranged his attendance at life-classes at Pulchri and introduced him to several of its members, including the well-known watercolourist J H Weissenbruch (1824–1903). Weissenbruch had a reputation for forthright critiques, and his favourable opinion of Van Gogh's efforts was confidence-building, as was Teersteeg's purchase of one of his recent drawings. Van Gogh was further heartened by his uncle Cor's decision to commission twelve views of The Hague from him. Working quickly, Vincent received thirty guilders for his efforts (his rent at the time was seven guilders per month).

His drawings for Cor present the city as Van Gogh experienced it daily in 1882, with scant reference to the historical centre that once inspired him (see 11). Their predominant subjects are street life in working-class neighbourhoods (30), and scenes of labour and production on The Hague's increasingly industrialized periphery. Between the old city and the country villas to which the most prosperous citizens escaped lay a marginal region where The Hague's pre-industrial past encountered its industrial present – a dunescape, for example, overrun with workers laying tracks for the steam tram

that would link Scheveningen to The Hague (31). When an artist friend, H J van der Weele (1852–1930), branded Van Gogh's drawing of this scene 'overcrowded', and suggested a more 'beautiful' alternative in the image of a single, backlit worker at sunset, Vincent retorted that a penchant for 'pleasant' things 'must not detract from the truth'. Aware that this commitment produced images that Cor and others might dislike, Vincent assumed the take-it-or-leave-it stance he eventually perfected.

His forays into urban realism can be linked to his love of English graphic art and his friendship with the Dutch artist G H Breitner in early 1882. After moving to the city in 1880, Breitner collaborated

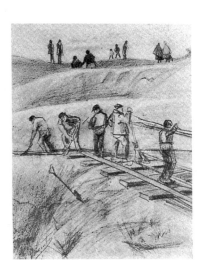

30
Bakery in the Geest,
1882.
Pencil, pen and ink;
20·5 x 33·5 cm,
8 x 13¼ in.
Gemeente-museum,
The Hague

31
Sand Diggers,
1882.
Pencil;
27 x 20 cm,
10⅝ x 7⅞ in.
Private collection

on Mesdag's panorama, but since its completion he had steered an independent course. In contrast to Hague School elders who ventured well outside the city to paint, the younger man was drawn to the heart of the modern metropolis, his interest fuelled by urban fiction by Dickens and the Goncourt brothers, Edmond and Jules. In Breitner's company, Van Gogh explored places Hague School artists overlooked: urban markets, public soup kitchens and the third-class waiting room at the railway station. Breitner apparently read *L'Amour* at Van Gogh's instigation, and in turn may have kindled his interest in French naturalist literature. Billed by its adherents as an antidote to the poetic excesses of Romantic prose and the moralistic

sentimentality of mainstream French fiction of the mid-nineteenth century, literary naturalism is characterized by its focus on contemporary life as experienced by people from all social strata. Rooted in the earlier work of Honoré Balzac and Gustave Flaubert, the naturalist movement gained prominence in the late 1870s, after publication of Zola's *L'Assommoir* (1878), the story of a laundress's drunken decline that, according to its author, was the 'first novel about the people that doesn't lie, that has the smell of the people'. A *succès de scandale*, *L'Assommoir* established Zola's reputation for probing unexplored sectors of society, and brought him a following of younger writers, including J-K Huysmans and Guy de Maupassant. Beyond this circle of self-declared 'naturalists', other, more established authors such as Edmond de Goncourt and Alphonse Daudet came to be so labelled (despite their own protests) because of their work's perceived affinity to naturalist fiction.

Van Gogh, who already knew Zola's *Mes Haines*, began his exploration of the author's fiction with *Une Page d'amour* (*A Page of Love*; 1878), a tale of illicit but decidedly middle-class love, and one of Zola's more lyrical novels. He was impressed by the extensive 'word paintings' of Parisian vistas that complement the storyline by establishing moods keyed to its characters' emotional states. Deciding to 'read everything by Zola', he took up six more novels by year's end. He particularly admired *L'Assommoir*, a book that vividly describes working-class haunts of the sort he and Breitner frequented.

Though Van Gogh was gratified when his uncle Cor commissioned six more townscapes, his heart was elsewhere. 'If I did not have to make city views for a living,' he confided to Van Rappard, 'I would do nothing but figure drawings these days.' Keen to generate emotion with his art, Van Gogh was drawn primarily to expressive human forms. *Sorrow*, a chalk drawing he made in April and considered the 'very best' thing he had yet done, epitomizes his aims (32). This unsparing depiction of a woman huddled in a landscape was intended, Van Gogh wrote, to convey what Michelet termed 'the void in the heart that nothing can fill'. The mournfulness communicated by posture and title is elaborated by a citation from Michelet

32
Sorrow,
1882.
Pencil and
black chalk;
44·5 x 27 cm,
17½ x 10¾ in.
Walsall Museum
and Art Gallery

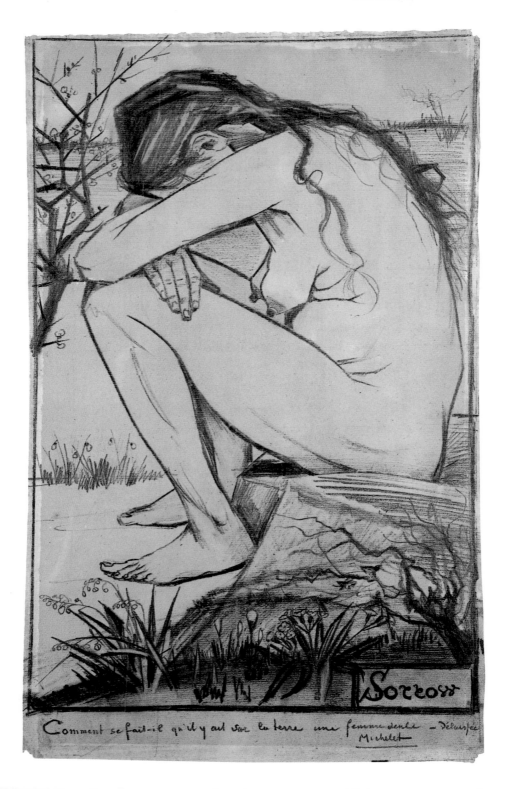

Comment se fait-il qu'il y ait sur la terre une femme seule – Délaissée
Michelet

('How can it be that there is a woman alone, abandoned on earth?')
and telling pictorial detail: the woman's unkempt hair bespeaks
neglect, the nakedness of her sagging breasts and distended belly
vulnerability. While flowers and budding branches signal renewal
around her, the woman – head buried in her arms – remains
poignantly oblivious.

Van Gogh drew *Sorrow* in the 'English style', with an emphasis on
'simple, characteristic lines'. Graphic similarities aside, *Sorrow*
lacks the specificity of the English illustrations he admired; it is
emblematic rather than anecdotal. The nude in the landscape is
a timeless subject, and the allegorical use of the female form to
personify an abstract entity (*eg* 'sorrow') is a classical conceit.
Despite the anti-classical appearance of Van Gogh's model and
drawing style, *Sorrow* is traditionalist in conception, and it is more
explicitly meaningful than most of his work. As Van Gogh came
to realize, verbal labels of the sort he affixed here are not only
unnecessary additions to truly expressive imagery, but may limit
audience and interpretation. His mature work was rarely titled, and
only infrequently inscribed with words. It was shaped, nonetheless,
by the communicative impulse that prompted Van Gogh to annotate
Sorrow. 'It's a painter's duty to try to put an idea into his work',
he remarked. 'I want to do drawings that touch people. *Sorrow* is
a small beginning ... something straight from my own heart.'

It soon occurred to him that emotion explicitly stated in one image
could be implicitly communicated by another. Very much in the
spirit of his age, Van Gogh tended to ascribe human feelings and
sympathies to natural motifs – a poetic conceit that English artist
and critic John Ruskin (1819–1900) labelled 'the pathetic fallacy'
when he decried its overuse in an essay of 1856. Though authors
from antiquity onwards had attributed emotion to natural forms, the
practice was central to English and Continental Romanticism around
1800, and by 1840 had taken on a quasi-religious dimension in the
New England Transcendentalism of Ralph Waldo Emerson. In 1882,
as Van Gogh wrote from The Hague of the expressive and soulful
qualities of trees, sprouting crops, and 'trampled grass at the

roadside [that] looks as tired and dusty as slum-dwellers', he worked to tap such motifs' potential to communicate metaphorically emotions that his figures conveyed more literally. He found an apt pendant for *Sorrow* in *Roots*, the cropped view of a gnarled tree that is formally at odds with it (33). As different as these motifs first appear (the pale volumes of the figure contrasting with the dark angularities of the tree), Van Gogh considered them to be thematically linked by 'the struggle for life' each embodied, and the 'grim tenacity' with which both figure and tree 'cling to the earth, though half-uprooted by gales'.

These pictorial expressions of solitary struggle stemmed from Van Gogh's own experience: 'I don't think I'd be able to draw "Sorrow" if I didn't feel it.' Still haunted by Kee's rejection and the rift with his parents, he was freshly wounded by fallings-out with Mauve and Teersteeg. His difficulties with Mauve started when Van Gogh began to bridle at their mentor–student relationship. He rejected Mauve's advice to draw from plaster casts, and was increasingly reluctant to work in watercolour, preferring 'to scratch what I want to express with a hard carpenter's pencil or a pen'. Meanwhile, Teersteeg angered Van Gogh by remarking on his drawings' lack of charm and pronouncing them 'unsaleable'. When he, too, recommended work in watercolour, Van Gogh seethed. That medium, Vincent insisted, was ill-suited to his subject matter. To Theo he railed, 'No, let me be true to myself, and express severe, rough, but true things in a rough manner. I shall not run after art lovers or dealers; let whoever wants to come to me.' This obstinacy alienated former friends and won him few new ones, but it served to set Van Gogh firmly on his own course. His refusal to conform to prevailing modes, and his willingness to risk personal rejection and commercial failure, served his artistic enterprise well, as did his early realization that a picture's meaning need not reside in motif alone, and may also derive from the mode and medium in which it is rendered.

Van Gogh's hopes of forming artistic friendships in The Hague dwindled with his realization that 'I shall always move in a different sphere from most painters, because my conception of things, the

33
Roots,
1882.
Pencil, chalk,
pen and ink and
watercolour;
51 x 71 cm,
20 x 28 in.
Kröller-Müller
Museum, Otterlo

subjects I want to make, inexorably demand it'. Mauve's circle closed him out, and when complications from venereal disease forced Breitner into hospital for an extended stay, Van Gogh found himself virtually without colleagues, relying on Van der Weele for occasional professional companionship.

He was hardly alone, however, having formed a relationship with the woman who modelled *Sorrow*, Clasina (Sien) Hoornik (1850–1904). In fact, this alliance was probably as much to blame for Van Gogh's professional isolation as his artistic differences with Hague School painters. Sexual dalliances between artists and their models were common, but Van Gogh's decision to 'live with the people I draw' outraged his bourgeois associates. Hoornik, a Catholic, was a native of the Geest, one of The Hague's poorer neighbourhoods.

A seamstress who supplemented her income with prostitution, she was a single mother with another child on the way when Van Gogh met her. As he later told it, he took her as a model and, eventually, into his home 'to protect her and her child from hunger and cold'. By mid-1882 they were living as man and wife, an arrangement that continued for more than a year, during which time Vincent weathered gonorrhoea-related health crises and Sien delivered a son (conceived before she met Vincent), whose arrival prompted their move to larger lodgings.

Coming on the heels of his disappointment with Kee, Van Gogh's relationship with Sien may be seen as both an antidote to that failed dream and variant on it. The two women came from vastly different backgrounds, and when Vincent contrasted Sien's lack of refinement to Kee's propriety it was mainly with satisfaction. Sien's company allowed him to drop his own 'mask of reserve' and any pretension to social status. On the other hand, both Kee and Sien were mothers in their thirties who had borne grief. In Van Gogh's eyes, both were in need of a man, and each inspired what the art historian Carol Zemel has described as a fantasy of rescue. While Kee, less needy, declined such rescue, Sien accepted Vincent's attentions for a time, enabling him to 'put into practice' reflections on love that Kee had inspired.

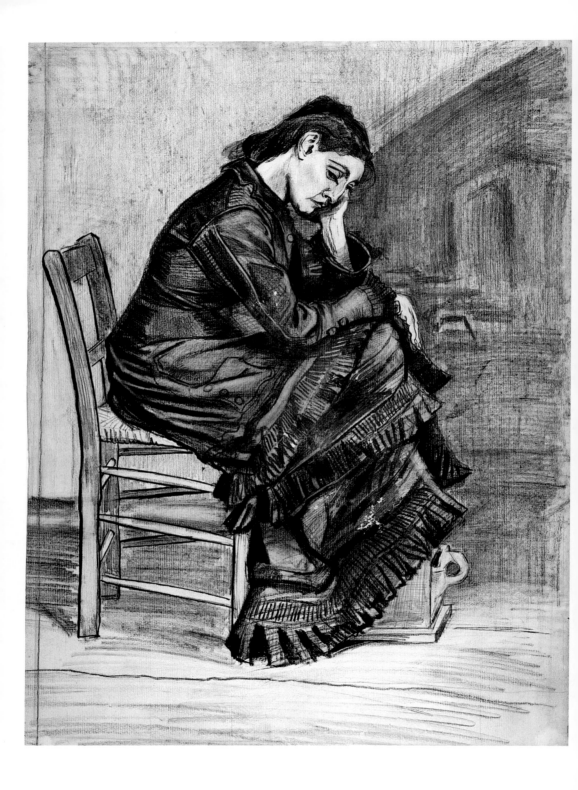

Zemel observes that Van Gogh took cues from Michelet and from Victorian popular culture as he played the role of saviour. Michelet wrote in *La Femme* that even a fallen woman may be redeemed by a caring man and eventually do him honour. Sien seems to have struck her protector as a living embodiment of the destitute women so often portrayed in the pages of *The Graphic* and *Illustrated London News*, and in the dark merino dress that he liked her to wear, she became yet another version of the 'woman in black' (34). Describing her to Van Rappard as 'ugly' and 'faded', Van Gogh declared Sien to be 'exactly what I want: her life has been rough,

34
Woman in Black, 1882.
Pencil, pen and ink and wash; 58 x 42 cm, 22¹⁄₄ x 16¹⁄₂ in.
Kröller-Müller Museum, Otterlo

35
Sien with Cigar, 1882.
Pencil, black and white chalk, ink and wash; 45·5 x 56 cm, 18 x 22 in.
Kröller-Müller Museum, Otterlo

and sorrow and adversity have put their marks on her – now I can do something with her'. His artist's eye saw the usefulness of her lined face, loose flesh and forlorn aspect, and he put them to work in images of alienation, material hardship and emotional distress (35; as well as 32 and 34). His conviction that Sien's busyness in his home and studio was good for her – indeed, essential to her salvation – dovetailed with his appetite for life drawing, and in the first months of their liaison he kept her well occupied. The modelling done by her and her family (mother, sister, children) yielded posed scenes and dozens of portraits (see 21).

36
*Orphan Man
with Umbrella*,
1882.
Pencil and wash;
48·5 x 24·5 cm,
19 x 9¾ in.
Kröller-Müller
Museum, Otterlo

37
*Fisherman
with Sou'wester*,
1883.
Pencil, black
chalk, pen
and ink;
47·5 x 29 cm,
18¾ x 11½ in.
Van Gogh
Museum,
Amsterdam
(Vincent
van Gogh
Foundation)

38
**Hubert von
Herkomer**,
*Heads of the
People: The
Coastguardsman*,
from *The Graphic*,
20 September
1879

Van Gogh found his male models among the pensioners at the Dutch Reformed Old People's Home. Locals referred to denizens of this church-run almshouse as 'Orphan Men', a designation Van Gogh adopted in written descriptions of the sunken-cheeked models he drew in their top hats and the numbered overcoats issued there (36). Most wear medals that identify them as veterans of the war of secession that liberated Belgium from Dutch rule in 1830. Their 'ruins of faces' pleased Van Gogh, who recalled similarly battered and expressive heads in the work of Rembrandt and Frans Hals

(1581/5–1666). Having made several full- and bust-length likenesses, he dressed some of the pensioners as fishermen in images that, as the art historian Lauren Soth remarks, are 'heads' rather than portraits, showing models impersonating characteristic types and occupations rather than appearing as themselves (37). Van Gogh himself made this distinction as he worked to transcend specifics and touch upon broad categories of humanity, citing a precedent in *The Graphic*'s feature called 'Heads of the People' – a gallery of 'types distilled from many individuals' (38).

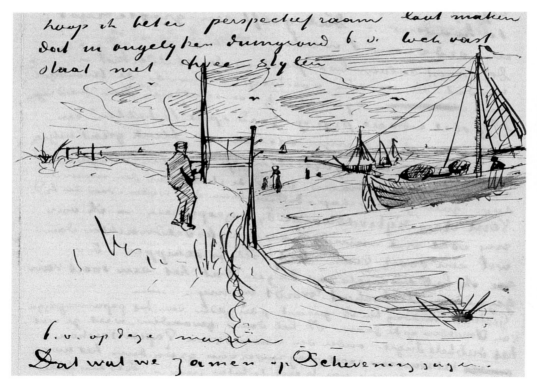

hoop ik beter perspectiefraam laat maken
dat in ongelyken duingrond b.v. toch vast
staat met twee stylen

b.v. op deze manier
Dat wat we zamen op Scheveningen zagen.

Van Gogh described himself as 'ten times' less interested in landscape than the figure. Cor's second commission kept him at it, however – as did the pleasure he took in the perspective frame he acquired in The Hague. Long used by artists (39), these devices have openings strung with taut wires that impose horizontal and diagonal guidelines on subjects viewed through them. Both Mauve and Roelofs used such frames, and Van Gogh's helped him work quickly and confidently before the sorts of vistas that once gave him pause. He took his frame to Scheveningen, where he set it up on the beach (40), as well as in the yard of a fish-drying barn (41), where it helped him plot the deep and slightly spiralling space that veers towards two distinct vanishing points (one on either side of the barn). With this linear substructure mapped, Van Gogh animated the scene with graphic marks of wide-ranging shape, direction, thickness and density of distribution. Playing herringbone patterns, stippling, striation and scallops against islands of untouched paper, he set up a rich play of textures and tones to which colour would be a superfluous addition.

It was only at this point (mid-1882) that Van Gogh felt ready to experiment with pigment. Dusting off his watercolours, he began by adding washes to black-and-white drawings, then pursued paint as a primary medium. Wary of watercolour's potentially prettifying effects, Van Gogh avoided 'nice colours' and luminous effects, working in murky hues that convey the drabness of lives led in The Hague's poorest sectors. A draughtsman first and foremost, he was ill at ease with the fluidity of water-based paint. The scattered colour patches of *The State Lottery Office* (42) are held in check by the sorts of thick, dark contours that typify Van Gogh's early drawings, and the bent forms of his *Coal Carriers* (43) are flattened by the heavy lines that bound them. Wielding his brush like a pencil, Van Gogh effectively *drew* both the cobbled pavement of *The State Lottery Office* and the snowy landscape of *Coal Carriers*.

His brief re-engagement with watercolour confirmed Van Gogh's unease with it:

39
Albrecht Dürer, The 'draughtsman's net', illustration from the *Treatise on Measurement*, revised edition 1538

40
Working at Scheveningen, sketch from a letter to Theo, August, 1882. Van Gogh Museum, Amsterdam (Vincent van Gogh Foundation)

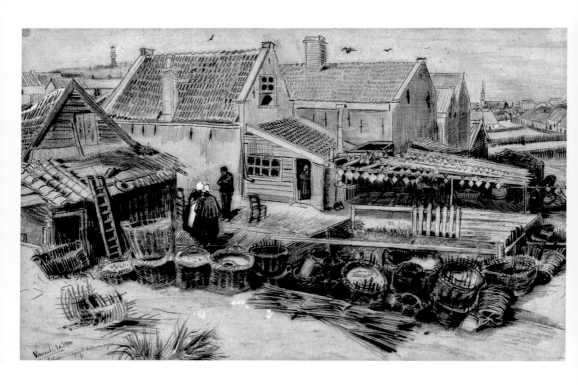

41
Fish-Drying Barn,
1882.
Pencil, pen and
ink and wash,
heightened
with white;
28 x 44 cm,
11 x 17¼ in.
Kröller-Müller
Museum, Otterlo

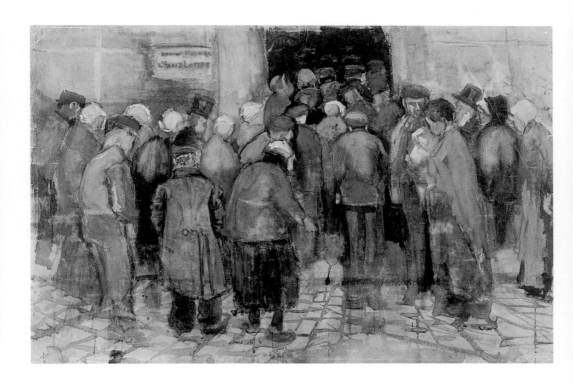

42
The State Lottery Office,
1882.
Ink and
watercolour;
38 x 57 cm,
15 x 22½ in.
Van Gogh Museum,
Amsterdam
(Vincent van Gogh
Foundation)

Watercolour is not the most congenial means for someone who particularly wants to express the boldness, vigour and robustness of the figure …
If my temperament and personal feeling draw me primarily to the character, structure and action of figures, can one blame me if … I don't express myself in watercolour, but in a drawing with only black and brown?

His insistence that personal temperament shape his work stems from Van Gogh's close study of Zola's *Mes Haines*, a rereading encouraged by Van Rappard as well as by Van Gogh's own enthusiasm for Zola's fiction. Van Gogh drew courage from Zola's assertions that art should reflect the person who made it. The author's famed maxim that 'art is a corner of nature seen through a temperament' neatly expressed Van Gogh's own sentiments, and buttressed his impassioned defence of his right to be true to himself at the expense of accepted conventions.

Finding watercolour 'only half fit to render what I want to express, according to my own character and temperament', Van Gogh put it aside. The 'half' that suited him, significantly, was colour, the expressive power of which had begun to command his attention. His desire to incorporate hue, while making 'firm, serious, manly' pictures, led him to oil paint. Oil's substantiality squared with Van Gogh's forceful touch, and seemed to him more appropriate to plebeian subjects than watercolour's delicacy. 'Sometimes the material, the nature of things themselves requires thick paint', he told Theo, and in a letter to Van Rappard he labelled oil 'more virile' than watercolour. He also found this viscous medium more challenging, and described his attempts to master it as drudgery that involved much trial and error. The heavy, laborious surfaces of his first oil studies bear witness to his travails (44).

While he continued to love drawing – 'the backbone that supports all the rest' – Van Gogh was now eager to pursue painting, convinced that oil would allow him to realize previously unattainable effects. His financial burdens, however, mediated against much experimentation in oil. Drawings were cheaper to produce, and Van Gogh saw them as potentially more marketable, given Cor's commissions (though no more were forthcoming) and the popularity of illustrated journals. With an eye to selling his work to magazines, Van Gogh took up

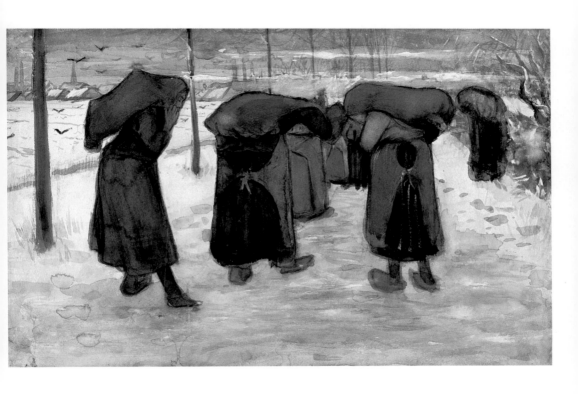

43
Coal Carriers,
1882.
Watercolour;
32 x 50 cm,
12½ x 19¾ in.
Kröller-Müller
Museum, Otterlo

lithography towards the end of 1882, producing print versions of *Sorrow* and several of his 'Orphan Man' drawings. He was eager that 'ordinary working people' buy his pictures, and saw lithography as a means of making his imagery available to those as poor as he was. The art historian Jan Hulsker has observed that the later mass reproduction of Van Gogh's work around the world may be seen as posthumous fulfilment of the artist's wish to play to the broadest possible audience.

In 1883 Van Gogh's financial woes and his inability to sell pictures in The Hague, along with his dearth of professional companionship and his deteriorating relationship with Sien (whom he described as veering towards 'former errors'), turned his thoughts to moving. He was torn between a return to the country and relocation to a different city. Having longed for 'the land of pictures' while in the Borinage and Etten, he now wrote of his 'everlasting homesickness for the heath and pine trees'. On the other hand, 'there are many things that tie me to the city, especially the magazines'. 'It would be no hardship for me not to see locomotives, but never to see a printing press would be difficult.' Thus, he weighed the possibility of returning to England (where he thought his work might sell) before deciding to travel to Drenthe, a northeastern Dutch province that was virtually untouched by the Industrial Revolution. Its flat, desolate landscape, dotted with windmills and moss-roofed cottages, was popular with Hague School artists. Van Rappard worked there often, and Van Gogh envisioned them painting together on heathland that resembled the Brabant of his youth. He considered taking Sien and her children along, hopeful that she might 'live a more natural life' there. Her own opinion of this plan is unrecorded, but Sien apparently resisted his efforts to 'save' her from her kin, her home town and herself. In September, Van Gogh took the train to Drenthe alone, and in his first weeks there he missed Sien mightily.

The gloomy weather in Hoogeveen, his first stopping place, suited Van Gogh's dark mood. The rain often prevented him from working, and in his lonely idleness he dwelt on past and present disappointments. When he did work, he lamented his lack of artists' supplies. His own

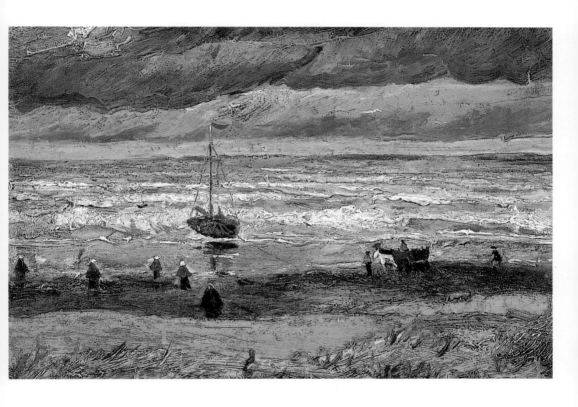

44
*Beach at
Scheveningen*,
1882.
Oil on canvas
on board;
34·5 x 51 cm,
13½ x 20 in.
Van Gogh Museum,
Amsterdam
(Vincent van Gogh
Foundation)

45
*Landscape
at Nightfall,
Drenthe*,
1883.
Watercolour;
40 x 53 cm,
15¾ x 20¾ in.
Van Gogh
Museum,
Amsterdam
(Vincent
van Gogh
Foundation)

situation struck him as almost comically sad, but he found 'gravity and dignity' in the scenery of Drenthe, which often reminded him of Barbizon School paintings as well as landscapes by Dutch masters. He journeyed by barge to the region's remote reaches, calm expanses of moorland where labourers 'struggled together against the barrenness', and the landscape, by Van Gogh's account, consisted simply of coloured bands that grew narrower towards the horizon (45). He found beauty in forlorn motifs, describing a tangle of rotten black roots in a mud pool, with a stormy sky above, as 'completely melancholy and dramatic, just like Ruisdael'.

The vastness of Drenthe's landscapes made Van Gogh feel small, yet grounded, and fuelled his conviction that 'in order to grow, one must be rooted in the earth'. He reflected on how stifling city-dwelling was to one accustomed to the country – 'transplanting him is a painful thing' – and, drawn though he was to urban culture, Van Gogh now remarked, 'I look upon life in harmony with, not against, nature as true civilization.' Nevertheless, the cold and loneliness of Drenthe proved insupportable as winter approached, and, throwing himself on his parents' mercy, Vincent made his way to their home in December 1883. Since his acrimonious parting from them two years earlier, Theodorus and Anna had moved to Nuenen, another Brabant village. It turned out to be the Revd Van Gogh's last posting, as well as the place in which Van Gogh the painter came into his own.

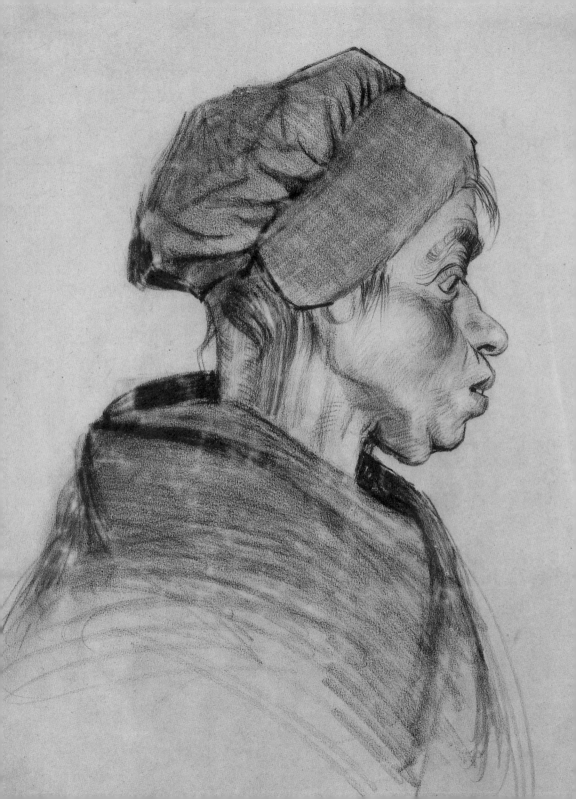

In December 1883 Nuenen's Protestant community was doubtless abuzz about the arrival of the new pastor's bedraggled artist son. His parents, wary of making trouble with him, decided to let Vincent dress and behave as he wished, since – as the Revd Van Gogh wrote to Theo – 'the people here have seen him anyway, and … we cannot change the fact that he's eccentric'.

For his part, the artist sensed his parents' trepidation, suspecting that 'they feel the same dread of taking me into the house as they would about a big, rough dog'. But that canine alter ego, he wrote, 'if only a dog, has a human soul, and even a very sensitive one, that lets him know what people think of him'. Now too 'rough' for well-bred company, Van Gogh nonetheless retained his cultivation; as he himself suggested, he was more like a house pet gone astray than a wild animal. He had positioned himself ambiguously between earthiness and refinement, nature and culture, the proletariat and the middle class. While he proclaimed his preference for the company of peasants and weavers, he also reflected on the labouring classes' ignorance of 'art and other things' and, in Nuenen, demanded an allowance that outstripped any local labourer's salary. During his two-year stay, this confused (and confusing) status caused consternation at home and tensions within the village community.

Though Vincent continued to disparage his father's narrow-mindedness, his need of a place to work resigned him to living at home. In many ways like Zundert and Etten, Nuenen differed from them in its proximity to a sizeable town, Eindhoven. There Van Gogh bought art supplies and fell in with some amateur painters who asked him for lessons: goldsmith/antiques dealer Antoon Hermans, tanner Anton Kerssemakers and postman Willem van de Wakker. He taught them much as Mauve had taught him, progressing from still lifes to landscapes *en plein air* and preaching tonal harmony.

46
Woman in Profile, 1885. Black chalk; 40 x 33 cm, 15¼ x 13 in. Van Gogh Museum, Amsterdam (Vincent van Gogh Foundation)

In other respects, however, Van Gogh was adamantly unconventional, disdaining academic techniques and – as Van de Wakker later recalled – sometimes working paint with his fingers.

Van Gogh also painted with Van Rappard occasionally, and ironically felt less professionally isolated in Brabant than he had in The Hague. At home, he established a rapport with his youngest sister, Wilhelmina (1862–1941), with whom he would correspond regularly in the last years of his life, sharing some of his most articulate and moving descriptions of his artistic aims.

He also made another stab at romance, befriending Margot Begemann, a 42-year-old neighbour whose late father had led the Protestant congregation for many years. Still eager to marry, Van Gogh considered proposing once Begemann fell in love with him. By Vincent's account, their relationship remained chaste, but her family's hostility to it led her to attempt suicide by strychnine. Margot was packed off to Utrecht, where Van Gogh visited but abandoned thoughts of marriage.

His overriding passion in Nuenen remained his work. Indeed, Van Gogh's productivity in 1884–5 was such that he was continually short of supplies. In early 1884 he embarked on a series of representations of weavers at their looms. Brabant was a centre of Dutch textile production, and almost a third of Nuenen's adult men worked as weavers in a local industry that was overseen by middle-class investors (including Margot Begemann's brother Lodewijk). Though European cloth manufacture in the late nineteenth century was increasingly mechanized, Nuenen remained an outpost of hand-weaving, with looms set up in workers' homes as well as small workshops. Village weavers relied on piecework parcelled out by larger concerns, and Van Gogh noticed they often sat idle, a circumstance that made them more amenable to posing than they might otherwise have been. In the first six months of 1884, the artist paid the practitioners of a dying handcraft to enact the work they sorely lacked.

His project was initially shaped by nostalgia for pre-industrial Holland, as well as by existing visual and verbal images of weavers.

Some of Van Gogh's depictions (47) recall those made two centuries earlier (48) – a reflection, perhaps, of his quest for continuities in rural Dutch life (Van Rappard took much the same tack when he painted weavers in Drenthe). Looms and their operators also figured in nineteenth-century European prints, where they served as signs of the broad shift from handcraft to mechanization. Van Gogh owned one such image, *Un Tisserand* (*A Weaver*; 1881), published in the Parisian journal *L'Illustration* with a caption remarking on hand-looming's imminent extinction (50). The craft's demise in England had already been noted by George Eliot, whose *Silas Marner* is a weaver – one of those 'pallid undersized men', she writes, who 'looked like the remnants of a disinherited race'. In her novel Eliot portrays weavers as stupefied by their rote activity. Van Gogh read *Silas Marner* in 1875, and it perhaps informed his own sense of weavers in the Borinage as 'sleepwalkers' who constituted 'a race apart'. Such notions were reconfirmed by reading Michelet's *Le Peuple* (*The People*; 1846), in which loom operators are portrayed as childlike daydreamers dulled by their monotonous work.

In the first half of 1884 Van Gogh haunted the work spaces of Nuenen's weavers, and made some thirty drawings and paintings. His impres-sion of their dreamy otherness was challenged by daily encounters with these artisans turned struggling wage labourers. As he became aware of Brabant weavers' precarious relationship to an industry in transition, Van Gogh described his wish to record the 'reality' of families crammed into spaces dominated by 'monstrous' oak looms. One image (47) shows a weaver engulfed by his apparatus sitting opposite a baby, similarly caged by its chair, in a 'miserable little room with a loam floor'. At the same time, the artist cherished visions of the cosy Dutch past he could conjure up from the components of such scenes, remarking with pleasure that the loom beside the high chair bore an eighteenth-century date, and that the room's dingy tones seemed to harmonize with old Dutch pictures he admired.

Van Gogh attributed the awkwardness of some of his weaver images to the perspectival problems presented by the looms' complicated geometries, viewed close-up in small spaces. Many of his weavers

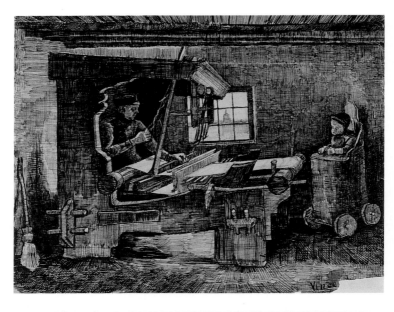

47
Weaver's Workshop, 1884.
Pencil, pen and ink;
32 x 40 cm,
12½ x 15¾ in.
Van Gogh Museum, Amsterdam (Vincent van Gogh Foundation)

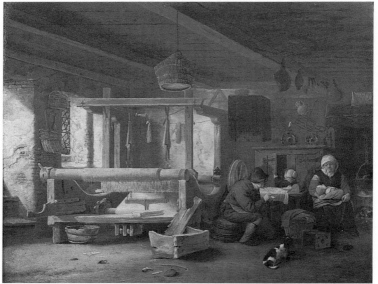

48
Adriaen van Ostade, *The Weaver's Siesta*, 1650.
Oil on panel;
46 x 57 cm,
18⅛ x 22½ in.
Musées Royaux des Beaux-Arts de Belgique, Brussels

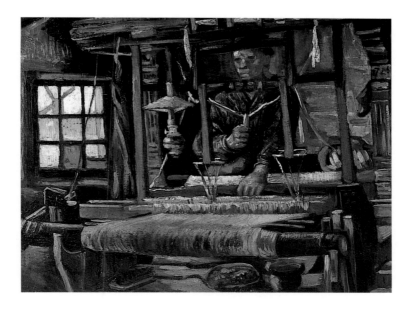

49
*Weaver at
his Loom*,
1884.
Oil on canvas
on panel;
48 x 61 cm,
19 x 24 in.
Museum
Boymans–van
Beuningen,
Rotterdam

50
Ryckebusch,
*Les industries
qui disparaissent.
Un Tisserand*
(Disappearing
industries. A
weaver), from
L'Illustration,
1881

LES INDUSTRIES QUI DISPARAISSENT. — UN TISSERAND

appear wooden and anonymous, perhaps as a result of the artist's preoccupation with the technical difficulties of rendering their looms (49). In a letter to Van Rappard, he suggested that well-captured machinery evokes its operators (whether they are actually depicted or not), and Van Gogh may have felt that the trap-like look of the looms spoke for itself. Art historian Carol Zemel suspects, moreover, that the gap between Van Gogh's romanticized image of the village craftsman and the troubling actualities he witnessed in Nuenen muddled his sense of the situation he sought to depict. She argues that ideological confusion accounts in part for the ungainliness of his weaver paintings.

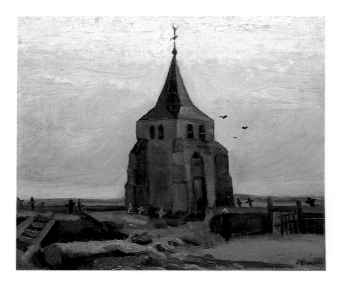

51
The Old Tower, 1884.
Oil on canvas on panel;
47·5 x 55 cm,
18¾ x 21¾ in.
Foundation
E G Bührle
Collection, Zurich

Without abandoning the weaver project, Van Gogh turned increasingly to landscape as winter gave way to spring, taking particular interest in the precincts of a defunct Catholic church (51). Only its graveyard and tower remained intact – the former a traditional burial place for Catholics and Protestants alike, the latter a prominent landmark (soon to be demolished) that Van Gogh had seen framed in the windows of weavers' cottages. Ever drawn to landscape motifs he deemed capable of generating human emotion, Van Gogh appreciated the mournfulness and transience suggested by the graves and dilapidated tower, countered by the

constancy of surrounding nature. Though his images recall the work (52) of German Romantic Caspar David Friedrich (1774–1840), Van Gogh cited a verbal rather than visual parallel, reminding Theo of Victor Hugo's saying, 'Religions pass away, God remains'. Vincent wrote that the scene he depicted showed that while 'faith and religion moulder … the life and death of peasants remain forever the same, withering regularly, like the grass and flowers growing in that churchyard'.

Van Gogh found that the landscape and rustic labours of his native region better expressed the continuity he sought in Brabant than did his scenes of weaving. When his wealthy student Hermans asked for

52
Caspar David Friedrich,
Abbey in the Oakwood,
1809–10.
Oil on canvas;
110·4 x 171 cm,
43½ x 67¼ in.
Schloss Charlottenburg, Berlin

help in designing decorative panels for his Eindhoven dining room, Van Gogh urged him to scrap the original idea of The Last Supper and saints in favour of scenes of agrarian work in the tradition of Labours of the Months imagery. The specific precedent here was Millet's *Labours of the Fields* (1852), and Van Gogh eagerly began a Brabant-flavoured variation in summer 1884. He made oblong oil sketches (53, for example) that Hermans could copy: images of sowing, planting, ploughing, harvest, wood gathering, a shepherd with his flock and an oxcart in the snow. After months spent in dim interiors, he was enthusiastic about the colouristic effects he observed outdoors, noting, for instance, that the fields' bronze hues were

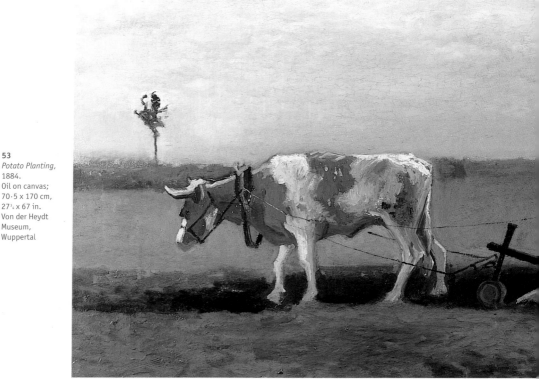

53
Potato Planting,
1884.
Oil on canvas;
70·5 x 170 cm,
27¾ x 67 in.
Von der Heydt
Museum,
Wuppertal

'raised to a maximum effect by contrast with the broken cobalt tone
of the sky'. Already in The Hague – when he first used oil paint – Van
Gogh had been struck by the way that colours in natural light looked
'variegated and full of vibration'. In Nuenen, his attention to such
effects was heightened by close study of nineteenth-century colour
theory when, on Van Rappard's advice, he revisited the writings of
Charles Blanc.

Van Gogh had first read Blanc's work while employed by Goupil.
In 1884 he took up *Les Artistes de mon temps* (*Artists of My Times*;
1876), and soon read Blanc's widely circulated *Grammaire des
arts du dessin* (*Grammar of the Visual Arts*; 1867). In each, Blanc
emphasized the expressive potentials of colour, line and light
(versus their merely descriptive functions) and cited examples of
their evocative usage by artists. Impressed by the innovative
colourism of Eugène Delacroix (1798–1863) and by Rembrandt's

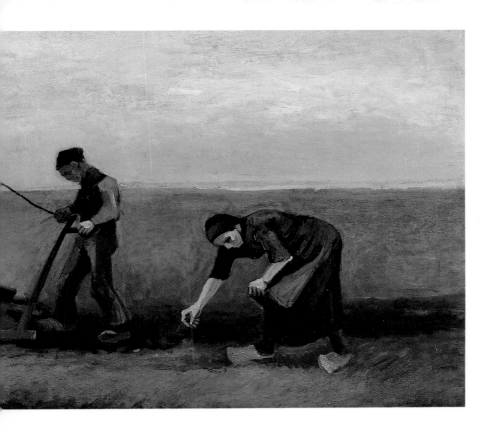

masterful chiaroscuro, Blanc presented them as exemplars.
He also expounded the theories of linear expression put forward by
Dutch artist Humbert de Superville (1770–1849) in his *Essai sur les
signes inconditionnels dans l'art* (*Essay on Unconditional Signs in Art*;
1827–39) and on analyses of colour interactions presented by
chemist Michel-Eugène Chevreul in *De la loi du contraste simultané
des couleurs* (*The Principles of Harmony and Contrasts of Colours*;
1839). In 1884–5, Van Gogh, especially interested in the latter,
detailed his attempts to come to grips with the principles of
complementary colour play.

Complementary colours are colouristic opposites. By conceptual
convention, the chromatic spectrum is broken into six basic hues
(54), three of them 'primary' (red, yellow, blue), three 'secondary'
(orange, green, violet). Each of the latter comprises a mixture of
two primaries: orange a combination of red and yellow, green

54
Charles Blanc,
Colour star from
the *Grammaire
des arts du
dessin:
Architecture,
sculpture,
peinture*, second
edition, Paris,
1870

of yellow and blue, violet of blue and red. Each primary is comple-
mented (in the sense of being *completed*) by the secondary that is
most unlike it – the one that results from mixture of the two other
primaries. (Orange – a mix of red and yellow – thus complements
blue.) As Blanc reports, Chevreul observed that juxtaposition of
any two complementaries yields 'simultaneous contrast', a clash
of opposites that has the visual effect of intensifying each.
(Red never looks redder, for instance, than it does beside green.)
Conversely, when mixed in equal amounts, complementaries 'destroy'
one another, producing 'an absolutely colourless grey'. If comple-
mentary hues are combined in uneven proportions, neutralization
is incomplete, the resultant grey 'colouristic'; Blanc calls such
colour-bearing greys 'broken tones'.

Citing examples from Delacroix's paintings, Blanc notes the music-
like 'vibration' created by complementary colour plays and the
expressive impact of colour 'orchestrations' that transcend narrative
to communicate with the viewer in a direct, non-literary way. Under
Blanc's influence, Van Gogh came to think of Delacroix as a supremely
'musical' painter, and – as both Kerssemakers and Van de Wakker
later recalled – he became so intrigued by the possible connection
between colours and musical tones that he took a few piano lessons

before his teacher, exasperated by the painter's continual comparisons of notes and colours, curtailed their sessions.

Though Van Gogh's notion of Delacroix's practice remained largely theoretical until his move to Paris in 1886, Blanc's descriptions had a profound impact. From *Les Artistes de mon temps* Van Gogh transcribed Delacroix's reported comment that local colour per se was less important than the context in which it was seen, so that the dirty grey of a city pavement might, in the right colouristic situation, suggest the flesh tint of a fair-haired nude. Likewise, Van Gogh observed, a dull greenish grey 'may express the very delicate, fresh green of a meadow' when placed beside a strong red-brown, and 'one need put very little yellow into a colour to make it seem quite yellow ... next to a violet or lilac tone'.

In the Brabant fields, Van Gogh began to see complementary colour contrast everywhere – in the sight of golden corn against an azure sky, or a reddish pathway amid green weeds. He noted that paired opposites dominated each season, writing of the pinks and tender greens of springtime, the vibrant combinations of orange and blue so prevalent in summer, the yellow leaves and purplish shadows of autumn, and black silhouettes on winter snow. Indoors, he designed still lifes with an eye to similar oppositions, remarking on the 'symphonic' effect of calculated colour plays.

Nonetheless, in Nuenen Van Gogh remained a tonalist whose pictures are scarcely recognizable as the colour studies he saw them to be. When Theo – fretting over the retrograde drabness of his brother's palette – tried to interest him in Impressionism, Vincent responded, 'It's not always easy for me to understand, because I've seen absolutely *nothing* [of avant-garde Parisian painting] ... From what you've told me about "impressionism", I've concluded that it's different from what I thought, but it's not quite clear to me what it really is.' Hague School pictures instead constituted his idea of contemporary art, and in Nuenen Van Gogh followed Israëls's practice of 'starting with a deep colour scheme, thus making even relatively dark colours seem light' (55). Speculating that Theo might find his production 'too black', Vincent compared his darkened hues

to those of such vaunted landscapists as Ruisdael and Dupré, and
pointed to Delacroix's *oeuvre* as another place where 'a dark colour
may seem *light*, or at least give that *effect*'.

As the onset of cold weather took him indoors, Van Gogh's palette
became even duskier. The field hands he had depicted at work had
fewer tasks (and less income) with harvesting done, and the artist
saw an opportunity to paint them at home. In The Hague he had done
a number of bust-length drawings of Sien, her family and various
'Orphan Men', and he now set himself the task of doing similar close-
ups in oil, hoping to make some thirty painted heads in preparation

55
Jozef Israëls,
*Labourer's
Family at Table,*
1882.
Oil on canvas;
75 x 105 cm,
29½ x 41⅜ in.
Van Gogh
Museum,
Amsterdam
(Vincent
van Gogh
Foundation)

56
*Woman with
Red Kerchief,*
1885.
Oil on canvas;
42.5 x 29.5 cm,
16¾ x 11½ in.
Van Gogh
Museum,
Amsterdam
(Vincent
van Gogh
Foundation)

for more ambitious figuration (and perhaps seeking to remedy the
problems in characterization that he and others had perceived in his
depictions of weavers). By spring he had made dozens of drawings
and paintings of labourers, portraits that emphasize physiognomy
over hue (see 46 and 56). Convinced that 'the best way to express
form is to use almost monochromatic colour', he toned down the
reds, blues and yellows of his oil renderings by mixing in black, and
avoided secondary colours.

Though he described the heads as 'studies in the literal sense',
intended to hone formal skills, they also have an ideological

dimension, for Van Gogh hoped they would speak to city people 'homesick for the fields and peasants', and '*teach* them something'. Having read Scottish philosopher Thomas Carlyle's account in *Sartor Resartus* (1831) of the modern divide between self-absorbed urbanites and the rural proletariat they complacently ignored, Van Gogh imagined that he, too, might draw city folk's attention to the beleaguered state of Carlyle's 'root eaters', who emerged from dark dwellings to dig the earth for mere subsistence. On the basis of his Brabant boyhood and recent observations, the bourgeois artist claimed insider's knowledge of how 'real peasants' looked, lived, and ought to be represented.

57
Léon Lhermitte,
Soup,
1881.
Oil on canvas;
71 x 94 cm,
28 x 37 in.
Towneley Hall
Art Gallery and
Museum,
Burnley

58
Woman with Bonnet,
1885.
Oil on canvas;
42 x 35 cm,
16½ x 13¾ in.
Van Gogh
Museum,
Amsterdam
(Vincent
van Gogh
Foundation)

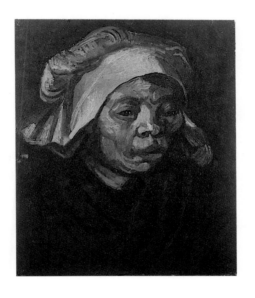

Van Gogh nevertheless viewed the rural proletariat through the lens of fond acquaintance with the work of other middle-class 'peasant painters' – Millet, Israëls, Léon Lhermitte (1844–1913; 57) – and approached agrarian workers as he had the weavers, with entrenched ideas about 'reality'. For instance, he sought out specific physiognomies: 'rough, flat faces with low foreheads and thick lips, not sharp, but full and Millet-like'. Van de Wakker later recalled Van Gogh's search for 'the ugliest models', and the caricatural quality of many of his heads suggests that Van Gogh overstated their coarseness. Their faces' bulbous features and

59
**Hubert von
Herkomer**,
*Heads of
the People:
The Agricultural
Labourer*,
from *The Graphic*,
9 October 1875

ungainly junctures are underscored by the blackened pigments
and choppy brushwork with which he cobbled together dark, uneven
paint surfaces (58).

Van Gogh referred to his bust-length studies as 'heads of the people',
reflecting his emulation of *The Graphic*'s series of that name and
his penchant for a similar sort of type-casting. Interestingly,
The Graphic's 'agricultural labourer' is removed from the context of
his work and shown reading in an interior – an apparent reference
to peaceful peasant piety (59). Van Gogh's agrarian workers are
likewise divorced from their working environment, their 'peasantness'
indicated by lack of comeliness (blunt profiles, weather-hardened
skin, unruly hair) and by characteristic headgear rather than by
implements of their labour or direct references to its sites and
products. The darkness that engulfs them suggests the squalid,
smoke-blackened cottage interiors Van Gogh's letters describe,
and, given his attention to Blanc's writings, doubtless constitutes
allusive use of colour and shadow.

The blackness of Van Gogh's paintings seems to connote his models' literal 'dirtiness', in keeping with longstanding notions of agrarian labourers' oneness with the earth they worked. In an essay of 1688 (well known to latter-day peasant painters), French moralist La Bruyère portrayed the peasantry as 'wild animals ... black, drab and scorched by the sun, bound to the soil they dig', and noted their nightly retreat to 'caves where they live on black bread, water and roots'. Millet's paintings were seen to reflect the inescapable earthiness La Bruyère described; as critic Théophile Gautier noted in 1851, Millet's peasants 'seem to be painted with the earth they sow'. Van Gogh had encountered both La Bruyère's and Gautier's pronouncements in Alfred Sensier's biography of Millet (1881), and echoed them when he observed that 'lumps of black earth' he saw in Brabant's winter landscape recalled the faces of its labourers.

Most of Van Gogh's peasant models were women, and as art historian Griselda Pollock observes, his depictions of them undermined popular fantasies of female rustics' sexual appeal. The idealized

60
Jules Breton,
The Gleaner,
1875.
Oil on canvas;
72 x 54 cm,
28⅜ x 21¼ in.
Aberdeen Art
Gallery

'natural' women painted by such Salon favourites as Jules Breton were the stuff of many (élite) men's dreams (60). Robustly beautiful, their uncorseted bodies suggested healthy physicality and pleasantly referenced the bountiful fertility of the earth itself. Van Gogh's bust-length renderings of haggard farm women scarcely signalled femininity, let alone the alluring vitality of popular stereotypes, and he knew many viewers would find them 'repulsive'. Targeting those who would instead recognize deviations from convention as marks of his sincerity, he declared, 'Painting peasant life is a serious thing, and I would reproach myself if I didn't attempt to make pictures that will rouse serious thoughts in those who think seriously about life and art.'

With that goal in mind, he set his sights on a more ambitious image of cottage life, a good-sized picture of 'peasants around a dish of potatoes in the evening'. The foodstuff on which it centres – a dietary staple of those too poor to eat meat and bread – signals the poverty Van Gogh aimed to document in *The Potato Eaters* (61). Yet he approached his unassuming subject much as an academically trained artist would tackle exalted narrative: beginning with drawings and oil studies of individual objects and gestures, he proceeded to an oil sketch of the entire composition before commencing the finished work. Based on recollections of evenings spent with householder Cornelia de Groot's extended family, this was the 'real peasant picture' for which months of rehearsal prepared him. Working mainly from memory, Van Gogh gave rein to 'thought and imagination' as he made *The Potato Eaters*, his largest painting to date.

A philosophical summation as well as an artistic culmination, *The Potato Eaters* was meant not only to render the look of peasant existence, but to communicate its tenor to an urban audience.

I tried to emphasize that those people, eating their potatoes in lamplight, dug the earth with the very hands they put into the dish, and so it speaks of *manual labour*, and how they honestly earned their food.

I wanted to give the impression of a way of life quite different from that of us civilized people. Therefore I am not anxious for everyone to immediately like or admire it.

Though his process of planning and developing his picture resembled an academic's, Van Gogh saw that his product did not. He initially attributed its indecorous facture to continuing technical difficulties, noting that whereas 'the great masters ... knew both how to be elaborate in the finishing and at the same time keep a thing full of life', he himself was unable to do so. Then, taking a different tack, he defended his departures from convention by evoking Zola's celebration of individual sensibility in art – that 'corner of nature seen through a temperament': 'At the point I am now ... I see a chance for giving a true impression of what I see. Not always literally exact, or rather never exact, for one sees nature through one's own temperament.'

In the end, however, he presented his pictorial transgressions as something more than reflections of his own technical difficulties and renegade tastes, aggrandizing them as deliberate markers of his rustic subjects' uncivilized otherness. His rude means, Van Gogh suggested, were the inevitable outgrowth of immersion in 'the spirit of peasant life', his picture's laboured surface an apt reminder of the rural worker's toil. Comparing his painted canvas to the cloth produced by Brabant weavers, he told Theo, 'All winter long I have had the threads of this fabric in my hands ... and though it has become a fabric of rough, coarse aspect, the threads have been chosen carefully.' Casting the roughhewn surface of *The Potato Eaters* as considered and even necessary, its maker insisted,

It would be wrong ... to give a peasant picture conventional smoothness. If a peasant picture smells of bacon, smoke, potato steam – all right, that's not unhealthy ... If the field has an odour of ripe corn or potatoes or guano or manure – that's healthy, especially for city people ... To be perfumed is not what a peasant picture needs.

As in his peasant heads, the interconnectedness of Van Gogh's means and subject extended to his palette. Describing *The Potato Eaters* as 'very dark', he noted that the grey of its lightest patches was made by mixing primary colours. This colouristic grey, designed to mediate between the blackened primaries that constitute the painting's most vivid hues, actually reads 'white' in the picture, he believed, as grey

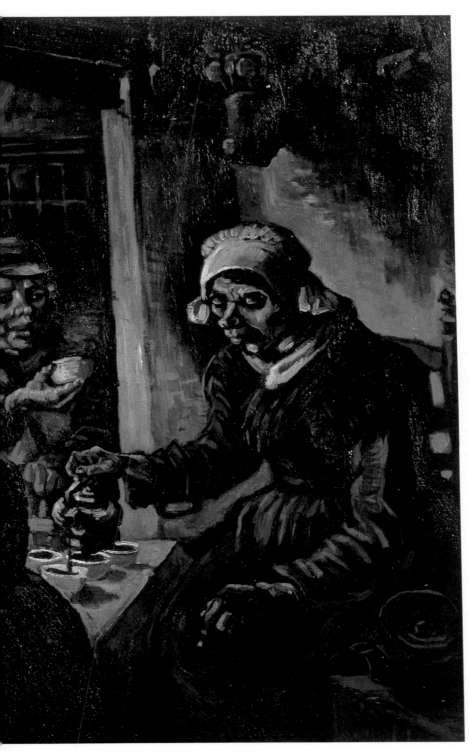

61
*The Potato
Eaters*,
1885.
Oil on canvas;
82 x 114 cm,
32¼ x 45 in.
Van Gogh
Museum,
Amsterdam
(Vincent
van Gogh
Foundation)

often did in pictures by Corot, Millet, Daubigny, Dupré and Israëls – none of whom, Van Gogh wrote, painted colour 'literally'. Inspired by these artists' departures from colouristic norms, he painted over the more predictable hues with which he began *The Potato Eaters*. Though he had brought the figures' heads to completion using flesh tints,

I immediately repainted them … *the colour of a very dusty potato, unpeeled of course*. While doing this I thought about how perfect that saying about [Millet] is: 'His peasants seem to be painted with the earth they sow.'

That phrase, Van Gogh wrote, justified his decisions to manipulate colour and texture to evoke the dirt, smoke and cooking odours of peasant life. He realized some viewers might balk, but reminded Theo, 'Millet and so many others have provided an example of character, and of not minding criticisms such as nasty, coarse, stinking, etc., etc., so it would be a shame to waver. No, one must paint the peasants as being one of them, feeling, thinking as they do.'

From Sensier's biography of Millet, Van Gogh discerned parallels between his life and that of the French painter. Millet, like him, was born and bred in a village, and, after learning to paint, chose to work in the countryside. Millet was the son of provincial landowners, but Sensier overstates the humility of his origins, and claims that he 'became a peasant again' after settling in Barbizon, taking time off from painting to work the land. Van Gogh liked to think of his Brabant picture-making as a rustic labour. In spring 1885 he wrote of his intention to keep his 'hand to the plough and cut my furrow steadily', and to eat, drink and dress in the manner of his subjects, since 'that's what Millet did'.

At the same time, however, Van Gogh pointed to the gulf between 'us civilized people' and the labourers he portrayed, and he consistently aimed his pictures at educated peers. Having painted *The Potato Eaters* for urbanites, he shipped it to Paris, eager for Theo to show it off. Van Rappard received a lithograph of the composition. Neither recipient liked what he saw, but while Theo's initial response

was measured, Van Rappard pronounced himself 'terrified' by the picture. He couldn't believe *The Potato Eaters* was meant seriously, and bristled at Van Gogh's audacious implication that Millet's work inspired it. This unbeautiful image of peasant life struck a raw nerve, and Van Rappard, unable to put his finger on just what it was that so disturbed him, peevishly enumerated its flaws (a too-short arm here, a badly drawn nose there), remarking, 'You can do better than that'.

Van Gogh, however, considered *The Potato Eaters* 'the best thing I've done', and he ascribed Van Rappard's scandalized dismissal to a small-minded focus on technical issues, suggesting that Van Rappard's social position hindered him. He scarcely bothered to defend *The Potato Eaters* to his erstwhile friend, but when Theo passed on similar criticisms from Parisian painter Charles Serret (1824–1900), Vincent felt compelled to explain himself anew. He observed that many admirable painters – Israëls, Lhermitte, Delacroix, for instance – were 'almost *arbitrary*' in their treatment of anatomy and 'often quite wrong "in the eyes of the academician"'.

Tell Serret I *would be desperate if my figures were correct*, tell him that I don't want them to be academically correct ... Tell him I adore figures by Michelangelo though the legs are undoubtedly too long, the hips and back-sides too large. Tell him that, for me, Millet and Lhermitte are the real artists for the very reason that they do not paint things as they are ... in a dry, analytical way, but as *they* – Millet, Lhermitte, Michelangelo – feel them. Tell him that my great desire is to learn to make those very mistakes, devia-tions, remodellings ... yes, lies if you like – but truer than the literal truth.

As before, Van Gogh turned to *Mes Haines* for support of personal style: 'Zola says a beautiful thing ... "In a painting I seek, I love, the man, the artist"'.

His enthusiasm for Zola had recently been refuelled by *Germinal* (1885), a novel set in a mining community in northern France (not far from Belgium's Borinage). It struck a deep chord, and inspired Van Gogh to make two new peasant heads, even as he noted the resemblance between Zola's descriptions of mine women and a bust he painted '*before* I read *Germinal*'. Zola, like Van Gogh, often

down-played his middle-class origins, and prided himself on truthful portrayals of the labouring classes intended to enlighten society's sheltered élites. In preparation for *Germinal*, he had not only researched the coal industry, but toured the mining district and descended a shaft. Van Gogh considered his own commitment to reality comparable, and, at Nuenen, became attentive to literary naturalism's blend of earthbound reportage and lyrical excess, which seemed to validate his own refusal to 'follow nature mechanically and servilely'. Vincent told Theo that Zola 'does not hold up a *mirror* to things ... [but] *poeticizes*, that is why it is so beautiful'.

Moved though he was by *Germinal*'s descriptions of desperate mining families, Van Gogh identified most closely with the novel's bourgeois mine manager and his fantasies of escape to a simpler, worker's existence. In a letter to Theo, Vincent transcribed a passage in which Zola writes that the boss 'would have given everything, his education, his well-being ... to live like a beast, having no possessions of his own, flattening the corn with the ugliest, dirtiest female coal trammer and being able to find contentment in it'. He was moved to copy this text, he said, because 'I have had almost literally the same longing ... And I was sick of the *boredom* of civilization'.

62
A Peasant Woman Gleaning, 1885. Black chalk; 51·5 x 41·5 cm, 20¼ x 16¼ in. Museum Folkwang, Essen

It's a good thing to be deep in the snow in winter; in autumn, deep in the yellow leaves; in summer, amid the ripe corn; in spring in the grass; it's a good thing to be always with the mowers and the peasant girls, with a big sky overhead in summer, by the fireside in winter, and to feel it has always been so and always will be. One may sleep on straw, eat black bread ... [and] only be the healthier for it.

The return of warm weather and its attendant activity helped him put aside the impressions of desolation that shaped *The Potato Eaters*, and in summer 1885 Van Gogh made his best renderings yet of field hands in action (62). Though he had 'no other wish than to live deep, deep in the heart of the country, and to paint rural life', his days in Nuenen were numbered. In March 1885 (shortly before Vincent began painting *The Potato Eaters*) Theodorus had died suddenly at the age of sixty-three. Vincent's mother remained in

the parsonage for some months thereafter, but when the painter's eldest sister, Anna, agitated for him to leave the house, he took up residence with the Catholic sexton from whom he already rented studio space. He vowed to remain in Brabant, and his work continued apace until Gordina de Groot, an unmarried Catholic working woman who sometimes modelled for Van Gogh, became visibly pregnant. The Protestant artist – a bourgeois interloper in peasant garb – was rumoured to be the father (unjustly, he insisted), and local priests warned him 'not get too familiar with people below my rank'. They also urged Catholics who posed for Van Gogh to desist, going so far as to promise them money if they refused. In September 1885

63
Still Life with Nests, 1885.
Oil on canvas;
33 x 42 cm,
13 x 16½ in.
Kröller-Müller
Museum, Otterlo

64
Still Life with Bible and French Novel, 1885.
Oil on canvas;
65 x 78 cm,
25½ x 30¾ in.
Van Gogh
Museum,
Amsterdam
(Vincent
van Gogh
Foundation)

the artist complained, 'I could by no means get anybody to pose for me in the fields these days.'

Forced from his peasant subjects by local gossip, he took up still life, and spent several weeks painting objects that evoked his former models: wooden shoes and clay pipes, simple crockery and foodstuffs, even a series of birds' nests Van Gogh compared to 'those *human* nests, those cottages on the moor', to which he now was denied access (63). From the time of his apprenticeship with Mauve, Van Gogh had considered still life a prime forum for technical experimentation, and after a brief trip to the newly opened Rijksmuseum, he explored heightened colour effects

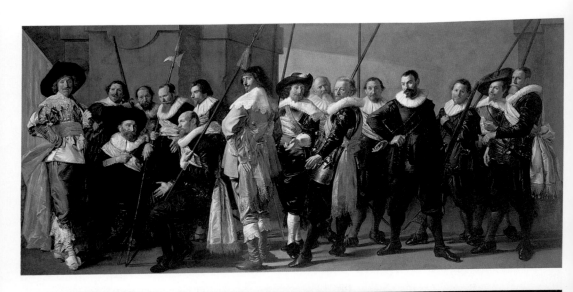

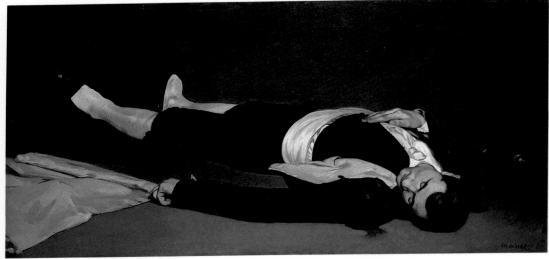

and attempted a lightened touch in his *Still Life with Bible and French Novel* (64), a painting indebted to Hals.

Once dismissed as slapdash and vulgar, Hals's work was enthusiastically reappraised in the nineteenth century. Romantics extolled the 'naturalness' and originality of Hals's talent (presumed to result from his legendarily freewheeling lifestyle), and mid-nineteenth-century critics, including Thoré and Blanc, focused particularly on his audacious colourism and lively brushwork. Admirers also commended Hals's scope: though he limited himself to portraiture, Hals took on public commissions of civic groups and casual renderings of street people as well as traditionalist renderings of merchants and their wives. Inveterate republican Thoré cast this inclusiveness in a favourable political light, praising Hals's portrayal of 'rough sailors ... burgomasters ... cheerful workingmen, the crowd, everyone, in a country of equality'.

The Rijksmuseum displayed a wide range of Hals's work, and Van Gogh was primed to admire it by his readings and his recent struggles with *The Potato Eaters*. Having grappled with the academic notion of 'finish' (the effects of which he found deadening), Van Gogh was heartened by encounters with Hals's brusque paint handling, which was said to lend individuality to his work and animation to his subjects. Moreover, as an ardent student of colour effects, Van Gogh noted Hals's tendency to deploy patches of vibrant hue in neutral expanses (much as he himself would poise the vibrant yellow novel of his subsequent still life against the black, brown and 'broken white' of its surroundings) and thrilled to his complementary colour plays, declaring Hals 'a colourist among colourists'. Singling out the grey-clad standard-bearer at the left edge (65) of Hals's *The Meagre Company* (1633–5, 1637; completed by Pieter Codde), Van Gogh speculated that the neutral tint of his costume was 'probably the result of orange and blue mixed'. 'But wait a minute! Into that grey [Hals] brings blue and orange ... side by side ... [like] poles of electricity ... Delacroix would have raved ... absolutely raved. I was literally rooted to the spot.' Careful examination of the grey rectangles that form the pages of Scripture in Van Gogh's *Still Life*

65
Frans Hals,
Officers of a Company of the Amsterdam Crossbow Civic Guard ('The Meagre Company'),
1633–5
(completed by Pieter Codde, 1637).
Oil on canvas;
207 x 427 cm,
81½ x 168⅛ in.
Rijksmuseum, Amsterdam

66
Édouard Manet,
The Dead Toreador,
1864–5.
Oil on canvas;
76 x 153·3 cm,
29⅞ x 60⅜ in.
National Gallery of Art, Washington, DC

with Bible and French Novel reveals his attempted replication of this effect: flecks of orange and blue animate the neutral tone Van Gogh mixed from those hues. Vincent sent *Still Life with Bible and French Novel* to Theo shortly after painting it, in answer to his brother's enthusiastic description of Manet's *Dead Toreador* (1864–5), a mostly neutral painting in which slabs of black flank the dirty pink and flesh patches that are its colouristic high notes (66). He proudly informed his brother that his own painting was made 'in *one rush*' – another tip of the hat to Hals, whose un-retouched brushwork was widely emulated (by Manet among others). In the Rijksmuseum, Van Gogh had been struck by how different Hals's paintings looked 'from pictures where everything has been smoothed out'. He now aimed to minimize reworking in his paint application, hoping to attain the effects of confident spontaneity he discerned in Hals's touch. Since his visit to Amsterdam, he was finding it 'quite easy', he wrote, 'to paint a given subject unhesitatingly, whatever its form or colour'.

Van Gogh's remarks on *Still Life with Bible and French Novel* do not mention its content, yet this image is an eloquent study in contrasts. The two books – Theodorus's leather-bound Bible and a paperback – not only differ in scale, colour and alignment, but thematically oppose one another. The open Bible's diagonal orientation conforms to the table's, and its mainly muted tones meld with the prevailing gloom. It is adjoined by extinguished candles, traditional symbols of death that often accompany old books (and human skulls) in symbolic still lifes known by the Latin label 'vanitas' (67). Particularly popular in the seventeenth century, *vanitas* still lifes emphasize the transience of earthly life and the uselessness of worldly knowledge and possessions in the face of death. Van Gogh's painting is clearly a meditation on his father's recent demise, but the Bible's pairing with a dog-eared paperback strikes a note of rebelliousness – against Theodorus and against pictorial convention.

The yellow book is a contemporary novel, Zola's *La Joie de vivre* (1884). Its author was a hero to Van Gogh and a controversial foreigner of whom his father had disapproved. Vincent had argued

with Theodorus about the sort of French fiction the yellow book represents, characterizing his father's objections as an indication of the narrow-mindedness that drove a wedge between them. '*Joie de vivre*', a common French phrase indicating carefree delight in life's pleasures, clearly opposes the admonishments of the Bible and traditional *vanitas* still lifes. The novel's storyline suggests a still more specific appropriateness to the artist's situation, since *La Joie de vivre* traces the demoralization of a sensitive pianist whose lack of professional success forces his return to the family home, where his artistic ambitions are squelched by provincial isolation and a disparaging parent.

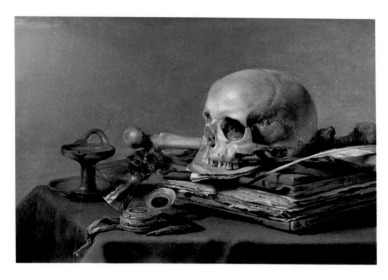

67
Pieter Claess,
Vanitas Still Life,
1639.
Oil on canvas;
39.5 x 56 cm,
15½ x 22 in.
Mauritshuis,
The Hague

In addition to recalling Van Gogh's father, the Bible also represents a piece of the painter's own past – as dutiful son, devout Christian, former preacher – and is thus pushed towards the background. The yellow novel signals more immediate concerns, and its haphazard placement and rumpled silhouette indicate recent and earnest use. During Van Gogh's stay in Nuenen, Zola and other French writers provided a vital link to contemporary culture; recent French fiction, he told Theo, helped him glimpse 'the soul of modern civilization', something 'Father never knew'. Even as the burnt-out candles of *Still Life with Bible and French Novel* evoke the past, the bright, beacon-like paperback indicates a new course.

Within a month of shipping the picture, Vincent left Holland, never to return. His first stop was Antwerp, where he spent three fruitful months, looking at pictures and enrolling (for the first time) in an arts academy. Stimulating as it was, however, Antwerp proved no more than a way station from which Vincent waged a campaign on Theo, begging permission to migrate on to Paris. His longing was great, his patience limited, and early in 1886 Vincent made his move without Theo's approval, eager to see how he might fare in the arts capital of the Western world.

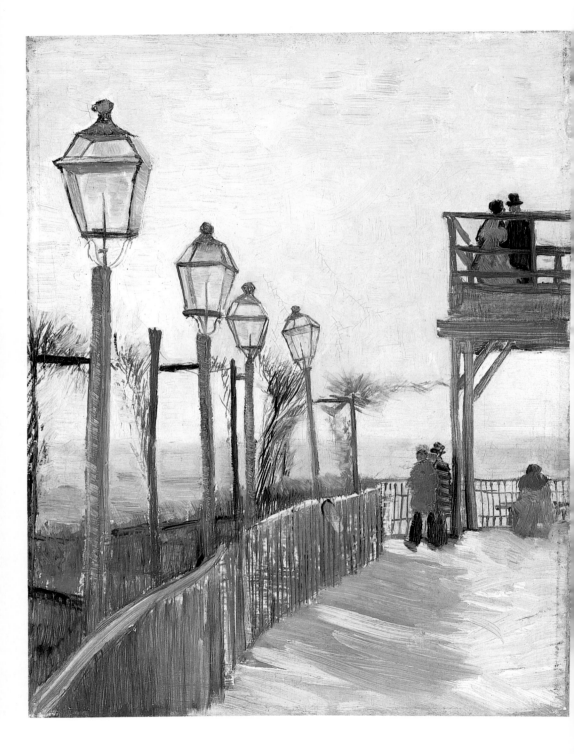

When Van Gogh arrived in Paris in March 1886, he went straight
to the Louvre, a favourite haunt from his previous Parisian
sojourns. Having turned up against Theo's wishes, he had no key
to his brother's flat and doubtless felt sheepish about dropping
into the gallery from which he had been dismissed a decade earlier.
Instead, he sent a note to Theo at Boussod & Valadon, suggesting
a rendezvous at the Louvre.

Despite misgivings, Theo agreed to let Vincent share his tiny
apartment. After several weeks in cramped quarters, the brothers
moved to a flat on the rue Lepic, a street that ascends the south-
western flank of the chalk hill known as the Butte Montmartre. A bit
more built-up than when Vincent had lived there before, Montmartre
retained its small-town air. The neighbourhood still boasted three
windmills, the highest of which had a raised observation deck (68)
with views of the city centre's domes and spires, the chimneys of the
industrial zone to Montmartre's north, and the gardens and grassy
expanses that graced its immediate vicinity (69). Though Vincent's
museum-going took him to the heart of Paris, he tended to work in
his own neighbourhood or the northern suburbs of Clichy, Asnières
and Saint-Ouen.

With their windmills and murky colour schemes, some of the
townscapes Van Gogh made during his first months in France might
just as well have been painted in Holland (70, for example). Others,
while identifiably Parisian in motif and somewhat 'impressionistic'
in their lighter palettes and chunky impasto (69, for example),
are nonetheless as closely related to Dutch traditions as French
trends. The sweeping vistas Van Gogh made from the Butte in
1886 are compositionally similar to such pictures as Ruisdael's
View of Haarlem from the Dunes at Overveen (see 10), while their
atmospheric overcast recalls the favoured weather conditions of

68
*The Terrace
of the Blute-fin
Windmill,
Montmartre,*
1886–7.
Oil on canvas
mounted on
pressboard;
44 x 33 cm,
17½ x 13½ in.
The Art
Institute
of Chicago

111 Van Gogh in Paris, 1886–1888

'Grey School' artists such as Mauve (see 23 and Chapter 1). If Impressionist pictures played a role in Van Gogh's *Roofs* series, it was probably an indirect one, channelled through impressionistic 'word paintings' the artist admired in Zola's *Une Page d'amour*.

A close associate of the Impressionists, Zola wrote *Une Page* in the movement's heyday, and consciously emulated his painter friends' attention to nuanced and transitory atmospheric effects. Describing the 'light, milky vapour' that makes the sky over Paris resemble 'weather-coloured muslin', Zola notes,

Now and then, patches of yellow smoke broke loose ... then melted into the air that seemed to drink them. And above the immensity of this cloud that slept atop Paris, an unblemished sky of washed-out blue, almost white, unfurled its deep vault.

In such texted panoramas, Zola fine-tunes his perceptions (*eg* 'washed-out blue, almost white'), as if struggling on the spot to describe what he sees. Deploying lively verbs, he conveys the fleeting nature of light that 'dances' on a scene or 'runs' across rooftops.

Van Gogh's mental image of modern Paris was shaped by its novelists, and – as his artist friend Émile Bernard later recalled – 'it was while reading Zola that Vincent thought of painting the humble shanties of Montmartre where the proletariat cultivate their little plots of sand in the morning sun' (71). He was surely delighted, too, to observe the resemblance between Zola's Paris and the view from his own windows. As Theo told a Dutch friend in 1887:

Since [Vincent] requires a lot of space for his work, we are living in a rather large apartment in Montmartre ... It has a magnificent view of the whole town ... and over it an expanse of sky nearly as large as when one is standing atop a dune.

With the different effects produced by the various changes in the sky, it is a subject for I don't know how many pictures ... A description of such a view, though seen from a different spot, is found in Zola's *Une Page d'amour* ...

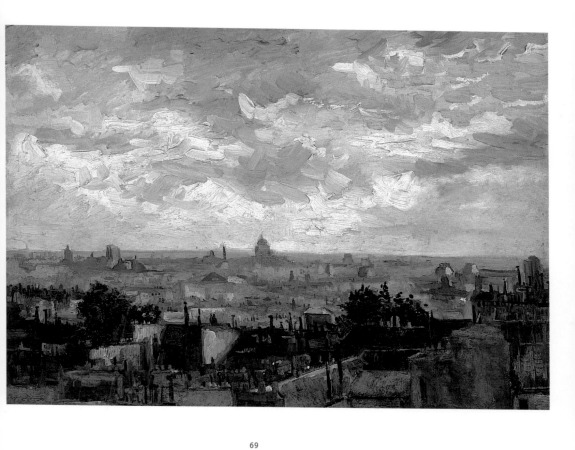

69
Roofs of Paris,
1886.
Oil on canvas;
54 x 72 cm,
21¼ x 28¼ in.
Van Gogh Museum,
Amsterdam
(Vincent van Gogh
Foundation)

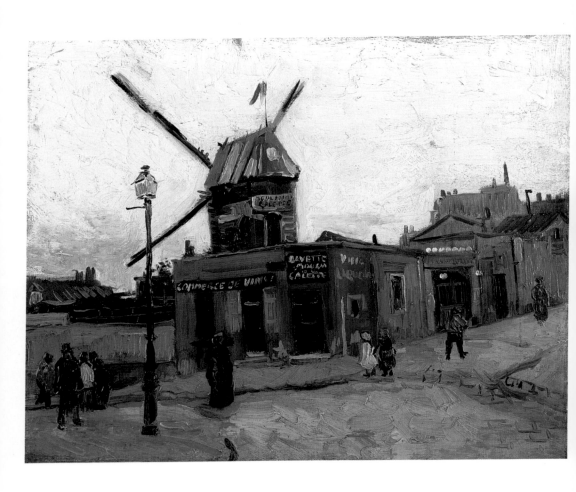

Though it probably did not occur to Vincent, Zola's Impressionist-inspired verbal imagery constituted his closest exposure to Impressionism before seeing it at first hand. Theo's epistolary attempts to describe Impressionist pictures had left him baffled, and even after reading Zola's art-world novel, *L'Oeuvre* (*The Masterpiece*; 1886), in Antwerp in the serial instalments in which it first appeared, he found he 'didn't even know what impressionism was'.

70
Moulin de la Galette,
1886.
Oil on canvas;
38·5 x 46 cm,
15¹⁄₄ x 18 in.
Kröller-Müller
Museum, Otterlo

71
A Garden in Montmartre,
1887.
Oil on canvas;
42·5 x 35·5 cm,
16³⁄₄ x 14 in.
Van Gogh
Museum,
Amsterdam
(Vincent
van Gogh
Foundation)

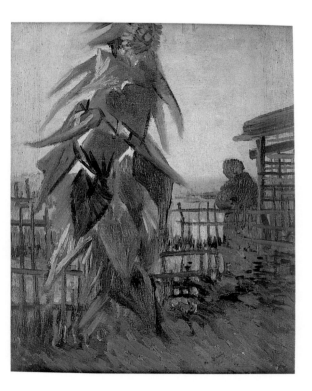

It has been suggested that Van Gogh's intensified interest in Hals in 1885 helped prepare him for the progressive Parisian pictures he saw the following year. It was a great leap, however, from Hals's work to Impressionist and Neo-Impressionist paintings, and it took months before Van Gogh came to terms with recent French modes. One can imagine the immediate effects of Impressionism's high-keyed palettes and loose brushwork (72) upon an artist who considered Hals 'a colourist among colourists' and regarded draughtsmanship 'the backbone that supports all the rest'.

Van Gogh later recalled:

One has heard talk about the impressionists, one expects a lot from them, and ... when one sees them for the first time one is bitterly, bitterly disappointed, and thinks them slovenly, ugly, badly painted, badly drawn, bad in colour, everything that's miserable. This was my first impression when I came to Paris, dominated as I was by the ideas of Mauve, Israëls and other clever painters.

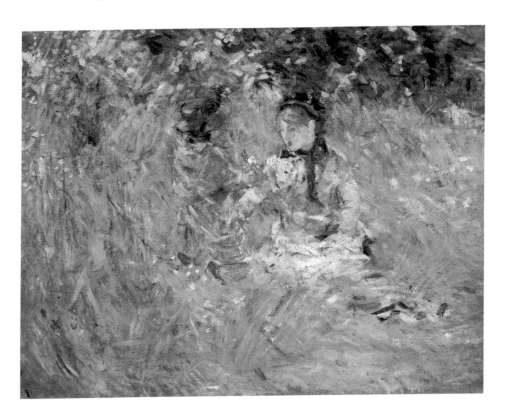

Just which Parisian pictures struck him as 'miserable' is hard to determine. Living with Theo, Vincent wrote few letters, resulting in a paucity of documenting correspondence for this period of his life. Theo was up on recent trends and sold the occasional Impressionist picture, but the branch of Boussod & Valadon that he managed in Montmartre did not have an inventory of them in 1886. Vincent probably had to wait until June for his first good look at what the most prominent Impressionists were doing, when dealer Georges

Petit showed recent work by Monet and Renoir at his gallery. Both were rethinking their approaches in the 1880s, distancing themselves from Paris and the movement they had launched there. Monet now lingered longer over individual motifs and paintings, and Renoir, newly interested in draughtsmanship, became painstaking with his pictures' finishes – so much so that his magnum opus of the decade, *The Great Bathers* (shown at Petit's in 1887) took him three years to complete.

Petit's 1886 exhibition opened as the last of eight group shows staged by the Impressionist circle closed. Twelve years after the first Impressionist exhibition, this final show ran from mid-May to mid-June. Little of what Van Gogh can have seen there constituted 'classic' Impressionism. Neither Monet, Renoir, nor their former associate Alfred Sisley (1839–99) participated. Pissarro (the only Impressionist who showed in all eight group shows) had twenty works on view, but, while he continued to specialize in rustic *plein-airisme*, his latest vistas were painted in a pointillist mode inspired by Georges Seurat (1859–91). Berthe Morisot and Armand Guillaumin (1841–1927), who had not veered substantially from styles developed in the 1870s, presented the most impressionistic pictures in the 1886 display (see 72). The other 'old guard' exhibitor, Edgar Degas (1834–1917), had never toed the Impressionist line, and in 1886 showed a suite of pastels depicting women attending to their toilettes in dimly lit boudoirs.

This last 'Impressionist' exhibition was actually dominated by artists who rejected 1870s-style naturalism in favour of stylizations developed in the studio – most notably Seurat, whose *Sunday Afternoon on the Island of La Grande Jatte* made its début there (73). Like Van Gogh, Seurat had fallen under the sway of Blanc's *Grammaire des arts du dessin*. Blanc's discussion of the 'simultaneous contrast' of colouristic opposites (first described by Chevreul, and applied by Delacroix; see Chapter 3) includes advice for maximizing that effect: painters should place 'separate touches' of pure colour in close proximity on the canvas, rather than mixing complex hues on the palette. The observer's eye, he speculates, will automatically blend

72
Berthe Morisot,
Garden at Bougival,
1882.
Oil on canvas;
59·6 x 73 cm,
23½ x 28¾ in.
National
Museum of
Wales, Cardiff

small dabs of juxtaposed colour, in an optical machination destined to produce 'more pure and vibrant colour ... than would be formed by the traditional combining of pigments on the palette'.

Intrigued by the possibilities of the process Blanc called 'optical mixture', Seurat began breaking observed hues into component parts (*eg* the local colour of a given object, the colour of light falling on it, the colours reflected on to it by other objects nearby), and applied constituent colours as small, separate marks. Seurat designated his practice 'divisionism' (referring to the analytic division of chromatic composites into discrete parts), but it became popularly known as 'pointillism'. After *La Grande Jatte* was shown again in late summer at the non-juried exhibition known as the Salon des Indépendants, Parisian critic Félix Fénéon dubbed Seurat's style 'Neo-Impressionism'. Fénéon's label acknowledges the Impressionist roots of paintings that record scenes of urban leisure and effects of natural light, while noting the novelty of Seurat's treatments. Academically trained, Seurat had a taste for classicism, and spent long studio hours transforming directly observed scenes he had sketched into large-scale paintings in which order and stasis reign. He suppressed the quirkiness of particular motifs and the 'accidents' of vision Impressionists prized, preferring artful generalizations that overrule the transitory nature of observed phenomena. The careful calculation implied by his brushwork adds to the viewer's sense of Seurat's deliberation, which in 1886 set his work apart from the haphazard-looking images of mainstream Impressionism.

Thus, Van Gogh arrived on the Paris art scene in a year of momentous transition, in which the torch of the avant-garde passed from the likes of Monet and Renoir to the 27-year-old Seurat and the followers who joined forces with him at both the final Impressionist exhibition and the 1886 Salon des Indépendants. It is not clear to what extent this much-remarked sea change registered with Van Gogh, a new-comer who may not have drawn much distinction between 1870s Impressionism and the spin-offs and revolts it engendered in the 1880s. In Van Gogh's lexicon, 'impressionist' emerged as a catch-all term denoting recent anti-academic painting of varied sorts.

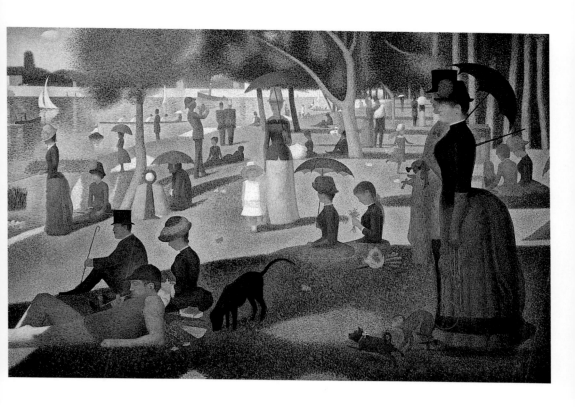

73
Georges Seurat,
*Sunday
Afternoon on
the Island of
La Grande Jatte*,
1884–6.
Oil on canvas;
207·6 x 308 cm,
81¾ x 121¼ in.
The Art
Institute
of Chicago

More inclined to divide the avant-garde along economic than stylistic lines, Van Gogh in Paris came to think of those painters who showed at the Durand-Ruel and Petit galleries (near the city's opera house and great thoroughfares) as 'impressionists of the grand boulevard', and those who had yet to make it big as 'impressionists of the petit boulevard' (*ie* the boulevard de Clichy in Montmartre). His own lack of professional success, as much as his artistic convictions, eventually allied him with the latter, though Van Gogh scarcely considered himself 'one of the club'.

Letters he wrote from Antwerp suggest that Van Gogh arrived in Paris with scant interest in entering the avant-garde. Instead, his primary goal was to advance his figural work through conventional academic study: drawing from nude models and plaster casts. In early 1886 Van Gogh drew live models at two Antwerp sketching clubs and took classes at the city's arts academy. After its painting master, Karl Verlat, denounced his efforts at figure painting and pointed him towards a remedial drawing class, Van Gogh spent his last weeks in Antwerp rendering plaster casts. Having rejected Mauve's advice that he draw from casts in The Hague, Van Gogh now proclaimed the usefulness of the practice, and stoically accepted harsh assessments of his drawings' oddities: 'Since I've been working absolutely alone for years,' he wrote, 'I suppose that while I want to learn from others and can, I shall always see with *my own eyes*, and render things originally.'

From Antwerp Vincent had looked ahead to working with Parisian academic Fernand Cormon (1845–1924), a painter of portraits and prehistoric scenes who headed a studio in Montmartre (where Breitner once studied). Apparently it was Theo who drew Vincent's attention to Cormon and unwittingly precipitated his move to France to study with him. Van Gogh later claimed to have spent three or four months with Cormon, although he seems to have postponed enrolment at his studio until the autumn of 1886. The recollections of contemporaries who remembered Van Gogh working with vibrant colour at Cormon's support this dating, since the artist's palette, dark on his arrival in Paris, brightened considerably over the summer.

In his attempts to work on his own at Theo's apartment, Vincent found that professional models in Paris were much more expensive than the peasants he engaged in Holland. Lacking both funds to hire models, and intimates he could prevail on to pose (oddly, he never painted Theo), the artist turned for the first time to self-portraiture in a series that culminated in his self-portrait before an easel (see 1). Also, as in Nuenen, he took up still life. His brief apprenticeship with Mauve had convinced him of still life's usefulness for study purposes (in this highly mediated art form, the artist's orchestration of motifs includes their prior selection and arrangement), and as Theo told their mother in summer 1886, Vincent was 'mainly painting flowers, with the intention of putting more lively colour into his next pictures'. Nascent admiration for Impressionism (he later mentioned Monet's landscapes and Degas's nudes as the paintings that won him over) probably fostered such aims, and encounters with divisionism may have intensified Van Gogh's interest in complementary colour plays.

His chromatic studies of 1886 continued experiments Charles Blanc inspired. In his art Van Gogh habitually took cues from his reading, and his descriptions of his Parisian still lifes recall texts perused at Nuenen. A letter Van Gogh wrote to an Antwerp acquaintance, English painter Horace Mann Livens (1862–1936), is composed in Livens's native tongue, but slips into French – the language of Blanc's *Grammaire* – when it comes to such terms as 'broken tones' ('*tons rompus*'):

I have lacked money for models, otherwise I would have given myself over entirely to figure painting. But I have made a series of colour studies ... simply flowers ... seeking oppositions of blue with orange, red and green, yellow and violet – seeking *tons rompus* ... to harmonize brutal extremes.

Intended as vehicles for intense colour, Van Gogh's floral still lifes of 1886 betray his continuing wariness of it. Strong hues, such as the reds on the right stem of *Hollyhocks in a Jug* (74), are undercut by darkening admixtures, clashes of paired opposites tempered by enveloping neutrals. The neutral tones of *Hollyhocks* – colouristic greys of the sort Blanc calls *tons rompus* – are composed of

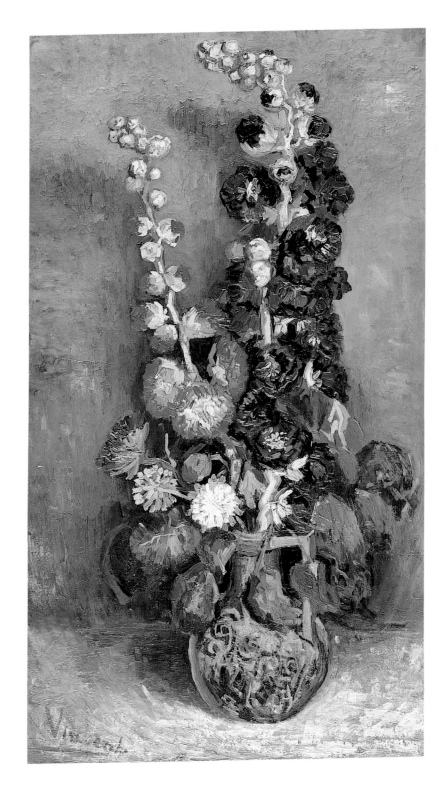

complementaries mixed in unequal proportions. The wall behind the flowers, for instance, holds patches of greenish and rose-tinged greys that Van Gogh made by mixtures of their brightest hues; these mongrel tints were born of the reds and greens they are meant to harmonize. That the chromatic fireworks of such a picture are more theoretical than actual indicates Van Gogh's initial hesitancy towards the clear-hued palettes of Impressionism and Neo-Impressionism.

That hesitancy may be attributed both to his Dutch background and to the pictorial precedents to which he looked. Theo's

74
Hollyhocks in a Jug,
1886.
Oil on canvas;
94 x 51 cm,
37 x 20 in.
Kunsthaus,
Zurich

75
Adolphe Monticelli,
Bouquet of Flowers in a Three-Legged Vase,
1875–6.
Oil on canvas;
51 x 39 cm,
20 x 15⅜ in.
Van Gogh
Museum,
Amsterdam
(Vincent
van Gogh
Foundation)

apartment was hung with flower paintings, including six by Adolphe Monticelli (1824–86). In Monticelli – an artist whose work he later credited with shaping his own – Vincent saw a 'colourist descended directly from Delacroix', yet (like Van Gogh himself in 1886) the older artist offset vibrant colour plays with sonorous tones, embedding gemlike hues in dark surrounds (75). Monticelli's thick, much-worked paint surfaces are comparable to those Van Gogh favoured on his arrival in Paris, and the impact of Monticelli's flower pieces on Van Gogh's is unquestionable.

If Van Gogh did spend his first months in Paris working on his own, he must have been drawn to Cormon's by hopes of artistic camaraderie as well as his desire to work with models and casts. Despite his imposing credentials, Cormon (a member of the Institut de France and a professor at the École des Beaux-Arts) had a reputation for open-mindedness that appealed to adventurous young painters including Louis Anquetin (1861–1932), Henri de Toulouse-Lautrec (1864–1901) and Émile Bernard (1868–1941), all of whom befriended Van Gogh in Paris. Anquetin shared Van Gogh's enthusiasm for Delacroix and colour theory, and was experimenting with Neo-Impressionism when they met. Toulouse-Lautrec, already an incisive portraitist, invited Van Gogh to weekly soirées at his studio, and introduced him to Montmartre café life (76). Bernard had probably been expelled from the studio by the time of Van Gogh's attendance (his relentless teenage rebelliousness had eventually exhausted even Cormon's tolerance), but the young painter still visited there.

76
Henri de
Toulouse-
Lautrec,
*Portrait of
Vincent
van Gogh*,
1887.
Crayon on
paper laid on
pasteboard;
57 x 46.5 cm,
22½ x 18¼ in.
Van Gogh
Museum,
Amsterdam
(Vincent
van Gogh
Foundation)

According to Bernard, and to Lautrec's friend François Gauzi, Van Gogh – a gauche foreigner as well as an unconventional draughtsman – was the butt of jokes during his brief tenure at Cormon's. Passionate and outspoken, he preferred to be 'left in peace', and when other students dispersed after formal sessions, Van Gogh remained alone, arduously revising drawings. A sheet of studies he made in 1886 (77) indicates the range of subjects he attempted. In addition to the study of live models (in this case a child), the studio curriculum included work from casts of antique nudes and more recent sculptures (for example, an *écorché*, or skinned figure, by Jean-Antoine Houdon; 1741–1828). Van Gogh, however, found the course of study less useful than he had hoped – perhaps, he thought, through some fault of his own. His fractious personality, and years of habit, predisposed him to solitary work, which, he told Livens, helped him 'feel my own self more'.

Nonetheless, Van Gogh benefited from the company of other artists in Paris. Theo introduced him to Pissarro (whose generosity and love of country life ensured their amity), and Vincent met Guillaumin

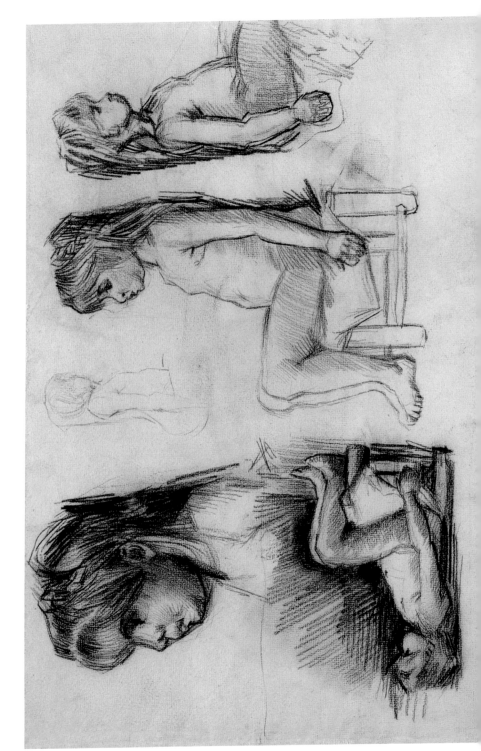

77
Studies of
plaster
statuettes and
a seated girl,
1886.
Black chalk;
47·5 x 61·5 cm,
18¾ x 24¼ in.
Van Gogh
Museum,
Amsterdam
(Vincent
van Gogh
Foundation)

127 Van Gogh in Paris, 1886–1888

78
Paul Signac,
*Rue
Caulaincourt:
Montmartre
Windmills*,
1884.
Oil on canvas;
55 x 27 cm,
21½ x 10½ in.
Musée
Carnavalet,
Paris

through Theo's friend Alphonse Portier, an art dealer who lived in
their rue Lepic apartment house. At some point in 1886, Vincent
began to frequent the art supplies shop of Julien Tanguy, a favourite
hangout of the 'impressionists of the petit boulevard'. Tanguy's small
establishment – which Bernard called 'a Parisian legend, the talk
of every studio' – was located just around the corner from the first
apartment the Van Gogh brothers shared. Many struggling painters
gave the merchant known as 'Père' Tanguy (an endearment that
translates as 'father' or 'old man') pictures in exchange for materials,
and his shop was hung with them. Tanguy's was the best place in Paris
to see the work of reclusive Provençal Paul Cézanne (1840–1906),
and, recalled Bernard, 'people would go there as if visiting a museum'.
Van Gogh admired Tanguy's radical politics (he had fought on the side
of the defeated Paris Commune in 1871) as well as his eye for and
support of avant-garde painting, and was deeply gratified when his
own work made it into the shop window.

Van Gogh's friendship with Bernard blossomed at Tanguy's, and in the winter of 1886–7 he met Neo-Impressionists Charles Angrand (1854–1926) and Paul Signac (1863–1935) there. His work with Signac proved particularly important. Ten years younger than Van Gogh, Signac, too, had taken up art around 1880. Entranced by Monet's recent work, he fell in with Guillaumin that year and adopted an Impressionist mode in views of working-class neighbourhoods (78). After encountering Seurat's large painting *Une Baignade* at the first Salon des Indépendants (1884), Signac joined forces with him, and, while Seurat kept mostly to himself, Signac became an ebullient advocate of the style he helped refine.

By the time he met Signac, Van Gogh, too, had absorbed the lessons of Impressionism, lightening his palette as well as his touch. Having spent much of 1886 working indoors, he was often on the street by year's end, painting the sorts of Montmartre scenes Signac favoured (see 68). In addition to their mutual admiration for Delacroix and nineteenth-century colour theory, Van Gogh and Signac shared a penchant for unglamorous Parisian locales and the working-class types they saw there. Aficionados of Zola and his school, both read naturalist chronicles of lowbrow Paris, and both had already, independently, made still lifes with modern novels.

In spring 1887, the period of his closest association with Signac, Van Gogh took up another book painting, one that shows the results of his colour studies and the impact of Neo-Impressionism's small, regularly positioned brushstrokes, as well as his allegiance to naturalism at a time when it was being vociferously challenged (79). During the 1880s proponents of the burgeoning 'Decadent' and Symbolist movements (critics Fénéon, Édouard Dujardin and Téodor de Wyzewa, and poets Gustave Kahn, Jean Moréas and Jules Laforge) called for an esoteric art of 'suggestion' that intertwined verbal, visual and musical effects. Aesthetes of the 1880s lionized the German philosopher Arthur Schopenhauer (1788–1860) and composer Richard Wagner (1813–83), and the French poet Stéphane Mallarmé (1842–98), and disparaged naturalism as

materialist and banal. Van Gogh was intrigued by the cult of Wagner and the Symbolists' stress upon the interconnectedness of the arts, but still preferred naturalist prose to the 'wildly contorted phrases' of Paris's literary upstarts. Aware of Zola's expulsion from the vanguard and Huysmans's flight from the naturalist fold, he remained loyal, declaring in 1887 that 'the work of the French naturalists, Zola, Flaubert, Guy de Maupassant, Goncourt, [Jean] Richepin, Daudet, Huysmans, is magnificent, and one can hardly be said to belong to one's time if one has ignored it'.

Painted on the oval lid of a Japanese tea chest, *Parisian Novels* testifies to that conviction. Its most prominent volume, atop the

stack in front, is Richepin's *Braves Gens* (1886), and its legible subtitle, *Roman parisien* (*Parisian novel*), indicates Van Gogh's wish to characterize Paris by way of books he found particularly revealing. *Braves Gens* describes the hardships endured by a musician and a mime who try to win audiences for the edgy art each performs. (Oddly prophetic of Van Gogh's own future, the novel recounts the musician's flight to a cheaper, less stressful life in the provinces, and the mime's alcoholism and premature death on the brink of renown.) The book it overlays in Van Gogh's painting, Edmond de Goncourt's *La Fille Élisa* (1877), tells the story of a troubled young woman who falls into prostitution, then lands in prison for murdering a client

who breaks her heart. It, too, is an account of dashed dreams among the city's down-and-outs (and Gauguin would remember Van Gogh invoking its heroine as he doled out charity to a Montmartre streetwalker). The still life's third book – red and hardbound – stands apart thematically as well as visually: Zola's *Au Bonheur des dames* (*The Ladies' Delight*; 1883) recounts the rise of a wildly successful businessman, Octave Mouret, who owes his entrepreneurial triumphs to his uncanny way with women. Its protagonist – Van Gogh's opposite in most respects – was one of the artist's favourite literary figures, a man of action who attained his goals. Vincent often urged Theo to be 'more like Mouret'. *Au Bonheur*'s proper, gold-embossed binding complements its saga of bourgeois prosperity. Its background placement in his still life may reflect the fact that Van Gogh read it before the others and thought of Zola as a precursor to other naturalists (erroneously, in Goncourt's case). Painted after a year's residence in the city, *Parisian Novels* – a self-conscious assertion of fluency with Parisian ways – indicates Van Gogh's awareness of the gulf between the city's solid citizens and those who lived precariously on its fringes.

Much of Van Gogh's time with Signac was spent painting in the industrialized suburbs that often figure in naturalist fiction. Signac's mother lived in Asnières, on the Seine northwest of Paris, and in spring 1887 Van Gogh regularly walked there to join him, following an itinerary mapped in several Parisian novels. Like Gervaise Coupeau in *L'Assommoir* and the Goncourts' Germinie Lacerteux (of the novel that bears her name), Van Gogh climbed Montmartre's populous southwestern slope to the crest of the Butte, then wended his way northwards towards the fortified walls, or ramparts, that had been erected in 1840. Though Gervaise and Germinie both pause there with boyfriends in the course of *extra-muros* larks, Daudet notes the ramparts' popularity among Parisian suicides (*Fromont jeune et Risler aîné* or *Fromont the Younger and Risler the Elder*; 1874), Huysmans the air of 'suffering and distress' that prevails there (*En ménage* or *Settled In*; 1881). From the fortifications, Van Gogh could survey the expanding industrial zone northwest of Paris (an area not unlike that separating The Hague

79
Parisian Novels, 1887.
Oil on wood;
31 × 48·5 cm,
12¹⁄ × 19 in.
Van Gogh Museum, Amsterdam (Vincent van Gogh Foundation)

80
*The Northern
Suburbs seen
from the
Ramparts,*
1887.
Watercolour;
39·5 x 53·5 cm,
15½ x 21 in.
Stedelijk
Museum,
Amsterdam

from Scheveningen), where factories and rail lines encumbered natural expanses (80). Zola writes of these northern reaches as 'a vague terrain' where, 'between a sawmill and button factory', one could still find 'a strip of green meadow', and the Goncourts describe the area as 'one of those arid landscapes that large cities create around themselves, that first zone of the suburbs where nature is dried up'.

Like the naturalists, Van Gogh and Signac found poetry in what Zola called 'this chalky and desolate banlieu' (81, 82). Adopting

81
Paul Signac,
Quai de Clichy,
1887.
Oil on canvas;
46 x 65 cm,
18¹⁄ x 25¹⁄ in.
Baltimore
Museum of Art

82
*Road Along the
Seine, Asnières*,
1887.
Oil on canvas;
49 x 66 cm,
19¹⁄ x 26 in.
Van Gogh
Museum,
Amsterdam
(Vincent
van Gogh
Foundation)

83
*Voyer d'Argenson,
Asnières*,
1887.
Oil on canvas;
49 x 65 cm,
19¹⁄ x 25¹⁄ in.
Van Gogh
Museum,
Amsterdam
(Vincent
van Gogh
Foundation)

diminutive brushstrokes that verge on pointillism, Van Gogh produced paintings of a delicacy unprecedented in his *oeuvre* (83). The tremulous quality imparted by the small, glancing brush Van Gogh applied to *Voyer d'Argenson, Asnières* is well-suited to a proletarian idyll in which affectionate couples woo beneath the flowering trees of a public park, its male figures uniformly clad in blue blouses and trousers that identify them as labourers. A modern and lowbrow variant on eighteenth-century *fêtes galantes* (scenes of outdoor courtship that also had inspired Renoir and Monticelli),

Van Gogh's painting shimmers with pastel tints of springtime, including the complementary play of green and pink he considered especially characteristic of that season.

In even his most earnest flirtations with pointillism, however, Van Gogh fell short of full-fledged devotion to that painstaking technique. Whereas Signac, in the mid-1880s, employed fine, uniform, evenly distributed strokes that merge at a distance to create solid forms with sharp silhouettes and subtle tonal gradations, Van Gogh used larger strokes of varied shape and direction that, rather than blending, actively jostle one another,

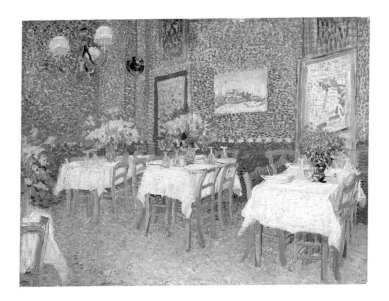

84
*Restaurant
Interior,*
1887.
Oil on canvas;
45·5 x 56·5 cm,
18 x 22¼ in.
Kröller-Müller
Museum, Otterlo

85
*Fritillarias in
a Copper Pot,*
1887.
Oil on canvas;
73·5 x 60·5 cm,
29 x 23¾ in.
Musée d'Orsay,
Paris

creating uneven, scintillating textures. Though he would continue to credit divisionism's 'real discoveries', Van Gogh – buoyed by the progress he had made – preferred intuition to dogma, and produced a take on Neo-Impressionism that is more decorative than analytic (84). It was Signac's tutelage, however, that pushed him to hone a more considered, varied and distinct brushwork.

After Signac's departure from Paris in late May, Van Gogh reinstated his larger brushes, combining free-form swirls and dabs with patterned striations and swarms of pointillist dots (85). In such paintings as *Fritillarias in a Copper Pot*, he achieved in oil a range

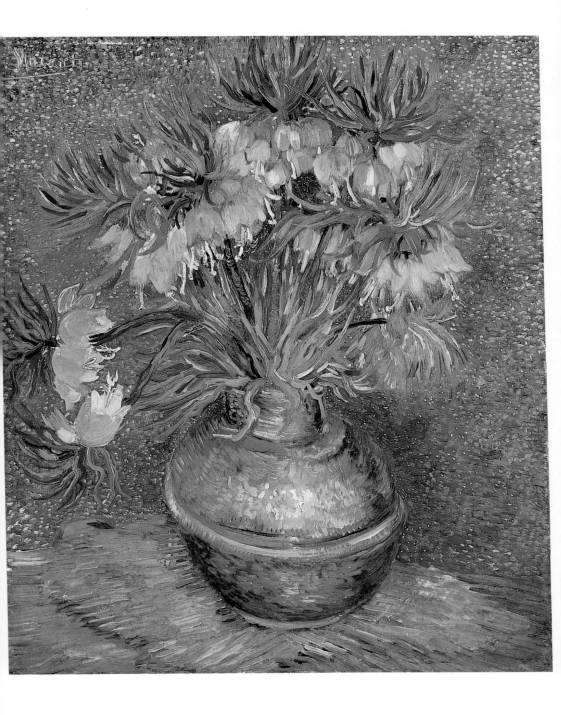

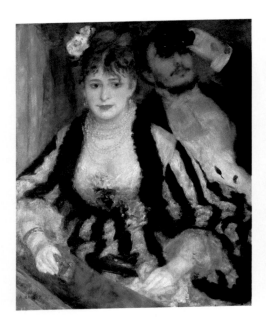
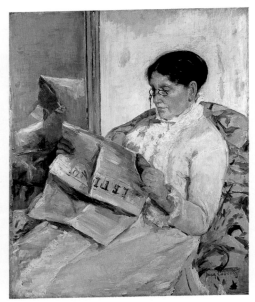

86
Pierre-Auguste Renoir,
The Loge,
1874.
Oil on canvas;
80 x 63·5 cm,
31½ x 25 in.
Courtauld
Institute
Gallery, London

87
Mary Cassatt,
Reading 'Le Figaro',
1878.
Oil on canvas;
104 x 84 cm,
41 x 33 in.
Private
collection

88
Edgar Degas,
Vicomte Ludovic Lepic and his Daughters (Place de la Concorde),
1875.
Oil on canvas;
79 x 118 cm,
31¼ x 46½ in.
State Hermitage
Museum,
St Petersburg

of marks and textures he had previously essayed only in drawings (*eg*, *Fish-Drying Barn*; see 41). At the same time, Van Gogh overcame the caution with which he had approached complementary colour combinations in still lifes of the previous year. By mid-1887 unmodulated hues dominated his production, and dazzling contrasts of warm and cool, dark and light animate the entirety of *Fritillarias*. Combining sprightly brushwork with new-found colouristic daring, Van Gogh turned a corner – arguably the most decisive of his career.

The expanded social circle he enjoyed in his second year in Paris encouraged Van Gogh's pursuit of figuration. 'The one thing I hope to achieve', he told his sister, 'is to paint a good portrait.' The French avant-garde had recently rethought and revitalized portraiture, and in 1887 Van Gogh explored (and eventually rejected) the sort of 'modern portrait' Impressionists made.

In the 1860s and 1870s the boundaries between portraiture and genre (scenes of daily life enacted by anonymous folk) were blurred by artists who presented portrait subjects in the midst of daily routines, and, concurrently, cast their friends and family members in the sorts of slice-of-life tableaux traditionally peopled by generic

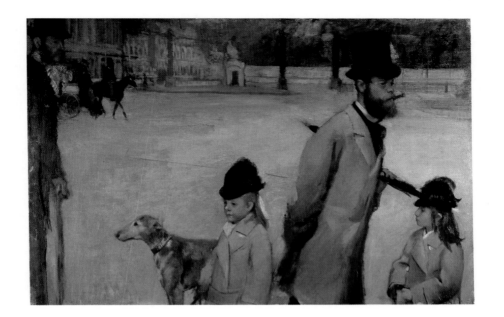

types. The status of such hybrid pictures is more easily determined by title than motif. For example, Renoir's *The Loge* (86), a lavish close-up rendering of recognizable individuals (Nini, a well-known model, and the artist's brother Edmond), is more portrait-like by conventional standards than Mary Cassatt's image of her mother engrossed in *Le Figaro* (87) or Degas's famed depiction of Ludovic Lepic and his daughters crossing the Place de la Concorde (88).

As Edmond Duranty had observed in *La Nouvelle Peinture* (*The New Painting*; 1876), his lengthy response to the second Impressionist group show, portraits made by his most adventurous contemporaries 'eliminate the partition separating the artist's studio from everyday life'. A novelist schooled in the precepts of Balzac and Zola, Duranty stressed the importance of milieu in shaping and reflecting character:

Our lives take place in rooms and on streets … And we will no longer separate the figure from the background of an apartment or the street. In actuality, a person never appears against a neutral or vague background. Instead, surrounding him … are the furniture, fireplaces, curtains and walls that indicate financial position, class and profession

... The individual ... will be having a family lunch or sitting in his armchair ... He might be avoiding carriages as he crosses the street or glancing at his watch as he hurries across the square ...

The mode of portraiture advocated in *La Nouvelle Peinture* – portraiture easily taken for genre on the basis of its subjects' envelopment by telling locales, absorption in quotidian concerns, unposed attitudes and seeming obliviousness to the viewer – was no longer new by the time Van Gogh moved to Paris. Toulouse-Lautrec's portrayal of Vincent – caught in the midst of an absinthe-fuelled discussion in a Montmartre cafe (see 76) – shows that it was current among younger Impressionists as well as their elders.

Van Gogh's own interest in capturing portrait subjects in their natural habitats is indicated by a painting he made of Agostina Segatori in early 1887 (89). Italian by birth, Segatori had once modelled 'exotic' figures for Corot and Gérôme, but by the time Van Gogh met her she ran Le Tambourin (The Tambourine), a café on the boulevard de Clichy where Vincent drank with Lautrec and Tanguy. As her friendship with him blossomed (and probably turned amorous), Segatori allowed Van Gogh to hang some of his flower pieces there, and to mount the exhibition of Japanese prints to which his portrait of her alludes (the rectangles that surround the sitter resolve vaguely into Japanese figuration in the picture's upper right). The original source of the prominent two-figure composition that is cut by the painting's right edge remains untraced, though its scale suggests a scroll painting (perhaps similar to 90) rather than a woodblock print.

Van Gogh's depiction of Segatori in her café is the most impression-istic of his portraits and participates in many of the conventions common to avant-garde likenesses of the 1870s. Like Degas's portrait of the Lepics, it refers to a specific locale, Segatori's café, identifiable by the painted motifs on the table- and stool-tops that make them resemble tambourines. The image is also time-specific, tied to the brief period in early 1887 when selections from the Van Gogh brothers' collection of Japanese prints were tacked to the café's walls. And, like many Impressionist portraits, Segatori's might be taken for a genre scene on the basis of the sitter's inattentive air and her

appearance in a public rather than private space. Indeed, one of the contemporaneous Parisian pictures it most resembles is Manet's *The Plum*, a genre painting featuring a portrait-like three-quarter-length close-up of its unidentified model (91).

Rather than denoting a specific person, *The Plum* evokes a type: the woman's presence, unescorted, in a café marks her as compromised, her cigarette mere icing on the cake of her impropriety. Van Gogh, of course, had a personal history with such women (most notably his former companion Sien Hoornick; see Chapter 2), and as a figure painter who harboured little hope of painting 'girls such as our sister', he had turned an appreciative eye on those he considered less respectable. After two years in a Dutch village, Van Gogh was so titillated by the bevy of loose women on parade in Antwerp that he contemplated the possibility of decorating café walls with images of 'those tarts', many of whom he found 'damned beautiful'. After painting 'a girl from a café-chantant' in Antwerp, he was eager to paint more women of the street:

Manet has done it, and Courbet, damn it, and I have the same ambition. Besides, I have felt to my core the infinite beauty of studies of women made by the great men of literature: Zola, Daudet, de Goncourt, Balzac.

In Paris – home to many more such women – Van Gogh specifically praised the Goncourts' *Germinie Lacerteux* and *La Fille Élisa* and Zola's *L'Assommoir* (all of which feature unfortunate female urbanites who fall prey to vice) for presenting 'truth, life as it is'. He prided himself on a similarly unflinching attitude towards working girls he encountered in the flesh as well as in painting and fiction, and told even his proper young sister about 'unseemly love affairs' he had pursued in Paris. One such affair probably involved Segatori, whose portrait (89), with arms crossed and elbows planted firmly on the table, suggests a free spirit, self-possessed and thoroughly at home in the café where she sits smoking. Her unfocused gaze hints at bored familiarity with her surroundings, though her hat, parasol and saucered mug of beer imply that she is a patron rather than the proprietress of the place, and may soon stub out her cigarette and seek a livelier venue.

89
*Agostina
Segatori,
Le Tambourin,*
1887.
Oil on canvas;
55 x 46 cm,
21¾ x 18 in.
Van Gogh
Museum,
Amsterdam
(Vincent
van Gogh
Foundation)

90
Hosodu Eishi,
*Beauties of
the Seasons –
Spring,*
c.1800.
Hanging scroll,
colour on silk;
175·6 x 49·8 cm,
69⅛ x 19½ in.
Freer Art Gallery,
Washington, DC

91
Édouard Manet,
The Plum,
c.1878.
Oil on canvas;
73·6 x 50·2 cm,
29 x 19¾ in.
National
Gallery of Art,
Washington, DC

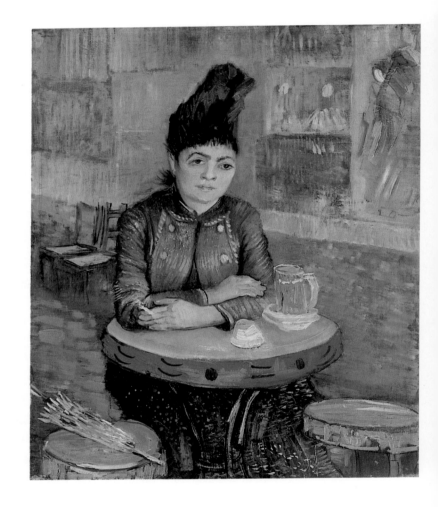

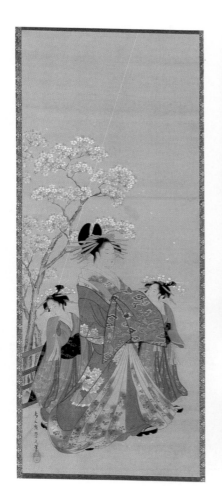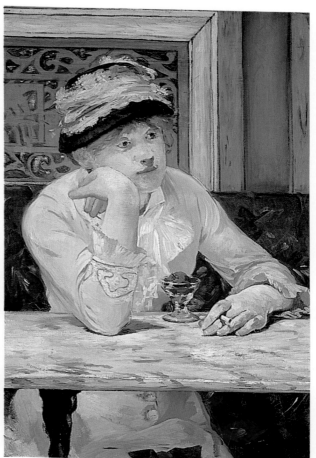

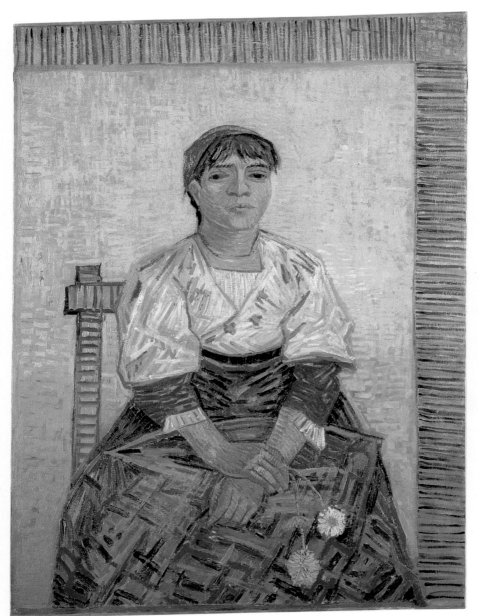

92
L'Italienne,
1887–8.
Oil on canvas;
81 x 60 cm,
32 x 23½ in.
Musée d'Orsay,
Paris

93 Frans Hals,
Portrait of
Mrs Bodolphe,
1643.
Oil on canvas;
123 x 98 cm,
48½ x 38½ in.
Yale University
Art Gallery,
New Haven

94
Frans Hals,
The Gypsy,
c.1628.
Oil on canvas;
58 x 52 cm,
22⅞ x 20½ in.
Musée du
Louvre, Paris

A letter Van Gogh wrote in summer 1887 indicates that he and Segatori had fallen out by then. A sense of distance is reflected in a second, larger portrait, made in the aftermath of their intimacy (92). Known as *L'Italienne* (*The Italian Woman*), the later picture is more emblematic than naturalistic, and lacks the emotional charge of its predecessor. Removed from any contextualizing milieu and attired in traditional costume rather than modern dress, its subject emerges as a type rather than a personality (and may have been painted from memory). This Segatori does not appear a contemporary inhabitant of Paris but instead reprises the role of colourful exotic she once played for Corot and Gérôme. Essaying the

145 Van Gogh in Paris, 1886–1888

sort of quintessence found in *The Graphic*'s 'Heads of the People', Van Gogh cast his erstwhile *amour* as the stereotypic female Italian of northern European imagination.

The strong palette and patterned brushwork of *L'Italienne* associate it with avant-garde trends and show the impact of *japonisme* (the adoption of Japanese stylistic traits by Western artists; see Chapter 5). The picture's asymmetrical internal border and unmodulated yellow backdrop reflect lessons Van Gogh absorbed from the Japanese prints he collected in Paris, as do the rectilinear fabric folds and clash of patterns found in *L'Italienne*'s skirt. Although at odds with the ethnicity of this sitter, Japanese print culture is

generally allied to her by its intriguing otherness, its tantalizing non-Frenchness reinforcing hers here.

For all its stylistic modernity, *L'Italienne* is conceptually incongruous with portrait modes that prevailed at the time. Its distance from them anticipates the idiosyncrasies of Van Gogh's future figuration and restates his ties to Dutch forebears. In composition and pose, this centralized figure on a plain ground, hands carefully arranged and gaze directed towards the viewer, recalls seventeenth-century portraits of burghers' wives (93). In its type-casting, however, Van Gogh's second portrait of Segatori comes closer to Dutch Masters' images of lower-class women, such as Hals's *Gypsy* (94), one of Van Gogh's favourite pictures in Paris (like most viewers before and since, he assumed it to represent a prostitute). Whereas Manet's *Plum* evokes a local and contemporary type in her milieu, Hals, in *The Gypsy*, moves in the direction of archetype – a path Van Gogh would follow as he developed his own notion of the modern portrait in Arles the following year (see Chapter 6).

The two years Van Gogh spent in the French capital were productive and enlightening. The artist's mature style – an amalgam of rich colour, distinctive draughtsmanship, Impressionist, Neo-Impressionist and *japoniste* stylistics, and firmly held convictions based on long and attentive study of critical texts and older art – took shape in Paris, as did his alliance with the avant-garde. At the end of 1887, he was able to put together a group show in which his own work hung with that of Lautrec, Anquetin and Bernard. Mounted at the Grand-Bouillon-Restaurant du Chalet (located, like Le Tambourin, on the boulevard de Clichy), this exhibition of work from the 'petit boulevard' featured about a hundred pictures, half of them by Van Gogh. An assertion of confidence and camaraderie, the show was a small triumph in which he took great pride. Anquetin and Bernard both made sales, and Paul Gauguin (1848–1903), recently returned to Paris from Martinique, traded one of his recent pictures for two of Van Gogh's pictures. Ignored by critics, the exhibition nonetheless drew Seurat, Signac, Pissarro and the dealer Georges Thomas.

Over the course of 1887, however, Van Gogh's personal life ran amok and his health deteriorated. A difficult housemate, he often quarrelled with Theo, who later recalled that Vincent's irascibility put people off and caused unpleasant scenes. Moreover, Vincent spent long hours drinking brandy, 'bad wine' and the popular anise-flavoured and wormwood-charged liqueur, absinthe (see 76). Banned in 1915 as addictive, mind-altering and nerve-damaging, absinthe was a favourite libation of *fin-de-siècle* Montmartre (its consumption in France increased fifteen-fold between 1875 and 1915). Van Gogh's absinthe-drinking (which Signac termed excessive) may have contributed to his volatility in Paris and to his breakdowns of the later 1880s.

By the winter of 1887–8, he found himself 'seriously sick at heart and in body', 'nearly an alcoholic', and 'headed for a stroke'. Determined to leave the city and turn over a new leaf, Van Gogh fantasized about journeying to Japan, a pipe dream induced by his passion for prints by Andō Hiroshige (1797–1858) and others (95). Like Coriolis de Naz, the artist protagonist of the Goncourts' *Manette Solomon* (1867), who uses Japanese prints to effect imaginative escape from Parisian winter, Van Gogh (a fan of that novel) fancifully envisioned himself transported to the land evoked by *ukiyo-e* ('pictures of the floating world', a term describing Japanese images of the seventeenth to nineteenth centuries). Having fallen under the spell of Japanese prints, Van Gogh, like Coriolis, 'lost himself in that azure ... that serves as a mount for the snowy flowers of peach and almond trees', abandoning 'the winter, the greyness of the day, the poor shivering Paris sky ... [for] those fields of lapis rock ... that greenness of damp plants ... those efflorescent hedges'.

As in The Hague, Van Gogh in Paris came to crave rusticity. The Millet exhibition he attended at the École des Beaux-Arts in May 1887 probably sharpened this recurrent yearning, which was surely fostered, too, by his budding friendship with Gauguin, who in late 1887 was planning a retreat to Brittany, in northwest France (where he already had spent time in 1886). A former sailor, the well-travelled Gauguin doubtless encouraged Van Gogh's interest in exoticism.

95
**Andô
Hiroshige**,
*Ishiyakushi:
Rice Fields and
Flowering Trees*,
1855.
Woodblock
print.
37 x 23·5 cm,
14¹⁄₂ x 9¹⁄₄ in.
Van Gogh
Museum,
Amsterdam
(Vincent
van Gogh
Foundation)

On the practical side, however, his decision to return to Brittany may have led Van Gogh to consider moving to provincial France rather than returning to Holland or going so far afield as Japan.

Perhaps believing Brittany to be insufficiently different from his native Brabant, Van Gogh looked southward. Signac had travelled to France's Mediterranean coast in May 1887, and Van Gogh knew that Monticelli and Cézanne – southerners by birth – had returned to Provence after working in Paris. Zola and Daudet were also southerners, and Van Gogh's notion of Provence's sunny lushness owed a great deal to Zola's *La Faute de l'Abbé Mouret* (*Father Mouret's Sin*; 1875), Daudet's *Lettres de mon moulin* (*Letters from My Windmill*; 1869) and *Tartarin de Tarascon* (*Tartarin of Tarascon*; 1872). Above all, however, it was his absorption in *ukiyo-e* that propelled him in that direction: 'We like Japanese painting … So why not go to Japan? That is to say, the equivalent of Japan, the South.'

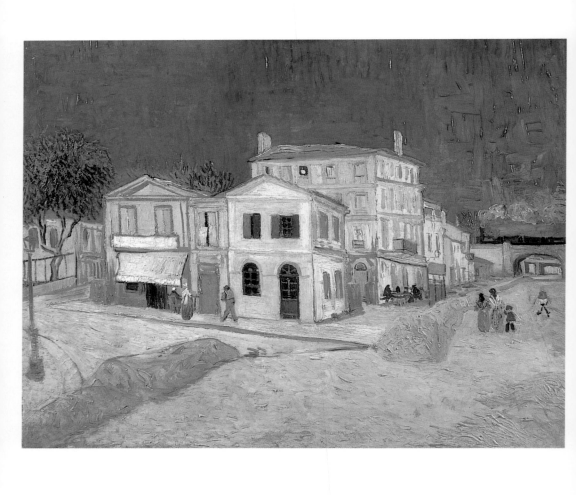

Under the spell of Japanese prints he avidly admired and collected in Paris in 1887, Van Gogh arrived in the south of France in early 1888 looking for colour, clarity and vivacity to compare with that of *ukiyo-e*. Perhaps the only thing odder than his journey to Provence in search of Japan is the fact that he found what he was looking for. 'I don't need Japanese pictures here,' Vincent told Wil from Arles, 'for I am always telling myself that *here I am in Japan*.' Partly aware of the whimsicality of his outlook, he later recalled his excitement at journeying south, 'peer[ing] out the window to see whether it was like Japan yet! Childish, wasn't it?' An equally childish capacity for make-believe allowed Van Gogh to see a dusty Provençal town as 'absolute Japan' for much of the time he lived there (96).

The fantasy of Japan that coloured Van Gogh's experience of Arles was cobbled together from art, popular literature, anecdote and imagination. He may have seen isolated examples of Japanese art while working as an art dealer, but the first recorded source of his mental construct 'Japan' was a European take on the land of the rising sun: the work of French academician Félix Régamey (1844–1907), who had travelled to Asia with the well-known *japoniste* Émile Guimet (1836–1918), whose *Promenades japonaises* and *Tokio-Nikko* (both published in 1880) he illustrated in a resolutely Western mode. Van Gogh's casual mention of Régamey's 'Japanese things' in a letter from The Hague suggests that he saw one of Guimet's books there, though he gave little further thought to Japan until *ukiyo-e* prints caught his eye in Antwerp in the winter of 1885–6. Even then, his interest was piqued by a fellow European's, for Van Gogh had read Edmond de Goncourt's preface to *Chérie* (1884) in his last month at Nuenen. The chronicle of a woman's coming of age, *Chérie* itself was not nearly so interesting to him as Goncourt's self-congratulatory preface, in which the author claims that he and his late brother launched the vogue for Japan that

96
The Yellow House, Arles, 1888.
Oil on canvas;
76 x 94 cm,
30 x 37 in.
Van Gogh Museum,
Amsterdam
(Vincent van Gogh Foundation)

'revolutionized Western ways of seeing'. Within weeks Van Gogh had acquired his first Japanese prints and decorated his Antwerp studio with images of 'little women's figures in gardens or on the beach, horsemen, flowers, knotty thorn branches'. He also found echoes of *ukiyo-e* as he surveyed that port city, with its

> figures of the most varied character ... water and sky a delicate grey – but above all – *Japonaiserie*. I mean, the figures are always in action, one sees them in the queerest surroundings ... and interesting contrasts crop up all the time ... A white horse in the mud ... the silvery sky above that mud ... a tiny figure in black ... stealing noiselessly along grey walls.

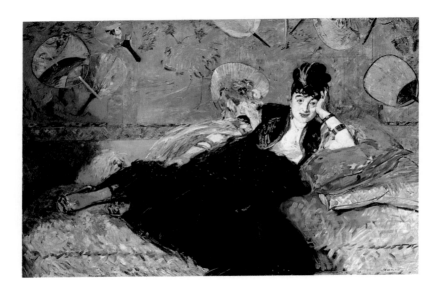

The term '*japonaiserie*' refers both to Western appreciation of Japanese exotica and to Japanese collectibles such as those seen in Manet's portrait of Nina de Callias, where a profusion of *uchiwa* (round paper fans) tacked to a Japanese screen enhances the sitter's aura of exotic chic (97). Van Gogh's initial interest in Japan was dominated by his sense of its compelling otherness – a notion shaped by the exaggerated forms, quirky silhouettes and peculiar juxtapositions of *ukiyo-e* prints. The colourful neighbourhood around Antwerp's docks became his first 'virtual Japan', and – reiterating the exclamation with which the Goncourts greeted the Japanese art they saw at the Universal Exposition of

1867 – Van Gogh proclaimed '*Japonaiserie* forever' as he detailed the droll types and spectacle on view there.

In Paris, Van Gogh's admiration for *ukiyo-e* was temporarily overshadowed by his encounters with Impressionism and Neo-Impressionism. By the winter of 1886–7, however, his passion for Japan surged anew. This reawakening probably owed something to his friendships with Toulouse-Lautrec (who had become infatuated with Japan in 1882) and John Peter Russell (1858– 1931), an

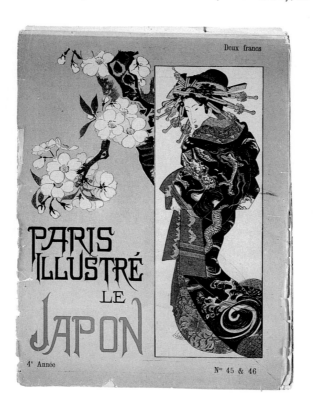

97
Édouard Manet,
Nina de Callias (The Lady with Fans),
1873–4.
Oil on canvas;
113 x 166 cm,
44½ x 65⅜ in.
Musée d'Orsay,
Paris

98
Cover of *Paris Illustré* with a reproduction of Eisen's *Courtesan* (or *Oiran*),
1886.
Van Gogh Museum, Amsterdam (Vincent van Gogh Foundation)

Australian painter who had travelled in China and Japan. Russell, who sometimes worked at Cormon's and painted Van Gogh towards the end of 1886, collected Asian art, which he doubtless discussed with Van Gogh. He and/or Lautrec perhaps recommended the recent publications on Japanese art that Van Gogh read in Paris, including Théodore Duret's article in *Gazette des Beaux-Arts* (1882; reprinted in *Critique d'avant-garde*, 1885), Louis Gonse's *L'Art japonais* (1883) and the special 'Japan' issue of *Paris Illustré* (1886; 98).

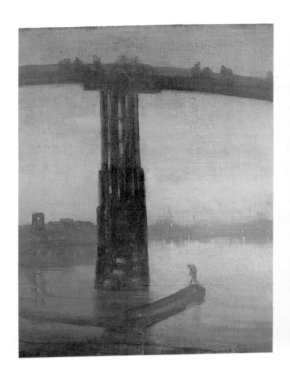
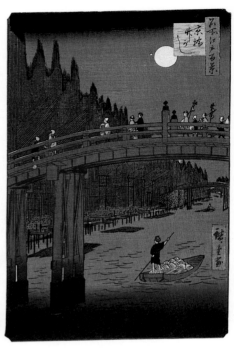

The European vogue for Japan had begun some thirty years earlier, when, in the mid-1850s, Japan ended two centuries of isolationism by establishing trade relations with several Western nations. Japanese goods soon hit Paris and London, and by the early 1860s a number of shops catered to collectors: La Porte Chinoise, L'Empire Chinoise and Mme Desoye's store on the rue de Rivoli were the best-known Parisian purveyors of *japonaiserie*, while English aficionados flocked to Farmer and Roger's Oriental Warehouse (later known as Liberty & Co). French printmaker Félix Bracquemond (1833–1914) and American expatriate James Abbott McNeill Whistler (1834–1903) were among the first Western artists to collect and emulate Japanese art (99, 100). Soon Degas, Manet, Millet and Monet built collections, as did the Goncourts and Zola. Meanwhile, displays of Japanese art at the London International Exhibition of 1862 and the Universal Exposition in Paris in 1867 raised its profile.

In 1872 the critic and collector Philippe Burty coined the word '*japonisme*' to designate the profound interest he and

99
James Abbott McNeill Whistler,
Nocturne in Blue and Gold: Old Battersea Bridge, 1872–5.
Oil on canvas; 67 x 49 cm, 26¹⁄₄ x 19¹⁄₄ in.
Tate, London

100
Andō Hiroshige,
Kyo Bridge, from the series *One Hundred Famous Views of Edo,* 1856–8.
Woodblock print; 37·5 x 25·2 cm, 14³⁄₄ x 9⁷⁄₈ in

101
Édouard Manet,
The Fifer Boy, 1866.
Oil on canvas; 160 x 98 cm, 63 x 38¹⁄₂ in.
Musée d'Orsay, Paris

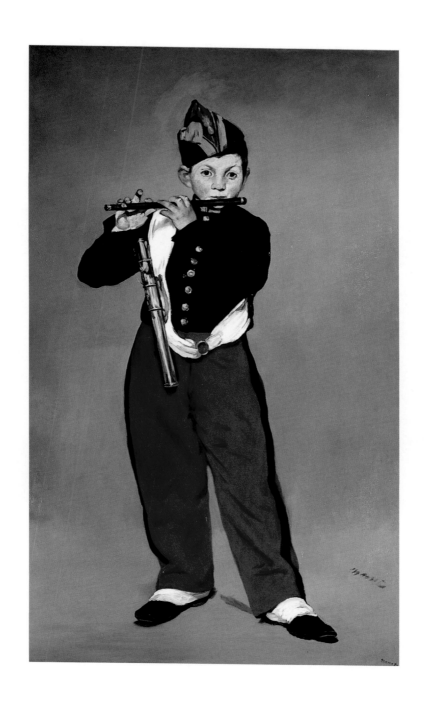

his contemporaries took in Japanese art and culture. Though sometimes used interchangeably with *japonaiserie*, *japonisme* has a particular meaning among art historians, who (following Mark Roskill's lead) use it to describe Western art practice that is inflected by Japanese aesthetics – as distinct from the mere depiction of Japanese exotica. Thus, while Manet's portrait of Nina de Callias (see 97) is marked by *japonaiserie*, his *Fifer*, though devoid of overt references to Japan, exemplifies *japonisme*, since its adamant outline, flattening of three-dimensional volumes, unmodulated contrasts of light and dark, and indeterminate

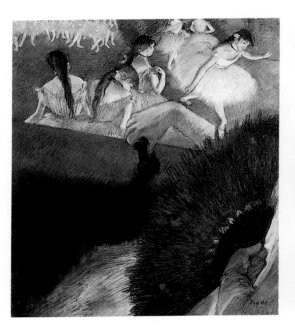

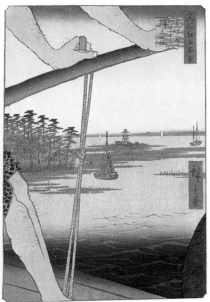

backdrop echo common traits of *ukiyo-e* figuration (101, compare 98). A fairly fluid term, *japonisme* encompasses varied stylistic traits. Degas, for instance, favoured more complex spaces than Manet, and his *japonisme* resides in asymmetrical compositions, radically cropped motifs and abrupt transitions from near to far (102, compare 103). Monet's affinity for Japanese aesthetics marks the gardens and décor of his house at Giverny, where he hung his collection of Japanese prints, and his *oeuvre* includes both playful *japonaiserie* (104) and sustained *japonisme*

102
Edgar Degas,
At the Theatre,
1880–1.
Pastel on paper;
55 x 48 cm,
21⅝ x 18⅞ in.
Private collection

103
Andō Hiroshige,
*The Benten
Shrine Seen from
Haneda Ferry*,
from the series
*One Hundred
Famous Views
of Edo*,
1856–8.
Woodblock print;
34·4 x 24 cm,
13½ x 9½ in

104
Claude Monet,
*La Japonaise
(Camille Monet
in Japanese
Costume)*,
1876.
Oil on canvas;
231·6 x
142·3 cm,
91¼ x 56 in.
Museum of
Fine Arts, Boston

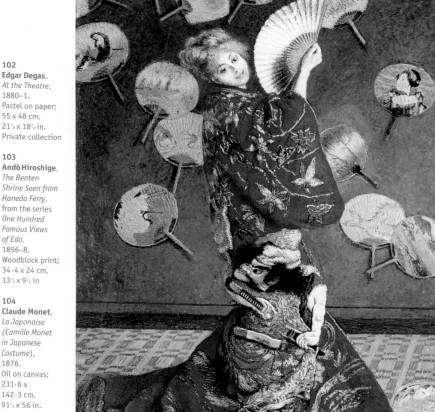

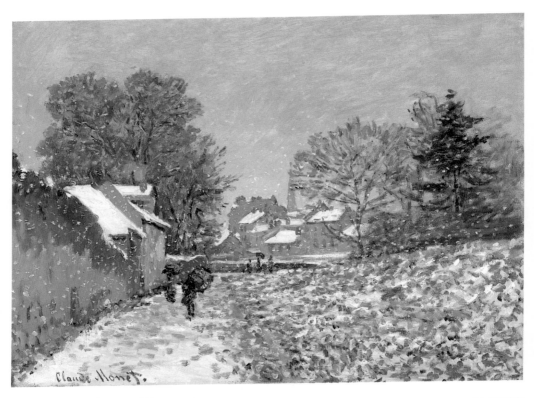

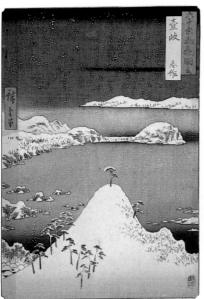

(105 and 107). His paintings of falling snow not only take up a favourite subject of Japanese printmakers, but, like many *ukiyo-e* landscapes, play surface effects against implied depth (105, compare 106). The bird's-eye vantage points (and resultant high horizons) of views Monet made at Belle-Ile recall Japanese practice, while the striking silhouettes of its rocks find parallels in *ukiyo-e* (107, compare 106).

By the 1880s, as *japoniste* aesthetics continued to generate inspired variants among avant-garde artists including Monet, Degas and Whistler, bourgeois consumers made Japan a popular fad. Japanese art had been a premier attraction of the Universal Exposition of 1878 and became better known through the shows Gonse organized for the Georges Petit Gallery in 1883, and dealer Siegfried Bing for the Central Union of Decorative Arts in 1887. In the era of Van Gogh's residence, fashionable Parisians could buy prints, accessories and knick-knacks at department stores. The taste for *japonaiserie* became such a middle-brow cliché that the protagonist of Maupassant's *Bel-Ami* (1885; see 131) – a charming mediocrity who follows trends rather than setting them – is said to cover the stained wallpaper of his bachelor's flat with five francs' worth of 'Japanese prints, fans and small screens'.

By this time, *japonisme* struck some as hackneyed, a perception that may account for the lull in younger artists' interest in the early 1880s. To the Dutchman new to Paris, however, Japanese prints (along with classic 1870s Impressionism) looked as novel as Seurat's *Grande Jatte* (see 73), and Van Gogh – populist that he was – was undeterred by *ukiyo-e*'s mass appeal. Once introduced to Bing's emporium (a favourite haunt of 1880s *japonistes*), he spent hours in its attic examining prints he bought by the dozens. Unable to afford Katsushika Hokusai (1760–1849) – the *ukiyo-e* artist most vaunted by French critics – Van Gogh collected slightly later work, by Andō Hiroshige, Utagawa Kunisada (1786–1864) and Utagawa Kuniyoshi (1797–1861).

As he brightened his own palette under the influence of recent French painting, Van Gogh was especially attentive to the colourism

159 The Impact of *Ukiyo-e*, 1887–1888

105
Claude Monet,
*Snow at
Argenteuil,*
1874.
Oil on canvas;
53 x 64 cm,
20¹⁄ x 25¹⁄ in.
Museum of Fine
Arts, Boston

106
Andō Hiroshige,
*Shisaku in
the Snow,*
1854.
Woodblock
print;
36·8 x 23·5 cm,
14¹⁄ x 9¹⁄ in

107
Claude Monet,
*Pyramids of
Port-Coton,*
1886.
Oil on canvas;
65·5 x 65·5 cm,
25¹⁄ x 25¹⁄ in.
Fondation Rau
pour le Tiers-
Monde, Zurich

of Japanese *nishiki-e* (polychrome woodblock prints), to which Duret credited that of Impressionism. 'Before the arrival of Japanese albums,' Duret wrote, 'there was no one in France who dared sit on the banks of a river and juxtapose a frankly red roof, a whitewashed wall, a green poplar, a yellow road and blue water.' Attributing the colouristic daring of *nishiki-e* to the 'atmosphere of extraordinary transparency' he had witnessed in Japan, Duret also noted that Japanese printmakers' sensitivity to 'fugitive aspects of nature' qualified them as 'the first and most perfect impressionists'. Van Gogh in turn came to think of 'impressionists' (*ie* the Parisian avant-garde) as 'the Japanese of France'. His advice that Wil look at Japanese pictures in order to gain 'practical understanding of the current tendency toward painting in bright clear colours' suggests the role *nishiki-e* played for Vincent himself as he examined and assimilated avant-garde painting in Paris.

Though his initial attraction to Japanese art was sparked by its otherness, Van Gogh's appreciation deepened as he became convinced of its relevance to developments in Parisian art and his own work. Eager to share his enlightenment, he got Segatori's permission to display some of his recent acquisitions on her premises in early 1887 (see Chapter 4), and later recalled, 'the exhibition of prints I had at Le Tambourin influenced Anquetin and Bernard a great deal'. When Van Gogh took his colleagues to Bing's, the timing was right, since both Bernard and Anquetin, who had experimented with Neo-Impressionism in 1886, were looking for redirection. Though they, like Seurat, were intent on pursuing an essentialist art in which visual reality was manipulated rather than mirrored, Bernard and Anquetin rejected pointillism, declaring the primacy of line over dot and quarrelling with Signac around the time of Van Gogh's closest collaboration with him. Once introduced to Japanese prints, the two took up contour-driven stylizations in which traditional Western tonal gradations gave way to unmodulated colour fields (108). Though the style they developed together was eventually dubbed 'cloisonnism' (a term derived from enamel work in which metal partitions – *cloisons*

108
Louis Anquetin,
Avenue de Clichy: Five O'Clock in the Evening,
1887.
Oil on canvas;
69·2 x 53·5 cm,
27¼ x 21 in.
Wadsworth Atheneum, Hartford, Connecticut

161 The Impact of *Ukiyo-e*, 1887–1888

– separate compartments of pure colour), the pictures Anquetin and Bernard unveiled at the 'petit boulevard' exhibition Van Gogh organized that November were more *japoniste* than anything else. Cloisonnism rode the crest of what Gerald Needham calls the 'second wave' of *japonisme*, which hit full force in the 1890s.

In the second half of 1887, after Signac left Paris, Van Gogh worked closely with Bernard and Anquetin, and his work, too, became increasingly *japoniste*. His *japonisme* differed from theirs, however.

Unwilling to sacrifice impasto, Van Gogh took cues from the most textural of Japanese prints, known as *crepons* ('crêpes') on the basis of their crinkled surfaces. Introduced in the later nineteenth century, *crepons* were made by dampening finished prints and compressing them repeatedly, from various angles, until they were irregularly crimped. According to English painter A S Hartrick (1864–1950), Van Gogh – a collector of *crepons* – sought to emulate their distinctive look in such paintings as the large *Parisian Novels* that was on his easel when Hartrick came to call (109), a picture in which remnants of Neo-Impressionistic stippling adjoin thick lines of paint applied in parallel striations and interwoven strands. Exaggerated oil translations of *crepons'* ridged textures, striated and basket-weave brushwork characterize the *japonisme* Van Gogh developed towards the end of 1887, and are seen, for instance, at the edges of *L'Italienne* and in its yellow background (see 92). These modes of paint application dominate Van Gogh's many take-offs on Japanese prints, including Hiroshige's *Ishiyakushi* (see 95) and Eisen's *Oiran* (see 98), both of which appear in a portrait Van Gogh made of Tanguy (see 113) – and neither of which is a *crepon*.

109
Parisian Novels,
1887–8.
Oil on canvas;
73 x 93 cm,
28¾ x 36½ in.
Private
collection

110
**Andō
Hiroshige,**
Ohashi, from
the series
*One Hundred
Famous Views
of Edo*,
1856–8.
Woodblock
print;
36·5 x 24·4 cm,
14¼ x 9⅝ in

111
*Japonaiserie:
Ohashi*, after
Hiroshige,
1887.
Oil on canvas;
73 x 54 cm,
28¾ x 21½ in.
Van Gogh
Museum,
Amsterdam
(Vincent
van Gogh
Foundation)

Even his most literal homages to *ukiyo-e* are not mere copies, as comparison of Hiroshige's *Ohashi* with Van Gogh's variant on it demonstrates (110, 111). Typically, Van Gogh combined aspects of his own aesthetic with preferred Japanese modes, and, significantly, adapted the motifs and graphic marks of admired prints to the oil medium, rather than suppressing oil's inherent weightiness to imitate the flatness of ink on paper. His version of *Ohashi*, for instance, is thick with impasto (the slanting lines of rain in Van Gogh's version cut *into* the paint-laden surface, rather than lying on the landscape like those of the print), and are colouristically altered to reflect the high-keyed hues he appreciated in other *nishiki-e*. Van Gogh's rain-washed bridge is improbably bright, and the vista's vibrant tones are framed by a garish border. Like other enthusiasts – from Manet and Degas to Monet and Anquetin – Van Gogh borrowed selectively. The traits that mark his mature *japonisme* are already on view in his *Ohashi* spin-off (though not all occur in Hiroshige's original): strong hues; wiry line and angular silhouettes; bird's-eye

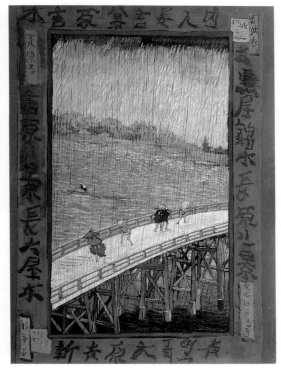

vantage points and steep ground planes; pronounced contrasts of colour, pattern and near/far.

Following a common pattern, Van Gogh passed through a phase of *japonaiserie* before fully integrating *ukiyo-e* aesthetics and Western-style representation. The tension between the two modes is evident in his first version of Tanguy's portrait (112), where the drab tones

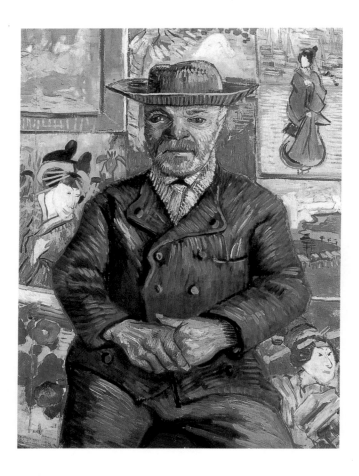

112
Père Tanguy,
1887–8.
Oil on canvas;
65 x 51 cm,
25½ x 20 in.
Stavros S
Niarchos
Collection,
Athens

113
Père Tanguy,
1887–8.
Oil on canvas;
92 x 75 cm,
36¼ x 29½ in.
Musée Rodin,
Paris

of the merchant's costume and flesh are offset by a jewel-toned backdrop, and Western-style *chiaroscuro* (highlight and shadow) lends Tanguy's form a volumetric substantiality his Japanese counterparts lack. Tanguy's hands and face are particularized by detail, unlike the ageless, idealized generalizations that dominate *ukiyo-e,* and his guileless expression and four-square pose contrast with the studied elegance of the geishas behind him. Whereas the

Asian exotica in Manet's portrait of Nina de Callias or Monet's of his wife conveys their subjects' stylishness (see 97 and 104), the *japonaiserie* of Tanguy's portrait has the opposite effect, emphasizing the sitter's artlessness. Tanguy, who neither sold nor collected *ukiyo-e* (the prints behind him belonged to Van Gogh), appears at odds with it – and may even be seen to elbow the

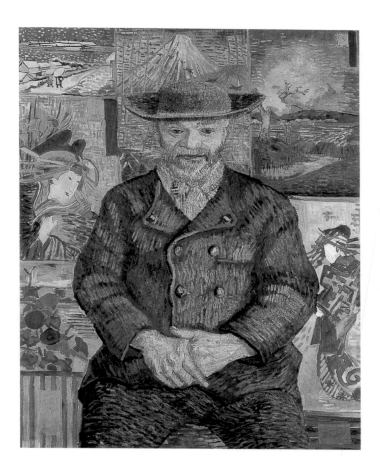

elaborately coiffed geisha at the lower right. As if to stress their distance, Van Gogh drew a coarse red line between the man and the prints: a boundary dividing reality from art, and Western-style illusionism from Japanese abstraction.

Entranced as he was by the 'floating world', Van Gogh – a displaced rustic with down-to-earth tastes and an affinity for Rembrandt and Hals – had difficulty relinquishing the solid materiality of his own

realm. In a second take on the Tanguy portrait, however, he achieved greater unity of figure and ground by both exaggerating the surface textures of the prints and tamping down the inherent robustness of his personal style (113). Tanguy's head is shrunken and flattened, its unnatural pastels echoing the powdered pallor of *ukiyo-e*'s geishas, and the visual merger of his hat with a print of Mount Fuji playfully references the sedge headgear of Japanese labourers. This 'japanified' portrait, in which model nearly merges with prints, reveals an artist who liked losing himself in the imagined Japan such prints conjured up. Tanguy's unfocused gaze suggests far-off thoughts, and if the old man seems less vital, less himself than in the earlier picture, the same may be said for Van Gogh's style.

Conceptually similar to Whistler's *Old Battersea Bridge*, in which a Western motif is bent to the shape of a Japanese one (see 99, 100), Van Gogh's later portrait of Tanguy manifests a sacrifice of actuality to aesthetics. While it has been suggested that Van Gogh's idealizing affection for Tanguy (an unpretentious art lover of socialist inclination) led to his pictorial transmogrification into a Buddha-like sage ensconced in a utopian realm of beauty and balance, the portrait's meaning is unclear. It may be as much about style as anything else, and in that respect represents a road not taken. In the winter of 1887–8 the imitative *japonaiserie* that reached its apogee in Van Gogh's later portrait of Tanguy gave way to the more vigorous *japonisme* of *L'Italienne* (see 92), where *ukiyo-e*'s influence is pronounced (in colour and pattern plays, flattened chair back and fabric folds, asymmetrical frame and strong silhouette on unfigured ground) but the artist's Westernness (and that of his model) is asserted by Van Gogh's energetic paint handling and his faithfulness to Segatori's features, flesh tone and full-bodied form.

Nevertheless, Van Gogh's *japonisme* did not reach full bloom until he moved to Provence. Convinced by Duret's writings that the effects and motifs he admired in *ukiyo-e* resulted from its artists' lives close to nature, in sunny climes and pellucid atmosphere, Van Gogh came to consider relocation essential to the advancement of his art. Though he had habitually returned to the countryside in search of

his rustic ideal, in February 1888 Van Gogh chose the South of France with Japan in mind, 'thinking', he wrote, 'that looking at nature under a bright sky might give me a better idea of the Japanese way of thinking and feeling'. Once settled in Arles, he reported to Bernard, 'This country seems to me as beautiful as Japan as far as the limpidity of the atmosphere and gay colour effects are concerned'.

Situated on the Rhône river, just 40 km (25 miles) from the Mediterranean coast, Arles is almost 800 km (500 miles) from Paris. In the mid-1880s it was surrounded by marshy flatlands that gave on to the undeveloped coastal region of the Camargue in the

114
The Crau seen from Montmajour, 1888.
Black chalk, pen, reed pen, brown and black ink;
49 x 61 cm,
19¹ x 24 in.
Van Gogh Museum, Amsterdam
(Vincent van Gogh Foundation)

southwest. The plains to the east of Arles, drained and irrigated by canals, are known as the Crau, and bounded at the north by the Alpilles mountains (114). Founded by Julius Caesar, Arles has the largest Roman arena in France and an ancient burial ground, the Alyscamps, where stone sarcophagi flank a tree-lined avenue (see 127). From its days as a medieval centre, Arles boasts a twelfth-century church and cloister, and the ruined abbey of Montmajour that dominates the Crau. Such monuments, however, held little appeal for an artist in search of the Far East, and Van Gogh preferred the outskirts of town.

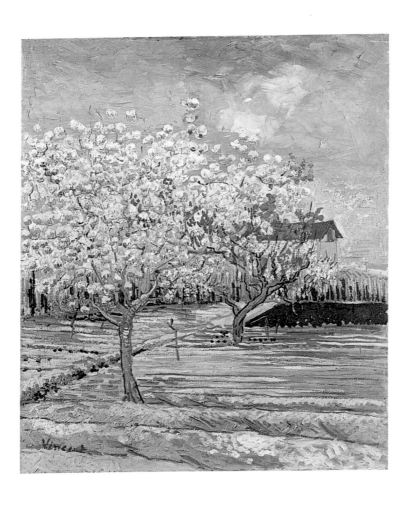

Arriving to a freak cold snap and deep snow, Van Gogh made the best of the unexpected (recalling 'winter landscapes the Japanese have painted'), but he was glad to see the end of Arles's coldest winter in a quarter-century. As a thaw announced spring's onset, he told Bernard:

Water forms pools of beautiful emerald green or rich blue in the landscape, just as we see in the *crepons*. The sunsets have a pale orange colour which makes the fields look blue. The sun is a splendid yellow. And all this though I have yet to see the country in its usual summer splendour.

In March and April he made more than a dozen paintings of flowering trees, a favourite *ukiyo-e* motif (see 95), and one Van Gogh especially admired in Hiroshige's *oeuvre*. In his own work, blossoming boughs symbolize the hopeful sense of renewal awakened by hints of spring. When a published tribute to the recently deceased Mauve left him 'choked with emotion', Van Gogh dedicated a painting of a flowering peach tree to his former mentor, inscribing it 'souvenir de Mauve' and signing his brother's name as well as his own. This gesture was as calculated as it was emotional. Eager for recognition in his native land, Vincent reasoned in letters to Theo that this picture, sentimentally offered to Mauve's well-connected widow, might 'really break the ice in Holland'. In addition to metaphorically connecting Mauve's passing to natural cycles of death and rebirth, the painting was apparently also linked to a more mundane concern: 'the rebirth of ... business relations in Holland'.

Convinced that 'this kind of subject delights everybody', Van Gogh begged for material support for his 'craze for painting orchards', and in gratitude for Theo's timely response made *Orchard in Blossom* (115) for his birthday. Its striking contrasts of white flowers, 'frankly red roof' and deep green plants on pervasive robin's-egg blue echo the flashy colour plays Duret, Van Gogh and their contemporaries thrilled to in *nishiki-e*. Its sparing but athletic line, which veers from supple to splintered, reflects the artist's study of Japanese prints in which linear detailing makes thatch, smoke,

115
Orchard in Blossom,
1888.
Oil on canvas;
72 x 58 cm,
28¼ x 22¾ in.
Private collection

vegetation and rushing streams out of colour patches that would otherwise be barely legible abstractions (116).

The linear perspective system Van Gogh used, however, follows European models (and points to his continued reliance on a perspective frame), and the impasto of the scene's furrows, flowers and sky reflects his Westerner's taste for tactility. Poised somewhere between *japonisme* and Impressionism, Van Gogh's final *Orchard in Blossom* is uniquely his – just as surely identified by its palette and brushwork as by the artist's signature.

The colour schemes Van Gogh explored in Arles (117), inspired in principle by Japanese prints, are actually less predictable and

116
Katsushika Hokusai,
Long, Lonely Night, from *100 Poems Explained by the Nurse*.
Woodblock print;
25·3 x 36·5 cm,
10 x 14⅜ in

117
Street in Saintes-Maries-de-la-Mer,
1888.
Oil on canvas;
36·5 x 44 cm,
14½ x 17¼ in.
Private collection

more wide-ranging than even the most colourful *nishiki-e*. While makers of polychrome prints are technically constrained by their need to cut a separate block for each colour applied, the oil medium facilitates picture-making in the full chromatic spectrum. In practice, Van Gogh's Arlésien colourism is equally indebted to his acquaintance with high Impressionism's prismatic palettes and to his long-term fascination with complementarity.

Impressionist painters had long since jettisoned studio conventions (*eg* that shadow is grey and water blue) for observed effects (purplish-blue shadow, polychrome water surfaces, white blossoms tinted pastel by the ambient colours of their surroundings; 118).

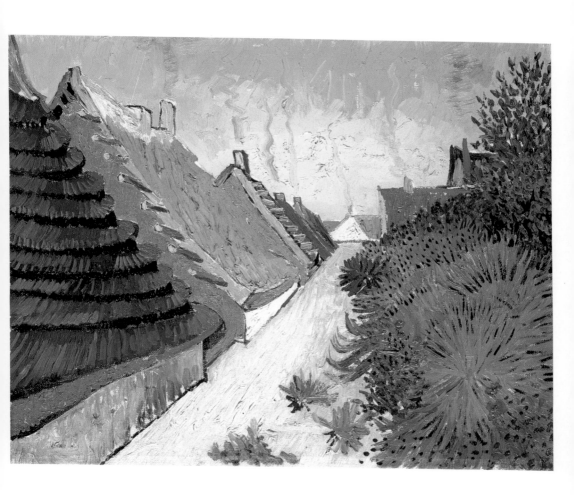

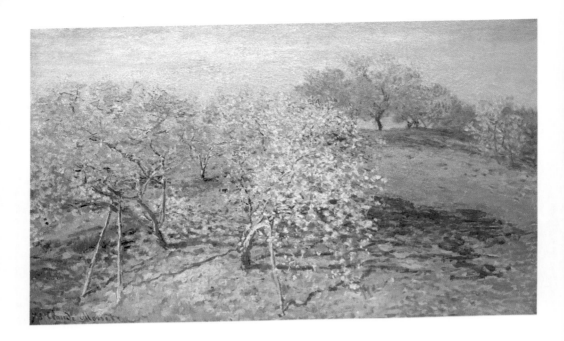

In like manner – and unlike Japanese printmakers – Van Gogh worked outdoors, taking cues from nature in flux rather than relying on fixed notions. As he remarked, the white mass of flowers in the painting made for Theo is touched with 'the faintest yellow and lilac'.

Prone, however, to exaggeration (recall the blackness of his peasant heads), Van Gogh often responded to the sumptuousness of Provençal hues by amplifying observed effects – especially those of opposed hues – rather than merely transcribing them. Even as he quoted Pissarro's advice to 'boldly exaggerate the harmonies and discords colours produce', Van Gogh at Arles came to feel that the liberties he took with colour constituted a departure from Impressionism, and a reversion to ideas gleaned from Blanc's *Grammaire*:

What I learned in Paris is leaving me and I'm returning to the ideas I had in the country, before I knew the impressionists. And I wouldn't be surprised if the impressionists soon find fault with my way of working, since it's been fertilized by Delacroix's ideas rather than theirs. Instead of trying to exactly reproduce what's before my eyes, I use colour more arbitrarily, to express myself forcibly.

118
Claude Monet,
*Apple Trees
in Bloom*,
1873.
Oil on canvas;
62·2 x 100·6 cm,
24½ x 39⅝ in.
Metropolitan
Museum of Art,
New York

While often unexpected, Impressionist colour choices rarely strain belief, as do the 'arbitrarily' blue and red trees and earth of Van Gogh's *Orchard in Blossom* (see 115) or the yellow sky and pink roadway of his *Street in Saintes-Maries-de-la-Mer* (see 117). The latter – *japoniste* in its sloping perspective, strong contours, graphic textures and fields of strong hue – may have put Van Gogh in mind of 'the Japanese artist [who] ignores reflected colour and puts flat tones side by side', but its imaginative pairings of opposed hues (such as lavender thatch against sulphurous sky) were probably 'fertilized by Delacroix's ideas', by way of Blanc.

Certainly, the idiosyncratic and inclusive *japonisme* Van Gogh practised at Arles merged earlier enthusiasms with admired aspects of Japanese prints. The pairing of colouristic opposites – not a particular hallmark of *nishiki-e* – became a prominent aspect of Van Gogh's *japoniste* Provence. At one point, for instance, he asked Theo to envision Arles 'surrounded by fields all covered with yellow and purple flowers … a real Japanese dream' (in fact, purple rarely occurs in Japanese woodblocks). Aware of the penchant for clashing patterns revealed in *ukiyo-e* (see 90 and 98), and intrigued by Pierre Loti's reference in *Mme Chrysanthème* (1887; a novel based on the author's sojourn in Nagasaki) to the Japanese taste for 'sugared peppers, fried ices, salted sweets', Van Gogh deduced a national love of 'piquant contrast' analogous to the sorts of chromatic counterpoints he himself preferred.

The oppositional effects of the colour combinations Van Gogh favoured in Arles were augmented by *japoniste* pattern plays. Although a few of the pictures he made there recall Japanese costume prints in their deliberate conjunctions of man-made patterns – checks with florals, stripes with dots – Van Gogh was most at home with *natural* pattern plays of the sort seen in landscapes by Hokusai and Hiroshige. Japanese patterning is usually created by repeating graphic marks (see 95, 100, 106, 110 and 116), and in spring 1888 Van Gogh worked to represent texture similarly, using line alone, in about two dozen drawings of Provençal vistas. Working with reed pens (rather than undertaking the tedious process of incising wooden

blocks), Van Gogh used strokes of wide-ranging size, orientation and density to indicate separate areas of the landscape and succinctly characterize its textures and tones (see, for example, 114 and 119).

The breadth of his graphic repertoire, with its jabs and curlicues, spikes and arabesques, recalls that of Japanese printmakers he admired, but did not entirely depend on their example. In The Hague in 1882 – before he started to paint (or scrutinize Japanese prints) – Van Gogh had already pushed line to its limits in such drawings as *Fish-Drying Barn* (see 41), a veritable lexicon of the penstrokes on which he eventually based the distinctive brushwork developed in Paris. His study of Japanese prints thus affirmed the longstanding interest in expressive line that prompted Van Gogh to overhaul the graphic dimension of his work in Arles.

Intent on streamlining and loosening his drawing style, Van Gogh envied the seeming rapidity with which his Japanese counterparts worked, remarking that they 'draw quickly ... like a lightning flash, because their nerves are finer, their feelings simpler'. He similarly admired the naturalness and ease the Japanese conveyed ('their work is as simple as breathing, and they do a figure in a few sure strokes, as if it were as easy as buttoning your coat') and strove for similar effects. Whereas *Fish-Drying Barn* began as a linear framework the artist laboriously filled with pattern, the penstrokes of *Irises Outside Arles* (119) seem to grow from observed motifs in a more spontaneous way.

This is not to say that the large drawings Van Gogh made in Arles were impromptu. The carefully chosen vantage point of *Irises* emphasizes the measured recession of its illusionistic space – from diagonal bands of flowers to grass, trees and town – which plays against the forward projection of the field's corner at the base of the composition. The marks that animate the scene seem equally well ordered, despite the apparent speed of their application. The distinctive shapes of iris blooms and shoots are captured 'in a few sure strokes', and the staccato stippling of the middle ground beautifully conveys the bristle of a new-mown field. Perspectival depth is bolstered by the shift from large marks at the bottom of the sheet to diminutive ones at centre, and none at all at the top.

119
Irises
Outside Arles,
1888.
Reed pen and
ink;
43·5 x 55·5 cm,
17 x 21³⁄ in.
Museum of Art,
Rhode Island
School of Design,
Providence

Van Gogh soon put his more intricate drawing style to work in views of the Crau (see 114). From the height of Montmajour, he rendered the variegated patchwork of the plain with reed pens and quills (the latter used for delicate hatches and dots). The drawings that resulted, 'the best things I have done in pen and ink', are marked by what the artist described as 'endless repetitions, stretching off to the horizon like the surface of the sea'. They 'do not look Japanese', he wrote, 'but really are'.

The effects of Van Gogh's *japoniste* drawing campaigns are readily discerned in contemporaneous paintings (some of which are oil versions of scenes he had drawn). Using his oil-laden brush like a pen, the artist joined colour to line and created textural juxtapositions within a lush, highly wrought impasto. His *Farmhouse in Provence* (120), for instance, incorporates yellow and grey-violet basket-weave that conveys the roughness of stone wall, dabs of red and green that are shorthand for wild flowers, and repeating verticals of gold and green that capture the look of scorched grass. Along the horizon, the geometries of the farmhouse oppose the haystacks' lopsided curves, and the spiky silhouettes of treetops pierce the broad, rhythmic swirls that evoke a wind-stirred sky.

Like his drawings of the Crau, *Farmhouse in Provence* is scarcely 'Japanese' on its surface but is loaded with visual effects Van Gogh associated with *ukiyo-e*. Yet in its full-spectrum colourism and amplitude of textures, it veers away from the bare-bones effects Van Gogh and his contemporaries admired in Japanese art. Another summer painting, *The Harvest* (121), comes closer to conveying what Van Gogh termed 'a *true idea* of the simplicity of nature here', the calligraphic patterns and figures of its lower half offset by subdued brushwork in the upper register. Typical of Van Gogh's mature *japonisme* in its confluence of Eastern and Western modes, *Harvest* combines a bird's-eye view with the European landscape conventions of centralized composition and ordered recession along a diagonal axis. Its effects of depth are enhanced by the sort of 'tactile perspective' common in Impressionist scenes, where the foreground paint is often thicker and more vigorously brushed

120
*Farmhouse
in Provence,*
1888.
Oil on canvas;
46 x 61 cm,
18 x 24 in.
National Gallery
of Art,
Washington, DC

121
The Harvest,
1888.
Oil on canvas;
72·5 x 92 cm,
28½ x 36½ in.
Van Gogh
Museum,
Amsterdam
(Vincent
van Gogh
Foundation)

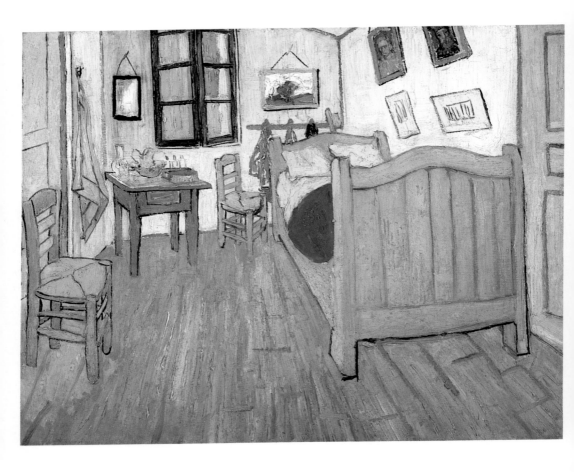

122
The Bedroom,
1888.
Oil on canvas;
72 x 90 cm,
28¼ x 35½ in.
Van Gogh
Museum,
Amsterdam
(Vincent
van Gogh
Foundation)

than that of mid- and background (see 118). Van Gogh himself found *The Harvest's* colouristic intensity comparable to that achieved by Delacroix and Cézanne, and declared this artful hybrid one of his most powerful works.

As summer turned to autumn, he took to emulating what he called 'flat washes' of colour in *nishiki-e*. The paint surface of *The Bedroom* (122), for instance, is thick but less churned up than in his summer landscapes. Meant to suggest 'absolute restfulness', this well-known interior features 'flat, free tints like Japanese prints', 'shadows suppressed'. Though he emphasized complementary colour contrast (which extended, he remarked, to the juxtaposed black and white of the mirror), he consciously suppressed pattern plays. Thinking back to the highly textured *japonisme* he had pursued under the influence of *crepons*, Van Gogh declared the painting of his room 'more virile and simple' than *Parisian Novels* (see 109), thanks to its reliance on 'flat colours in harmony', with no stippling or hatching. Its tilted ground plane and oddly concave floor, which probably resulted from the difficulty of painting a small space at close range, may reflect Van Gogh's attempt to mimic Japanese spatial conventions; moreover, an old floorplan indicates that the room was oddly shaped.

The Bedroom celebrates Van Gogh's long-awaited occupation of his 'Yellow House'. After renting it in May, he used the house as a studio throughout the summer, but did not sleep in it until it was repainted and furnished in mid-September. Loti's *Mme Chrysanthème* clearly influenced that months-long process. Struck by Loti's accounts of the spare appointments of Japanese interiors – 'very bright ... quite bare' – Van Gogh adopted a minimalist aesthetic for his own rooms, which were whitewashed, bare-floored and mostly furnished with sturdy, unupholstered pine. Loti's amusement at the overdone, bric-à-brac-laden 'Japanese' salons of fashion-conscious Parisians clearly hit home with Van Gogh. 'I am set on making an artist's home,' he told Theo, 'but ... not the usual knick-knack-filled studio ... Have you read *Mme Chrysanthème* yet?'

Van Gogh settled into the house with high hopes for continued productivity under the 'magnificent blue' sky and 'sulphurous yellow'

sunlight he was keen to capture in painting it (see 96). He mused on leading a life 'more and more like a Japanese painter's', which he contrasted to the sorry existence he had led among Parisian 'decadents':

If we study Japanese art, we see a man who is undoubtedly wise, philosophical and intelligent, who spends his time ... [studying] a single blade of grass.

This blade of grass leads him, however, to draw every plant, and then the seasons, broad vistas of the countryside, animals, the human figure. Thus he passes his life, and life is too short to do it all. Come now, isn't it almost a true religion which these simple Japanese teach us, who live in nature as if they were flowers?

It seems to me that you can't study Japanese art without becoming happier and gayer, and we must return to nature in spite of our education and our work in a conventional world.

This idealizing conception of Japanese artists as philosophers in tune with the cosmos conformed to prevailing European interpretations of Japanese art, which viewed its makers as 'primitives' whose imagined purity allowed them unimpeded and intuitive access to nature's profundities. Although Europeans routinely judged the indigenous peoples of other continents to be unsophisticated and even 'savage', an eighteenth-century tendency to extol 'primitive' peoples' untainted 'naturalness' led to the popular nineteenth-century comparison of non-Europeans' untarnished state with the deplorable artifice and vice of the 'civilized' world. Van Gogh's stereotypic image of the Japanese – with their fine nerves and simple tastes – became more specifically indebted to Samuel Bing's once he received the first two numbers of *Le Japon artistique* (1888) in September. Bing describes the Japanese artist as both a nature-loving 'poet' and a scrupulous observer guided by his belief that 'there is nothing in creation, be it even the smallest blade of grass, that doesn't deserve a place' in 'high art'.

Scholars are less certain about the source of Van Gogh's erroneous impression of the monkish and cooperative lives led by Japanese

artists, who, he insisted, 'exchanged works among themselves ... liked and supported one another ... [and] lived in a kind of fraternal community, quite naturally ... like simple workmen'. Debora Silverman notes allusions to picture exchanges in Gonse's *L'Art japonais* but Tsukasa Kodera – citing Van Gogh's career-long interest in artists' collaborations and identification with labourers – sees the painter's notions of harmonious alliances and workaday attitudes among Japanese printmakers as wishful fabrications that (if partially inspired by snippets read here and there) stemmed from his own utopianism. Van Gogh's image of artistic fellowship almost certainly also drew on his knowledge of the artists' community Gauguin and Bernard enjoyed at Pont-Aven in Brittany, and on the picture exchange he made with Gauguin in Paris the previous winter: two studies of cut sunflowers for a Martinique picture (123).

However muddled in origin, Van Gogh's musing on Japanese artists' happy fraternity led him to arrange a self-portrait exchange with Gauguin, Bernard and their friend Charles Laval (see Chapter 6) and to envision the rise of a Provençal artists' cooperative, or 'studio of the South', that would do for 'this lovely country ... what the Japanese have done for theirs'. Eager to dwell amid fellow artists as well as unspoiled nature, Van Gogh longed for his colleagues' physical presence, and considered the Yellow House's rental a step in that direction. In letters to his brother and his friends, Vincent began to exult in the potential dividends of fellow artists living like monks in Arles – not, he explained, as complete celibates (he himself went to a brothel 'every two weeks') but as a community of temperate, like-minded souls dedicated to art. His pitch to Gauguin – whose legendary distaste for modern urban life was already pronounced – stressed Arles's distance from the 'stultifying influence of our so-called civilization'. To Bernard, who shared his attraction to *ukiyo-e*, Van Gogh described Provence as a *japoniste* paradise, observing, 'It's a damned useful thing to see the South – where so much more of life is spent in the open air – in order to understand the Japanese better'.

123
Paul Gauguin,
Martinique (At the Pond's Edge),
1887.
Oil on canvas;
54 x 65 cm,
21¼ x 25⅝ in.
Van Gogh Museum,
Amsterdam
(Vincent van Gogh
Foundation)

Whereas Bernard planned to make his usual summer trip to Brittany rather than venture south, Gauguin wrote from Pont-Aven of his willingness to consider relocation. So the dance began, with Theo as well as Vincent encouraging his move to Arles, and Gauguin weighing options. Newly forty, strapped for funds, and worn down by the malaria and dysentery he had brought back from the Caribbean, Gauguin was, in mid-1888, much more attracted to the promise of room, board and a stipend from Theo (as well as that influential dealer's goodwill) than he was to the vision of building an artists' utopia in Provence. (He, after all, had ample companionship in Pont-Aven, and Bernard's late-summer visit to look forward to.) He probably sensed, however, that his move to Arles on most any pretext would delight Vincent and satisfy Theo.

Both Van Goghs were convinced of Gauguin's great talent. In the winter of 1887–8, around the time Gauguin and Vincent exchanged paintings, Theo had purchased one of Gauguin's most ambitious Martinique scenes, *Les Négresses*, for the brothers' private collection, paying more for it than anything else they owned and hanging it over the living-room sofa. Vincent, meanwhile, found 'high poetry' in the related picture he acquired in trade (123) and was almost as enchanted by Gauguin's air of sophistication as by the 'gentle, astonishing character' of his painting. As a former sailor, Gauguin struck Van Gogh as a man in the mould of Pierre Loti (pseudonym of Julien Viaud), a French naval officer whose travels inspired his tales of exotic adventurism. Gauguin, however, had abandoned the high seas for a stockbroker's post in Paris, where he collected the avant-garde painting that eventually inspired him to abandon a career in commerce to pursue the picture-making he (like Van Gogh) was wont to portray as a quasi-spiritual mission. What better person, Van Gogh reasoned, to lead an order of artist-monks in his virtual Japan?

Heart set on Gauguin as 'abbot' (his word), Van Gogh prepared for his friend's installation in the Yellow House, though, as summer waned, he was increasingly doubtful about Gauguin's sincerity, suspicious of his motives, and irked by his inaction. Gauguin pleaded poverty, perhaps angling for the travel money, settling of

outstanding debts and stepped-up promotion of his work he eventually wheedled from Theo. He may also have feared losing momentum in his work, which had taken a new turn in Bernard's company. Inspired by the latter's cloisonnist rendering of *Breton Women in a Meadow* (124), Gauguin had radically transformed his pictorial mode. Comparison of his *Vision After the Sermon: Jacob Wrestling with the Angel* (125), made in August/September 1888, with *Martinique*, of summer 1887, makes this clear. *Vision*'s debts to *ukiyo-e* are both direct (its wrestlers inspired by those of Hokusai's *manga*) and indirect (Gauguin's interest in Degas's work, as well as the impact of Bernard's, may be discerned in its radical croppings,

124
Émile Bernard, *Breton Women in a Meadow*, 1888. Oil on canvas; 74 x 92 cm, 29¹⁄ x 36¹⁄ in. Private collection

125
Paul Gauguin, *Vision After the Sermon: Jacob Wrestling with the Angel*, 1888. Oil on canvas; 73 x 92 cm, 28¹⁄ x 36¹⁄ in. National Gallery of Scotland, Edinburgh

near/far juxtapositions and other features). The picture is a decidedly *japoniste* abstraction, much bolder in colour and line than anything he had made before. But, while Gauguin claimed to have 'sacrificed everything to style' in its making, *Vision* is ultimately more noteworthy in its narrative dimension and 'meaningful' colour (the red of the ground plain meant to indicate the unreality of the focal event) than in the formal effects derived from other artists.

Sent to Theo in Paris (in the hope it could be sold), *Vision After the Sermon* was known to Vincent only through a sketch Gauguin sent by

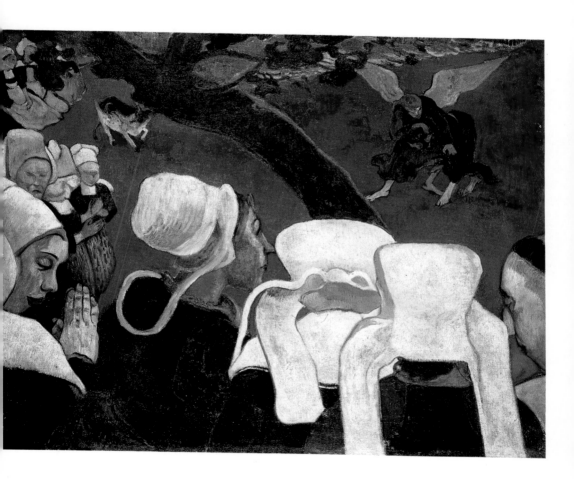

mail, accompanied by a high-flown disquisition on his aims. Anxious about his own work's ability to measure up to that of 'so great an artist', Van Gogh confided to his awaited colleague, 'In comparison with yours, I find my own artistic concepts extremely ordinary.'

Gauguin arrived in Arles prepared to agree with such self-deprecating assessments, but must have quickly realized that Van Gogh was at least his equal. Douglas Druick and Peter Zegers propose that the challenges to his superiority that Gauguin discerned in his friend's Arlésien production – including the recent *Sunflower* canvases (126) that graced the Yellow House's second bedroom – prompted him to begin formulating the patent misrepresentations he later committed to print. Rather than write off the erroneous assertions of Gauguin's memoir, *Avant et après* (*Before and After*, 1903), as 'misrememberings', Druick and Zegers characterize them as purposeful fabrications long since set up.

Avant et après casts Van Gogh as a hapless amateur in the autumn of 1888, 'floundering' and 'still trying to find his way'. Gauguin describes his friend's obsession with complementary colour as a hindrance that made him miserable, and writes, 'I undertook the task of enlightening him … and from that day, my Van Gogh made astonishing progress … The result was that whole series of sunflowers.'

In addition to claiming a pivotal role in the production of some of Van Gogh's best-known works, Gauguin alludes to other 'valuable lessons' bestowed on his colleague-cum-underling, at the same time insisting that he took nothing from his housemate but the satisfaction of helping him.

Van Gogh surely fostered the dynamic *Avant et après* describes by deferring to the visitor in whom he saw not only a great artistic gift but an enviable talent for manliness. Van Gogh wrote to Theo that his realization that Gauguin had been 'a real sailor', 'gives me enormous respect for him and still more absolute confidence in him as a man. He has … an affinity with Loti's Icelandic fishermen.'

126
Sunflowers,
1888.
Oil on canvas;
93 x 73 cm,
36½ x 28¾ in.
National Gallery,
London

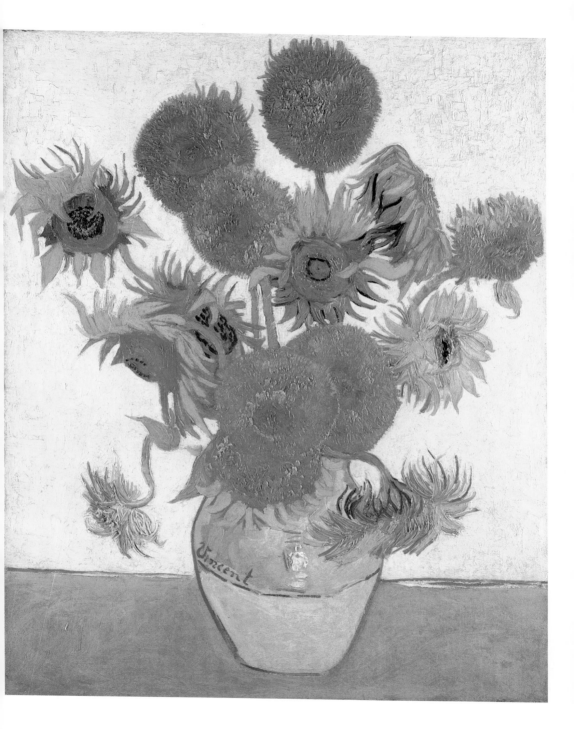

Those fishermen are Loti's most heroic characters, Bretons who leave home and family to ply their trade in northern waters. Van Gogh considered Gauguin equally determined and capable, and having long since cast himself as a Robinson Crusoe type (since Daniel Defoe's shipwreck survivor recoups himself in industrious isolation), Van Gogh was glad to see an able seaman come ashore at Arles. At the same time, to Bernard, he described Gauguin as a 'virginal being with the instincts of a savage' – an indication of both the effectiveness of Gauguin's self-promotion as noble 'primitive' and the depth of Van Gogh's desire to work with one.

Gauguin's decision to reprise a Martinique subject in the first painting he made at Arles, *Une Négresse*, was perhaps dictated by Van Gogh's expectations as well as by his own unfamiliarity with his surroundings. It also demonstrated his comfort with a practice Van Gogh had yet to master – working from his mind's eye rather than direct observation – and set up a leitmotif of their discussions at Arles.

More attuned to Arles and his housemate by the second week of his stay (which lasted from late October to late December), Gauguin joined Van Gogh in making views of the Alyscamps – a site Van Gogh had not yet painted. Intent on making Arles interesting to his esteemed friend, Van Gogh introduced him to one of the town's most picturesque precincts, and ended by painting four Alyscamps pictures to Gauguin's two. The first pair Van Gogh made there are fairly naturalistic vertical views, the second boldly stylized horizontals (127). Designed as pendants, the latter – destined for Gauguin's room – were very much to his taste, dominated by tonal harmonies and featuring paint surfaces thin enough to expose the weave of their jute support. While Van Gogh did not renounce complementary colour schemes under his colleague's disapproving eye, he muted their clashes, and in response to Gauguin's declared repugnance for 'messy' impasto, Van Gogh, already inclined towards the 'flat washes' of Japanese prints, reined his brush. His horizontal Alyscamps views owe their distinctive texture to the coarse jute Gauguin had bought in Arles; the surface effects of pictures marked

127
The Alyscamps,
1888.
Oil on jute;
73 x 92 cm,
28¼ x 36¼ in.
Kröller-Müller
Museum, Otterlo

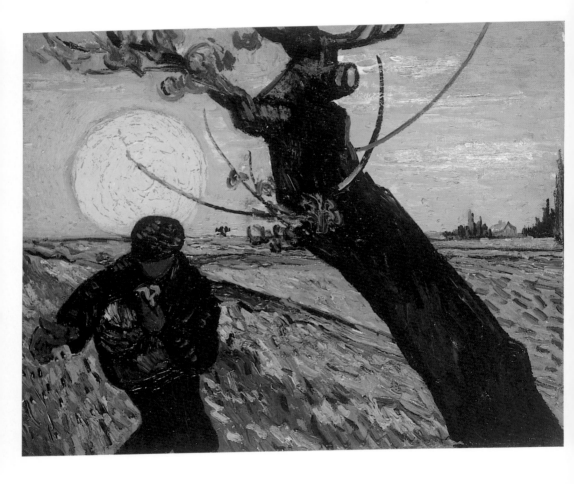

128
The Sower,
1888.
Oil on canvas;
32 x 40 cm,
12½ x 15¾ in.
Van Gogh Museum,
Amsterdam
(Vincent van Gogh
Foundation)

by the jute's weave bear some resemblance to that of *crepons*. Precedents for the strong contours, cropped and flattened motifs, exaggerated colour and pitched perspective of *The Alyscamps* may be found in *ukiyo-e* and Van Gogh's own *oeuvre*, yet this painting's stylistics seem inflected by the less reality-bound *japonisme* of Bernard's *Breton Women* (which Gauguin brought with him to Arles and Van Gogh copied there) and Gauguin's *Vision* (see 124, 125). It may have been made in the studio, rather than on the spot, in another concession to Van Gogh's would-be mentor.

Increasingly disdainful of the Impressionists' attachment to the visible world, Gauguin was intent on rendering what he described to Van Gogh as the mysterious poetry glimpsed 'in the corners of my heart'. In Arles, he urged his colleague to do likewise by relinquishing seen motifs for things felt and envisioned. An accomplished practitioner of artful distortion, Van Gogh usually drew the line at working without a model. Although he saw the practicality of working from a mental construct when the weather kept him indoors, he remained wary of relying on 'pure imagination'.

I cannot work without a model. I won't say that I don't turn my back on nature to transform a study into a picture, arranging the colours, exaggerating, simplifying, but when it comes to form I'm too fearful of departing from the possible and the true ... I exaggerate, sometimes I make changes ... [but] I do not invent the whole picture.

In his efforts to follow Gauguin into what he later called the 'enchanted ground' of invented motifs, Van Gogh found himself unable to go the distance. When the two worked without a model at the Yellow House, he was inclined to paint 'by heart' (in the sense of remembering), recasting subjects from his own work and that of other artists. The *Sower* (128) he made in November is a case in point, a 'made up' scene that includes a figure based on Millet's (see 20), a *japoniste* tree Gauguin's *Vision* inspired, and a field of the sort Van Gogh often painted in the Crau. The most imaginative part of the picture is perhaps its palette, and even that seems less fanciful than the one used for *Street in Saintes-Maries-de-la-Mer* (see 117).

Under the spell of Gauguin's supreme, articulate self-confidence, Van Gogh sometimes fell prey to uncharacteristic self-doubt in the last months of 1888. His colleague's stress on the divide between poles Van Gogh characterized as 'vulgar resemblance' and motifs 'seen in a dream', led him to lose sight of the middle ground he mined with great success when left to his own devices. Fearful that his work was modest, coarse and clumsy in comparison to the products of Gauguin's inner vision, Van Gogh attempted to modify his way of working. His assertion, in November 1888, that 'Gauguin gives me the courage to imagine things' suggests his misguided belief that he had theretofore lacked that ability.

It seems that both Van Gogh and Gauguin, in their focus upon the self-conscious envisioning that yielded invented motifs, overlooked and/or undervalued the sustained imaginative enterprise that allowed Van Gogh to find 'Japan' in the South of France and fuelled his work there for months. From his first weeks in Arles, as he felt able to 'see things with an eye more Japanese', Van Gogh sought 'the creation of a more exalting and consoling nature than a single brief glance at reality ... allows us to perceive'. If, indeed, Provençal scenery seemed to Gauguin as 'shrivelled, scorched and trivial' as his complaints to Van Gogh indicated, surely this ardent proponent of poeticization should have credited the remarkable inventiveness that nourished Van Gogh's Japanese dream and his *japoniste* work at Arles.

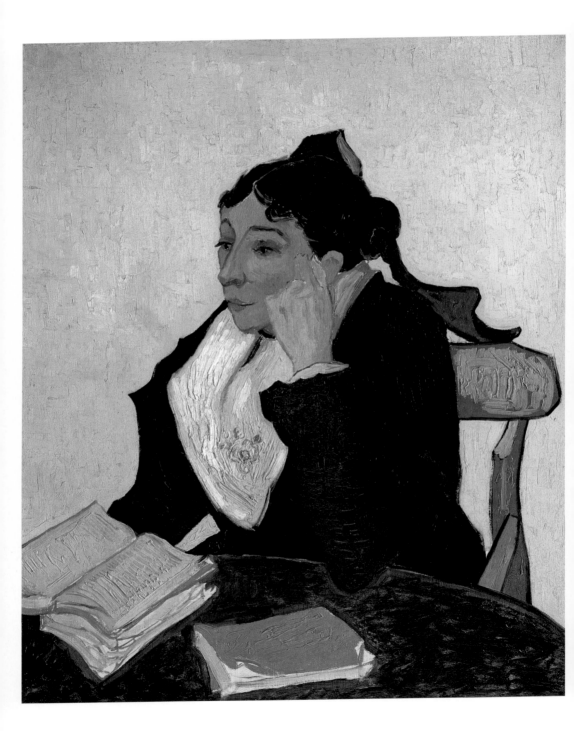

Although Provençal landscape proved a rich source of inspiration to Van Gogh's *japoniste* eye, he still saw himself mainly as a painter of the figure, 'the only thing that moves me to the depths of my soul'. Arles was a small community by comparison with Paris or even The Hague, but its population (some 23,000 in the 1880s) offered an enticing variety of types he considered 'picturesque caricatures':

Zouave soldiers, prostitutes, adorable little Arlésiennes going to first communion, the priest in his surplice, who looks like a dangerous rhinoceros, the people drinking absinthe, all seem to me creatures from another world.

129
The Arlésienne (Marie Ginoux), 1888.
Oil on canvas; 91·4 x 73·7 cm, 36¼ x 29 in.
Metropolitan Museum of Art, New York

Intrigued by his neighbours' tanned countenances and the 'naïve and well-chosen colour combinations' and prints they wore, Van Gogh thought they cried out to be painted by someone who might 'be to figure painting what Claude Monet is to landscape ... *a colourist such as never yet existed'.*

His treks into the countryside (130) sometimes reminded him of Millet's rustic scenes, but Van Gogh soon realized that the 'colourless grey' of a painting such as *The Sower* (see 20) did not accord with the vibrancy of the south. In Arles he rethought Millet's figuration in terms of Delacroix's, Monticelli's and Monet's palettes. In their demeanours, the country people reminded Van Gogh of 'figures seen in Zola's work', particularly *La Terre* (*Earth*; 1887), a novel that exploded popular myths of a contented rural proletariat with portrayals of cut-throat farmers who would literally kill for more land. The townspeople, too, seemed Zolaesque caricatures ('the public garden, the night cafés and the grocer's are not Millet but Daumier, and absolute Zola'), who put Van Gogh in mind of both contemporary French types rendered by Honoré Daumier (1808–79) and the antic figures Hokusai 'sketched on the spur of the moment'.

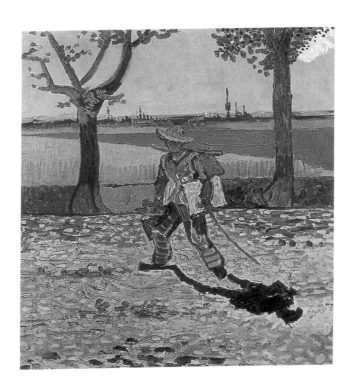

130
*Painter on
the Road to
Tarascon*, 1888.
Oil on canvas;
48 x 44 cm,
19 x 17¼ in.
Formerly
Kaiser Friedrich
Museum,
Magdeburg
(destroyed)

Van Gogh's sense of the natives' caricatural aspects had been formed by the writings of Zola's and Daumier's fellow southerner, Alphonse Daudet, who found great success with regional tales centred on a cartoonish Provençal named Tartarin, whose propensity for exaggeration Daudet characterized as typically Southern. Van Gogh read *Tartarin de Tarascon* in Paris, and probably read Daudet's *Lettres de mon moulin* there too. A collection of short stories ostensibly written in an abandoned windmill near Arles, *Lettres* vividly details local characters, vistas and legends, and may have influenced the artist's decision to move to the land of extremes Daudet describes.

Van Gogh often wrote of the south as 'Tartarin country' but when it came to painting Tartarin's feminine compatriots, the book he thought of was Maupassant's *Bel-Ami*, wherein a handsome provincial takes Paris by storm. Maupassant's fictional ladies' man, nicknamed Bel-Ami, epitomized the sort of winning fellow Van Gogh would never be. After reading *Bel-Ami* in Paris, Van Gogh painted it with a statuette of a voluptuous nude and a copy of the Goncourts'

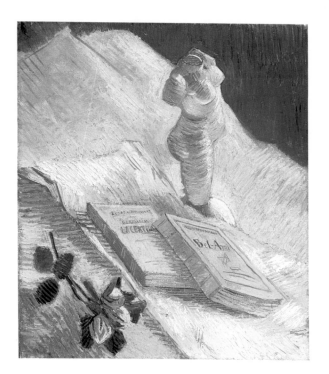

131
Still Life with Plaster Cast, 1887–8. Oil on canvas; 55 x 46·5 cm, 21½ x 18¼ in. Kröller-Müller Museum, Otterlo

Germinie Lacerteux (1865), the story of a gullible spinster whose younger lover betrays and abandons her (131). Bel-Ami was the sort of man for whom Germinie would have pawned her mother's jewellery, and Van Gogh's painterly matchmaking seems uncharacteristically arch, his levity doubtless encouraged by a book he found as breezy as the Goncourts' is dark. 'There are some not-too-serious things which I like very much', he wrote from Arles, 'such as a book like *Bel-Ami*.'

As he gaped at the women of Arles (known throughout France for their beauty), he decided, 'the best thing to do here would be to make portraits, all kinds of portraits of women and children', adding resignedly, 'I don't think I'm ... enough of a *Bel-Ami* for that'. Citing his false teeth and ageing body as bars to his pursuit of portraiture, he worried, too, that he lacked the easy joviality that enterprise demanded. He envisioned the successful painter of Provençals as 'a kind of Guy de Maupassant in painting', able to 'portray the beautiful people here lightheartedly'. While he wrote

of his willingness to 'wait for the next generation [to] do in portraiture what Claude Monet does in landscape, the rich daring landscape *à la* Guy de Maupassant', he was clearly preparing to attempt it himself. 'As for portraits', he told Theo in May, 'before I start along that line I want my nerves steadier, and also to be settled in …'

Throughout the spring he delighted in the 'colourful multitudes' without soliciting models, convinced that, when the time was right, 'I shall make a furious assault on the figure, which I seem to be giving a wide berth at the moment … although it is really what I aim at'. Once he and his studio were ready, however, he found that Arlésiens gave *him* a wide berth, steering clear of the excitable, paint-spattered foreigner, even when he offered them money to pose. 'The poor little souls', he speculated, 'are afraid of being compromised, and think people will laugh at their portraits.'

Van Gogh had had little expectation that his services would be sought out. By 1888 he was accustomed to asking people to sit for him rather than being solicited by paying customers. Indeed, he often paid them – a reversal that art historian Joanna Woodall links to the broader rise of uncommissioned likenesses in the later nineteenth century, when many artists painted friends and family rather than patrons. While few so routinely made portraits of virtual strangers whom they paid to pose, this may have been Van Gogh's preference, since it freed him from any obligation to achieve likeness and allowed him to give precedence to general ideas over personal particularities. (The heads he made at Nuenen – see 46, 56 and 58 – say more about stereotypic 'peasantness' than individual models.)

Though Van Gogh briefly experimented with portraiture in the Impressionist mode – subjects captured off-guard in telling postures and surroundings (see 89) – he soon returned to emblematic figuration (see 92). At Arles, he tended toward static renderings on neutral grounds and engaged in the sort of typecasting he appreciated in *The Graphic's* 'Heads of the People', as well as the caricatural exaggeration Daudet and others convinced him was appropriately Provençal (see 129). He remodelled sitters to suit his purposes, in a process that usually began with the conceptual manoeuvre of

affixing categorical labels (for example, 'the old peasant', see 135, 138) that substituted for proper names. Like the 'Orphan Men' (see 36) and Nuenen labourers before them, Van Gogh's first Arlésien models are known only as representative types. The proper names of both a rakish Zouave soldier (see 132, 133) and a demure girl he called a '*mousmé*' (see 134) are absent from his letters as well as his picture titles.

In Van Gogh's day, a regiment of Zouave soldiers was stationed at Arles. This Franco-Algerian force was formed in the 1830s to support France's colonialist mission in North Africa, its exotic roots signalled by its name (derived from that of the indigenous group from which its first African members were recruited) as well as its uniform: ballooning red trousers, broad cummerbund, embroidered jacket and tasselled *chéchia*. The Zouaves' striking get-ups dazzled Van Gogh, as did their self-assured command of the brothels he frequented. Indeed, these soldiers were so closely tied to local libertinage in Van Gogh's mind that he described his studies of one anonymous Zouave infantryman as his answer to the Parisian brothel scenes Bernard was making. Rather than literally delineating Arlésien sex-for-hire, Van Gogh alluded to such transactions in images of a man he compared to a predatory animal. This moustachioed Zouave, with 'bronzed feline head', 'bull neck, and the eye of a tiger', personifies the potent sexuality of the alpha male, his swarthy complexion and North African garb signifiers of the hot-blooded foreigner of popular cliché. His colourful head and torso are painted against a green and orange ground, which made for 'a savage combination of incongruous tones, not easy to manage' (132). Though the results struck Van Gogh as harsh and vulgar, even 'ugly', he was not displeased. Given the purposeful crudeness with which he painted *The Potato Eaters* (see 61) some three years earlier, he probably intended the painting's brutal hues to help characterize its subject. A larger, less successful portrait followed: a full-length view in which the Zouave's splayed legs, self-referential gesture and garish, suggestively highlighted trousers showcase expansive virility (133).

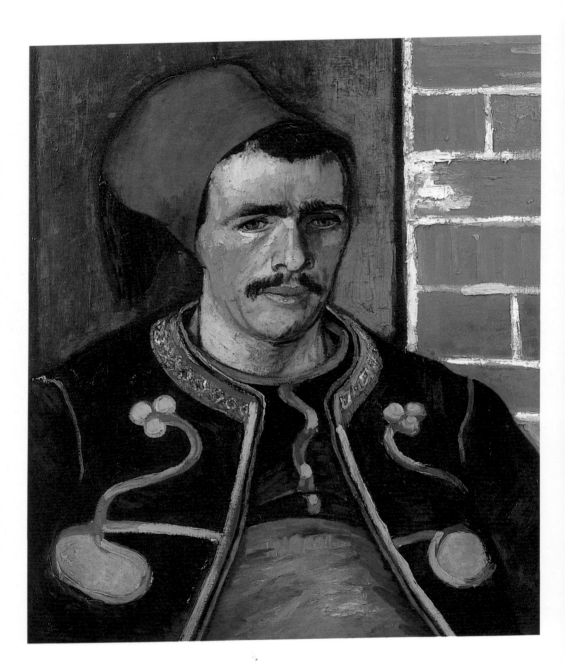

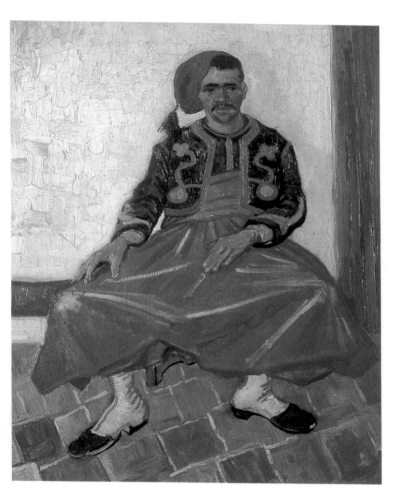

132
The Zouave,
1888.
Oil on canvas;
65 x 54 cm,
25½ x 21¼ in.
Van Gogh
Museum,
Amsterdam
(Vincent
van Gogh
Foundation)

133
The Zouave,
1888.
Oil on canvas;
81 x 65 cm,
32 x 25½ in.
Private collection

Van Gogh's next Arlésien portrait subject also was a colourfully clad exotic, though the artist explored a quite different persona when he took up the prim adolescent he dubbed *la mousmé* (134). Dressed in a boldly patterned outfit of the sort Van Gogh liked, the model is decidedly Provençal. Yet, as the picture's title suggests, he saw something Japanese in this slender, dark-haired girl decked in contrasting fabrics. The term *'mousmé'*, borrowed from Loti's *Mme Chrysanthème*, means, as Vincent explained to Theo, 'a Japanese girl – in this case Provençal – about twelve or fourteen years old'. He did not elaborate, and Theo (who had not read *Mme Chrysanthème*) may have assumed that the model's age was her sole link to Loti's *mousmés*, though other aspects of the girls Loti describes were probably in play as Van Gogh addressed this model.

Mme Chrysanthème is one of the novels Loti based on his own experiences as a captain in the French navy. Their plots are of a piece: a European man arrives in a foreign land and takes up with a native woman; their intimacy – which ostensibly facilitates his entry into an alien mind-set – ends when his curiosity and lust abate and other ports-of-call beckon. The teenaged title character of *Mme Chrysanthème* is leased to a naval officer by her family at a nominal monthly rate, and the author's description of her selection probably influenced Van Gogh's approach to the *'mousmé'* he hired for a week. Loti extols Chrysanthème's lack of conventional allure, seeming boredom with the proceedings, and reluctance to be singled out, and finds her maidenly manner even more appealing than her slanting eyes, full cheeks, and the fleshy but well-modelled mouth he describes as 'half sulky, half smiling'.

Like Loti's chosen consort, Van Gogh's *mousmé* – not conventionally pretty – has the puffy cheeks and mouth of youth and wears an equivocal expression. Much of her charm resides in an apparent hesitancy to ingratiate. Although she makes eye contact, her stiff posture, lowered chin, slightly averted face and body, and self-consciously positioned hands suggest unease with the attention focused upon her (compare the directness of *L'Italienne*, see 92), her buttoned-up bodice and tightly beribboned coiffure signal modest

134
La Mousmé,
1888.
Oil on canvas;
74 x 60 cm,
29¹₄ x 23¹₂ in.
National
Gallery of Art,
Washington, DC

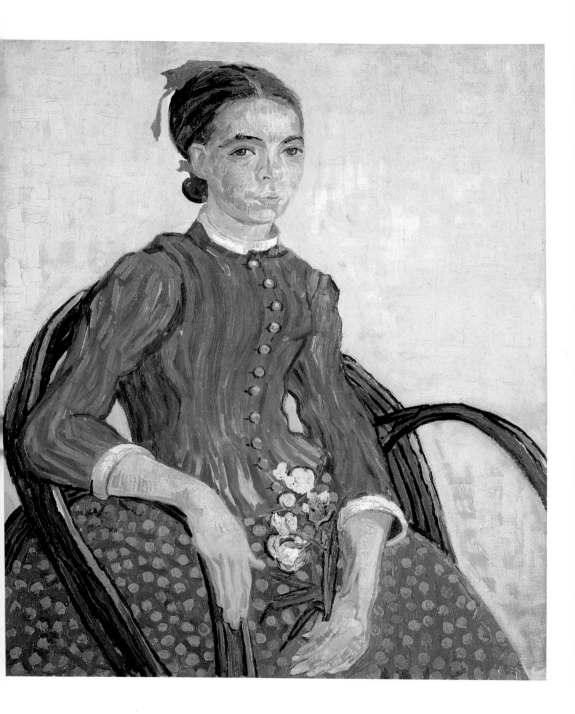

restraint. Unlike the Zouave's posture of extreme openness (see 133), the girl's containment is underscored by the enclosing chair and the tightly balled oleander she holds. According to Van Gogh, oleander 'speaks of love'; *la mousmé* holds this emblem of amorous sensuality rigidly and at arm's length (compare, again, *L'Italienne*, whose flowers, having seen better days, droop against her).

'That makes two portraits now,' Van Gogh reported, 'the Zouave and her.' In painting them, he not only re-immersed himself in the work he valued most, but managed to portray distinctive southern types. Contemplating a sustained campaign, he wrote to Bernard of artist predecessors whose *oeuvres* evoke an entire people or epoch, and observed that Zola and Balzac, too, 'in their quality as painters of a society ... embrace the entirety of the epochs they depict'. Indicating his own ambitions, Van Gogh directed Bernard to take particular note of Hals and Rembrandt:

Hammer into your head that master Frans Hals, that painter of all kinds of portraits, of a whole, gallant, alive, immortal republic. Hammer into your head the no less great and universal painter of portraits of the Dutch republic: Rembrandt ... I am just trying to make you see the great, simple thing: the painting of humanity, or of a whole republic, by the simple means of portraiture.

Surely aware of the low esteem in which contemporary critics held portraiture (Duret branded it 'the triumph of bourgeois art'), Van Gogh was eager to rethink and revitalize the genre. Conventional portraits are primarily personal documents that bespeak individual appearance, status and temperament, and thus may be said to lack broad-based public appeal. In the conviction that images of one's contemporaries could be taken in a different direction, Van Gogh wrote from Arles of his hope to 'win over the public by means of the portrait', declaring that he could scarcely see the painting of the future as anything other than 'a succession of powerful, simple portraits, comprehensible to the general public'. He planned to capture recognized types rather than idiosyncratic individuals, using both exaggeration and simplification to stress stereotypic qualities and downplay personal quirks. To achieve timelessness,

he would choose the 'neutral or vague backgrounds' Edmond Duranty had all but outlawed in his decade-old essay on *La Nouvelle Peinture*. While *The Graphic*'s 'Heads of the People', Balzac's multi-volume *Comédie humaine*, and the interlinked novels of Zola's Rougon-Macquart series (1871–93; an extended chronicle of French life in the Second Empire) inspired his enterprise, Van Gogh eschewed the welter of detail that ties their subjects to specific eras and locales. He hoped to produce a series of images that would constitute a collective portrait of Provençal society and an enduring panorama of humanity.

His main model was seventeenth-century Dutch portraiture, one of those bodies of art, he told Bernard, that 'renders the infinite tangible'. The infinite to which Van Gogh referred was both temporal and cosmic. The people Hals painted centuries before still seemed alive and hence 'immortal'; moreover, Van Gogh felt Rembrandt and Hals had imbued representations of the human with sparks of the divine. He found this especially remarkable in the work of Hals, who 'never painted ... angels, crucifixions or resurrections', making 'portraits and nothing else'. Enumerating the many (and often unexalted) types Hals portrayed, from soldiers and magistrates to 'gypsy whore [see 94], babies in diapers ... vagabonds and laughing urchins', Van Gogh observed that Hals's work was nevertheless 'surely as valuable as Dante's Paradise and your Michelangelos and Raphaels'.

Having long since abandoned orthodox Christianity, Van Gogh was attentive to manifestations of God in nature and humanity. As he pondered portraiture's future, he dared imagine that, in a progressive non-sectarian society, images of the sort he envisioned might take the place of religious icons, conveying a sense of the eternal and providing glimpses of the infinite. As he told Theo, 'I want to paint men and women with that something of the eternal which the halo used to symbolize, and which we seek to convey by the radiance and vibration of our colour.'

Van Gogh believed that portraiture's late nineteenth-century revival demanded 'a colourist such as never yet existed'. When he wrote of the next generation doing portraits in the manner of Monet's landscapes, he meant that they should move beyond documentation of physical

appearance and into the realm of the expressive and soulful (as
Monet had in the 1880s), by way of distinctive brushwork and,
more importantly, rich hues, daringly combined. Van Gogh felt the
colouristic 'radiance' achieved thereby could lend a transcendent
glow to the most mundane types (see 135, 138), and his mention
of colour-activated 'vibration' (a concept originally encountered
in Blanc's writings) indicates renewed interest in musical painting
in the manner of Delacroix. Colour in such painting is dictated by
the artist's emotions and speaks to those of the viewer in the direct,
non-imagistic manner of music. At Arles, Van Gogh was determined to
'make painting into something like the music of Berlioz and Wagner,
a consoling art for broken hearts', and 'say something comforting,
as music is comforting'.

It was in Paris, apparently, that he reopened his investigations
into the interrelatedness that had led Delacroix to characterize
colours and forms as 'the music of the picture'. Whereas the piano
lessons Van Gogh took while living in Nuenen had done little to
advance his understanding, in the French capital he found the idea
of 'correspondance' much discussed. The Wagnerism rampant among
the city's cultural sophisticates resided in enthusiasm not only for
the German composer's immoderately lush music but also for his
anti-classical aesthetic of structural fluidity and his mergers of once
separate art forms in the Gesamtkunstwerk ('unified work of art').

By the end of the nineteenth century, intellectuals and aesthetes
held instrumental music in unprecedented esteem. As recently
as 1790 the philosopher Immanuel Kant had derided it as the
least impressive of the fine arts, since music's effects – dependent
on sensation rather than concept – were emotive rather than
intellectual. With the rise of Romanticism, however, music
came to be valued for the very aspects long considered to limit
its impact: lack of concreteness and resistance to linguistic
translation. Its intangibility now marked music as metaphysical,
its effects more profound than those of the representational arts.
As described by Thomas Carlyle in On Heroes and Hero Worship (1841)
– which Van Gogh read in 1883 and cited from Arles – music was 'a

kind of inarticulate, unfathomable speech which leads us to the edge of the Infinite'. Similarly, Blanc held it to provide transport to 'ethereal reaches, impenetrable worlds'.

In the 1880s, the age-old injunction that painting should be like poetry – *ut pictura poesis* – was replaced by *ut pictura musica*, as music's fusion of form and content presented a new paradigm to painters. From 1885 to 1888 musicality in painting was vigorously promoted by the *Revue Wagnérienne*, a Parisian journal founded by critic Édouard Dujardin and dedicated to Symbolist literature and anti-naturalist trends in the visual arts as well as innovative music. Imprecision and suggestion were operative terms as *Revue* contributor Téodor de Wyzewa urged painters to use colour and forms 'abstractly' (rather than in imitation of mundane appearance) to elicit emotion, and to combine them 'in a manner that produces ... a total impression, comparable to a symphony'.

While living in Paris, Van Gogh attended 'a few Wagner concerts', and surely discussed parallels between music and art with colleagues. Signac was part of a Symbolist coterie that embraced musicality, and by the mid-1880s was quite conversant with aesthetician Charles Henry's researches into the expressive potential of pure line and colour. Henry's *Theory of Directions* (1885), *A Scientific Aesthetic* (1885) and *Law of the Evolution of Musical Sensations* (1886) encouraged Seurat's anti-naturalist manipulation of colour and line to expressive ends in 1887, the year in which Signac painted with Van Gogh and collaborated with Henry on *The Spirit of Forms* and *The Spirit of Colours* (both published 1888). Anquetin, one of Dujardin's closest friends, was also well connected to the discourse of *correspondance*, and may have introduced Van Gogh to the *Revue Wagnérienne*, whose editorial philosophies were also familiar to Bernard. At the time Van Gogh met Gauguin in Paris, the latter was framing his '*Notes synthétiques*', a manuscript in which colour's musical aspect is addressed.

Van Gogh's concern with 'colour music' was thus in keeping with Parisian trends, and his pairing of composers Hector Berlioz and Richard Wagner – both known for the drama, excess and 'chromatism'

of their music – indicates a working knowledge of the theoretical underpinnings of pictorial 'musicality', a term that in the 1880s indicated the liberation of colour and line from representational/ imitative functions, to bolster *abstract* expressiveness. Though he would continue to work in a representational mode, Van Gogh was increasingly inclined to take liberties with observed motifs.

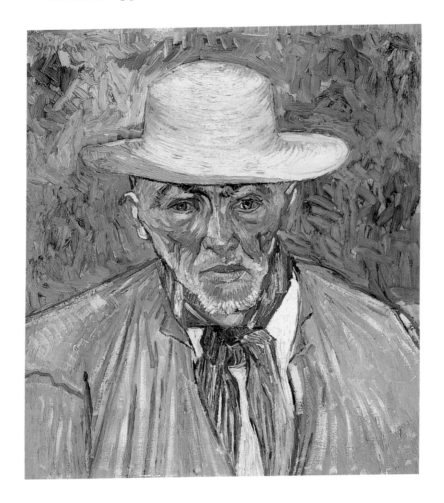

In his quest to make portraits of universalist dimension, he counted on colour, in particular, to communicate on a fundamental level, as music was said to do. His brushwork was similarly intended to enhance suggestiveness; from Arles he wrote of his struggles to make it 'firm and interwoven with feeling, like a piece of music played with emotion'.

Among the most decidedly 'musical' of Van Gogh's Arlésien portraits are two paintings he titled *The Old Peasant*. Their model, Patience Escalier, was a labourer in whom Van Gogh saw the essence of peasantness: '*You* know', he told Bernard, 'what a peasant is, and how strongly he reminds one of a wild beast – at least when you've found one of the true race.' Van Gogh prided himself on tracking down this prime specimen, and the first image he made of Escalier (135) seemed to him 'an absolute continuation' of peasant heads made in Nuenen. 'If not so black' as *The Potato Eaters*, *The Old Peasant* resembled it, he thought, in 'crudeness' and 'ugliness' – Van Gogh's terms for the colouristic clashes and rude brushwork he meant to signal abstractly the model's lack of refinement, and that of the 'race' he represented.

135
*The Old Peasant
(Patience
Escalier)*, 1888.
Oil on canvas;
64 x 54 cm,
25¹⁄₄ x 21¹⁄₄ in.
Norton Simon
Museum,
Pasadena

In Nuenen Van Gogh used dusky hues to paint labourers (see 56, 58 and 61). In Arles, however, he found the drabness of northern 'peasant pictures' at odds with both the scenery and the 'present-day craving for colour'. He took to viewing agrarian labour through the prism of Delacroix's work, which 'speaks a symbolic language through colour alone', whereas 'Millet's *Sower* is a colourless grey, like Israëls's pictures'. Wondering whether one might 'paint the sower in colour, with a simultaneous contrast of yellow and violet', such as Delacroix favoured, Van Gogh transferred Millet's famed figure to a setting of colouristic 'excess': a blue-violet field lit by yellow sun and sky (136).

Impatience for figural work, combined with a dearth of willing models, induced Van Gogh's sporadic attempts to work from his imagination in Arles, but he destroyed invented images of Christ in Gethsemane and a 'poet against a starry sky', 'because the form had not been studied beforehand from a model'. Millet's *Sower* (see 20) was a next-best-thing in several respects. A two-dimensional 'model' he knew well, it was also an acceptable stand-in for both Christ and poet, since Jesus cast himself as sower in one of the parables – those lyric and allusive tales Van Gogh considered 'the very highest summit reached by art'. Indeed, Christ's parables were one of his many models for the 'symbolic language' deployed

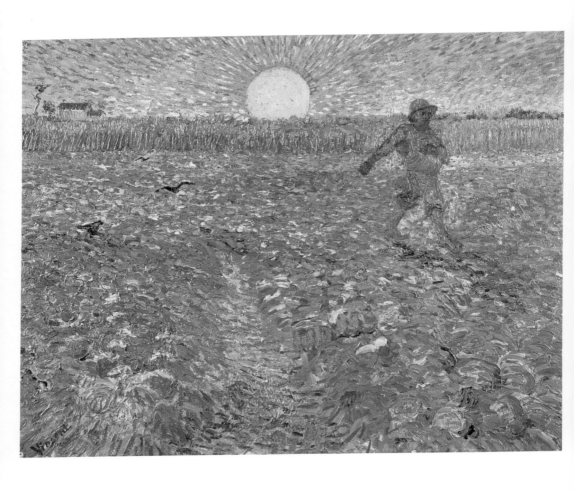

in such works as his colourized *Sower* – a picture that gave him considerable trouble. He never managed to ground Millet's figure convincingly in its new milieu, and after packing his 'failure' off to Theo, Vincent wrote that 'the idea of the *Sower* continues to haunt me'. It clearly hovered close by as he turned to Escalier.

To Van Gogh's mind, 'Millet painted the synthesis of the peasant', and in Arles he sought to update that project, with an eye to colour that was 'modern' in its unadulterated intensity and its musical dimension. Escalier did not so much remind him of *The Sower* as of Millet's *Man with a Hoe* (137) – the image of one brutalized

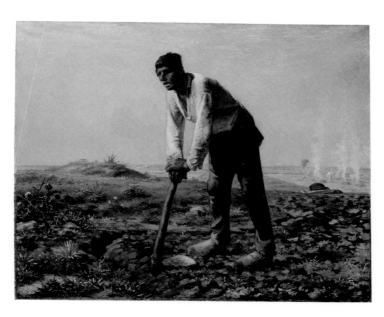

136
The Sower,
1888.
Oil on canvas;
64 x 80·5 cm,
25¼ x 31¾ in.
Kröller-Müller
Museum, Otterlo

137
**Jean-François
Millet,**
Man with a Hoe,
1860–2.
Oil on canvas;
80 x 99 cm,
31½ x 39 in.
J Paul Getty
Museum,
Los Angeles

and thoroughly exhausted by his labours – and likewise recalled Zola's prose-painted proletariat. In formulating his own synthesis, Van Gogh imagined 'the old peasant',

in the furnace of the height of harvest-time, surrounded by the whole Midi. Hence, the orange hues flashing like lightning, vivid as red-hot iron, and hence the luminous tones of old gold in the shadows … And proper folk will see the exaggeration as caricature. But what has that to do with us? We've read *La Terre* and *Germinal,* and if we are painting a peasant, we want to show that what we've read has come close to being a part of us.

Suggesting that he understood peasants in a way squeamish urbanites did not, Van Gogh lamented the fact that most Parisians lacked 'a palate for crude things'. Predicting that many would find *The Old Peasant* (see 135) as disturbing as *The Potato Eaters*, he defended his right to paint the working class as he himself had read and seen them. Though his initial portrait of Escalier does not embody a specific Zola character, this close-up, sharp-focus view suggests naturalist-style scrutiny, and the blunt posing, brash colours and rough facture cast the grizzled model as one of the fierce, resilient beings Zola describes in *La Terre,* 'beasts' hardened by lifelong struggles with nature.

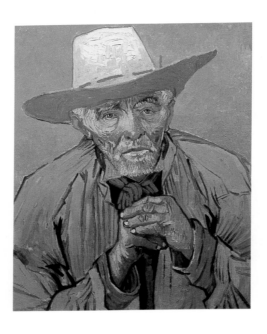

138
The Old Peasant (Patience Escalier), 1888.
Oil on canvas; 69 x 56 cm, 27¼ x 22 in.
Stavros S Niarchos Collection, Athens

Van Gogh's second rendering of *The Old Peasant* (138), though strongly hued and textured, seems mellow by comparison. As Vincent observed to Wil, 'By intensifying all the colours, one arrives again at quietude and harmony ... similar to what happens in Wagner's music, which, though played by a large orchestra, is nonetheless intimate.' The play of cool blues amid the heated hues of Escalier's 'sun-steeped' skin, and against the vivid warmth of kerchief, cuffs and backdrop, makes for an uncannily calm effect. In this second image, Van Gogh traded the colouristic commotion of 'the height of harvest-time' for the 'sunset radiance' of a

palette that is heightened and allusive rather than 'locally true': the orange ground, he remarked, 'does not pretend to be the image of a red sunset', but 'may nonetheless suggest one'. In conjunction with explicit markers of age and fatigue (the model's bleary-eyed gaze beneath greying brows, and round-shouldered posture over his stick), this colouristic hint of day's end implies the closeness of death, even as the man's smock and hands bespeak his labouring life.

Within a few weeks, Van Gogh painted another man poised on the cusp of the great beyond (139). Unlike the labourer, however, *The Poet* seems scarcely tethered to this world, head and shoulders floated on a star-filled sky. Modelled by Belgian painter Eugène Boch (1855–1941), who spent the summer in nearby Fontvieille, *The Poet* – like the pictures Escalier posed – takes up a concept Van Gogh had nurtured long before finding its embodiment. Boch's 'face like a razor blade' reminded him of portraits of Dante, a poet Carlyle described as imbuing 'whatsoever he delineates' with 'infinitude', and Van Gogh had mentally cast the Belgian as the 'man who dreams great dreams' weeks before securing a sitting. He intended to begin with a 'faithful' rendering of Boch's features but then 'exaggerate the fairness of the hair' and, in the background, 'paint infinity ... the richest, intensest blue'. Van Gogh expected 'this simple combination of the bright head on the rich blue background' to yield 'a mysterious effect, like a star in the depths of an azure sky'. The dark green hair of the actual image is ringed with a gold contour that gives it a backlit effect, while the gold, green and red of *The Poet*'s remarkably colourful costume are reprised as highlights in skin and beard.

While its unconventional palette removes Boch's image from the realm of the ordinary, a more profound suggestiveness resides in the starry sky that betokens transcendence. Van Gogh was fascinated by the night sky in Arles, which provoked him to reflect upon the cosmic and eternal, and the continuum of creative activity. He liked to think of death as transportation rather than culmination ('Just as we take a train to get to Tarascon ... we take death to reach

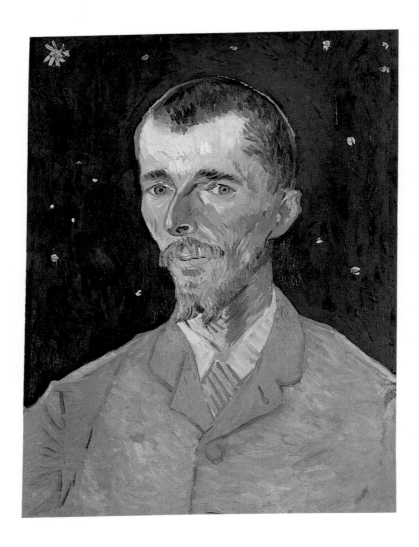

139
The Poet
(Eugène Boch),
1888.
Oil on canvas;
60 x 45 cm,
23½ x 17¾ in.
Musée d'Orsay,
Paris

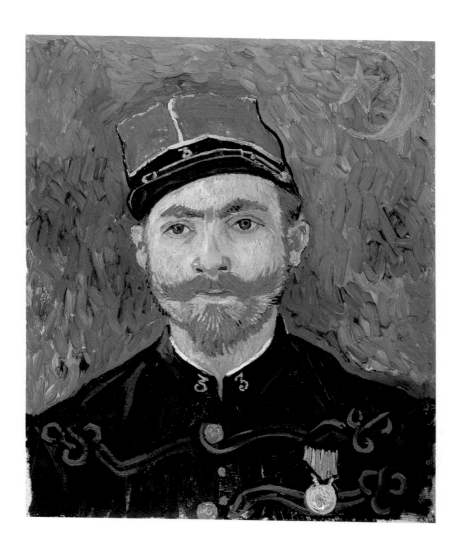

140
*The Lover (Paul-
Eugène Milliet)*,
1888.
Oil on canvas;
60 x 49 cm,
23½ x 19¼ in.
Kröller-Müller
Museum, Otterlo

a star'), and imagined 'the Greeks, the old Dutch masters, and the Japanese continuing their glorious schools on other orbs'. As he pondered mortality in the wake of Mauve's untimely death at forty-nine, Van Gogh expressed hope that he and his friends might flourish in the afterlife, 'painting under superior and changed conditions' on 'one of the innumerable heavenly bodies' (as he told Bernard).

In light of Vincent's remarks to Theo that painting under the 'gemlike' stars of Provence made him muse upon a group portrait of 'our comrades', *The Poet* should be seen as a composite portrait expressing admiration for those 'who dream and paint from the imagination' (as Van Gogh wrote of Rembrandt). Marked by his esteem for Gauguin (whose *Martinique* was 'high poetry') and his affection for Bernard (who shared his verse with Van Gogh), *The Poet* also alludes to Van Gogh's own 'poetic' project: the alliance of naturalism and colour-based lyricism, or 'musicality'. He and his friends had been exchanging thoughts on poetic painting, and echoing Gauguin's assertion that colours and forms 'produce poetry on their own', Vincent told Wil, 'One can make a poem merely by arranging colours, just as one can say comforting things in music.' The title he gave Boch's image signifies one whose work – be it verse, prose, music or painting – is inspired and transportative. Boch's, in Van Gogh's assessment, did not put him in that league, but his 'look of Dante' served Van Gogh's idealizing vision of the artistic persona immortalized against a backdrop of infinity. 'Thanks to him,' Van Gogh had made 'the picture I've dreamt of for so long – the poet'.

He hung *The Poet* over his bed – the locus of dreams – where it was joined by a likeness of Van Gogh's friend and sometime student Paul-Eugène Milliet, a Zouave lieutenant and an aspiring draughtsman (140). Though shown in uniform under his regiment's crescent-and-star coat of arms, Milliet was, to Van Gogh's mind, more lothario than soldier (like the lower-ranking Zouave who posed before him; see 132, 133), and his image was titled *The Lover*. Van Gogh believed that 'there are colours that cause each other to shine ... which form a *couple*, which complete each other like man and woman', and the play of complementaries in *The Lover* might be seen to suggest the sort of

coupling at which Milliet reputedly excelled. Moreover, for Van Gogh the sitter's uniform – 'which these good little women dote on' – signified desirability in itself.

Milliet's straightforward likeness, however, fails to live up to its title. It may be that Van Gogh had a harder time recasting male intimates than he did paid subjects (Escalier), casual acquaintances (Boch) and female friends (Segatori). His portraits of Joseph Roulin, his closest friend at Arles, are among the most prosaic he made there (141), whereas Roulin's wife Augustine

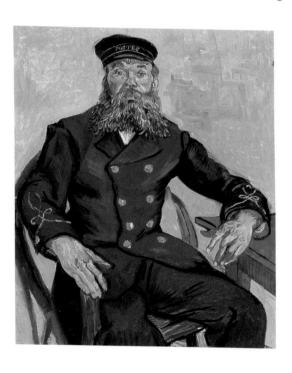

141
Joseph Roulin in Cane Chair, 1888.
Oil on canvas;
81 x 65 cm,
32 x 25½ in.
Museum of Fine Arts, Boston

became the iconic embodiment of consoling maternity Van Gogh christened *La Berceuse* (see 154).

Similarly, a single, matter-of-fact rendering of his friend Joseph Ginoux – owner of his favourite haunt, the Café de la Gare – is countered by the suite of images inspired by Ginoux's wife Marie, whom Van Gogh styled the quintessential Arlésienne (another type he dreamt of painting well in advance of finding his chance to do so). Marie helped run the café, and it is not surprising that Van Gogh's

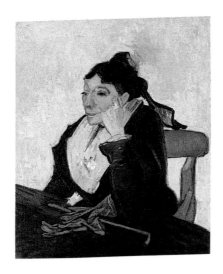

142
*The Arlésienne
(Marie Ginoux)*,
1888.
Oil on jute;
93 x 74 cm,
36½ x 29¼ in.
Musée d'Orsay,
Paris

143
*Paul Gauguin
(Man in a Red
Beret)*,
1888.
Oil on jute;
37.5 x 33 cm,
14¼ x 13 in.
Van Gogh
Museum,
Amsterdam
(Vincent
van Gogh
Foundation)

first painted impression of her – in a quick study he considered an
'*étude*' (142) – recalls, in attitude and props, his portrait of Segatori
at Le Tambourin (see 89). In a second, more considered rendering
(see 129) he called a *tableau* (*ie* a finished painting rather than
a study), Van Gogh darkened and clarified Marie Ginoux's features
(*café-au-lait* complexions and Roman noses being recognized
aspects of southern beauty). In addition to distilling an elegant
and thoughtful countenance from that of a drained and distracted
looking model, Van Gogh replaced the *étude*'s parasol and gloves
with books that situate his *tableau* in a domestic interior and recast
Ginoux as a kindred spirit.

He apparently found male subjects less tractable. Van Gogh
attributed his problems in painting his friends to their failures as
models (Roulin was 'too stiff', he wrote, and Milliet 'poses badly'),
but another probable factor was unspoken unease with painting the
men he held dear. During two years in Paris, Vincent seems never to
have painted Theo, and his only painted image of Gauguin's features
is a small, unresolved, over-the-shoulder view that looks as if it
were captured on the sly (143).

Van Gogh's image of Milliet as *Lover* was, conceptually, as much
at home in his bedroom as that of *The Poet*, though the painter in
fact did more dreaming than love-making in his Arlésien quarters.

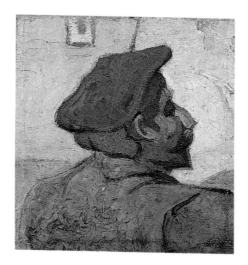

Indeed, in placing Boch's and Milliet's images side by side, Van Gogh
may have made purposeful reference to his either/or attitude towards
art- and love-making. Though he had once considered marriage
essential to artistic success, in Arles Van Gogh routinely declared
the incompatibility of painterly productivity and sexual encounters
in excess of two a month. This conviction – doubtless connected
to his fears of waning attractiveness and reliance on satisfactions
obtained at a price – may have been fostered by Van Gogh's readings.
Womanizing and marriage are presented as threats to masculine
creativity in the Goncourts' and Zola's novels of artistic life –
Manette Salomon (1867) and *L'Oeuvre* – and in Edmond de Goncourt's
posthumous tribute to his beloved brother/collaborator, *Les Frères
Zemganno* (*The Zemganno Brothers*; 1879), which Van Gogh read
while living with Theo in Paris. From Arles Vincent warned Theo
that 'if your brain and marrow are going into your work, it's pretty
sensible not to exhaust yourself more than you must in love-making'.
In a similar spirit, he advised Bernard to conserve 'creative sap',
so that his painting could be 'all the more spermatic'. While conceding
the necessity of 'going to the brothel or the wine shop if the spirit
moves us', Van Gogh declared that 'if we want to be really potent
males in our work we must sometimes rein ourselves in', 'living
almost like monks or hermits, with work our master passion'.

Van Gogh's existence in Arles, he admitted, was 'not very poetic, but I feel duty-bound to subordinate my life to painting'. Its monkish aspect found pictorial expression in *Self-Portrait as Bonze* (145), which added a priestly type to his Arlésien repertoire. '*Bonze*', a term used by Loti, is a French version of a Japanese word for Buddhist monk.

Though Van Gogh later observed that he had painted himself as both 'impressionist' and 'worshipper of the eternal Buddha', he knew little of Buddhism. That dimension of the label '*bonze*' is less central to his self-image than its general connotation of monkishness. The *bonzes* Loti describes are not artists, and Van Gogh's image of painter-as-monk is more readily linked to European prototypes. He was surely aware that medieval monasticism supported a vast network of artistic communities, and in 1888 he specifically compared his 'double nature ... of monk and painter' to that of Hugo van der Goes (c.1440–82), a Netherlandish artist who entered a monastery in mid-career (and later suffered a mental breakdown).

Van Gogh similarly identified with St Luke, the evangelist/painter who is patron saint to artists and symbolized by an ox, as Van Gogh reminded Bernard. Describing himself and his friend as yoked to a difficult profession requiring 'the patience of an ox', Van Gogh suggested that they and their colleagues adopt the cooperative spirit that prevailed 'in the days of the Guilds of St Luke'. His notion of artistic fraternity was not unlike that which motivated a band of classmates from the Vienna Academy to found their own Brotherhood of St Luke in 1809 (relocating to Rome, they occupied an abandoned monastery and were dubbed Nazarenes), and a group of English painters dissatisfied with conventional Victorian art who joined forces as the Pre-Raphaelite Brotherhood in 1848, dedicating themselves to a nature-based art of serious moral purpose. Van Gogh's ideal of artistic communality was a Eurocentric one that, grafted on to his appreciation of Japanese printmakers, led him to assume *ukiyo-e* masters worked cooperatively, like monks or guild members of old.

The European spin Van Gogh put on Japanese monks and artists came full circle when he portrayed himself as a *bonze*. Though Van Gogh saw his poverty, asceticism and craving for communality

as monklike, the specific impetus for this self-portrait came from his having shaved both hair and beard in response to summer heat. He told Theo he resembled figures in Émile Wauters's *Madness of Hugo van der Goes* (144): 'My whole beard shaved off, I think I'm as much like the very placid priest [who seeks to soothe with music] ... as the mad painter so intelligently portrayed therein.' Hence Van Gogh's decision to depict himself as both the 'crazed' painter he considered himself to be and the 'placid priest' he was working to become. As he later told Gauguin, Van Gogh recognized his need to 'recover somewhat more from the stultifying influence of our so-called civilization to have a better model for a better picture'.

144
Émile Wauters,
*The Madness of
Hugo van der Goes*,
1872.
Oil on canvas;
186 x 275 cm,
73¼ x 108¼ in.
Musées Royaux
des Beaux-Arts
de Belgique,
Brussels

Van Gogh's painted head, with opposed curves and angles barely concealed, and features taut, has a look of honed intensity. The artist took 'a terrific amount of trouble' with its wan tints of 'ashen' pink and greyed green (hues he later associated with illness and grief), which suggest privation and suppressed carnality. This self-image might seem to 'speak a symbolic language through colour alone', were it not for the eyes – the self-portrait's most explicitly significant feature. Their pronounced slant bespeaks the artist's identification with the 'simple Japanese' – the profundity of that allegiance indicated by his decision to show himself physically altered by it, rather than attired *à la japonaise* or in the company of Japanese objects. In painting his eyes to *look* Japanese, Van Gogh refers to his conceptual quest 'to *see* things with an eye

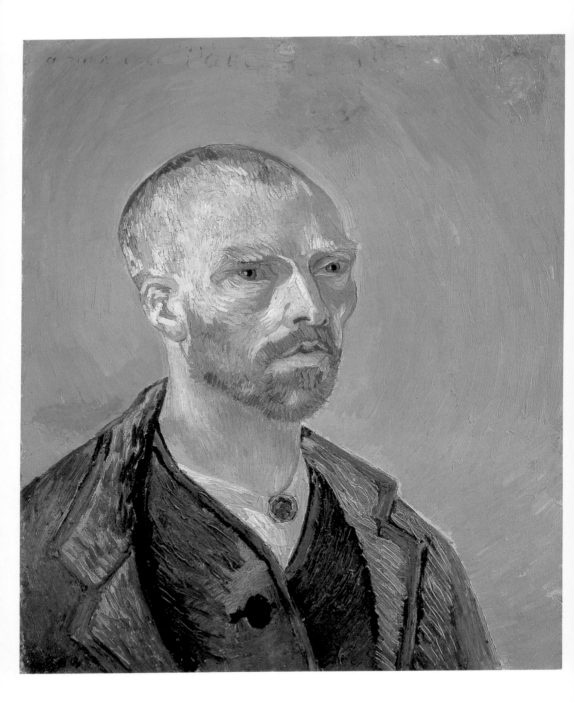

145
*Self-Portrait
as Bonze*, 1888.
Oil on canvas;
62 x 52 cm,
24½ x 20½ in.
Fogg Art Museum,
Harvard University
Art Museums,
Cambridge,
Massachusetts

146
Paul Gauguin,
*Self-Portrait,
Les Misérables,*
1888.
Oil on canvas;
46 x 55 cm,
18 x 21½ in.
Van Gogh Museum,
Amsterdam
(Vincent van Gogh
Foundation)

more Japanese' – that is, with an eye to heightened colour and simplified form.

Self-Portrait as Bonze was given to Gauguin as part of a picture exchange Van Gogh engineered with him and Bernard, each of whom sent a self-portrait to Arles in October. A description of Gauguin's painting (146) preceded it. Comparing himself to Jean Valjean, the beleaguered protagonist of Victor Hugo's *Les Misérables* (1862), Gauguin told Van Gogh that his hot-blooded ruffian's face masked 'inner nobility and gentleness'. Hugo's long-suffering hero had much in common, Gauguin wrote, with 'the impressionist of today', and 'in endowing him with my features I offer you an image of myself as well as a portrait of us all'. Gauguin added the inscription '*les misérables*' to his painting's lower right corner – a label meant for Bernard (whose profile appears in the picture-within-the-picture above the inscription) and Van Gogh (whose first name appears directly below it) as well as himself.

Van Gogh reciprocated by offering his own image, wherein, he wrote, 'I also exaggerate my personality'. Perhaps in reaction to Gauguin's suggestion that the Valjean-inspired self-portrait stood for them all, Vincent insisted to Theo that he, too, intended 'to convey not only myself, but an impressionist in general'. He used that term – as Gauguin had – to denote a modern painter in general rather than a mainstream Impressionist, since both artists rejected what they perceived as the Impressionists' excessive concern with truth to natural appearance. Neither man's self-image conforms in style or concept to portraits now considered 'Impressionist', such as Renoir's *Monet Painting in his Garden* (147). A depiction of classic Impressionist practice as well as a likeness of his colleague, Renoir's picture shows Monet engulfed in his subject, physically engaged in his craft, and pushing paint in direct response to visual stimuli. As images of the modern painter, Gauguin's and Van Gogh's self-portraits suggest a new departure: emphasizing the head, seat of thoughts and dreams, each absents the hands that, along with brushes and palette, constitute the tools of the painter's trade. These omissions indicate a practice that privileges the ideas behind

the pictures over the physical act of making them. (Gauguin does, however, refer to the product of his manual labour by including a 'painting' of Bernard – a more conventional artist's image that includes Bernard's thumb-held palette.)

As cool as Gauguin's is overheated, Van Gogh's self-portrait seems minimalist by comparison. Gauguin's self-portrait is 'telling' in the literal sense – its inscription spells out his misery, and the picture-within-the-picture bespeaks work and camaraderie. Whereas *Les Misérables* demands to be 'read', Van Gogh's self-portrait is about looking – or, perhaps, *not* looking. Unlike most self-portraits throughout the ages, Van Gogh's features an averted gaze,

147
Pierre-Auguste Renoir,
Monet Painting in his Garden,
1873.
Oil on canvas;
50·3 x 106·7 cm,
19⅞ x 42 in.
Wadsworth Atheneum,
Hartford,
Connecticut

suggesting that the artist was not locked on his mirror as he worked. Proceeding from his mind's eye as much as his physical eye, he was less concerned with visual facticity than faithfulness to a mental construct. A remark Van Gogh made about Zola in 1885 sheds light on his own priorities: for all his candour, Van Gogh observed, the dean of literary naturalism 'does not hold up a *mirror* to things', but '*creates, poeticizes*, that is why it is so beautiful'. Again like the Japanese, who distilled rather than directly transcribed natural forms, Van Gogh rejected the age-old Platonic analogy that compares pictorial art to a mirror. Instead he embraced (if unwittingly) the Romantic position inspired by the writings of the third-century AD

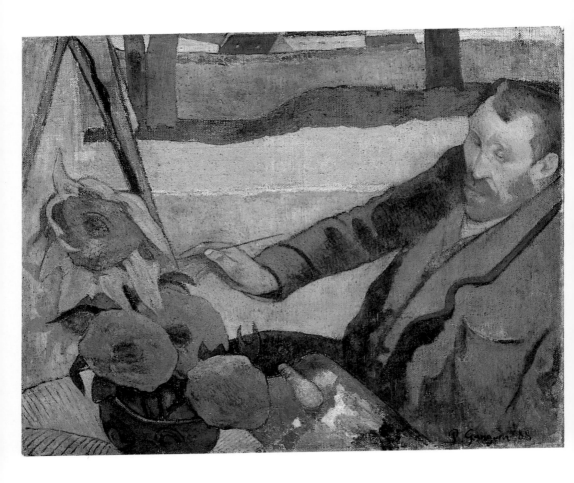

148
Paul Gauguin,
Van Gogh Painting
Sunflowers,
1888.
Oil on canvas;
73 x 92 cm,
28¾ x 36¼ in.
Van Gogh Museum,
Amsterdam
(Vincent van Gogh
Foundation)

philosopher Plotinus, namely that representation should function in the manner of a lamp, illuminating rather than merely reflecting. As the critic William Hazlitt observed in 'On Poetry in General' (1818), 'the light of poetry' is both direct and reflected; it not only 'shows us the object', but 'throws a sparkling radiance on all around it'.

The premium Van Gogh put on art's capacity to elucidate is attested by his painting of *Gauguin's Chair* (see 150), a painting illumined by candle and gas-jet. Their yellow light is the picture's animating force. Dappling the carpet, bathing the books and tracing the curves of the chair, it becomes a metaphor of vision and the visionary in this emblematic evocation of 'the new poet living here, Paul Gauguin'. Having chastised Bernard for his reluctance to paint their friend's portrait in Pont-Aven, Van Gogh vowed to do one himself when Gauguin came to Arles. Once they were face to face, however, he found himself equally stymied – despite the fact that Gauguin made a portrait of him (148). *Van Gogh Painting Sunflowers* is comparable to Renoir's portrayal of Monet in its depiction of an artist intent on real-world motifs. An imaginative re-creation of Van Gogh's process (since sunflowers are not late-autumn blooms), Gauguin's picture was perhaps designed to imply (as he later did in *Avant et après*) that he had been on hand to guide it. At the same time, his image seems a thinly veiled criticism of a painterly procedure Gauguin found lacking in inventiveness: features distorted and eyes almost crossed, the Van Gogh of Gauguin's portrait looks vaguely imbecilic. Vincent may have discerned something of what he himself called 'the delusive realist' in Gauguin's image of him, and the latter's disdain for artistic literal-mindedness surely discouraged Van Gogh from requesting a conventional portrait sitting from Gauguin.

Intent, nevertheless, on chronicling Gauguin's presence, Van Gogh resorted to painting him literally behind his back (see 143). In an even more oblique approach, he commemorated their time together in paired pictures of their chairs (149, 150). The armchair Gauguin favoured is seen in the evening, decked with 'lighted torch and modern novels'. Its pendant, a daytime view of Van Gogh's preferred

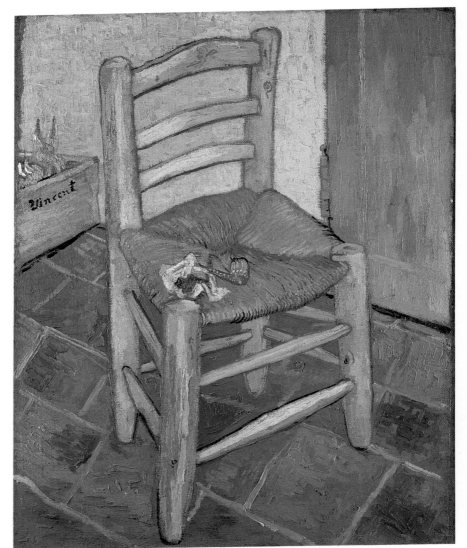

149
*Van Gogh's
Chair*, 1888.
Oil on jute;
93 x 73.5 cm,
36½ x 29 in.
National Gallery,
London

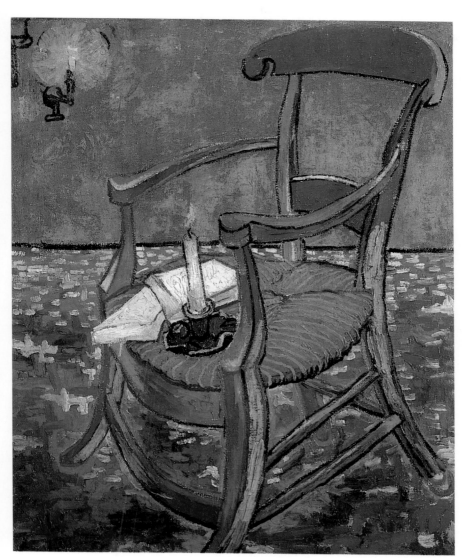

150
Gauguin's Chair,
1888.
Oil on jute;
90·5 x 72 cm,
35⅝ x 28⅜ in.
Van Gogh
Museum,
Amsterdam
(Vincent
van Gogh
Foundation)

pine chair, bespeaks the feelings of unvarnished 'coarseness' he experienced so accutely in Gauguin's company. With Van Gogh's at left and Gauguin's at right, the two chairs turn towards each other like spouses in Dutch portrait pairs, and almost humorously point up the day-and-night differences brought to light by the artists' cohabitation. *Van Gogh's Chair* alludes to the painter's most basic needs: 'To produce good work', he had noted that autumn, 'one must eat well, be well housed, have one's fling from time to time, smoke one's pipe and drink one's coffee in peace.' *Gauguin's Chair* bespeaks more elusive assets: the ideas and illumination books and candles betoken, and the potency suggested by the flaming taper's position in the armchair.

As a group, Van Gogh's images of *Poet*, *Bonze* and *Chairs* – devoid of direct references to the shared profession of their 'sitters'– suggest his changing notions of the painter's enterprise. Just months before, he had painted himself as the creature of his craft, 'loaded like a porcupine with poles, painter's easel, canvas', and workman-like in his attire (see 130). As summer turned to autumn he was less inclined to see himself and/or the modern artist in this way. Preoccupied with the idea-based, 'musical' art his exchanges with Gauguin and Bernard encouraged, Van Gogh seems to have consciously omitted a brush-wielding craftsman from his Arlésien portraits suite, substituting the transcendent types he and Boch embody there.

He could not, however, sustain the 'high yellow note' he felt he had attained in 1888. The nervous collapse he suffered in December (see Chapter 7) exacerbated his self-doubt, and his neighbours' stand-offish response to his mental imbalance made 'the great, simple thing' ever more complicated. In the months just before his breakdown, however, Van Gogh had made changes in the face of private portraiture. As he worked to make that élite genre legible and engaging to a broad audience, he downplayed 'what one might call likeness' and amplified 'poetic character', colourizing and decontextualizing models, refining and reshaping them, and, in his *Chair* pictures, abandoning the model for 'the suggestion of one'.

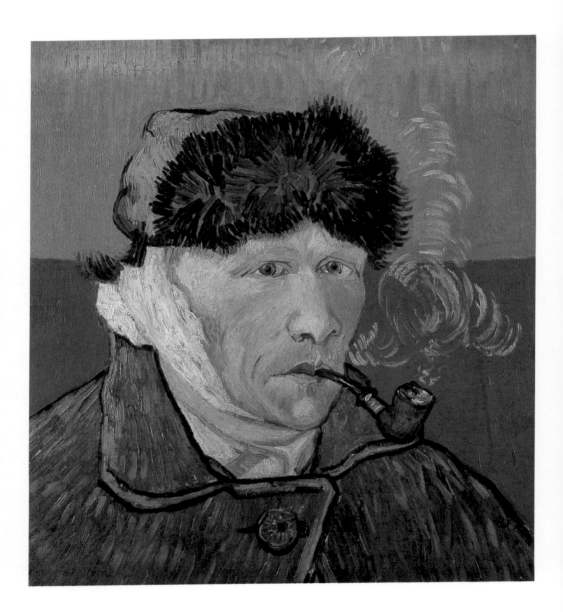

For all his attempted asceticism in Arles, Van Gogh was no stranger to its brothels, and also kept himself 'pretty well keyed up' on coffee and alcohol there. These were consumed in abundance at the Ginoux's cafe (see 152). Open all night, the Café de la Gare struck Van Gogh as a perfect place to 'ruin oneself, go mad, or commit crimes'. In September 1888 he spent three nights painting its gas-lit late-night scene, using acrid yellow and clashing reds and greens to 'express terrible human passions'. His bird's-eye view, with tilted floor and strident hues, reminded him of certain Japanese prints, though the picture's 'ugliness', he wrote, rivalled that of *The Potato Eaters*.

151
*Self-Portrait
with Bandaged
Ear*, 1889.
Oil on canvas;
51 x 45 cm,
20 x 17¾ in.
Stavros S
Niarchos
Collection,
Athens

Van Gogh joked that *The Night Café* might strike some as the product of alcohol-induced delirium. Such asides, coupled with the picture's disquieting aspect, contextualize Van Gogh's later admissions of high-flying frenzy in the months preceding his breakdown. The agitation that helped Van Gogh 'reach the heights' in 1888 – and crash at year's end – was propelled by Provençal sun and wind as well as chemical stimulants, then exacerbated by Gauguin's two-month stay, a period of brothel-going, drinking and charged aesthetic debate Van Gogh found both electrifying and exhausting. According to Gauguin, drinking fuelled mutual provocations: he claimed that Van Gogh once flung an absinthe-filled glass at him, and recalled that he, in turn, threatened to strangle the obstreperous Dutchman.

It was under such strained circumstances that Van Gogh temporarily lost his mind: two nights before Christmas, alone at home and despairing of his abandonment by Gauguin (who planned to return to Paris) and Theo (who was getting engaged), Vincent – probably inebriated – severed his left earlobe with a razor. After venturing out to a brothel to present the bloody fragment to a prostitute, he was helped home by Roulin, and would probably have bled to death

152
The Night Café,
1888.
Oil on canvas;
70 x 89 cm,
27½ x 35 in.
Yale University
Art Gallery,
New Haven

in bed but for the intervention of police, who ordered him hospitalized. Theo arrived on Christmas Day at Gauguin's summons, but – with his fiancée waiting in Paris and little sense that his presence was helpful – the younger Van Gogh left within hours, perhaps in Gauguin's company. Though Theo resigned himself to the possibility of Vincent's death, the painter soon rallied and was released from hospital.

Convinced that work 'keeps me under control', Van Gogh soon made a striking self-portrait in which his blue hat and green coat contrast with an orange and red backdrop that divides at the artist's eye-line (151). The painting's high colourism underscores its subject's pallor (familiar from *Self-Portrait as Bonze*, see 145) and offsets the white bandage that both conceals and emphasizes his wound. Van Gogh's fixed stare suggests reluctance to engage, and the bundling of body, head and ear contributes to his air of inaccessibility. Mouth pressed to his pipe, the artist looks determined to maintain composure; while convalescing he noted that a 'pipe of tobacco' was part of an anti-suicide regimen Dickens recommended.

He also returned, in January, to a canvas in progress when illness intervened: the image of Augustine Roulin he called *La Berceuse* (see 154). In late autumn, having decided to paint the five-member Roulin family, Van Gogh made three other images of Augustine, the earliest of which show her with baby in arms. Solo in *La Berceuse*, she is ever the caregiver: rope in hand, she rocks her baby's cradle, and the picture's title, written into the paint surface, translates as both 'nursemaid' and 'lullaby'. Her ample bosom and hips further emphasize her motherly function, while her stolid form and simple toilette indicate the approachable, desexualized femininity Western culture often associates with maternity.

The crisis Van Gogh weathered while making *La Berceuse* intensified memories of faraway times and places with which he already had toyed when, in mid-November, he painted his mother and Wil in the parsonage garden at Etten/Nuenen, places they had long since left. Prodded by Gauguin, Van Gogh made this stylized memory picture in an allusive mode he called 'poetic', noting, 'The violent citron yellow

of the dahlias suggests mother's personality to me' (153). 'During my illness,' Vincent told Theo, 'I saw again every room in the house at Zundert.' To Gauguin he confided that, when delirious, he sang 'an old nursemaid's song'.

Van Gogh nostalgically compared his attentive friends, the Roulins, to his parents. Impressed by Joseph's proud middle-aged paternity (Roulin greeted his third child at age forty-seven), Van Gogh took him as a father figure whom he compared to Père Tanguy (see Chapter 4). He found a substitute for the faraway mother of memory when he cast Roulin's wife as yellow-complexioned cradle-rocker on a dahlia-spangled ground. In painting *La Berceuse* (154) to knee-length only, the artist facilitated imaginative return to infancy: the viewer assumes the place of Mme Roulin's cradled infant.

The feminine ideal suggested by Van Gogh's painting of Marie Ginoux as literature-loving soulmate (see 129) shifted considerably after his breakdown. As he told Theo in spring 1889, he sometimes felt 'a tempest of desire to embrace something, a woman of the domestic hen type' – a side-effect, he believed, of 'hysterical overexcitement'. Such longings surely informed his obsessive remaking of *La Berceuse*, an image he reprised four times after completing it in January.

As he worked to style a mother substitute in paint, Van Gogh recalled images of the Virgin that years of museum-going had ingrained. He tapped their conventions when he centred Roulin's monumental form against a floral ground that recalls the lavish cloth suspended behind the Madonna in many early northern European paintings (155), and stressed *La Berceuse*'s ties to Christian art when he specified its display between two *Sunflowers* as 'a sort of triptych' (a three-panelled format common to altarpieces). Hung thus (156), the flanking canvases would 'form torches or candelabra' and 'the yellow and orange tones of the head will gain in brilliance by the proximity of the yellow wings'.

Though its broadest lines call up church art, the projected triptych's central entity – sour-faced and middle-aged – contrasts with idealized portrayals of saintliness to which Christians are accustomed (155, for

153
*Memory of the
Garden at Etten,*
1888.
Oil on canvas;
73·5 x 92·5 cm,
29 x 36½ in.
State Hermitage
Museum, St
Petersburg

154
*La Berceuse
(Augustine
Roulin)*,
1889.
Oil on canvas;
92 x 73 cm,
36¼ x 28¾ in.
Kröller-Müller
Museum, Otterlo

155
Jan van Eyck,
*Madonna at
the Fountain*,
1439.
Oil on panel;
19 x 12 cm,
7½ x 4¾ in.
Koninklijk
Museum voor
Schone Kunsten,
Antwerp

156
Van Gogh's
sketch showing
the proposed
triptych with
La Berceuse and
Sunflowers, from
a letter to Theo,
22 May 1889.
Van Gogh
Museum,
Amsterdam
(Vincent
van Gogh
Foundation)

example). According to Van Gogh, *La Berceuse* was an attempt to make 'portraits of saints and holy women from life', 'middle-class women of the present day' who had 'something in common with the very primitive Christians'. His concept had sources in Rembrandt's portrayals of the Holy Family in modest Dutch interiors, allusions to sacred prototypes in 'peasant pictures' such as Millet's *Baby's Slumber* (157) and Israël's *Cottage Madonna* (1867), and in Van Gogh's belief that the power of Delacroix's depictions of 'holy women' derived from their resemblance to 'present-day descendants'.

157
Jean-François
Millet,
Baby's Slumber,
c.1855.
Oil on canvas;
46·5 x 37·5 cm,
18¼ x 14½ in.
Chrysler
Museum of Art,
Norfolk, Virginia

Debora Silverman believes Van Gogh may have linked *La Berceuse* to local treatments of Christ's nativity: crèches in which Provençal types descend on the Bethlehem stable, and an Arlésien theatre piece that set Christ's nativity on local terrain, amid – as the artist reported – 'a family of gaping Provençal peasants'. His attraction to holiness in plain wrapper, however (like his interest in stereotypic 'heads of the people'), predated his move to Arles. *La Berceuse* probably owes something to Ernest Renan's *Life of Jesus* (1863), a biographical

refutation of the Church's claim that Christ was God made man, which portrays him as mere mortal (albeit one of great goodness and charisma). Van Gogh did not reread 'Renan's excellent book' at Arles, but often thought of it in southern climes that, to his mind, suggested the Holy Land. In 1889 he declared Renan's flesh-and-blood Christ 'a thousand times more comforting than the papier mâché Christs' he had encountered in churches. The artist's notion of 'primitive Christians' probably derived from Renan, who describes Christ's first followers as country bumpkins whose provincial slang makes them laughing stocks among Jerusalem's urbane inhabitants. Renan reminds the reader that Christianity's founders were not rich, scholarly or priestly, but 'men and women of the people'.

Van Gogh's wish to paint provincial neighbours as 'holy women' may also be tied to his contemporaneous interest in Leo Tolstoy's *What I Believe* (1884), a polemical tract that describes the Russian novelist's renunciation of élitist pursuits and retreat to rustic life, where he found true faith. Tolstoy's linkage of peasantry and piety must have struck a familiar chord with Van Gogh, and that author's paeans to his old nursemaid may have hit even closer to home. *What I Believe* forecasts what Van Gogh described as a 'revolution ... from which a new religion will be born ... which will have the same effect of comforting, of making life possible, that the Christian religion used to have'. In his own unorthodox 'triptych' Van Gogh arguably aimed for 'the same effect of comforting' Christian imagery once had.

The text he himself connected to *La Berceuse*, however, was Pierre Loti's *Pêcheur d'Islande* (1886), a novel of Breton fisherfolk. In discussing the book with Gauguin in autumn 1888, Van Gogh – moved by Loti's description of the ocean as a nursemaid who rocks seafarers to sleep in the cradlelike hulls of their ships – began thinking of a picture painted 'in such a way that sailors, who are at once children and martyrs, seeing it in the cabin of their Icelandic fishing boat, would have that old sense of being rocked come over them, and remember their old lullabies'. After his violent episode of illness, Van Gogh saw himself as metaphorically storm-tossed,

both 'child and martyr', and sought to be similarly lulled. He remarked in a letter to Gauguin that his thoughts 'navigated many seas' and often turned to 'the old nursemaid's song ... sung by the *berceuse* who rocked the sailors and which I sought in an arrangement of colours before I fell sick'.

With both senses of *berceuse* in mind, he provided his picture's cradle-rocker with the 'musical' accompaniment of interacting hues: 'discordant sharps' of pink, orange and green, softened 'by flats of red and green'. Convinced that the antidote for madness and neurosis existed 'in Delacroix, Berlioz and Wagner', Van Gogh tried to make *La Berceuse* melodious, though 'whether I really sang a lullaby in colours I leave to the critics'. The picture's strong, clashing hues, however, are difficult to reconcile with a cradle song's soothing strains, and reflect Van Gogh's belief that Provence and its people demanded 'a colourist such as never yet existed'. His lullaby was a distinctly southern one, an attempt 'to get all the music of the colour here into *La Berceuse*', and to find a visual parallel for the southern patois that 'is extraordinarily musical in the mouth of an Arlésienne'.

Its palette, Van Gogh acknowledged, might lead some to liken *La Berceuse* to 'a chromolithograph from a cheap shop' – that is, a mass-market colour print distinguished by forceful linearity and saturated hue (158). Arguing that chromolithographs reflected popular taste, he sought to validate the 'crude' effects of his own work: 'The common folk, who are content with chromos and melt when they hear a barrel organ, are in some vague way right, and perhaps more sincere than certain men about town who go to the Salon'. Colouristic vulgarity (a visual equivalent of barrel-organ music and idiomatic speech) went hand in hand, Van Gogh noted, with *La Berceuse*'s flawed proportions, suggesting 'a picture such as a sailor at sea who couldn't paint would imagine when dreaming of a woman ashore'. (He may have been thinking of Roulin, transferred to Marseilles and living apart from Augustine, whose portrait supposedly delighted her husband.) Pre-empting élitist criticisms, Van Gogh claimed that he deliberately mimicked a low-brow aesthetic, to make *La Berceuse* accessible to all.

The painting also has *japoniste* antecedents, particularly in Bernard's and Gauguin's use of dark, heavy contours and areas of flat colour. Gauguin, the former sailor who made *Pêcheur d'Islande* come alive for Van Gogh, was very much on the painter's mind as he made a picture for those literally and figuratively at sea. Vincent was keen that Gauguin have a copy of *La Berceuse*, doubtless expecting his former housemate (who, as Van Gogh noted, lived apart from his wife) to understand his intentions more readily than most. He perhaps also hoped *'le misérable'* would benefit from the painting's solacing effects. Gauguin, however, manifested little interest in owning a *Berceuse*.

Van Gogh's wish to share his picture's salutary effects accounts, in part, for his multiple remakings. Unlike Monet, whose serial images involved revisitations and refinements pursued mainly for personal satisfaction, Van Gogh, like an old-fashioned icon-maker, aimed at almost exact replication of an emotionally charged original

158
Chromolithograph of the Virgin, from Pierre Louis Duchartre and René Saulnier, *L'Imagerie populaire*, Paris, 1925

intended for public address. He advanced his project under trying circumstances; paranoia prompted his second hospitalization in February, and though doctors soon deemed him capable of working outside by day (if supervised at night), concerned neighbours circulated a petition calling for his full-time incarceration. The superintendent of police responded by ordering 'this madman' deprived of liberty, paint, books and pipe. After a month, Van Gogh worked outside once more, though hospitalized – an arrangement he found almost ideal. He did not consider himself 'a madman properly speaking', but 'the thought of beginning to live alone again is an absolute horror to me', and 'I wish to remain shut up for my own peace of mind'.

MAISON DE SANTÉ
DE
SAINT-RÉMY DE PROVENCE
(BOUCHES-DU-RHÔNE.)

ÉTABLISSEMENT PRIVÉ
CONSACRÉ AU TRAITEMENT DES ALIÉNÉS DES DEUX SEXES.

159
Advertisement
for *Maison
de Santé* at
Saint-Rémy

Dispirited by his neighbours' hostility, Van Gogh voluntarily relocated to Saint-Rémy in May, anticipating a summer's rest at its sanatorium. Twenty-four kilometres (15 miles) northeast of Arles, Saint-Rémy had a population of 5,000 in 1889. It boasted a spectacular setting and Roman ruins as well as the Romanesque buildings of Saint-Paul-de-Mausole – a former monastic complex that had been converted to a private mental asylum (159). One might have expected Van Gogh – as self-cast monk – to appreciate the lingering atmosphere of religiosity lent by Saint-Paul's ecclesiastical architecture and staff (three-quarters of them nuns), but instead he felt that aspect of the institution stirred 'perverted and frightful ideas about religion'.

The institution admitted male and female patients in varied degrees of distress, treating them mainly with rest and hydrotherapy. Its director, Dr Théophile Peyron, found Van Gogh relatively sane on arrival but thought it 'advisable to keep him under prolonged observation'. Since only half the beds were occupied, Van Gogh was allowed a painting room at Saint-Paul, but in the fine May weather preferred outdoor work. He scarcely minded restriction to a walled garden, since 'I have ... hardly any wish for anything belonging to ordinary life'.

The institution's 'unkempt' flower-filled grounds perhaps reminded Van Gogh of Le Paradou, the overgrown Provençal garden that figures prominently in Zola's *La Faute de l'Abbé Mouret*, the tale of a high-strung priest who, like Van Gogh, recuperates from mental collapse in an abandoned walled enclave. Conveniently amnesiac as a result of his illness, Zola's protagonist breaks his vows of chastity with the caretaker's teenage niece, who introduces him to Le Paradou's provocative bowers and secluded nooks (reminiscences of which perhaps informed Van Gogh's remarks on the asylum garden's 'nests of greenery for lovers'). Le Paradou was a favourite fictional locale of both Vincent and Theo, who applied its name to any spot suited to amorous adventures. In 1883 the painter told his brother he might one day 'attack a Paradou subject', and five years later, as he explored the overgrown garden of Montmajour with Milliet ('The Lover'), he wrote that he was reminded anew of Zola's paradisiacal retreat.

Irises, one of the pictures made in the garden, is surprisingly vigorous in light of the painter's professed apathy (161). Its plays of warm and cool colours, floppy blooms and sword-like leaves complement a dynamic diagonal composition that is asymmetrically poised upon a single white bloom. When he painted *Irises Outside Arles* (see 119), Van Gogh panned over dozens of flowers, but in the asylum garden he captured a few head-on. Close-up and life-size, his Saint-Rémy *Irises* are almost figural in their scale and individuality, like the *Sunflowers* painted in loving detail at Arles (see 126). Unlike his *Sunflowers*, however, Van Gogh's *Irises*

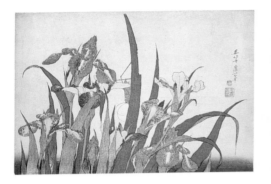

160
Katsushika Hokusai,
Irises, from the
Large Flowers
series, 1833–4.
Woodblock print;
26·8 x 39·4 cm,
10¹⁄₂ x 15¹⁄₂ in.

161
Irises, 1889.
Oil on canvas;
71 x 93 cm,
28 x 36³⁄₄ in.
J Paul Getty
Museum,
Los Angeles

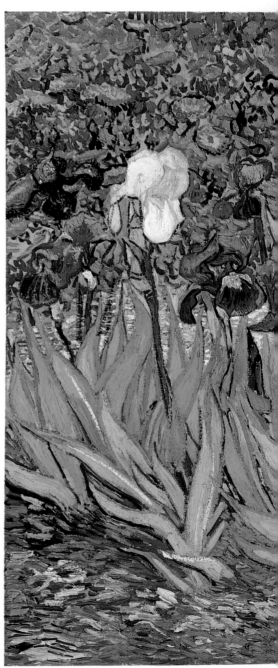

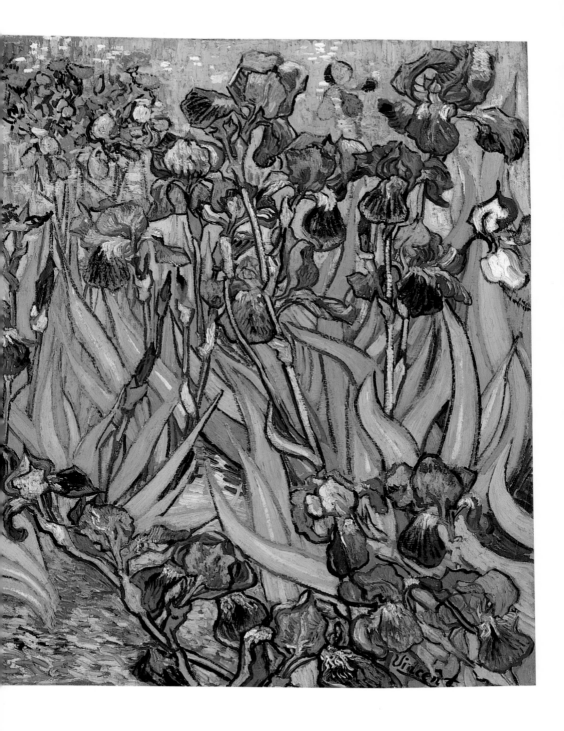

remain rooted to the ground, in a painting that stands midway between landscape and still life. Displaced himself, Van Gogh was perhaps reluctant to sever blooms from life source, and adopted the approach he ascribed to Japanese artists, studying a 'single blade of grass' close up (as, for example, in 160). The animistic attitude that had led him, years earlier, to see 'slum dwellers' in 'trampled grass' (see Chapter 2), almshouse men in stunted willows, and the purity of a newborn in 'young corn', is evident in *Irises*. Its vibrancy bespeaks Van Gogh's command of his craft, his subject and himself.

In late May the painter's thoughts turned to the wheat he saw 'through the iron-barred window' of his second-floor room (162).

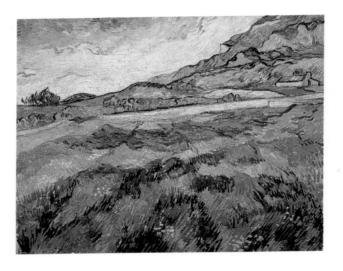

162
Green Wheat Field, 1889.
Oil on canvas; 73 x 92 cm, 28¾ x 36¼ in.
Kunsthaus, Zurich

163
The Reaper, 1889.
Oil on canvas; 72 x 92 cm, 28¾ x 36¼ in.
Kröller-Müller Museum, Otterlo

That ripening expanse, in reminding Van Gogh of the natural order of things, helped him accept his fate: in letters to Wil and Theo, he wrote of his realization that struggles against day-to-day uncertainties were fruitless, since humans were ultimately as powerless as wheat, subject to 'being reaped when we are ripe'. That symbolic connection was a venerable one, familiar through the Parable of the Sower, and visually reinforced for Van Gogh early on by Van der Maaten's *Funeral Procession through the Fields* (see 5), in which a field hand in a half-mown, sheaf-strewn field pauses before a passing cortege. Van Gogh may well have recalled that print (which he had known all his life, heard his father sermonize upon,

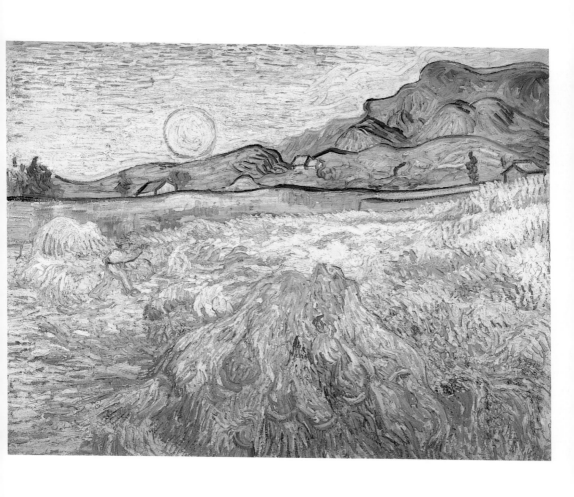

and annotated with Scripture himself) as he watched a worker reap the crop he had painted from his window, and began a series of pictures in which the harvester embodies death (163):

It is – if you like – the opposite of that Sower I tried to do before. But there's nothing sad in this death. It goes its way in broad daylight, the sun flooding everything with a light of pure gold.

Side-stepping the conventional image of the 'Grim Reaper' (and rejecting the melancholic tenor of an image like Van der Maaten's), Van Gogh aimed for radiance, his painting a reflection (like its antecedent sowers) of the parable wherein 'the field is the world ... the harvest is the end of time', and the wheat-like righteous, gathered in by angels, 'shine as brightly as the sun in the kingdom of their father' (Matthew 13: 36–43).

With Peyron's consent, the artist ventured beyond the asylum's walls in June and July, painting olive groves and cypress-studded fields in the Alpilles' rugged foothills, becalmed, he wrote, by encounters with 'a blade of grass, the branch of a fir tree, an ear of wheat'. Intent on avoiding 'dizzy heights' in his work, Van Gogh strove to simplify and to lessen contrasts. 'Begin[ning] again with the simpler hues', he shied away from oppositional colour schemes; the interrelated blues and greens that dominate *Olive Trees* are warmed by a modicum of pale yellow, with hardly a complementary orange or red in sight (164). Moreover, while he continued to favour dense impasto, he worked towards more uniform brushstrokes, less interested in pattern play than in marks that 'follow in the direction of the objects' portrayed. 'Certainly,' he wrote, 'this is more harmonious and pleasant to look at, and you add whatever you have of serenity and cheerfulness.'

A general softening of line and colour parallels reduced contrast in pictures Van Gogh made in Saint-Rémy. The angular, disjunctive silhouettes common to his Arlésien *oeuvre* give way to curving contours, often filled with the swirls and whorls of paint for which the artist is well known. Although he did not banish bright hues from his palette, 'what I dream of', he wrote, 'is not so much striking

colour as once again the half-tones'. He often greyed pure hue with admixtures of 'dull, dirty white', noting that 'disease and misfortune do the same thing to us'. He was convinced that his tendency towards grey (which drew him to olive trees' dusty-looking foliage) had something to do with the enforced sobriety of life in the asylum.

Greyed tonalities aside, *Olive Trees* has an almost drunken look. Its undulations suggest a painter 'at sea' on dry land. Though the painting's turbulence has been ascribed to oddities in the actual landscape, the Alpilles' bizarre rock formations cannot account for the seeming fluidity of the pictured ground plane or the gyrations of foreground trees. Despite the inclusion of recognizable landmarks (the two-holed rock left of the cloud, Mont Gaussier at right), *Olive Trees* is more emotive than topographical, a picture that questions presumptions of the world's solidity, and of the observer's secure place within it. Less systematically structured than orchard pictures Van Gogh made at Arles (see 115), *Olive Trees* lacks perspectival depth, since equivalencies of colour, line and implied movement link near to far, ground to sky.

Van Gogh considered *Olive Trees* an apt companion piece to the contemporaneous *Starry Night* (165). Although one is a sunlit landscape painted on the spot, the other a nocturnal vision shaped in the studio, he considered both 'exaggerations' with 'warped lines'. In *Olive Trees* Van Gogh took up a recent enthusiasm – trees he found typically Provençal and associated with earthly pain – but *Starry Night* marked his return to a poetic motif he already had explored in hopes of 'doing people's hearts good'. In Arles he had used a starry sky to expressive ends in *The Poet* (see 139); included the glimpse of one in his painting of a gas-lit restaurant terrace; and depicted an astral expanse in *Starry Night on the Rhône*, which he painted outdoors at night (166). Pleased by the absence of black in his Arlésien nocturnes, Van Gogh was especially proud of *Starry Night on the Rhône*'s unconventional colourfulness. From the asylum, however, he was less assured: even as he suggested that Theo submit it to the Salon des Indépendants, Vincent allowed that *Starry Night on the Rhône* 'might give someone else the idea of doing night effects better than I did'.

164
Olive Trees,
1889.
Oil on canvas;
72.5 x 92 cm,
28¼ x 36¼ in.
Museum of
Modern Art,
New York

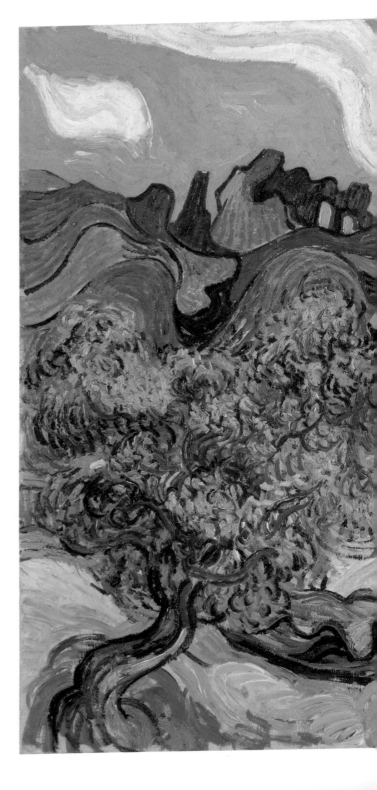

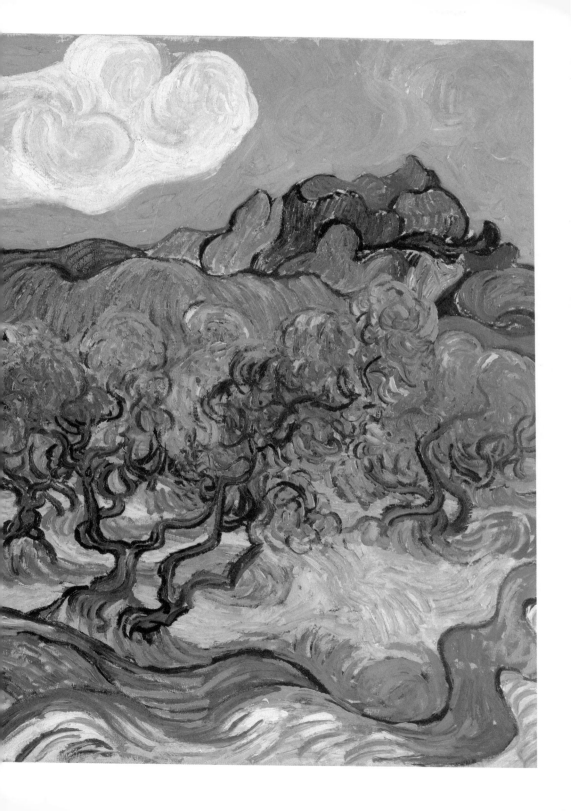

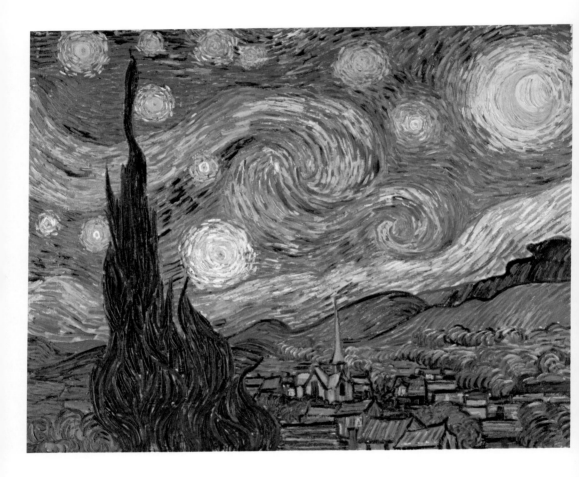

165
Starry Night,
1889.
Oil on canvas;
73 x 92 cm,
28¾ x 36¼ in.
Museum of
Modern Art,
New York

Shortly thereafter, he sought to outdo himself. At Saint-Rémy, his view of the night sky was unimpeded by buildings, its starlight virtually uncorrupted by gas illumination. Though he may have been frustrated by asylum rules that prevented him from painting outdoors after dark (something he enjoyed immensely), this situation actually liberated Van Gogh. The 'night effect' that he was obliged to paint from memory is extravagantly animate and lushly hued, the sky's energetic unfurling dominating the picture in a way the luminous heavens of *Starry Night on the Rhône* do not. His longtime wish to free up his imagination – a faculty that 'can lead us to the creation of a more exalting and consoling nature' – found outlet in *Starry Night*, though Van Gogh was less impressed with the result than subsequent viewers have been.

Ironically, the painting his modern audience most readily associates with him is atypical of Van Gogh's *oeuvre*, and one he accorded scant mention in his letters. One of few landscapes he composed in the studio, *Starry Night* is an amalgam of previously observed and painted motifs, pieced together and aggrandized. Its brilliant, windblown sky, oddly shaped mountains, and bushy cypress reflect the artist's Provençal experience, while the spindly steeple at the village centre is that of a Dutch church, inserted in the same spirit of retrieval that sparked *Memory of the Garden at Etten* (see 153). The orange moon is the sort of fat crescent Van Gogh favoured, its points coming almost full circle and its corona – like those of the stars – fantastically large, colourful, palpable.

In the context of Van Gogh's belief in the night sky's promise of life beyond 'this thankless planet', the celestial spectacle that comprises two-thirds of *Starry Night* may be seen to reflect dreams of enhanced existence on a star made accessible by death. The small, mostly dark village indicates earthly life's relative marginality within a grander scheme – and the limited enlightenment available to those caught up in it. In this respect, Van Gogh's vision compares to Caspar David Friedrich's Romantic evocations of miniscule mortals' inability to see beyond the fog of the mundane (see 52). Whereas Friedrich's ruined cathedrals

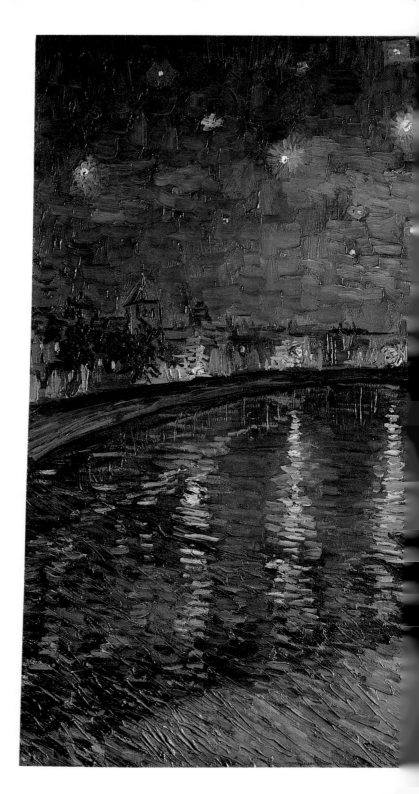

166
*Starry Night
on the Rhône*,
1888.
Oil on canvas;
72·5 x 92 cm,
28½ x 36¼ in.
Musée d'Orsay,
Paris

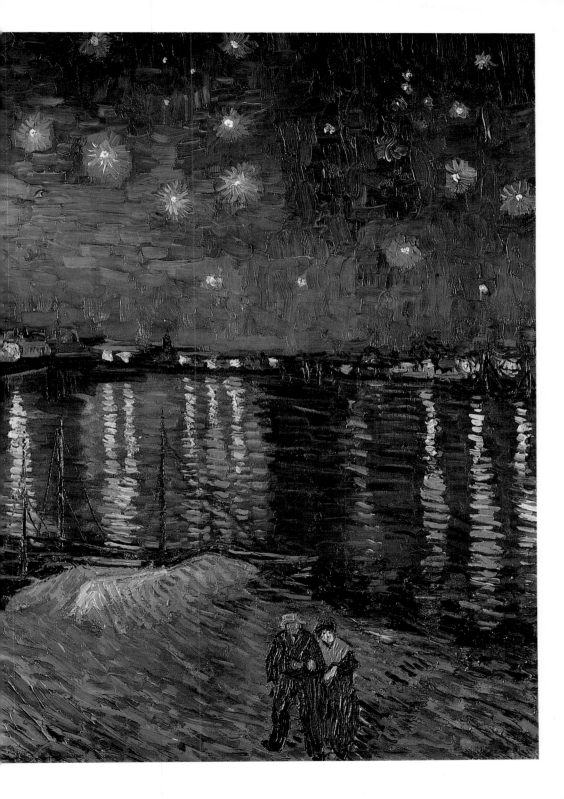

bespeak the paltriness of human constructs in the face of God and self-renewing nature, the church in *Starry Night*, intact and upward-straining, may represent human attempts to touch the beyond through religious practice. The year before Van Gogh remarked that his own 'terrible need' of religion made him 'go outside at night to paint the stars'. The flamelike cypress, which extends well beyond the horizon, may represent the more effective means of accessing the 'other hemisphere of life'. Cypresses are fixtures of Mediterranean cemeteries, traditionally associated with mourning (by virtue of their darkness) and immortality (since they are aromatic evergreens). Van Gogh, who noted that cypresses were 'always occupying my thoughts' at Saint-Rémy, considered them 'funereal', and probably intended the prominent specimen in *Starry Night* to emblematize death, the trainlike transport 'one takes ... to reach a star', knowing 'we cannot get to a star while we're alive'.

Like *The Reaper, Starry Night* manifests Van Gogh's attempts to come to terms with his mortality, a topic thrown into high relief by his illness. The sunlit picture personifies death as an 'almost smiling' labourer, intent on his job, and the moonlit one posits life beyond the dim and circumscribed earthly realm, in a limitless beyond that pulsates with energy and illumination.

Remarkably productive in his first months at Saint-Paul-de-Mausole, Van Gogh believed that 'work will preserve me to some extent' from the 'extreme enervation' that crippled fellow patients. Pointing to his regular habits and sobriety, the painter felt that 'with the number of precautions I'm taking now, I'm not likely to relapse'. The severe attack he suffered in July was therefore deeply demoralizing – an indication that work and clean living would not prevent the episodes he dreaded. Their underlying causes remain undetermined. Peyron suspected epilepsy, and posthumous diagnosis continues (bipolar disorder aggravated by substance abuse is one of the more plausible theories). Emotional overload clearly triggered the debilitating attacks that left Van Gogh incapacitated for weeks at a time – in the ten days before his

July breakdown, for instance, Vincent had learned Theo's wife was pregnant, and revisited Arles for the first time.

His recurrent dementia was treated with isolation and imposed rest that left Van Gogh pining for picture-making. Fears that a 'violent attack may forever destroy my power to paint' made him work 'like one possessed' during periods of lucidity, like 'a miner who is always in danger and makes haste in what he does'. When he felt well, painting, 'can go on as usual and is even my cure', a distraction that 'drives away … abnormal ideas'. A self-portrait made in the asylum affirms his determination to press on: putting best ear forward, and regarding himself with steady gaze, the painter appears an island of stoic calm amid unsettled and unsettling surroundings (167). The picture's tonal harmonies and interlocking strokes testify to Van Gogh's quest for simplicity, sobriety and serenity – especially when compared to the contrasting colours and marks that animate *Self-Portrait with Bandaged Ear* (see 151).

Reluctance to associate with fellow patients made him his own best model at Saint-Paul-de-Mausole. The robust-looking man he painted in an outdoor setting is perhaps an asylum gardener or local farmer (168), and in September Van Gogh mentioned painting sessions with Saint-Paul's chief orderly and his 'faded' wife, a woman as undramatic as 'a dusty blade of grass by the roadside'. Having thus exhausted his supply of ready models, he returned to his own countenance, and – desperate for further figuration – also took up oil renderings of black-and-white prints.

Copying well-known works was a time-honoured student practice, but few painters continued, in maturity, to make copies of other artists' pictures. At Saint-Rémy Van Gogh asked himself why that must be so: 'We painters are always asked to compose ourselves … but it isn't like that in music … [where] the *interpretation* of a composer is something.' After making an oil version of C F Nanteuil's lithograph after a *Pietà* by Delacroix (169), he compared himself to a musician who plays previously composed music rather than writing it himself ('my brush … like a bow on a violin'), and

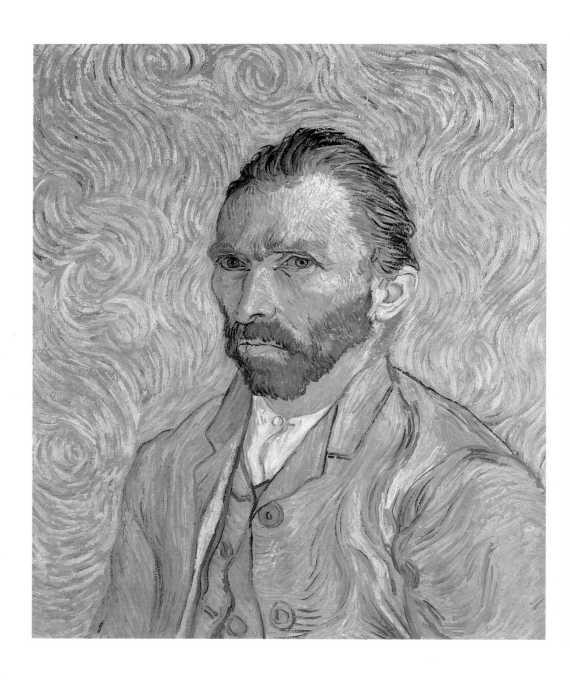

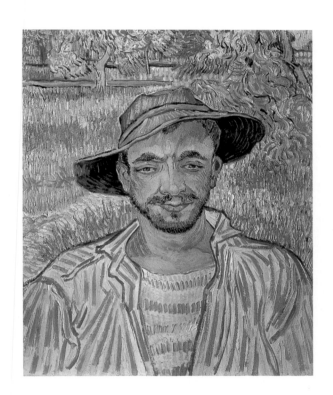

167
Self-Portrait,
1889–90.
Oil on canvas;
65 x 54 cm,
25½ x 21¼ in.
Musée d'Orsay,
Paris

168
Man in Stripes,
1889.
Oil on canvas;
61 x 50 cm,
24 x 19¼ in.
Peggy
Guggenheim
Collection,
Venice

observed that an instrumentalist who performs Beethoven is not
disparaged as imitative but rather may be credited for putting a
personal slant on an existing piece. In the painter's case, the most
inventive dimension of interpretation resides, according to Van
Gogh, in colourization. In describing his *Pietà*, he remarked that the
Virgin's forlorn aspect was as much indebted to her 'greyish-white
countenance' as her 'lost, vague look of a person exhausted by anxiety
and weeping'. Both her colouring and expression reminded Van Gogh
of the Goncourts' pitiful Germinie Lacerteux, whom he considered

169
*Pietà, after
Delacroix*,
1889.
Oil on canvas;
73 x 60·5 cm,
28¾ x 23¾ in.
Van Gogh
Museum,
Amsterdam
(Vincent
van Gogh
Foundation)

170
Paul Gauguin,
*Christ in the
Garden of Olives*,
1889.
Oil on canvas;
73·6 x 91·4 cm,
29 x 36 in.
Norton
Museum of Art,
West Palm
Beach, Florida

the epitome of despair and who would 'obviously not ... be Germinie
Lacerteux without her colour'.

He felt that 'letting black-and-white prints by Millet and Delacroix
pose for me' was not only acceptable in light of his infirmity and
isolation but also instructive. The creative copy work Van Gogh called
'translation' 'teaches me things', he wrote, and it substituted to
some extent for regular discourse with living colleagues. In copying
J A Lavieille's wood engravings after Millet's *Labours of the Fields*

Van Gogh retraced familiar terrain, but the Delacroix-inspired work he did at the asylum added new material to his repertoire. He generally shunned overtly religious subjects, preferring veiled references to the sanctity he saw in mundane motifs (in the manner of the parables and Millet). His attempts to paint 'Christ in the Garden of Olives' while living in Arles, however, indicate a wish to give explicit form to the Saviour's suffering, and his Delacroix-based *Pietà* provided a receptacle for unresolved longing. In illness, Van Gogh found 'religious thoughts' solacing, and the image of a concerned mother

(whom he called 'Mater Dolorosa') fussing over her battered adult son surely resonated with him. The strength of his identification with the martyred Christ accounts for that figure's Van Gogh-like red hair. The bereft Madonna bears no resemblance to his mother, yet called up vanished boyhood, since a Goupil print of Delaroche's *Mater Dolorosa* (see 4) 'was always hanging in father's study in Zundert' (a room Van Gogh imaginatively revisited during his first breakdown).

The conceptual similarity between Van Gogh's self-projection into the *Pietà* and Gauguin's nearly contemporaneous treatment of *Christ in the Garden of Olives* (170) is uncanny. The two artists had been incommunicado since Gauguin's departure from Arles, and Van Gogh had no knowledge of Gauguin's picture, in which Gauguin, too, gives Christ his own features, until weeks after his own was made. Once Van Gogh received a description and drawing of it, and a photo of Bernard's treatment of the same subject, he became strangely infuriated, fuming to Theo, 'With me there's no question of doing anything from the Bible'. ('Translations' of others' biblical pictures apparently did not count.) Disparaging his friends' *'Christs in the Garden with nothing really observed'*, Vincent described his own intention to paint olive trees, explaining that, when 'Delacroix did a "Gethsemane", he went to see firsthand what an olive grove was'. With their crotchety limbs, sombre grey leaves and biblical link to Christ's betrayal (he was on the Mount of Olives when arrested), olive trees were allied in Van Gogh's mind to earthly woes, a concept he planned to convey allusively, since 'one can give an impression of anguish without aiming straight at the historic Garden of Gethsemane'. Warning against literal depictions of biblical subjects, Van Gogh advocated the sort of suggestiveness Millet often achieved, and felt his colleagues should 'make up for' their biblical works' 'failure' by 'painting your garden just as it is'.

That was what he was doing. In the absence of models, Van Gogh looked to 'sprouting wheat, an olive grove, a cypress', and painted the asylum garden in its autumnal mode (171), 'soil scorched by the sun' and covered with fallen pine needles:

Now the nearest tree is an enormous trunk, struck by lightning and sawed off. But one branch shoots up very high and lets fall an avalanche of dark green needles. This sombre giant – like a defeated proud man – contrasts, when considered as a living creature, with the pale smile of the last rose ... You will realize that this combination of red-ochre, green gloomed by grey, black streaks around the edges, produces something of [a] sensation of anguish ... Moreover, the motif of the great, lightning-struck tree, the sickly green-pink smile of autumn's last flower, serve to confirm this impression.

Long intent on mastering 'the language of nature', and making its 'sentiment … intelligible to others', Van Gogh routinely relied on natural forms' potential to signify metaphorically. As early as 1882, he discerned equivalence to the corporeal expressiveness of *Sorrow* (see 32) in the non-human motif of *Roots* (see 33). *Asylum Garden* represents a continuation and advancement of that project. Inspired by contact with the French avant-garde, Van Gogh updated and personalized the established lexicon of empathetic nature in Provence, allying it to a formal language of exaggerated and expressive line and hue.

171
Asylum Garden,
1889.
Oil on canvas;
73·5 x 92 cm,
29 x 36¼ in.
Museum
Folkwang, Essen

Nevertheless, natural vistas did not assuage the painter's appetite for figuration. In the winter of 1889–90 (during which he suffered breakdowns at Christmas, in January and again in February) and into the spring, Van Gogh continued to make oil translations of black-and-white prints (branching out to paintings based on Daumier, Doré and others). Still, his inability to make portraits, a genre he considered 'better and more serious than the rest of my work', rankled. In February his frustrating lack of flesh-and-blood subjects, along with his desire for collegial interaction, led him to embark on a collaborative portrait project with Gauguin – albeit

unbeknownst to his former housemate – taking up their once-shared model, Marie Ginoux.

It was Gauguin, apparently, who had induced Ginoux to sit for her portrait at the Yellow House in November 1888. He made a drawing of her on the spot (172), Van Gogh an oil study (see 142), and both men later made *tableaux* based on their *études*. While Van Gogh recast Ginoux as a woman of literary leanings (see 129), Gauguin portrayed her much as he routinely saw her: in her husband's place of business, surrounded by its *habitués* (173).

Gauguin's painting went with him when he fled Arles, but the drawing, left behind, ended up in Saint-Rémy, where it became the basis for yet another painting of *The Arlésienne* (174). Van Gogh again portrayed Ginoux as a kindred spirit; by a coincidence the artist considered remarkable, Ginoux 'was taken ill at the same time as myself' – Christmas 1888 – and fared poorly thereafter. When he visited her in Arles in January 1890, Van Gogh found Ginoux much changed by menopausal 'nervous attacks', noting that he and she 'suffered together'. His perception of their bond strengthened after his collapse a few days later, and once he was clear-headed again, Van Gogh decided to paint 'our dear patient', taking Gauguin's drawing as his model. A relic of happier times, that rendering recalled the one who posed as well as the one who made it, and the period of relative health in which Van Gogh enjoyed their company. 'Like furniture one knows', he observed, portraits 'remind us of things long gone'. The likeness Van Gogh based on his friend's drawing was 'a synthesis', he later told Gauguin, 'belonging to you and me as a summary of our months of work together'.

Gauguin's input is most evident in the figure's sinuous silhouette and rounded volumes, which counter the sharp, flat shapes of the earlier *Arlésienne* with books (see 129). While Van Gogh claimed to be faithful to the style of Gauguin's drawing (which suited his own proclivities at Saint-Rémy), he took the predictable 'liberty of colouristic interpretation' to emphasize their former sitter's diminished state. He considered sensitive colourism the most important component of his adaptations of other artists' work, as well as the most evocative aspect of his portraiture.

I'd like to make portraits which would appear to people living a century from now as apparitions ... I do not endeavour to achieve this by a photographic resemblance, but by ... using our knowledge of and modern taste for colour as a means of arriving at the expression and intensification of character.

In his Saint-Rémy portrait, Van Gogh made Ginoux's complexion 'drab and lustreless', overlaid her dark hair and costume with 'dull, dirty white', and surrounded her with the greyed hues he associated with sobriety, illness and decline – including the 'sickly green-pink' of autumn's last flower. (The pink Van Gogh used at Saint-Rémy has faded considerably, however, and was not so anaemic then as it appears today.)

The changes in Ginoux – and himself – that Van Gogh conveyed by 'the abstract means of colour', are also signalled by her portrait's props. Like the books of the earlier *Arlésienne*, those of the Saint-Rémy *Arlésienne* were his, not hers. But while the unidentified volumes of the earlier painting represent recent fiction in bright paper bindings, the books displayed in 1890 are older works. Closed and clearly titled, they are French editions of Dickens's *Christmas Stories* and Beecher Stowe's *Uncle Tom's Cabin* – mid-century publications that Van Gogh read in younger years and returned to in crisis. He took up Dickens's feel-good holiday tales regularly at Zundert, and read *Uncle Tom's Cabin* while living in the Borinage (see Chapter 1). While hospitalized in Arles, he hoped to put 'a few sound ideas into my head' by rereading *Uncle Tom's Cabin* 'for the very reason that it is a book written by a woman, written, as she tells us, while she was making soup for the children, and after that, also with extreme attention, Charles Dickens's *Christmas Stories*'.

His resurgence of interest in both books stemmed from the nostalgia for boyhood and yearning for maternal ministrations his illness brought on. Old-fashioned and sentimental, they contribute to the grandmotherly aura of the Saint-Rémy *Arlésienne*, where their 'sound ideas' seem proffered to those who, like Van Gogh's ailing model, hope to endure unsoundness cheerfully.

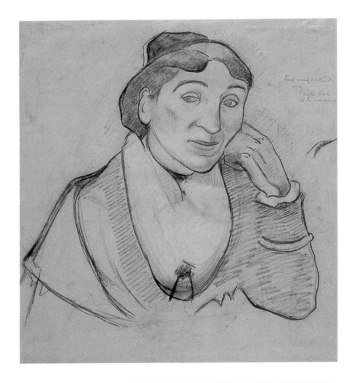

172
Paul Gauguin,
*Madame Ginoux
(study for The
Night Café)*,
1888.
White and
coloured chalks;
56·1 x 49·2 cm,
22 x 19¼ in.
Fine Arts
Museums of
San Francisco

173
Paul Gauguin,
The Night Café,
1888.
Oil on jute;
72 x 92 cm,
28¾ x 36¼ in.
Pushkin State
Museum of Fine
Arts, Moscow

174
*The Arlésienne
(Marie Ginoux)*,
1890.
Oil on canvas;
65 x 54 cm,
25½ x 21¼ in.
Museu de Arte de
São Paulo Assis
Châteaubriand

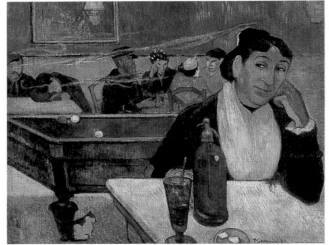

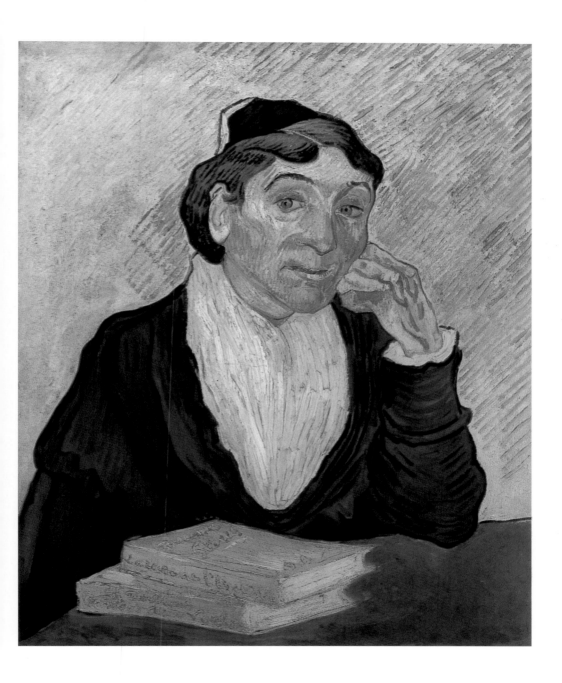

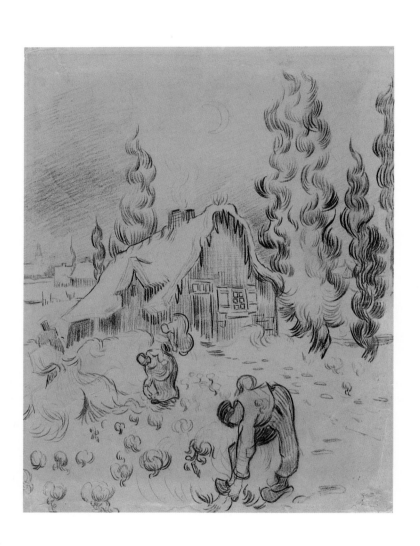

Like *La Berceuse,* the *Arlésienne* Van Gogh made in 1890 exists in several versions; Van Gogh made four copies after the original within three weeks. The two series were surely as firmly linked in his mind as the women who inspired them, loyal friends who proved kind and gentle when he was sick. 'You get very fond', Vincent told Theo, 'of people who've seen you ill.' In late February he made his last ever trip to Arles, eager to give Mme Ginoux a copy of the new portrait. He collapsed before delivering it, however, and had to be retrieved by orderlies from Saint-Paul. He spent the next two months isolated and unwell – his longest 'episode' yet – but tried to work, making drawings and a few small paintings from memory. As usual, his illness induced thoughts of faraway times and places; most of the pictures from March and April recall Brabant fields, farmhands and moss-roofed houses. Van Gogh labelled them 'reminiscences of the north', though southern motifs crept into a few (one thatched cottage is flanked by cypresses; 175).

175
Reminiscence of the North: Diggers before a Cottage with Cypresses, 1890. Pencil; 31·5 x 23·5 cm, 12½ x 9¼ in. Van Gogh Museum, Amsterdam (Vincent van Gogh Foundation)

When his head cleared, in late April, the artist felt drained but determined, as his poignantly personalized variant on Rembrandt's *Raising of Lazarus* suggests (176). Theo had recently sent a reproduction of Rembrandt's etching – hoping to buoy his brother's spirits with a favourite artist's image of miraculous revivification (177) – and as Vincent himself struggled to revive, he made a sunlit *Lazarus* based on a corner of Rembrandt's. Its clear, light palette finds no counterpart in Rembrandt's *oeuvre*. More signifiant, however, is Van Gogh's focus on a mere fragment of Rembrandt's print. Eliminating its commanding Christ figure and several onlookers, Van Gogh homed in on the prone man and his sisters, Martha and Mary. This radical pruning changed the scene's tenor from a celebration of supernatural power to a meditation on human frailty. The Lazarus of Van Gogh's translation, a shrouded self-portrait, seems left to his own devices by the powers that be. Rising effortfully by dint of his own will, he is exhorted by caring kinswomen modelled on Augustine Roulin (centre) and Marie Ginoux (right), 'middle-class women of the present day' in whom he saw holiness. The painting's figures, Vincent told Theo, were 'the characters of my dreams' – an indication of the wishfulness with

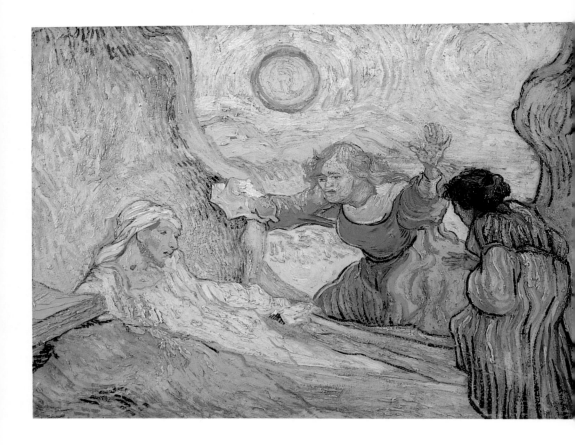

176
*Lazarus, Martha,
and Mary, after
Rembrandt's Raising
of Lazarus,*
1890.
Oil on paper,
mounted on
canvas;
48·5 x 63 cm,
19 x 24¾ in.
Van Gogh Museum,
Amsterdam
(Vincent van Gogh
Foundation)

177
After Rembrandt
van Rijn,
*The Raising
of Lazarus*,
1632.
Etching;
36·5 x 25·7 cm,
14⅜ x 10⅛ in

which he hankered for both reinvigoration and reunion with concerned friends and siblings.

Up and about in May, but 'sadder and more wretched than I can say', Van Gogh vowed to leave Saint-Paul-de-Mausole, convinced he had deteriorated in consequence of his year-long stay. He had also decided to leave Provence for more familiar and familial terrain. 'Without you', he told Theo, 'I'd be very unhappy', and he had yet to meet his brother's wife and baby son, Vincent Willem (born 31 January). Much as he loved it, Van Gogh suspected that Provence had a truly maddening effect on him, 'though it would be ungrateful on my part to curse the south, and I confess I leave it with great grief'.

Although well enough to work outside, he often remained indoors in his last days at Saint-Paul. When he painted roses and irises from the asylum garden, they were cut stems brought inside. Vivid enough still lifes, these floral arrangements seem staid by comparison to the *Irises* painted the year before (see 161), – or the *Almond Blossoms* Van Gogh made for his newborn namesake nephew in mid-February, when he tackled Provence's earliest blooms *au naturel* (178). After patiently detailing the almond branches' every knot and bloom, he built a dazzling sky of thick blue slabs that lighten towards the centre, as if an azure vault were opening out behind the trees. Emblems of renewal and continuance, multitudinous wind-stirred white petals bespeak the vitality, freshness and fragility of infancy. Like *Irises, Almond Blossoms* represents a small piece of a larger, living whole, uncontained.

As he prepared to depart, Van Gogh also painted two landscapes. They, too, are studio pictures – in this case, imaginative 'abstractions' that draw on fond memories rather than direct observation. Wary of painting from his mind's eye, Van Gogh felt that giving free rein to imagination was a risky business, since 'one soon finds oneself up against a wall'. But in May 1890, walled in by his own mental state, he probably felt he had little to lose, and gave himself over to fanciful figuration in two moonlit scenes. One shows the red-bearded artist in blue workman's clothes strolling with a reinvigorated Marie Ginoux (179). Like the olive

178
Almond Blossoms,
1890.
Oil on canvas;
73 x 92 cm,
28¾ x 36¼ in.
Van Gogh Museum,
Amsterdam
(Vincent van Gogh
Foundation)

179
*Evening
Promenade*,
1890.
Oil on canvas;
49.5 x 45.5 cm,
19½ x 18 in.
Museu de Arte
de São Paulo
Assis
Châteaubriand

trees around them, the figures hold their ground in rugged terrain,
their movements dancelike. Funereal cypresses hover – but at
a distance – and the sickly grey-green of the slippery slope is
countered by vibrant hues. A wistful envisioning, *Evening Promenade*
portrays Provence as Van Gogh would have it: a natural paradise
in which he felt the infinite, forged fast friendships, and turned in
many a good day's work.

On 16 May Dr Peyron wrote his last remarks on the painter. The
patient had suffered several attacks at Saint-Paul, during which he
was 'subject to frightful terrors' and tried to poison himself with
paint and purloined kerosene, but was otherwise 'perfectly quiet
and devoted ... to his painting'. In summary, Peyron pronounced him
cured. Van Gogh, for his part, bid adieu to Provence, where he had
more than once 'let myself go reaching for stars that are too big',
and boarded a northbound train.

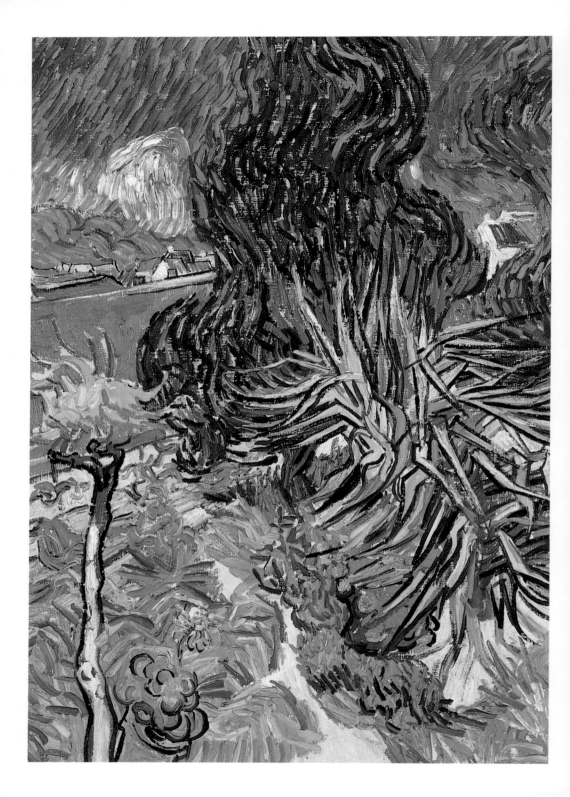

After arriving in Paris on a Saturday morning, Van Gogh spent
a long weekend catching up with his brother's family and
re-examining his work. Some canvases – *The Potato Eaters,
The Harvest, Starry Night on the Rhône, Almond Blossoms* – hung
at Theo's, where many more were heaped under the bed and sofa,
and a number were stored at Tanguy's, where the Van Goghs went
to see them. They also visited an exhibition of recent painting at
the Champ de Mars, where Vincent was impressed by Pierre Puvis
de Chavannes's (1824–98) preliminary version of his just-
completed mural *Inter Artes et Naturam* (*Between Art and Nature*).
Van Gogh found Puvis's modern-dress meditation on artistic
inspiration a 'strange and happy meeting of very distant antiquity
and raw modernity' (181).

By Tuesday he was off again, having arranged to settle north
of Paris, in Auvers, a small town on the Oise river. Some 32 km
(20 miles) from the city, Auvers-sur-Oise was a short train ride
away in 1890 – but 'far enough', according to Van Gogh, 'to be
the real country'. Thatched cottages sat amid vineyards, market
gardens, wheat and alfalfa fields (182), while modern villas
accommodated seasonal visitors. Van Gogh found the spectacle of
this 'new society developing in the old ... not at all unpleasant',
and was reminded of the air of tranquillity he had noted in Puvis's
picture, particularly the 'happy meeting' of nature and artifice,
old and new.

The town and its environs had drawn many painters since their
'discovery' by Daubigny, who in 1861 built the Auvers home and
studio that he used until his death in 1878. Daumier, Corot,
Cézanne and Pissarro were among the best-known artists to follow
Daubigny, and it was Pissarro who steered Theo towards Auvers
when he asked advice on his brother's relocation. This advice was

180
*Dr Gachet's
Garden*,
1890.
Oil on canvas;
73 x 51·5 cm,
28¾ x 20¼ in.
Musée d'Orsay,
Paris

based not only on the town's rusticity and proximity to Paris
but also on the presence there of a congenial physician, Paul Gachet
(see 186). This sometime artist looked after various members of
the Impressionist circle, collected their work, and encouraged the
printmakers among them to use his etching press. In his medical
practice, Gachet was particularly involved in homoeopathy and in
the treatment of mental malaise (his 1858 thesis was 'A Study of
Melancholy'). Having met Gachet in advance, Theo gave his brother
a letter of introduction to present at the commodious country home
to which the doctor (who still did regular consultations in Paris)
had moved his family almost twenty years before.

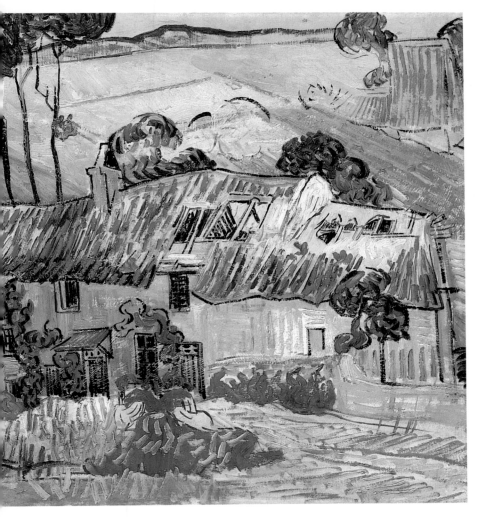

181
**Pierre Puvis
de Chavannes**,
study for *Inter
Artes et Naturam*,
1890.
Oil on canvas;
64·3 x 170·1 cm,
25¼ x 67 in.
National Gallery
of Canada,
Ottawa

182
*Thatched
Cottages, Auvers*,
1890.
Oil on canvas;
50 x 100 cm,
19¼ x 39½ in.
Tate, London

After his own meeting with Gachet, Vincent told Theo that he was dubious about the doctor's potential usefulness in a crisis, since 'he seems to me as ill and distraught as you or I'. Theo had remarked upon Gachet's physical resemblance to Vincent, and the painter now concurred, adding that the older man was 'something like another brother, so much do we resemble each other physically and mentally'. Despite his scepticism about Gachet's ability to keep him sane (Van Gogh cited the parable of 'the blind leading the blind', Matthew 15:14), he found him kind and likeable, and the two were soon fast friends, exchanging reflections on art past and present. Van Gogh admired Gachet's collection, and Gachet found the recent work Van Gogh brought with him to Auvers (including his *Self-Portrait, Pietà* and the Saint-Rémy *Arlésienne*; see 167, 169 and 174) immensely compelling. The art-loving physician offered heartening advice: 'He said I must work boldly on and not think at all of what went wrong with me.'

Worried about family finances in the wake of his visit to Theo, Vincent rejected the lodgings Gachet recommended as too expensive and instead took an attic room. His quarters were too cramped for work, but in good weather Van Gogh spent most days painting in Auvers's fields and byways, and even posed models outdoors (183). He had a standing invitation to work at Gachet's house, which was full of '*very* fine' pictures, dark furniture and knick-knacks that furnished still life motifs. Gachet's garden, seen from above in a view made in May, held a seemingly riotous mélange of what Van Gogh described as 'southern plants' (see 180). They include a spindly foreground tree that looks sickly and vulnerable opposite the bristling vitality of an aloe, whose sharp projectiles combine with a writhing cypress, tilted ground plane and dark, agitated sky to create an atmosphere of overwhelming unease. The painting seethes with the sorts of linear and colouristic contrasts that Van Gogh suppressed at Saint-Rémy. His exasperation with his confinement there perhaps informs this charged treatment of a walled enclosure, and probably contributed, too, to Van Gogh's fascination with local vistas he found 'boundless as the sea'.

At Auvers, he took to painting on canvases twice as long as they are high (some 50 x 100 cm; 20 x 40 in), and made about a dozen pictures in this friezelike, double-square format (see 182, 184, 189, 190 and 191). The shape was one Van Gogh associated with decorative suites and had used, for example, when designing the panels for Hermans's Eindhoven dining room (see 53). In Paris, he had considered grouping horizontal cityscapes (and made several urban views that are almost double squares), but never followed

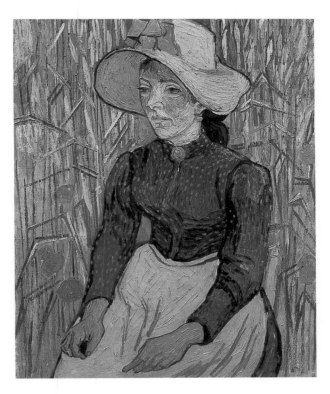

183
Woman in the Wheat, 1890.
Oil on canvas; 92 x 73 cm, 36¹⁄ x 28³⁄ in.
Bellagio Gallery of Fine Art, Las Vegas

that plan through, and more or less abandoned the long horizontal format during his Provençal sojourn. His concerted return to it in mid-1890 was surely linked to his contemporaneous enthusiasm for Puvis, as well as by the sense of expanded horizons his release from Saint-Paul occasioned. Most of the double-square pictures from Auvers are landscapes, and some of them are as disconcertingly still as *Dr Gachet's Garden* is agitated, suggesting the artist's self-described 'mood of almost excessive calmness' (184).

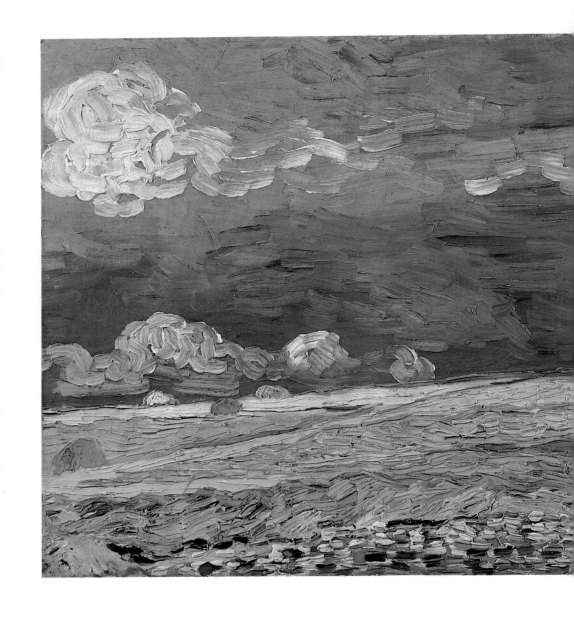

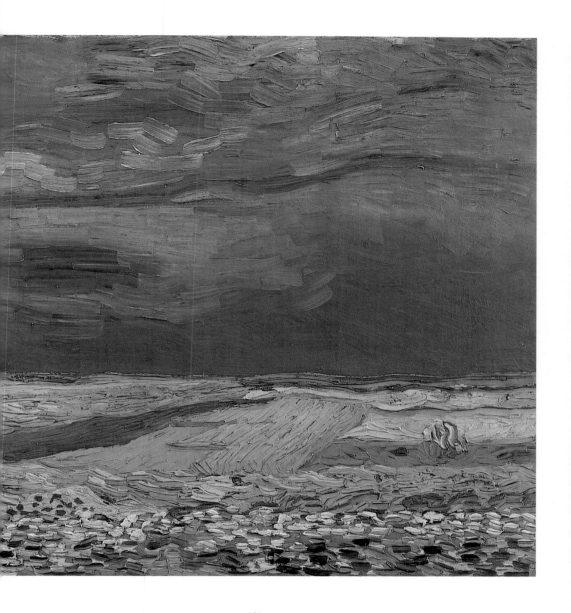

184
*Wheat Field under
Clouded Sky*, 1890.
Oil on canvas;
50 x 100 cm,
19¹⁄₄ x 39¹⁄₂ in.
Van Gogh Museum,
Amsterdam
(Vincent van Gogh
Foundation)

Convinced that his illness was 'mostly a disease of the South', that might dissipate now that he had left Provence, Van Gogh claimed his mental restlessness had quieted in what he described to his mother as 'the surroundings of the old days'. Though Auvers was not specifically part of his past, 'reminiscences of the north' sometimes coloured his perceptions of it. In a letter to Wil he described his painting of the town's Gothic church (185) as 'nearly the same thing as the studies I did in Nuenen of the old tower and cemetery, only now the colour is probably more expressive, more sumptuous' (see 51).

Meantime, his missives to his city-dwelling relations stressed the healthfulness of country life. Convinced that his brother and sister-in-law would benefit from Auvers's air and sunshine, and that his nephew should grow up in the country, as he and Theo had, the artist made paintings designed to show the beauties of rustic living: luxuriant landscapes and images of their robust inhabitants (see 183).

Van Gogh's productivity at Auvers is often remarked. In the nine weeks he spent in Auvers (mid-May to late July) he made more than a hundred finished works (some thirty drawings and over seventy paintings). Jan Hulsker considers that level of activity unlikely, and speculates that some of the pictures now attributed to Van Gogh at Auvers may be fakes. The artist's firmly documented output from this era, however, is amazingly large. Acting on Gachet's suggestion that work would keep him 'balanced', Van Gogh rose at five to paint all day, and turned in at nine to be fresh for the next onslaught. As at Saint-Rémy, he saw himself in a race against time, since 'I hardly dare count on always being in good health'.

He was eager to establish himself as a portraitist, since – as he wrote from Auvers – 'what impassions me most, much, much more than all the rest of my work, is the portrait, the modern portrait'. Encouraged by Gachet's enthusiasm for his figural work from Saint-Rémy, Van Gogh hoped the doctor would 'lend a hand in getting me models'. In the meantime, he painted his new friend in an ambitious likeness that took the *Self-Portrait* (see 167) and the Saint-Rémy *Arlésienne* (see 174) as points of departure, but emerged a more complex rendering than either (186).

185
The Church at Auvers, 1890. Oil on canvas; 94 x 74 cm, 37 x 29½ in. Musée d'Orsay, Paris

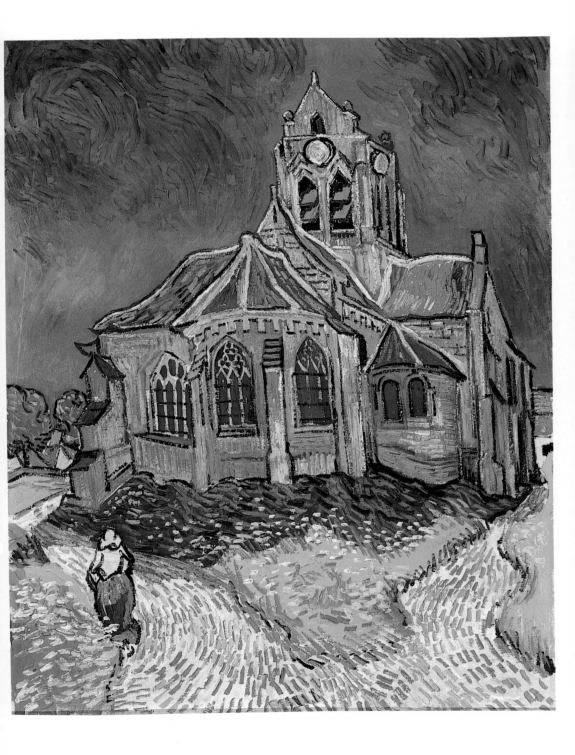

186
Portrait of
Dr Gachet,
1890.
Oil on canvas;
66 x 57 cm,
26 x 22½ in.
Private collection

187
Albrecht Dürer,
Melancholia I,
1514.
Engraving;
24 x 19 cm,
9½ x 7½ in

188
Pierre Puvis
de Chavannes,
Portrait of
Eugène Benon,
1882.
Oil on canvas;
60·5 x 54·5 cm,
23¾ x 21½ in.
Private collection

Like the *Self-Portrait*, the doctor's likeness is predominantly blue, though its tones are richer and more varied. Having presented himself as an island of steadfastness in a sea of swirling strokes, Van Gogh painted Gachet slumped but steadily moored to a table, against a wavy backdrop of stylized sky and hills, aquiver with parallel dashes. The downheartedness and disequilibrium implied by colour and line reinforce more specific markers of the doctor's despondency: his slouching posture, with head supported by balled fist, is one conventionally associated with the melancholy (187) that his drooping features, furrowed brow and vacant stare suggest.

Van Gogh mentally linked Gachet with Ginoux – both fellow sufferers – and though they never met, the two are forever coupled by the portraits he made of them in 1890. While its air of dejection separates Gachet's portrait from both *Self-Portrait* and the Saint-Rémy *Arlésienne*, it resembles the latter so closely in size, composition and background texture as to function as its pendant. The differences between the two portraits (which the artist began to consider companion pieces as he worked on Gachet's) may be attributed to gender stereotypes and to Van Gogh's shifting attitude towards his own illness, as well as to his sitters' personalities. Whereas Gachet poses

the 'broken man' Van Gogh sometimes felt himself to be, Ginoux exudes the good cheer he worked to summon. While her portrait's palette and 'lustreless' finish indicate illness, Ginoux sits erect (her head-on-hand pose more coquettish than melancholic), wearing what Van Gogh once called 'her habitual smile'. Yet if artist and model literally put a good face on trying circumstance, Van Gogh's remark that Gachet understood Ginoux's portrait 'exactly' as it was hints that the doctor (perhaps with the artist's prompting) discerned the malaise beneath her mask.

Gachet's portrait makes no such attempt to soften its model's 'grief-hardened face' (which the artist attributed to long-term depression spurred by Mme Gachet's death in 1875). The doctor's 'heartbroken expression' put Van Gogh in mind, he wrote, of Gauguin's description of *Christ in the Garden of Olives* (see 170). In its pathetic, martyred aspect, Gachet's portrait bears comparison not only to Gauguin's sad Saviour, but to the mourned Christ of Van Gogh's own *Pietà*. Gachet – who had looked at that *Pietà* 'a long time' – told Van Gogh 'that if I wished to give him great pleasure, he'd like me to do [it] over for him'. The painter never complied, but he did bring something of the *Pietà* to the doctor's image, which resembles the Van-Gogh-like Christ in its wilted, S-shaped pose and expression of stoic resignation.

In the main, though, Van Gogh found Gachet's 'heart-rending expression' very much 'of our time', and thought the portrait it inspired was one of those 'modern heads people will go on looking at for a long time to come, and perhaps mourn over after a hundred years'. Clearly, he considered Gachet a nineteenth-century *misérable* in line with those described by the Goncourt brothers in the books at the sitter's elbow: *Germinie Lacerteux* and *Manette Salomon*. Germinie is a lamentable figure Van Gogh equated with misery (and recalled when he painted his *Pietà*); Coriolis de Naz, the protagonist of *Manette Salomon*, is a nervous, sensitive painter with a *japoniste* sensibility (see Chapter 4), who suffers the heartbreak that, according to the Goncourts, 'seems to crown the careers and lives of this century's great painters of modern life'. Married to his model, Manette Salomon, Coriolis finds his ambitions stymied by familial obligations that spell his downfall.

To Van Gogh's mind, yellow books epitomized his era (see Chapter 4), and though the novels in Gachet's portrait were written decades earlier, their inclusion identifies the sitter as a modern man in the mode of those rendered by Ernest Meissonier (1815–91), Albert Besnard (1849–1934) and Puvis. All three had painted contemporary men holding books, in portrayals Van Gogh thought to strike 'the nineteenth-century note'. In December 1889 Van Gogh wrote that Puvis's portrait of Eugène Benon (188), which he (mis)remembered as 'an old man reading a yellow novel and beside him a rose and some watercolour brushes in a glass', was his figural ideal, and it clearly provided another point of reference for Van Gogh's image of Gachet with yellow novels and flowers in a glass. He doubtless aspired, in his new friend's portrait, to communicate something of the sentiment he discerned in Benon's: that modern life was 'something bright, despite its inevitable griefs'.

Convinced that contemporary ills could be offset by the very work they inspired, Van Gogh found his own existence brightened by the consumption and production of 'modern' art: books and pictures that, because they confront grief as well as aspiring to beauty, satisfy 'the need we all feel of being told the truth'. He conceived Gachet's portrait in the spirit of candour he ascribed to naturalist novels of the sort seen there (books that, according to Gachet's son, the doctor neither owned nor read – and props omitted from a second version of the painting, now in the Musée d'Orsay, Paris). The doctor's image lacks the optimistic forbearance suggested by the figure and books of the Saint-Rémy *Arlésienne*, though its foreground flowers impart some hopefulness. The stems displayed are foxglove, a member of the genus *Digitalis* that can be used as a heart stimulant. They betoken Gachet's own brand of illness-inspired art: his medical practice and its homoeopathic dimension. Van Gogh, who imagined that his friend's 'experience as a doctor must keep him balanced enough to combat ... nervous troubles', perhaps intended the medicinal plant to emblematize the physician's capacity to heal himself, though Gachet's doleful air suggests his personal heart-sickness would go untouched by digitalis.

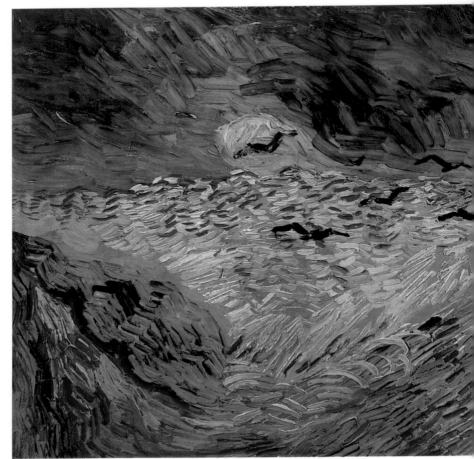

189
*Crows over
Wheat Fields,*
1890.
Oil on canvas;
50·5 x 100·5 cm,
20 x 39½ in.
Van Gogh
Museum,
Amsterdam
(Vincent
van Gogh
Foundation)

**Aware of the almost unpleasant effect of the doctor's 'grimace',
Van Gogh insisted that such harshness was necessary:**

Otherwise one could not grasp the extent to which, in comparison to
the calmness of old portraits, there's expression in our modern heads,
and passion … Knowing what I know now, if I were ten years younger,
how ambitiously I would work at this!

**The mood swings suggested by comparison of Gachet's portrait
with Ginoux's also are suggested by double-square landscapes
Van Gogh made at Auvers. Of uniform dimensions, they vary in
effect – some are disturbingly animated (189), some almost eerily
becalmed (184), others innocuous (182). These panoramic views**

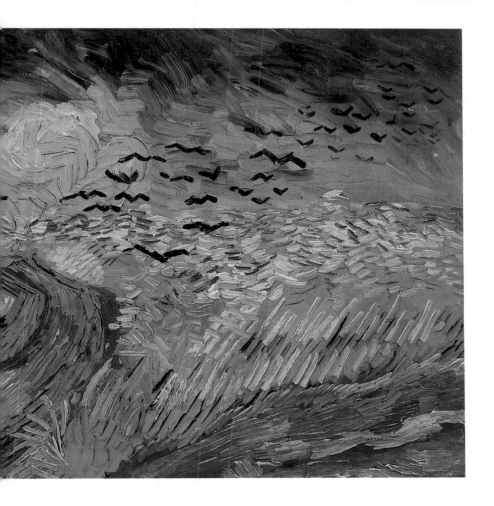

were intended to present characteristic views in the topographic tradition. The suite includes vistas of Daubigny's garden and the tumble-down dwellings for which Auvers was known; scenes of open-air leisure; and images of agrarian productivity. At the same time, these canvases functioned as forums for emotive expression in the manner of *Asylum Garden* (see 171), tapping 'modern sensations common to us all' to convey visually that which 'I cannot say in words'.

In early July, for instance, Van Gogh reported that, when tensions engendered by Theo's financial worries made him feel as if his life were 'threatened at the very root', he picked up his brush and began, with trembling fingers, to paint 'vast fields of wheat under

troubled skies' – a coping strategy that recalls his rueful observation of the previous summer:

What else can we do, when we think about all the things we don't have reasons for, than go out and look at a field of wheat? ... I, who have neither wife nor child, feel the need of seeing the wheat fields ...

As he painted the Auvers plain beneath dark skies, 'I didn't need to go out of my way to express sadness and extreme loneliness'.

The painting that best fits the motifs and emotions Van Gogh describes is a landscape devoid of humans and their dwellings, a stretch of farmland that looks immense in relation to the haystacks that punctuate it (see 184). The artist wrote, however, of painting two 'big canvases' in this vein, and it is generally agreed that the famed *Crows over Wheat Fields* (189) is the other. Often romanticized as Van Gogh's last painting (which it almost certainly was not), *Crows* has been read as a virtual suicide note – its blackening sky and flock of dark birds taken for portents of his imminent death. Though Van Gogh would, in fact, shoot himself in a wheat field at the end of July, he probably had no plan to do so when he painted *Crows*, a vibrantly hued and lushly textured picture. Indeed, the artist felt that, despite their sad and lonely tenor, his vistas of wheat under heavy skies were visually expressive of something he had trouble describing verbally: a sense of 'the health and fortifying forces I see in the country.' Despite *Crows*'s turbulent weather and low-flying birds, the spectacle of a mature crop – a testament to nature's generative capacities as well as human productivity – must have heartened Van Gogh, who perhaps saw a metaphor there for his own 'harvest': the pictures that justified his existence and his allowance.

In light of his comments on *The Reaper* he painted at Saint-Rémy (see 163), one suspects that Van Gogh entertained thoughts of his mortality as he looked on swaying wheat, and *Crows* indeed bears some resemblance, in format and motif, to Van der Maaten's *Funeral Procession through the Fields* (see 5). Van Gogh, however, was disinclined to view death as sad or dark, and it seems unlikely that the painter of *The Reaper* and *Starry Night* (see 163 and 165) would

emblematize his own demise with black birds or sombre skies. 'Death', as Van Gogh saw it, 'goes its way in broad daylight with a sun flooding everything with a light of pure gold.' The double-square canvas he more probably associated with his earthly end is a sun-soaked one in which regular, rhythmic strokes delineate monumental sheaves, vibrant yellows and golds interwoven with pale blue-violet (190). Some two years before, at Arles, he remarked, 'I'm still charmed by the magic of hosts of memories of the past, of a longing for the infinite that the sower, the sheaf symbolize.' Enraptured by the allusive connotations of the rural work cycle, he acknowledged the mutuality of planting and harvest, and took comfort in the glimpses of a grand schema ('the infinite') that nature's cycles afforded. The almost figural sheaves Van Gogh painted in July 1890 recall his earlier observation that humans 'are to a considerable extent like wheat', and their presentation may owe something to the ecstatic vision presented in the Parable of the Sower:

The harvest is the end of time. The reapers are angels ... And then the righteous will shine as brightly as the sun in the kingdom of their father. (Matthew 13:39–43)

It is also probable that Van Gogh related the swooping birds of *Crows over Wheat Fields* (see 189) to the sinister forces that undermine the efforts of the parable's sower ('And it happened that as he sowed, some seed fell along the footpath, and birds came and ate it up', Mark 4:5) – and Millet's (see 20). Thus contextualized, *Crows* would seem to proclaim the defeat of those agents of evil, since birds cannot harm a crop that stands ready to be reaped. That Van Gogh saw the painting as a triumphal image is further suggested by a letter Gauguin wrote to him in early 1890. Well aware of his friend's fascination with sowers, Gauguin compared the modern painter's struggle to that of the agrarian labourer (as Van Gogh sometimes did):

Having prepared the earth, man casts his seed, and by defending himself daily against the chance of bad weather he manages to reap. But we poor artists? Where does the grain we plant go, and when will the harvest come?

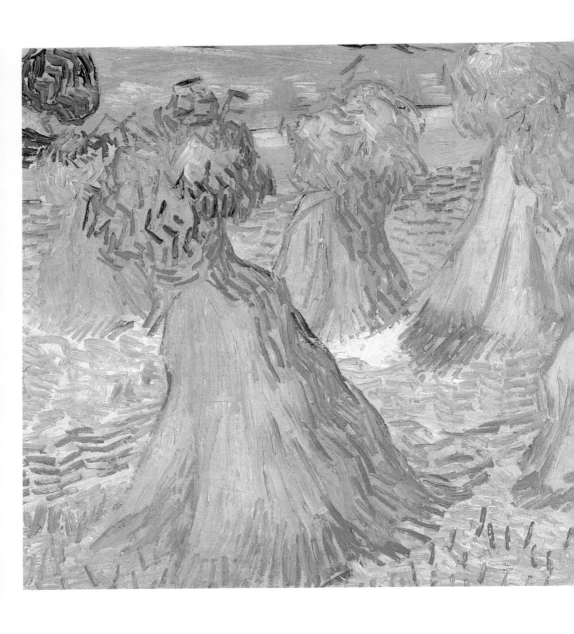

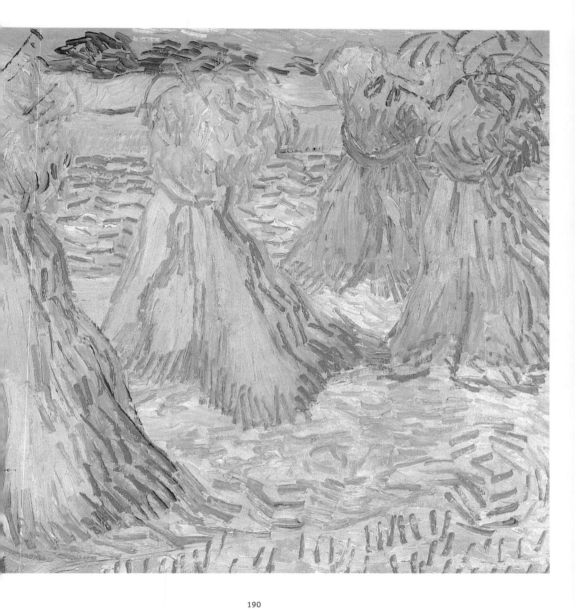

190
*Sheaves of
Wheat,*
1890.
Oil on canvas;
50·5 x 101 cm,
20 x 39¾ in.
Dallas Museum
of Art

Crows may be read as an affirmation that, despite all obstacles, the harvest approaches – an encouraging sight, surely, to one who felt life 'threatened at its very root'.

That verbal reference to uprooting is particularly pertinent to another of Van Gogh's double-square pictures, a tableau of trees that lose their grip on a steep, unstable embankment (191). Gnarled trunks and roots jostle and interlock with clumps of unruly foliage in a strained choreography set against a horizonless, almost impenetrable backdrop. Fragmented and hard to read, the painting's real-world subject matter seems secondary to the formal effects produced by its twisted, attenuated shapes and caustic hues. If the abstract elements of this picture make a kind of 'music',

191
Roots and Tree Trunks,
1890.
Oil on canvas;
50·5 x 100·5 cm,
20 x 39½ in.
Van Gogh
Museum,
Amsterdam
(Vincent
van Gogh
Foundation)

it is a cacophonous din played in a space too shallow to contain it. Rife with intimations of erosion and exposure, it constitutes (perhaps unwittingly) a revisiting of *Roots* (see 33) – a picture in which Van Gogh saw 'compulsive, passionate clinging to the earth' in response to the threat of a storm. Although he never brought himself to abandon the motif completely, Van Gogh came close in *Roots and Tree Trunks*, pushing to the limit the abstract expressiveness that would be his prime contribution to painting's future.

Though it would seem to betray a strained psyche, *Roots and Tree Trunks* does not portend suicide. On the contrary, it bespeaks Van Gogh's wilful 'clinging to the earth'. His suicide – probably not premeditated, and perhaps even half-hearted – is not prefigured in his work.

On Sunday 27 July, towards dusk, the artist shot himself as he stood in a field near town. The ambiguity of his intentions is hinted by the fact that the bullet hit below the heart, lodging in his side. Wounded, he returned to his attic room, where the innkeeper found him groaning. A local doctor was called, and – at Van Gogh's insistence – was soon joined by Gachet. After deciding that the bullet could not be removed, the physicians left the patient – conscious and smoking his pipe – to wait it out. According to Gachet, he remarked that recovery would oblige him to shoot himself all over again.

Since Van Gogh refused to divulge his brother's address, Gachet sent a message to Boussod & Valadon. By the time Theo arrived in Auvers on Monday, Vincent was losing strength. Theo tried to take comfort in recalling the way his brother's strong constitution had pulled him from the brink at Arles, though it seemed to him that this time Vincent was determined to die. Having expressed his wish to 'pass away like this', the 37-year-old painter did so in the first hours of 29 July, his brother beside him.

On Wednesday, local and Parisian friends (including Bernard and Tanguy) gathered at the inn where Van Gogh had lived and died. His easel, painter's stool and brushes were set before his sunflower- and dahlia-bedecked coffin, and the *Pietà* was among the pictures displayed around it. Gachet's brief eulogy was disrupted by his tears, and Theo sobbed non-stop as the coffin was carried through blazing sun to a hilltop cemetery Bernard described as 'overlooking the harvest fields, under a great blue sky'.

In 1891 the writer and critic Octave Mirbeau, remarking on the pomp prompted by the death of academician Ernest Meissonier, observed in *L'Écho de Paris* that a young Dutch painter's virtually unnoticed suicide some months before was an 'infinitely sadder loss for art':

even though the populace has not crowded to a magnificent funeral, and poor Vincent van Gogh, whose demise means the extinction of a beautiful flame of genius, has gone to his death as obscure and neglected as he lived ...

192
Francis Bacon,
Study for a
Portrait of
Vincent van
Gogh, VI, 1957.
Oil on canvas;
198 x 142·2 cm,
78 x 56 in.
Arts Council
Collection,
London

Though Van Gogh's early admirers often painted it thus, this version of his career overlooks certain aspects of the story: his links to the art world, his brother's financial support, his cadre of well-connected proponents, and the growing awareness of his work in the months preceding his death. If he lacked the recognition that accrued to an artist such as Meissonier, the self-taught Dutchman, who painted for less than a decade, had done fairly well in Paris (especially as he had decided to live in the provinces) and was becoming known in Belgium and Holland, too, when he ended his life.

Despite his ambivalence about showing it, Van Gogh's work had been increasingly visible in Paris since 1887, when Segatori used it to decorate her café (see 89), André Antoine hung *Voyer d'Argenson* alongside paintings by Seurat and Signac at his Théâtre Libre (see 83), and Tanguy began displaying Van Goghs at his shop (where, according to the artist, his work first sold – Tanguy collecting a few francs for portraits by Van Gogh). Towards the end of his stay in Paris, the artist put his recent work before a broad audience at the Restaurant du Chalet. Although few went out of their way to see it there, the dealer P F Martin did, and is thought to have taken some of Van Gogh's paintings on consignment.

Once Vincent left Paris, Theo tended the flickering flame of his brother's growing reputation. Unable or unwilling to show Vincent's pictures at Boussod & Valadon (where he displayed works by Gauguin, among others), Theo hung a full complement in his apartment, where they were viewed by cognoscenti. He also stage-managed public displays of his brother's work, meeting about as much resistance from Vincent as from the art world. In autumn 1888 the painter rejected Édouard Dujardin's offer to exhibit at the offices of *La Revue Indépendante,* an offbeat venue, which – though Vincent characterized it as a 'black hole' – was frequented by Symbolist literati whose interest in him was something of a coup. Philosophically attuned to a suggestive, idea-based art (and arguably more 'Symbolist' than many who claimed that label), Van Gogh nonetheless disliked the Symbolists' obfuscating approach to even 'the most obvious things', and may have been as much put off by perceived editorial élitism as by *La Revue*'s premises. Van Gogh's own choice of the Restaurant du Chalet as an alternative exhibition space attests to his commitment to populist art for a popular audience. His reaction to Dujardin's proposal was probably also influenced by Gauguin, who resented *La Revue*'s advocacy of the Neo-Impressionism he loathed.

Van Gogh manifested more enthusiasm for the open exhibitions organized by the Society of Independent Artists (founded in 1884 by artists frustrated by the exclusionary policies of the official Salon). Though he had not shown with the Indépendants while in Paris, from Arles he approved Theo's submission, in 1888, of his ambitious *Parisian Novels* (see 109) and two views of Montmajour. The following year two stunning works represented him at the Salon des Indépendants: the Saint-Rémy *Irises* and *Starry Night on the Rhône* (see 161 and 166). These works elicited Georges Lecomte's remarks (in *Art et Critique*) on the powerful effects of Van Gogh's 'ferocious impasto' and vivid, 'symphonic' palette. Meanwhile, Van Gogh had attracted lukewarm praise from Symbolists Gustave Kahn and Félix Fénéon.

He also gained a supporter in the Symbolist poet-critic Georges-Albert Aurier, who denounced academic idealism and naturalist materialism in his pursuit of *idéisme* – idea-driven art in which form and meaning

merged. After Bernard showed him some of Vincent's letters and pictures, Aurier did more looking at Theo's and Tanguy's. In spring 1889 he lauded the 'fire, intensity, sunshine' of Van Gogh's paintings in *Le Moderniste*, a short-lived journal he edited.

Perhaps anticipating Vincent's objections, Theo made only glancing reference to Aurier's budding partisanship in letters. In addition to being suspicious of the Symbolists, Vincent sometimes seemed opposed on principle to critical acclaim from any quarter. When the painter J J Isaäcson (1859–1943) called him a 'unique pioneer' in one of his regular 'Parisian Letters' to the Dutch journal *De Portefeuille*, Van Gogh dismissed his remarks as hyperbolic, and insisted, 'I'd prefer that he say nothing about me.' Theo, however, continued to welcome journalists (the Dutch portraitist and critic Jan Veth visited his flat in 1889, as did Johan de Meester, Paris correspondent for the Amsterdam daily *Algemeen Handelsblad*), and doubtless encouraged Aurier's interest.

Aurier's full-fledged meditation on Van Gogh appeared in the inaugural issue of *Mercure de France*. Entitled 'Les Isolés' ('The Isolated Ones'), it was the first in a projected series of essays on contemporary artists. The isolation Aurier headlined was that wilful removal from the world at large that – by his Symbolist lights – exquisite sensibilities sought. His Van Gogh profile contrasts the mental afterglow left by the 'baffling strangeness' of the painter's 'quasi-supernatural' imagery with quotidian realities Aurier encouraged artists to shun. Even as he remarked a realist tendency that reflected Van Gogh's Dutch heritage, Aurier stressed the artist's concomitant attention to transformative effects afforded by 'the secret character of lines and forms but, even more, colours'. Noting his use of 'dazzling symphonies of colour and line' in '*processes* of symbolization', Aurier declared Van Gogh a Symbolist as well as a realist – albeit one who 'feels the continual need to cloak his ideas in ... material envelopes'. Pointing to both the 'orgiastic excess' and 'fearless simplification' of Van Gogh's pictures, Aurier lauded their violence, *naïveté* and suggestions of drunken madness.

The first of many to tie Van Gogh's style to psychosis, Aurier took the painter's 'madness' to confirm his membership of the age-old fraternity of visionaries whose flights of creative fancy were ascribed to loss of sanity. As early as the first century the Roman dramatist Seneca wrote that 'there has never been a great talent without a touch of madness'. Though Van Gogh's institutionalization was voluntary and his lapses into irrationality intermittent, critics from Aurier onwards made much of his 'lunatic' side – routinely cited as an explanation for stylistic idiosyncrasies that some found wildly enthralling, others incomprehensible, disturbing, 'unhealthy'.

Declaring that the meaning ('Idea') Van Gogh inserted into his paintings' 'morphic envelopes' was readily accessible to 'those who know how to see it', Aurier presented himself as the sort of attuned viewer Van Gogh envisioned when he declared his wish 'to paint in such a way that everyone, at least if they had eyes, would see it'. Nonetheless, Van Gogh was taken aback by 'Les Isolés', which he characterized as 'a work of art in itself'. In a letter to Aurier, he noted that in the critic's prose renderings his pictures came off 'better than they are ... richer, more full of meaning'. Intent on attracting a mass audience, he was uneasy with Aurier's suggestions of his work's esoteric aspect, and clearly bridled at being labelled an 'isolé'. Although – or because – he had spent much of his artistic life cut off from his fellows, Van Gogh was strongly committed to an ideal of collaborative work. As a corrective to Aurier's image of his singularity, he stressed his debts to other artists, from Gauguin and Monticelli to Meissonier (whom Aurier reviled) and Mauve.

Doutbtless perplexed that Aurier should make a virtue of the marks of mental imbalance he had attempted to eradicate from his work, Van Gogh pronounced himself profoundly prosaic. In a letter to Theo he insisted, 'I think I would rather be a shoemaker than a musician in colours.' To Wil, he wrote: 'The ideas [Aurier] discusses are not my property, since all of us impressionists are generally like that ... more or less neurotic.' He nonetheless urged Theo to circulate 'Les Isolés', and sent Aurier a painting by way of thanks.

193
Red Vineyard,
1888.
Oil on canvas;
75 x 93 cm,
$29\frac{1}{2}$ x $36\frac{1}{2}$ in.
Pushkin State
Museum of Fine
Arts, Moscow

An abridged version of Aurier's essay was reprinted to coincide with the January 1890 opening in Brussels of the annual exhibition organized by Les Vingt (Les XX), an avant-garde showcase where Van Gogh had two *Sunflowers* and four Provençal views. Whereas the Salon des Indépendants was a non-juried round-up that accommodated artists of varied persuasions and uneven talent, the shows organized by Les Vingt were invitational. Van Gogh's inclusion alongside such artists as Cézanne, Renoir, Signac, Sisley and Toulouse-Lautrec is evidence of the buzz his work had begun to generate, and during the

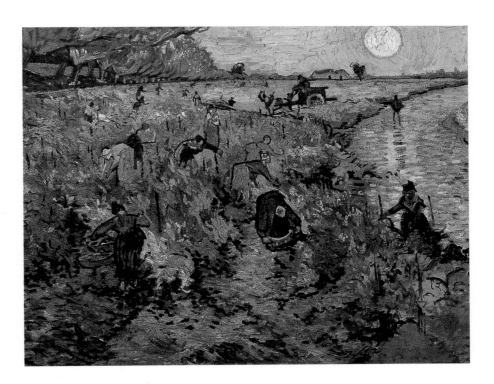

1890 run of Les Vingt, one of the works he sent, *Red Vineyard* (193), was bought by the painter Anna Boch (a *Vingtiste* and sister of Van Gogh's friend Eugène) for 400 Belgian francs. On the heels of that success, Van Gogh's work caused a stir at the 1890 Salon des Indépendants. Monet told Theo that Vincent's work there – a *Sunflowers* canvas and nine Saint-Rémy landscapes – was the best on view, and both Gauguin and Guillaumin sought to trade for one of his exhibited pictures.

The artist's death added momentum to interest that had been stirring well before it. As Theo wrote to their mother soon after, 'Now, as often happens, everybody is full of praise for his talents.' Having shown mainly landscapes, Van Gogh was best known for his visionary pantheism, though the growth of his reputation in Paris was slowed by the untimely deaths of his great advocates, Theo (who died in January 1891, after syphilitic dementia forced his institutionalization) and Aurier (who died of food poisoning in 1892), and by his work's removal to Holland by Theo's widow, Johanna. With her cooperation, Signac arranged a posthumous retrospective at the 1891 Salon des Indépendants – the occasion for Mirbeau's effusive tribute to an artist 'evangelist' who was 'restless, tormented ... [and] drawn perpetually toward the summits where the mysteries of human life reveal themselves'. Mirbeau wrote no more about Van Gogh until 1901 (though in the meantime he bought some fine paintings, including *Irises* and a portrait of Tanguy).

Thanks to Bernard and to the interest of the poet and critic Julien LeClercq (friend and colleague of the late Aurier), Van Gogh's ideas were circulated through the publication of some of his letters. In 1894 Signac noted in his journal, 'The young people are full of admiration for Van Gogh' (a reference, probably, to the enthusiasm of the Nabi circle, including the painters Maurice Denis, Paul Sérusier and Édouard Vuillard). As Van Gogh himself once observed, however, 'Painters speak to the next generation through their work', and once the paintings were gone, critical commentary dried up. Tanguy's shop survived Johanna's departure from Paris by just three years. After the paint-merchant's death in 1894 (and the subsequent dispersal of his stock), the dealer Ambroise Vollard mounted two Van Gogh shows in his Paris gallery, but these generated little interest.

In the decade following his death, the epicentre of the Van Gogh cult shifted northwards. Once resettled in their native land, Johanna van Gogh-Bonger worked to raise Vincent's profile in Holland (where his work had never been exhibited). His first Dutch advocates were those who had seen Van Goghs abroad: Symbolist Jan Toorop (1858–1928), who had seen the 1890 Les Vingt show;

correspondents Isaäcson and De Meester; psychiatrist and novelist Frederick van Eeden – an acquaintance Johanna called to Paris in autumn 1890 for consultation on Theo's deteriorating condition.

Early Dutch commentaries focused (in the manner of Mirbeau's) on Van Gogh's tortured, emotive and spiritually questing persona. His *oeuvre*, addressed in general terms only, was portrayed as unique to its maker. Isaäcson stressed Van Gogh's heroic subjectivity, while De Meester, whose sensibilities were more socialist than individualist, saw Van Gogh as a realist of democratic impulse (not the sort of Symbolist *isolé* Aurier described) whose Dutch-period works brimmed with empathy for the underclasses. Van Eeden (a prose stylist Van Gogh had admired) wrote of Van Gogh's painting as a layman drawn to the pictures' beauty, a psychiatrist intrigued by their maker's biography, and a cultural élitist who placed the painter among 'that noble and immortal race the common folk call madmen but people of our kind call saints'. Published in *Die Nieuwe Gids* (*The New Guide*), Van Eeden's critique irked the journal's resident art critic, R N Roland Holst (1868–1936), a painter who warned against viewing Van Gogh's *oeuvre* through the prism of personal tragedy. He later conceded, however, that 'Nothing can be done about the fact that preachers and writers will continue to glorify Van Gogh as a saint or tortured martyr.'

Roland Holst believed that the work – 'crude', 'fierce' and 'unsettling' as it might seem to a Dutch public scarcely even acquainted with Impressionism – should stand on its formal merits, without recourse to the pathos of the artist's life. His first encounter with Van Gogh's work had taken place at a small show that Toorop helped to organize in an Amsterdam gallery in early 1892. Toorop, a Vingtiste well-versed in French modes, had become a force in Dutch cultural life since returning from a sojourn in Brussels. Despite his lack of stylistic affinity with Van Gogh, Toorop became an advocate who, in the wake of the Amsterdam gallery show, turned his attention to a memorial exhibition in The Hague. So popular that it was both expanded and prolonged, The Hague memorial show was followed by a sweeping retrospective organized by Roland Holst at Amsterdam's Panorama Gallery in December 1892. Its catalogue was the first of many to use

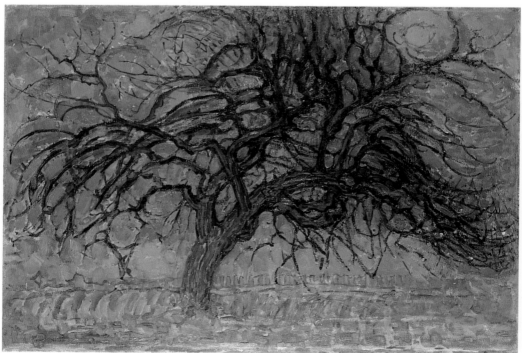

excerpts from Van Gogh's letters to elucidate his work. It featured an introduction and cover art by Roland Holst, the latter emblematizing Van Gogh as a haloed sunflower, rooted but drooping as the sun sinks (194).

Sunflowers, traditionally associated with the faithful (who orient themselves towards divine illumination), had been claimed as his own by Van Gogh at Arles, and in 1890 he chose paintings of the blooms Aurier called 'vegetal stars' of 'heliomythic allegory' for display at Les Vingt and the Indépendants. Gachet laid a bunch on Van Gogh's coffin, where Bernard took them to symbolize the light the deceased had 'dreamt of in hearts as well as paintings'. Sunflowers suit the public persona Van Gogh's admirers crafted after his death: field flowers of rustic air, their solar colours and forms evoke the quest for spiritual and physical illumination that was held to drive his art, and their halo-like ruffs of petals suggest the saintliness ascribed to him.

By the mid-1890s Van Gogh was becoming a cultural hero in his homeland. His explosively expressive work was held to reflect tensions inherent to modern times, and the painter was revered as a Christlike man of the people who bucked convention in his pursuit of the spiritual (his youthful proselytizing was invoked in this connection). Too socially engaged to be considered a Symbolist *isolé*, the Van Gogh of popular imagination nonetheless stood apart. Early commentary so tightly bundled his psyche and style that his technical procedures were considered inseparable from his 'unique' persona – hence, virtually inimitable. Even such dedicated fans as Toorop and Roland Holst took few formal cues from his work.

It was not until 1905, after an exhibition of almost 500 of his pictures was mounted by the Stedelijk Museum, that Van Gogh's style was taken up by some of the younger painters in Toorop's circle, including Piet Mondrian (1872–1944), who had begun his career in the orbit of Van Gogh's former friend Breitner. Drawn to the ecstatic aura that Van Gogh lent mundane motifs, Mondrian passed through a brief 'Van Gogh phase' that peaked around 1908. Having forsaken, by his own account, 'natural colour for pure colour', Mondrian sought a 'new way to express the beauty of nature'. His *Red Tree* (195)

194
Richard Roland Holst, *Vincent* (cover for an exhibition catalogue), 1892. Kröller-Müller Museum, Otterlo

195
Piet Mondrian, *Red Tree,* 1908. Oil on canvas; 70 x 99 cm, 27½ x 39 in. Gemeentemuseum, The Hague

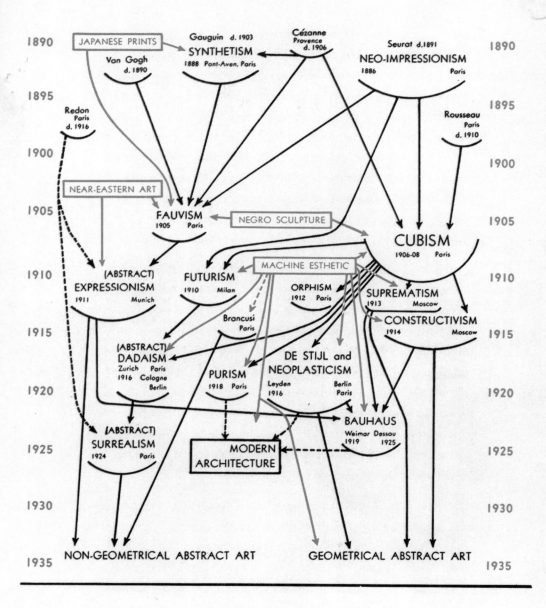

1890 JAPANESE PRINTS Gauguin d. 1903 Cézanne Seurat d.1891 1890
SYNTHETISM Provence NEO-IMPRESSIONISM
Van Gogh 1888 Pont-Aven, Paris d. 1906
d. 1890 1886 Paris

1895 Redon Rousseau 1895
Paris Paris
d. 1916 d. 1910

1900 1900

NEAR-EASTERN ART

1905 FAUVISM NEGRO SCULPTURE 1905
1905 Paris CUBISM
 1906-08 Paris

1910 (ABSTRACT) FUTURISM MACHINE ESTHETIC 1910
EXPRESSIONISM 1910 Milan ORPHISM SUPREMATISM
1911 Munich 1912 Paris 1913 Moscow
 Brancusi CONSTRUCTIVISM

1915 Paris 1914 1915
(ABSTRACT) Moscow
DADAISM DE STIJL and
Zurich Paris PURISM NEOPLASTICISM
1916 Cologne
 Berlin 1918 Paris Leyden Berlin

1920 1916 Paris 1920
 BAUHAUS
(ABSTRACT) Weimar Dessau
SURREALISM MODERN 1919 1925

1925 1924 Paris ARCHITECTURE 1925

1930 1930

1935 NON-GEOMETRICAL ABSTRACT ART GEOMETRICAL ABSTRACT ART 1935

and a series of evocative single-bloom images of wilting flowers (including sunflowers) testify to his engagement with the tactility of Van Gogh's paint surfaces, the vibrancy and unnaturalness of his palette, the emotional charge with which he imbued plant life. Though Alfred Barr's famous flow-chart of Modernism would place them on opposite sides (196), Van Gogh's exploitation of hue's pure expressive power might be indirectly linked to the colour-animated grids Mondrian went on to develop, minimalist paintings that speak through line and colour alone.

Imitative homages in the manner of Mondrian's *Red Tree* were few in Holland, where interest centred on the artist's persona, particularly after the publication of Van Gogh's collected letters in 1914 (which Theo's widow Johanna van Gogh-Bonger organized, edited and prefaced with a family history and personal memoir). Even the painters in Van Gogh's public seem to have been more intrigued by the 'tragic life' Just Havelaar probed in a book-length study (1915) than stylistics that continued to seem foreign in his native land.

These were more readily assimilated in France, where Van Gogh's mature mode was born. Parisian interest was rekindled by a show in 1901 at the Bernheim-Jeune gallery organized by LeClercq. The exhibition had something of a ripple effect; it was critically noted (by Mirbeau, among others) and well attended – Henri Matisse (1869–1954), who had begun to buy Van's Gogh's work, met his future colleagues André Derain (1880–1954) and Maurice Vlaminck (1876–1958) there. Though Pablo Picasso (1881–1973) moved to Paris too late in 1901 to see it, he nonetheless took on Van Gogh. His decision to emulate Van Gogh's style in the posthumous portrait of an artist friend who had shot himself suggests his acquaintance with the Dutchman's own tragic tale (197). Van Gogh-like in its motifs (displayed wound, burning candle) as well as its polychrome impasto, *Casagemas Dead* recalls his work on an emotive level, too, in its poignant union of pathos and radiance.

It took longer before the *abstract* expressiveness of Van Gogh's work made a strong mark on French painting, despite the notice it drew in 1901 from the poet and critic André Fontainas. Remarking on the

196
Alfred H Barr Jr., Chart for the jacket of the exhibition catalogue *Cubism and Abstract Art*, Museum of Modern Art, New York, 1936

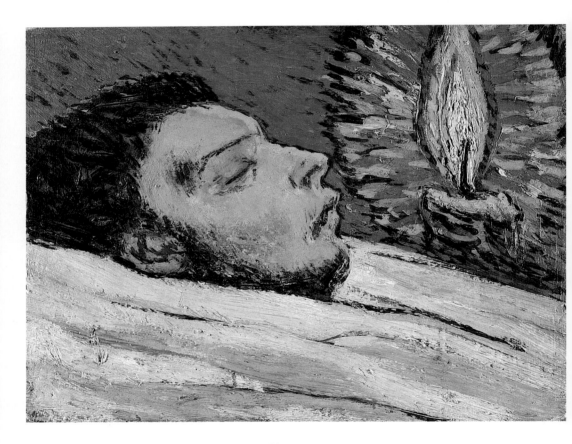

197
Pablo Picasso,
Casagemas
Dead, 1901.
Oil on panel;
27 x 35 cm,
10⅝ x 13¾ in.
Musée Picasso,
Paris

arbitrariness of Van Gogh's palette, Fontainas wrote in *Mercure de France* that, by releasing colour from its imitative function, the artist 'made it sing'. Whereas Aurier had presented Van Gogh's colour as part of a 'process of symbolization' deployed in the service of an underlying Idea, Fontainas suggested a more spontaneous procedure that allowed hues to signify directly, apart from motif. That vein of his *oeuvre* was not fully mined by painters until 1905, when the fifteenth anniversary of Van Gogh's death occasioned a retrospective at the Salon des Indépendants. Matisse, Derain, Vlaminck and Rotterdam-born Kees van Dongen (1877–1968) were among those galvanized by Van Gogh's freewheeling palette and brushwork, and the thematic simplicity of his work. In the aftermath of the Indépendants they forged the group style that earned them the sobriquet '*fauves*' ('wild beasts') when they unveiled it at the Salon d'Automne that year (198).

Blazing up most spectacularly in Fauvism, where it surged to what Vlaminck called 'maximum intensity' at mid-decade, the French Van Gogh vogue soon burned down. The vanguard had moved on to the next thing by the time Bernheim-Jeune staged another Van Gogh retrospective in 1908. That next thing was Cézanne (whose death in 1906 prompted a Salon d'Automne memorial). The tempestuousness associated with Van Gogh was all but jettisoned as Parisian painters embraced Cézanne's analytical approach to space and form. Cézanne's orderliness appealed to French artists' and viewers' deep-seated love of classicism, and his stylistic *gravitas* suited the pensive mood that gripped Paris in the years preceding World War I. While Van Gogh's innovations were acknowledged by French Modernists (he would ever after be considered the grandfather of Fauvism; see 196), his formal contributions won much less attention than his personal saga, which conformed to that of a compelling Romantic type: the disparaged artist-genius who suffers for his work.

Before the nineteenth century, European painters were usually respected professionals who associated with the rich patrons who commissioned their work. A decidedly modern construction, the so-called *peintre maudit* ('cursed painter') – a bohemian who lived at

the margins and struggled to get by – became a well-known entity during the Romantic era (which spanned the late eighteenth and early nineteenth centuries). Such artists rebelled against academic hierarchies and time-honoured subjects, representational conventions and technical procedures, often sacrificing patronage to artistic liberties. The history of nineteenth-century painting abounds with rebels in that mould. When the Impressionist apologist Théodore Duret portrayed Van Gogh in this way in a monographic study (1916), he expressed a common view of the Dutchman, whose indomitable artistic will was lauded long after his colourism and brushwork became old hat. His lonely fight to realize a compelling personal vision and his presumed indifference to commercial and critical success were considered paradigmatic. As Picasso later observed, Van Gogh's 'essentially solitary and tragic adventure' was the archetypal artist's saga 'of our times'.

In Germany Van Gogh's work tapped into longstanding proclivities for nature worship and expressionistic art. The critic Albert Dreyfus, for instance, remarked on the 'German Romanticism of his character', Paul Fechter the 'mysterious Gothic quality' of his paintings. The German art historian and aesthetician Julius Meier-Graefe bought his first Van Gogh in 1893 in Paris, where his nine-year residence fostered an appreciation of modes that many of his Francophobic countrymen rejected out of hand. Meier-Graefe first wrote of Van Gogh as a latter-day Impressionist who stylized nature to decorative ends, but over the next two decades – as he searched for a totalizing encapsulation of Van Gogh's persona and production – he essayed varied, even contradictory characterizations (*eg* anarchist, traditionalist). He eventually settled on a transcendent, ahistorical image of the artist as heroic idealist, his pictures born of the essentialist struggle between humans and nature, of which 'great works of art are trophies'. Fascinated by Van Gogh's personal saga, Meier-Graefe took it up in earnest in *Vincent* (1921), an impressionistic biographical study subtitled a *Novel of One Seeking God*.

In the meantime, private and public exhibitions of Van Gogh's pictures abounded in the cultural hotbeds of Berlin and Munich,

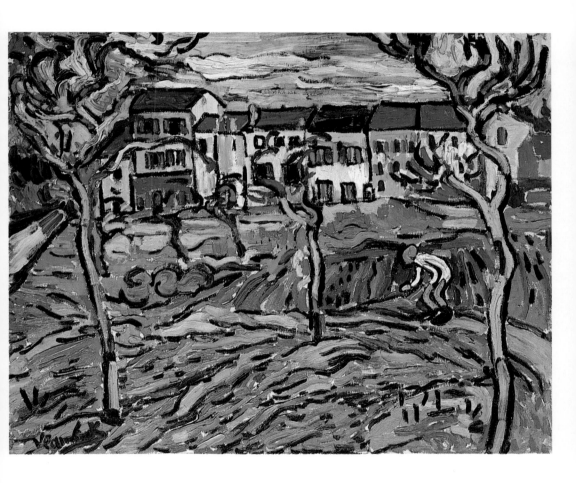

198
Maurice
Vlaminck,
Houses at
Chatou,
1905–6.
Oil on canvas;
81·9 x 100·3 cm,
32¼ x 39½ in.
The Art Institute
of Chicago

and also made their way to other German cities. Promoted most assiduously by dealer Paul Cassirer, Van Goghs sold much more briskly in Germany than in France. After 'discovering' Van Gogh at Bernheim-Jeune in 1901, Cassirer engineered his work's inclusion in the annual exhibition of the Berlin Secession, and in 1903 the Munich Secession followed suit. In 1905 Cassirer organized a monographic Van Gogh show that travelled from Berlin to Hamburg and Vienna before opening in Dresden, where the pictures' formal *éclat* and overt emotionality appealed to the recently formed Die Brücke (The Bridge) group. Self-taught artists who put a high premium on originality, Die Brücke founders Ernst Ludwig Kirchner (1880–1938), Erich Heckel (1883–1970) and Karl Schmidt-Rottluff (1884–1976) later discounted Van Gogh's influence on the strident group style – dubbed Expressionism – for which they became known in the years preceding World War I. In its eroticism and exoticism, Expressionist figuration seems as much indebted to Gauguin and Matisse as Van Gogh, and even Die Brücke landscape can be traced back to him by way of Fauvism (199). Die Brücke's antagonists, however, were inclined to brand its members 'Van Gogh imitators' (in Fritz von Ostini's formulation). As Ferdinand Avenarius observed in 1910:

Van Gogh is dead, but ... everyone Van-Gogh-izes. Good people, who could perform contentedly and usefully in an office or even an artist's workshop ... torture their artistic organs into convulsions. However much they scream, that is all they say.

In light of such remarks, Die Brücke artists' denials of Van Gogh are as understandable as their ideological links to him are obvious. Like Van Gogh, Kirchner and company were autodidacts whose distance from the academy lent their work freshness of vision and facilitated their departures from conventional illusionism in favour of personal styles in which psychic tensions denoted by distortion and exaggeration reign.

Van Gogh's formal influence on Munich's Blaue Reiter (Blue Rider) group is hard to separate from that of Gauguin, Munch, the Fauves, 'orphist' painter Robert Delaunay (1885–1941) and the Bavarian

folk art its members admired. Moreover, Blaue Reiter affiliates – Vasily
Kandinsky (1866–1944), Franz Marc (1880–1916), Auguste Macke
(1887–1914), Gabriele Münter (1877–1962), Alexei Jawlensky
(1864–1941) and Paul Klee (1879–1940) – never sought or practised
a unified group style. Though Kandinsky admiringly recalled the
'bomb' dropped by a Van Gogh exhibition staged in Munich in 1908,
and included a Van Gogh portrait of Gachet in the *Blaue Reiter Almanac*
(1912) he compiled with Marc, the group's most profound connection
with the Dutchman was philosophic.

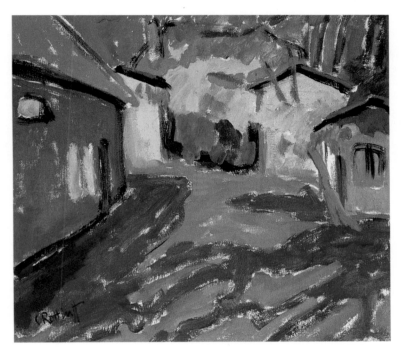

199
Karl Schmidt-
Rottluff,
Manor House at
Dangast, 1910.
Oil on canvas;
86·5 x 94·5 cm,
34 x 37¼ in.
Neue
Nationalgalerie,
Berlin

Blaue Reiter artists were committed to 'musical' painting made to
expressive rather than mimetic ends: 'None of us', Kandinsky wrote,
'seeks to reproduce nature ... We aim to give form to inner nature,
spiritual experience.' His personal quest for a transcendent mode
that vibrates in the viewer's soul, coupled with his firm belief in the
signifying potential of pure colour, line and form, led Kandinsky
to nature-based but non-representational picture-making in 1910
(200) – a terrain Van Gogh eyed in 1890 (see *Roots and Tree Trunks*,
191) but never entered.

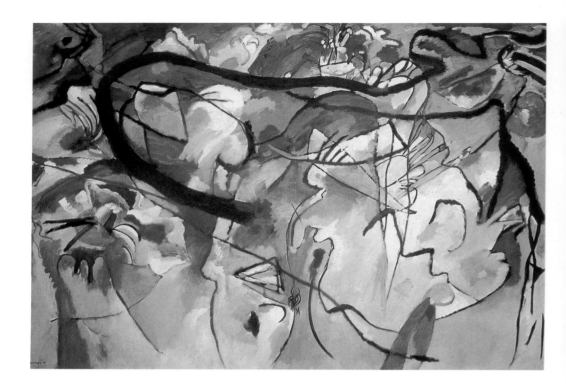

As Continental artists broke new ground in the early twentieth century, the British school hung back. The introduction of Van Gogh's work at a show of recent French painting that Roger Fry organized at London's Grafton Galleries in 1910 did nothing to rouse its ranks, though the English press had a field day with the 'shocking' production of the Dutch 'lunatic'. Fry himself was dubious about Van Gogh's ultimate achievement, and after seeing the Van Gogh show mounted at the Leicester Galleries in 1923, he still worried over the painter's 'indifference to plastic structure' and childish 'self-abandonment'. Fry finally decided that 'here was a personality more beautiful and interesting than anything it accomplished'.

In the years between the wars many of Van Gogh's admirers effectively privileged personality over artistic accomplishment, writing of the pictures as extensions of the psyche and revelations of the spirit rather than formal experiments or commercial products. A public familiar with the *oeuvre* spent the 1920s and 1930s poring over his letters (which appeared in numerous editions and

translations after their initial publication in 1914) and eye-witness accounts by those who had known him. After the philosopher and psychiatrist Karl Jaspers published what he termed a 'pathographic analysis' in 1923, a whole subcategory of Van Gogh commentaries emerged. Jaspers's psychiatric assessment of the artist's work and letters, with corroborating evidence drawn from the published recollections of his intimates, led him to conclude that Van Gogh was schizophrenic, and to suggest that illness had liberated the artist from inhibitions, allowing the unconscious to play freely in his work. A spate of spin-offs and refutations of Jaspers's diagnosis ensued. In popular literature the 'psychobiographical' approach to Van Gogh's work became *de rigueur*.

Those intrigued by the man behind the *oeuvre* eagerly constructed and consumed a romanticized version of Van Gogh's life that emphasizes its peaks and valleys, sliding past the even keel of his work and daily routines, and the mundane concerns the letters indicate (dental woes, the state of his underwear). If Meier-Graefe, in *Vincent*, initiated a trend towards the life's novelization, Irving Stone's *Lust for Life* (1934) is the ultimate incarnation of that genre. Translated into multiple languages and, later, into film (1956), Stone's biodrama – like others of its kind – makes recourse to paintings only as they serve to illustrate the life. To art historian A M Hammacher, this constitutes an inversion of priorities that impedes 'proper understanding' of Van Gogh's *oeuvre*, although he concedes that such treatments have induced thousands to attend to the pictures.

Surely *Lust for Life* fuelled what Hammacher calls the 'unpredictable Van Gogh boom' of the mid-1930s, the period in which US audiences embraced the man and his *oeuvre*. Three of Van Gogh's pictures had been included in the notorious Armory Show mounted in New York in 1913; dozens were seen (but none sold) at New York's Montross Gallery in 1920; and the Art Institute of Chicago, Detroit Institute of Arts and Kansas City Art Museum owned Van Goghs. Yet the work was not widely known outside art circles until 1935, when Alfred Barr organized a 125-work retrospective for the Museum of Modern Art,

200
Vasily
Kandinsky,
Composition V,
1911.
Oil on canvas;
190 x 275 cm,
74³⁄₄ x 108¹⁄₄ in.
Private
collection

New York, which travelled on to Boston, Cleveland and San Francisco. Barr had already presented Van Gogh as a founding father of Modernism in MoMA's inaugural exhibition (1929) and the genealogy he charted in *Cubism and Abstract Art* (1936; see 196). The security of the artist's place in the art world had also been affirmed by a proliferation of Van Gogh fakes (most notably by Berlin dealer Otto Wacker, whose forgeries made it into the Van Gogh catalogue Jacob-Baart de la Faille published in 1928). When Barr proposed a monographic exhibition, MoMA's advisory committee fretted that the celebration of a painter now forty-five years dead would lend credence to criticisms that the institution was more historical than contemporary.

Unswayed by objections, MoMA's trustees (five of whom lent drawings to the show) launched one of the art world's first blockbusters. People queued for hours, the catalogue sold out, and department stores displayed 'Van-Gogh-coloured' fashions alongside reproductions. According to MoMA chronicler Russell Lynes, this was the birth of the Van Gogh tie-in, in the form of sunflower-patterned scarves, shower curtains and ashtrays. Lynes suggests that New Yorkers made despondent by the Great Depression identified with Van Gogh's personal distress, and, at the same time, were cheered by the work. At 25 cents a head, the MoMA show raised $20,000 in admissions in its two-month run. It did even better in San Francisco.

Though museum press releases downplayed the sensationalism of Van Gogh's biography, newspapers across the country helped circulate the romanticized biography Stone's book detailed. The art-historical Van Gogh that was deemed old news by MoMA's advisory board – heir to Impressionism, closet Symbolist, Modernist trailblazer – was overshadowed by the ever-fascinating mythic one, whose manner, sprung from mad genius, seemed to float free of the continuum of European art in which Van Gogh placed himself. Even Walter Pach, whose *Vincent van Gogh: A Study of the Artist and his Work in Relation to His Times* (1936) aimed to contextualize the *oeuvre*, was inclined to credit the artist with a capacity for

transubstantiation. As Pach had observed years before, in reviewing the Montross show, 'Van Gogh's symbol might well be the flame, consuming what it feeds on to give it back in terms of force and light.'

The heroic individualism Van Gogh came to epitomize went down particularly well in the United States, a nation in the thrall of the popular cowboy myth throughout the mid-twentieth century. Uneasy in society, the cowboy was a rough-hewn free spirit in search of open ground, a noble loner whose idealism often coexisted with a violent streak. When Abstract Expressionist Jackson Pollock (1912–56) sought a niche in the New York art scene in the 1940s, he styled himself a western outsider in the gunslinger mould. Pollock was linked to Van Gogh by his legendary personal excesses and early, violent death, as well as a gestural technique that many thought psyche-revealing. His mid-century celebrity and shocking demise gave Van Gogh's style and saga new resonance, and the film version of *Lust for Life* – released in the year of Pollock's death – boosted Van Gogh's own celebrity as the artist became a cross-over screen star.

A mélange of fact, fabrication, elision and artful modification, director Vincente Minnelli's *Lust for Life* draws on the artist's letters (snatches of which are incorporated into dialogue), scholarly treatments and the *oeuvre* itself, as well as Stone's bestseller. Shots of paintings are interspersed with the action, and several well-known works (*The Potato Eaters, Night Café, Painter on the Road to Tarascon*) appear as *tableaux vivants*. Kirk Douglas, a rising star who made his name playing arrogant roughnecks, enacted the gifted, 'tender' protagonist in constant 'struggle with himself' (in the words of the movie's Theo). The psychosis Douglas's Van Gogh embodies in pained expressions, clenching gestures and abrupt movements is corroborated by other actors' lines: 'Vincent' is repeatedly labelled lonely and crazy by those around him. Though the painter's respect for Rembrandt, Delacroix and Millet is duly noted, and *Lust for Life* places him in the company of advice-offering peers (Mauve, Pissarro, Seurat, Gauguin), Minnelli's Van Gogh is a unique phenomenon

whose work – as described by the filmic Gauguin (Anthony Quinn) – 'owes nothing to anybody … *nothing'*.

Using a medium known for veristic effects, and filming on location in a bid for authenticity, Minnelli gave lasting visual form and a certain facticity to such legendary incidents as Van Gogh painting *Starry Night on the Rhône* under a hatful of blazing candles. Gauguin's apocryphal account of confrontation with a razor-wielding Van Gogh is lent credence by its filmic enactment, and the movie version of Van Gogh's suicide reifies the false but enduring notion that the dramatic *Crows over Wheat Fields* (see 189) was the artist's last work. Minnelli's rendering of Van Gogh's overdetermined last stand unfolds in the Auvers landscape *Crows* represents, with that picture in progress on the painter's easel. As the townspeople celebrate Bastille Day (which actually took place some two weeks before Van Gogh's death), the depressive Dutchman, oppressed by others' gaiety, seeks solitude in nature and work, only to be set upon by a flock of inexplicably aggressive crows (Hitchcockian *Birds, avant la lettre*) – the last straw in a situation that Van Gogh/Douglas declares 'impossible!' In a scrawled explanatory note the real-life artist never wrote, his Minnellian counterpart records distress at seeing 'no way out'. A pistol is produced and fired, though Van Gogh's self-directed violence is rendered auditorily rather than visually (similarly, Minnelli represents the ear-cutting with an off-screen howl). A deathbed scene is followed by a coda in which *The Reaper* is accompanied by a voice-over paraphrase of the artist's own comments on that picture, discounting death's 'sadness'. When 'The End' finally appears on screen, it is floated on a panoramic display of the *oeuvre,* the words' finality countered by the popular trope that true artists live on through their work.

Minnelli's *Lust for Life* was more a beginning than 'the end'. Decades later, it remains the paradigmatic treatment of Van Gogh's saga, which dozens of subsequent films and videos – by Robert Altman (*Vincent and Theo*, 1990), Akira Kurosawa (*Dreams*, 1990) and many others – have revisited rather than revised. The earnest,

impulsive genius that Douglas's acclaimed performance brought to life continues to inform popular notions of the artistic personality and to haunt modern painting – his restless spirit envisioned, for instance, by Francis Bacon (1909–92) as a 'phantom of the road' (192). Well versed in art history and Van Gogh's letters, Bacon admired his predecessor's ability 'to be almost literal, yet give you a marvellous vision of the reality of things' – an approach Bacon himself pursued most memorably in cheeky take-offs on Velázquez's mid-seventeenth-century portrait of Innocent X, in which the decorous pope of the original morphs into maniacal screamer. In 1951 Bacon overlaid Innocent's distorted features with those of a Van Gogh self-portrait. Five years later – prompted, surely, by the just-released *Lust for Life* – Bacon began a series based on Van Gogh's *Painter on the Road* (see 130). Like Van Gogh, that painting had met a violent end, destroyed by a fire bomb in the last months of World War II. Bacon, who worked from a reproduction, seems to have alluded to those circumstances by using hot colours and forms that appear to melt. In a listing landscape that looks war-scarred, with trees denuded and earth scorched, the intrepid artist/labourer of Bacon's translation trudges on, an existentialist trooper who casts his shadow before him.

That shadow has proved a long one, as painters from Italy to Iceland to Japan, which had its first major Van Gogh show in Tokyo and Kyoto in 1958, continue to reflect upon Van Gogh's place in both art and popular imagination. Erró's (b.1932) *Background of Pollock* (201) – a visual take-off on art-historical mapping projects in the spirit of Barr's chart – traces its protagonist's artistic roots through Fauvism, Cubism, Surrealism and German Expressionism, to Munch and Van Gogh, along a timeline composed of well-known works, including many memorable self-portraits. Van Gogh's is singled out by way of the outsized, thumbtack-wielding hand that is about to pierce its cranium. Echoing Pollock's head-touching gesture (and thus underscoring the artists' connectedness), the hand that lights on Van Gogh's head seems also to satirize – by virtue of its scale, its entry from beyond and above the canvas, and its pointed assault on the artist's mind – the notion of divine inspiration.

Others consider Van Gogh's 'outsider' image, which coexists ever more ironically with his worldwide renown. After seeing Bacon's Van Gogh suite in Cologne in 1981, Friedemann Hahn (b.1949) – long intrigued by the media of mass culture and the sorts of celebrity they foster – embarked on his own series, painting over pages torn from de la Faille's catalogue, translating stills from *Lust for Life* into densely impastoed oils (202), and producing variants on *Painter on the Road*. An aptly iconic presentation of frontal figure on rich-hued ground, *Kirk Douglas in 'Lust for Life'* records the historic persona's subsumption in modern stardom. Hahn's versions of *Painter on the*

201
Erró
(Gudmundur Gudmundsson),
The Background of Pollock,
1966–7.
Acrylic on canvas;
260 x 200 cm,
102⅛ x 78¾ in.
Musée National d'Art Moderne, Centre Georges Pompidou, Paris.

Background works allude to paintings by the following artists:
1 Marcel Duchamp
2 Vincent van Gogh
3 Edvard Munch
4 Max Beckmann
5 Marc Chagall
6 Paul Klee
7 Juan Gris
8 Alexei Jawlensky
9 Max Ernst
10 André Derain
11 Raoul Dufy
12 Pablo Picasso
13 Gino Severini
14 Piet Mondrian
15 Emil Nolde
16 Umberto Boccioni
17 Georges Braque
18 Salvador Dalí
19 Pablo Picasso
20 Henri Matisse
21 Vasily Kandinsky
22 Pablo Picasso
23 Piet Mondrian
24 Lady Butler

202
Friedemann Hahn,
Kirk Douglas in 'Lust for Life',
1956,
1982.
Oil on canvas;
270 x 256 cm,
106¼ x 100¾ in.
Städtische Galerie Wolfsburg

Road, distanced from their lost source, draw on Minnelli's and Bacon's treatments as well as a prewar photograph of the painting, raising questions about the relationship between the aura surrounding a hand-made 'original' and the new-fangled auras generated by mass-market image replication that puts 'Van Gogh' on every street corner.

While much of the Van Gogh literature remains biographical, art historians have been increasingly inclined to sidestep the legendary persona and focus on the painter's production, intent on grounding it in cultural, economic, sociopolitical and material circumstance.

Such efforts have altered the tenor of scholarly writing on the artist but have had scant impact on popular perceptions of his singularity. The latter have been bolstered by such events as the opening (1973) and later expansion (1999) of Amsterdam's Van Gogh Museum, the celebrations surrounding the centenary of the artist's death (1990) and the $82 million paid for his portrait of Dr Gachet that year (a record-breaking auction price that remains unmatched more than ten years later), and a steady stream of one-man blockbusters (whose ballooning admission fees reflect the insurance costs for paintings that are also blue-chip commodities).

In an essay of 1970, Hammacher called for the historic Van Gogh's rescue from the flood of words in which his work had become submerged. But, rather than attempting to pluck some 'real' Van Gogh from the relentless waves of melodrama and hyperbole that engulf his name and production, several art historians, following Griselda Pollock's lead, have focused on the popular construct 'Van Gogh' as an entity in its own right, and have turned their sights on Van Gogh's 'mythology'. Though the pop culture version of Van Gogh presents an extreme example of the widely cherished artist-genius construct, the processes by which it was manufactured are not unique. Analyses of the shape and shaping of the Van Gogh myth shed light on the cult of personality that has informed much art-historical discourse and, by extension, popular notions of artistic temperaments and practices.

Firmly inscribed in popular consciousness around the world, the Van Gogh legend resists significant modification. The material legacy of the historic Van Gogh – his letters as well as his pictures – is, ironically, more tractable (conceptually speaking), its meanings and internal relations still pondered, its maker's intentions still debated. Artists' production becomes, to a large extent, that which subsequent generations choose to make of it. In Van Gogh's case, the *oeuvre*, animated by the interest of contemporary viewers (and viewed in terms of their concerns) retains freshness, even as his myth turns stale. It has proved to be what the artist hoped – a body of work that 'people will go on looking at for a long time to come'.

Glossary

Avant-garde From the French for 'vanguard' (*ie*, the first line in a military advance), 'avant-garde' is used by cultural historians to refer to those styles, practices and creative personalities (*eg*, writers, artists, musicians) that spearhead an up-and-coming trend.

Barbizon School A group of French landscape painters who worked outside Paris, in the Forest of Fontainebleau, particularly in the vicinity of Barbizon, a village at the forest's edge. Rejecting the idealizing classicism of the French landscapist Claude Lorrain, Barbizon artists took inspiration from the more naturalistic views made by Dutch painters in the seventeenth century and, more recently, by John Constable in England. Members of Barbizon's loose alliance, active from the 1830s to the 1870s, included Narcisse Diaz, Jules Dupré, Theodore Rousseau and Constant Troyon; in 1849, the controversial peasant painter **Jean-François Millet** joined their ranks. Barbizon painters' commitment to actual scenes, directly observed *en* **plein air**, influenced younger painters in France and abroad, and, most notably, informed Impressionist practice.

Cloisonnism Developed by **Louis Anquetin** and **Émile Bernard** in 1887–8, cloisonnism is an anti-naturalistic painting style characterized by simplified forms bonded by dark, heavy contours and filled with bold, unshaded colour. Particularly as practised by Bernard (whose cloisonnism sidesteps traditional perspectival devices), the style is one of self-consciously naïve effects, and may be linked to the late nineteenth-century vogue of primitivism. Cloisonnism was inspired by Japanese prints and, possibly, stained glass, though its name – bestowed by critic Édouard Dujardin – references a medieval enamel technique whereby compartments created by metal partitions ('*cloisons*') are filled with vitreous enamel. Probably at the behest of his close friend Anquetin, Dujardin noted (in *La Revue indépendante*) that cloisonnist stylizations reflected their practictioners' 'symbolic conception of art'. This premise, and the abstractions it inspired, influenced **Gauguin**, the Pont Aven group and the Nabis.

Étude French for 'study', *étude* refers to a quick and fairly spontaneous response to a model or motif. As distinct from the preparatory sketch (the *esquisse*), the *étude* may or may not lead to a more considered treatment.

The Hague School A group of Dutch landscape and genre painters who worked on the outskirts of The Hague and in the nearby fishing village of Scheveningen in the last three decades of the nineteenth century. Influenced by France's **Barbizon School**, Hague School artists often painted outdoors and were inclined towards undramatic, workaday scenes. Known for vistas of dunes and meadows and scenes of working-class domesticity, Hague School artists' preference for low-keyed, close-toned palettes inspired their nickname, the 'Grey School'.

Japonaiserie A catch-all term encompassing the wealth of Japanese objects that flooded Paris in the second half of the nineteenth century (*eg*, fans, tea sets, lacquerware, garments), *japonaiserie* also refers to European copies of Japanese goods (*eg*, knick-knacks, fabrics, accessories); to Western art that depicts Japanese objects, settings and/or models; and to Western enthusiasm for things Japanese.

Japonisme Coined in 1872 by critic Philippe Burty 'to describe a new field of study', the term *japonisme* is often employed interchangeably with **japonaiserie** to connote Westerners' embrace of things Japanese. In the later twentieth century, however, it took on a more specific meaning among art historians, who use *japonisme* to denote Western artists' assimilation of Japanese aesthetics, and the varied (often subtle) ways in which Japanese stylistic traits and compositional devices inflect such artists' renderings of Western scenes and models.

Naturalism In art, naturalism refers to image-making grounded in direct observation of actual (rather than invented) motifs and effects, and dedication to their faithful transcription. In literature, the term was imbued with a more particular meaning by the novelist/critic **Émile Zola**, who advocated a quasi-scientific creative practice informed by empirical evidence, impartially gathered and recorded. The approach Zola outlines in *Le Roman expérimental* (best translated as *The Experiment-like Novel*; 1880) treats contemporary society and its individual components as organisms acted upon by natural forces (heredity, environment, physical drives). The naturalist novel, according to Zola, is the literary equivalent of a laboratory in which carefully gathered specimens are observed and analysed, in order to test and 'prove' hypotheses about humanity and its interactions.

Neo-Impressionism First applied by critic Félix Fénéon to works exhibited by Georges Seurat and his disciples in 1886, the term 'Neo-Impressionism' acknowledges these paintings' links to Impressionism's themes of urban leisure and engagement with natural light and colour effects observed *en* **plein air**. The prefix 'neo', however, points up the novelty of the paintings Seurat and his circle presented – a novelty that resided in their orderly compositions and their subjects' seeming stasis as well as in the small-scale brushstrokes

with which Neo-Impressionist paintings are built. Seurat had devised the practice of painting with diminutive dots and dashes of pigment – 'pointillism' – as a means to an end. Tiny touches of colour, closely juxtaposed, were intended to reflect and facilitate the analytic process Seurat called 'divisionism': the quasi-scientific 'dissection' of observed hues into component parts, with an eye to the contextual actualities that alter an object's 'true' colour (eg, colours reflected from adjacent objects or the yellowing effects of sunlight).

Nishiki-e From the Japanese for 'brocade', *nishiki-e* refers to full-colour woodblock prints, the first of which were issued in 1765.

Plein-air From the French for 'open air', *plein-air* paintings are those made outdoors, '*en plein air*' ('in open air'), with an eye to nature's actual, often transitory, effects. Most closely associated with the Impressionists (who made it standard practice), *plein-air* painting substantially predates their work. Its earliest products were studies and preliminary sketches that helped artists create naturalistic effects in the studio. **Barbizon** painters' advocacy of work *en plein air* inspired successive generations, whose outdoor work was facilitated by the development of portable easels and premixed paint in tubes. With the rise of Impressionism, *plein-air* work on pieces intended for exhibition became commonplace.

Salon The government-sponsored exhibition of contemporary art in Paris. The first Salon was staged in 1667 by the Royal Academy of Painting and Sculpture. A display of Academy members' work, it took its name from the room in which it was mounted, the Louvre's Salon d'Apollon. In 1737, the Salon exhibition became a biennial event, and, after the French Revolution (1789), it was an almost annual display to which non-academicians could contribute – provided their work passed the scrutiny of the generally conservative Salon jury. Having grown to fill several rooms, the Salon was moved to the Palais Royale in the early nineteenth century, and from 1857 onward it was mounted in the vast Palace of Industry on the Champs Élysées. By that time, the number of rejected works was roughly equal to the number selected for exhibit, and disenchantment with the jury's hidebound exclusivity was widespread. Rejected artists, eager to show their work, devised several alternatives to Salon display in the last decades of the nineteenth century.

Salon des Indépendants An alternative to the official **Salon**, the Salon des Indépendants was an annual display sponsored by the Société des Indépendants, an inclusive artists' organization founded in 1884 by Odilon Redon, Georges Seurat, Paul Signac and others who opposed the exclusionary policies of France's arts establishment. Nonjuried, the Salon des Indépendants provided exhibition space for any artist who wished to exhibit (and paid a fee). It was a major showcase of the avant-garde from the mid-1880s to 1914.

Symbolism The literary movement known as Symbolism arose in opposition to literary naturalism. Dedicated to the imaginative evocation of amorphous inner states (rather than the description of material realities), Symbolism gathered steam in Paris in the mid-1880s, as Zola's former disciple, J-K Huysmans, made waves with his *À Rebours* (1884) – a much-discussed paean to esoteric aestheticism – and poets Jean Moréas and Gustave Kahn published Symbolist manifestos in Parisian dailies. With Stéphane Mallarmé (whose praises were sung in *À Rebours*) as its guiding light, ambiguous suggestiveness became literary Symbolism's hallmark. Visual artists intent on expressing inner states struggled towards equivalent allusiveness – so long as their work remained representational. Though some tapped the communicative potential of unnatural colour and exaggerated space and line, many *fin-de-siècle* painters who aspired to 'Symbolism' fell back on conventional symbols and allegory to communicate meaning.

Tableau French for 'picture' and 'painting', *tableau* denotes a finished work intended for display (rather than a sketch or study).

Les Vingt A Belgian exhibition society, founded in 1883 by a group of unconventional artists who voted the organization's dissolution in 1893. French for 'the twenty', Les Vingt (alternately written Les XX), began with just eleven members (including James Ensor, Fernand Khnopff, and Théo Van Rysselberghe) who invited other progressive artists to join them. In *Les Vingt*'s ten-year history, thirty-two artists became affiliates (Anna Boch, Félicien Rops, Paul Signac and Jan Toorop among them), though not all at once. Committed to artistic freedom, Les Vingt did not advocate any one style, but instead had links to several movements (Impressionism, **Neo-Impressionism**, **Symbolism**, Art Nouveau). The group promoted vanguard music, poetry and decorative arts through its official organ *L'Art Moderne* (1881–1941), a periodical that predated and outlived it, but achieved real prominence through the exhibitions it sponsored, which were showcases of cutting-edge Belgian and French production.

Ukiyo-e Usually translated, 'pictures of the floating world', the term *ukiyo-e* derives from the Japanese word '*ukiyo*', a proper noun denoting the brothel and theatre district of Edo (now Tokyo) during the reign of the Togukawa shoguns. (As a common noun, '*ukiyo*' refers to the here and now.) The suffix 'e' means image or painting. *Ukiyo-e* thus describes paintings and prints that deal with the world of pleasure and entertainment and, more specifically, those made in Edo during the Tokugawa shogunate (1615–1868) – an epoch known as the Edo period. While the earliest *ukiyo-e* prints took up the contemporary urban subjects their name implies, landscape became a popular pictorial subject in the Edo period's last decades. *Ukiyo-e*'s links to Impressionism are both stylistic and thematic, but later French painters were more interested in its formal stylizations than its subject matters.

Brief Biographies

Louis Anquetin (1861–1932) After youthful explorations of Impressionism and **Neo-Impressionism** while studying at **Fernand Cormon**'s studio in Montmartre, Anquetin joined forces with **Émile Bernard** and devised the *japoniste* style that came to be known as **cloisonnism**. He achieved fleeting notoriety among the Parisian **avant-garde**, but soon relinquished cloisonnism's strong, dark outlines and unmodulated hues. In the 1890s he shifted gears, turning to allegorical and narrative subjects, and looked to the Old Masters for formal inspiration.

Georges-Albert Aurier (1865–92) Aurier, a Symbolist poet, playwright and novelist, is best known for the extravagant art criticism he penned for *Mercure de France* around 1890. Trained as a lawyer, Aurier never practised, instead immersing himself in subjectivist philosophy and publishing poems in Symbolist periodicals. His acquaintance with **Émile Bernard** piqued his interest in contemporary art, particularly that of Van Gogh, **Gauguin** and the painters known as the Nabis. Aurier advocated an art of ideas, and identified Gauguin as its supreme practictioner in an 1891 essay on 'Symbolism in Painting'. Food poisoning caused his death the following year.

Émile Bernard (1868–1941) A force in French painting while still in his teens, Bernard retreated from art's cutting edge early on. He is as well known for his writings on art – particularly his published dialogues with the recluisive Paul Cézanne and his correspondence with and recollections of Van Gogh – as for the innovative paintings he made in the late 1880s. From 1884 to 1886, Bernard worked in the studio of French academician **Fernand Cormon**, where he met **Louis Anquetin**, his collaborator in the development of **cloisonnism** in 1887-8. The radical stylizations of Bernard's cloisonnist *Breton Women in a Meadow* caught the attention of Gauguin, who adopted them to striking effect in *The Vision after the Sermon* in 1888. In the 1890s, however, Bernard fell out with Gauguin and reverted to a more traditionalist manner. In later life, he was disappointed by critics' failure to acknowledge adequately his contributions to the course of modernism.

Siegfried Bing (1838–1905) A notable *japoniste* and pivotal figure of Art Nouveau, Bing was a dealer and collector who became an arbiter of taste in *fin-de-siècle* Paris. Trained as an industrial designer in his native Germany, Bing continued his studies in Paris. After travelling in the Far East in the 1870s, he opened an Asian crafts shop in the French capital. In the 1880s he established himself as one of **japonisme**'s most illustrious proponents. A connoisseur and scholar, Bing built an outstanding private collection, organized exhibitions, and circulated his views in his periodical *Le Japon artistique* (1888–91). He had his own pavilion, Art Nouveau Bing, at the 1900 Universal Exposition.

Charles Blanc (1813–82) Trained as an engraver, Blanc also worked as France's director of fine arts under liberal administrations. His first love, however, was critical writing and theorizing. Blanc founded the enduring journal *Gazette des Beaux-Arts* in 1859, taught aesthetics at the Collège de France, and authored the widely read *Histoire des peintres de toutes les écoles* (*History of Painters of All Schools*; 1853–75), *Artistes de mon temps* (*Artists of my Time*; 1876), and *Grammaire des arts du dessin* (*Grammar of the Visual Arts*; 1867).

George Hendrik Breitner (1857–1923) Trained in drawing and painting at The Hague (where he studied with Willem Maris), Bretiner also worked as a photographer. Though he took up **plein-air** painting under their influence, Breitner rejected **The Hague School**'s picturesque rusticity, preferring cityscapes – which he made in Paris, London, Berlin and his native Holland. A devotee of fleeting effects and the dynamism of urban life, Breitner became part of the Amsterdam Impressionist school after settling in that city in the mid-1880s.

Fernand Cormon (pseudonym of Fernand-Anne Piestre, 1845–1924) A pupil of academicians Alexandre Cabanel and Eugène Fromentin, Cormon made his **Salon** debut in 1868, and won the Prix de Salon in 1875. He specialized in allegorical and narrative works, including scenes of prehistoric life. His large panels decorate several public spaces, including Paris's Museum of Natural History and Petit Palais. Despite his own conservatism, Cormon ran a fairly freewheeling studio; in addition to **Anquetin**, **Bernard**, Toulouse-Lautrec and Van Gogh, the young Henri Matisse studied there.

Alphonse Daudet (1840–97) Born at Nîmes, in Provence, Daudet worked as a teacher in Arles before moving to Paris and establishing himself as a novelist, dramatist and writer of short stories. Often autobiographical, his work was praised for its warmth, humour and vivid characterizations. In novels including *Froment jeune et Risler ainé*, *Les Rois en exil (Kings in Exile)* and *Le Nabab*, Daudet took up Pairisian social life under the Second Empire (1852–70), while his Provençal background shaped his popular *Tartarin* trilogy and *Lettres de mon moulin* (*Letters from my Windmill*; 1869).

Théodore Duret (1838–1927) His father's wealth allowed Duret to devote himself to art collecting and criticism as well as leftwing politics. A

friend and supporter of Édouard Manet, Duret also took an active interest in Impressionism and the English art scene. His enthusiasm for **ukiyo-e** was born of a trip to the Far East in 1870. Thereafter, he became a well-known collector and connoisseur of Japanese prints, illustrated books and albums, and was one of France's most astute commentators upon them. Duret's *Histoire des peintres impressionistes* (1878) ties Impressionist style to *ukiyo-e* as well as the **Barbizon School**. His *Critique d'avant-garde* (1885), a collection of essays in which he ruminates upon contemporary philosophy and music as well as the art of Manet and **Hokusai**, reveals the range of his interests and expertise.

Paul Gauguin (1848–1903) A talented print-maker, ceramicist and sculptor, Gauguin is best known for his paintings of the South Seas. Born in Paris, he spent his early childhood in Lima, Peru, where his maternal grandfather – the descendent of Spanish colonists – resided. Returned to France at seven, Gauguin was schooled at Orléans before enlisting in the merchant marine. After five years at sea, he settled in Paris and found work on the stock exchange. Acquaintance with Camille Pissarro led Gauguin to make and collect art. He first showed with the Impressionist group in 1881, and left the financial world in 1883. His pursuit of an economical, non-urban existence prompted travels to Brittany, Panama and Martinique – as well as his brief stay with Van Gogh in the South of France. In 1888, work with Émile Bernard brought Gauguin to a turning point in his career: under the influence of **cloisonnism**, he developed the personal style he called Synthetism – a synthesis of his wide-ranging enthusiasms (for Degas's compositions, Cézanne's brushwork, japoniste stylizations, and the 'primitive' forms of artefacts he admired at the 1889 World's Fair in Paris). Synthetism's most notable aspect, perhaps, is its celebration of imagined rather than observed motifs – an antinaturalism that allies it to the literary **Symbolism** in vogue at that time. Gauguin's first trip to Tahiti (1891–3) yielded a published 'diary', *Noa Noa*, which fuelled his celebrity as a primitivist and shed light on the colonialist sensibility that shaped his vibrantly hued images of exotic paradise. He returned to the South Seas in 1895 and died in the Marquesas.

Edmond and Jules de Goncourt (1822–96; 1830–70) Both Goncourts began as artists, but, as a fraternal team, they achieved renown as writers, producing novels, plays, art and social histories, and a journal (which Edmond kept up after Jules's death) that provides an intimate account of Parisian society from 1851 to 1896. Aficionados of eighteenth-century style and manners, the Goncourts published volumes on its leading artists, as well as on eighteenth-century women and French life during the Revolution (1789–91) and under the Directory (1795–9). Their novels focus on the lives of nineteenth-century working women – a segment of society that previous literature rarely touched upon. After Jules's death, Edmond wrote a tribute to brotherly collaboration in the novel *Les Frères Zemganno* (1879), and penned two more novels on contemporary women, *La Fille Élisa* (1877) and *Chérie* (1884). Having decided

that *Chérie* would be his final work of fiction, he used its preface to review his and his brother's achievements, asserting that publication of the Goncourts' *Germinie Lacerteux* (1865) launched the naturalist movement **Émile Zola** claimed as his own. Edmond's will provided for the establishment of the Goncourt Academy, which continues to award an annual fiction prize.

Andō Hiroshige (1797–1858) One of the most prolific and best-loved artists of **ukiyo-e**, Hiroshige was a master of boldly hued and subtly shaded landscape prints. As a young man, he studied with artists of the Kano and Utagawa schools, and, at the same time, became aware of the Western-influenced landscapes coming out of Nagasaki. Hiroshige came into his maturity in the heyday of polychrome prints (**nishiki-e**) and designed some 5,000 colour woodblocks, many of them lyrical renderings of well-known vistas and tourist meccas.

Katsushika Hokusai (1760–1849) An immensely productive and versatile artist, Hokusai is renowned for his technical virtuosity, compositional vigour and humorous whimsicality. A colourful personality and relentless self-promoter, he was **ukiyo-e**'s pre-eminent practitioner, and is credited with adding landscape to its repertoire. Hokusai's reputed eccentricity informs his widely admired and emulated *Thirty-Six Views of Mt Fuji* (1831) – a suite in which naturalism and exaggeration mingle and the famed peak often plays second fiddle to arresting foreground motifs. In addition to such wildly popular polychrome prints, Hokusai produced at least 30,000 black-and-white drawings over the course of his 70-year career. Those collected in his famed *manga* (sketches) – a fifteen-volume picture book (1814–78) that provides a vivid overview of Hokusai's Japan – were particularly influential in the West in the later nineteenth century.

Pierre Loti (pseudonym of Julien Viaud, 1850–1923) A French naval officer who retired with the rank of captain in 1910, Loti wrote novels and travel books on the side. His picaresque romances set in exotic locales – such as *Rarahu* (reprinted as *The Marriage of Loti;* 1880), a novel of Tahiti, and the *japoniste Mme Chrysanthème* (1887) – celebrate the 'primitivism' and sexual adventurism he viewed through a colonialist lens. Critics preferred the more sombre narratives that unfold in the French provinces, including *Pêcheur d'Islande (An Icelandic Fisherman;* 1886) – a saga of Breton fisherfolk that won Loti a prize from the French Academy and abetted his election to that body in 1891 (beating **Émile Zola**).

Guy de Maupassant (1850–93) Born in Normandy to an aristocratic family, Maupassant was a protégé of Gustave Flaubert in his youth, but spent nearly a decade working as a government functionary before devoting himself to fiction. The author of six novels, he is better known for his 360-odd short stories. Maupassant, whose work is marked by his sardonic wit, knack for local colour and eye for the telling detail, made his literary debut in 1880, when one of his stories was published in a collection of tales by **Émile Zola** and his followers. In his subsequent association with that circle, Maupassant

adopted a rather naturalist outlook, though he refuted his membership in any single school. Syphilis induced the dementia that led to Maupassant's suicide attempts, insanity, and eventual institutionalization.

Anton Mauve (1838–88) Born in Zaandam, Mauve studied with animal painter P F van Os. Heavily influenced by French landscapists of the nineteenth century, Mauve adopted both the naturalist approach of the **Barbizon School** and the silvery tonalities favoured by Corot. A leading light of **The Hague School** from 1871 to 1885, Mauve specialized in beach scenes as well as farm animals. He married a Van Gogh cousin, Jet Carbentus, in 1874, and tutored Van Gogh in drawing and watercolour in 1881 and 1882. Mauve retreated to small-town life at Laren in his last years.

Jules Michelet (1798–1874) A historian possessed of great Romantic vision, Michelet is best known for his multivolume *History of France* (1833–67). In the 1830s and 1840s, Michelet – a section chief at the National Archives and professor at the Collège de France – was a vociferous opponent of monarchy, aristocracy and the Catholic Church's dominant role in French society. When he refused to swear allegiance to the newly declared Second Empire in 1851, Michelet was dismissed from both posts. In his later years, he turned to books on nature and romantic love.

Jean-François Millet (1814–75) A renowned painter of peasants, Millet, the son of prosperous farmers, grew up in rural Normandy. After studies with Paul Delaroche in Paris, Millet commenced his career as a portraitist, and had a portrait accepted to the **Salon** of 1840. He became acquainted with the **Barbizon** circle after meeting Théodore Rousseau, and settled in the village in 1849. Using an earthy palette and broad facture, Millet painted rural genre subjects there, many of them tinged by memories of Norman farm life. He took up proletarian subjects in a political climate charged by Marx and Engels's *Communist Manifesto* and the 1848 workers' revolt that forced King Louis-Philippe's abdication and the formation of a short-lived Republican government. In this context, Millet's genre scenes were widely interpreted as sociopolitical statements, and drew impassioned commentary from both left- and rightwing critics. By 1860, however, his work was widely respected. Millet was honored with a retrospective at the 1867 Universal Exposition and awarded the Legion of Honour in 1868. In retrospect, his *oeuvre* seems more conservative than radical, dominated by nostalgic celebrations of reassuring continuities in country life.

Anthon Ridder van Rappard (1858–92) The scion of an aristocratic family, Van Rappard began his art studies at the Amsterdam Academy. He met Theo van Gogh while studying with French academician Jean-Léon Gérôme in Paris, and befriended Vincent van Gogh in Brussels, when 'Rappard' (as Vincent addressed him) was enrolled at the Académie Royale des Beaux-Arts in Brussels. A draughtsman and watercolourist as well as a painter, Van Rappard

was preoccupied with technical issues. Having started as a landscapist, he was increasingly interested in modern figuration (thanks, perhaps, to Van Gogh) and produced industrial scenes as well as portraits.

Théophile Thoré (1807–69) Thoré established his anti-establishment credentials by championing Delacroix and the **Barbizon School** in his early critical essays. A staunch Republican, he lived outside France during Napoleon III's early years in power, and spent a good portion of his decade-long exile (1849–59) researching painters of the northern school. Writing under the pseudonym Willem Bürger, Thoré characterized the realism of Dutch seventeenth-century painting as a natural outgrowth of the democratic society that produced it, and lauded its down-to-earth accessibility and popular appeal. He participated in the reappraisal of Frans Hals, and spearheaded Jan Vermeer's nineteenth-century 'rediscovery'.

Émile Zola (1840–1902) Reared in Aix-en-Provence, Zola moved to Paris in 1858, where he supported himself as a journalist before his literary career took off. In the 1860s, he entered the orbit of Manet (who painted Zola's portrait in 1868), and began to publish art reviews in which he took up the causes of **avant-garde** painters, including Monet and Pissarro. Meantime, under the influence of the novelist Honoré Balzac, the positivist philosopher Hippolyte Taine and the physiologist Claude Bernard, Zola began to define himself as a novelist. Hoping to revolutionize the art of fiction, he took cues from observational science, drawing characters from close examinations of contemporary life, and using the novel as a laboratory of sorts – one in which Taine's assertion that individual personality was shaped by genetics, environment and the spirit of one's age, would play out. Zola's approach became known as **naturalism** and his *magnum opus*, *Les Rougon-Macquart* (1871–93), is that movement's monument. A twenty-novel suite devoted to a single extended family (whose members people every sector of French society), it was conceived as 'a natural and social history', albeit fictional, and includes Zola's best-known novels (*L'Assommoir, Germinal, La Terre, La Bête Humaine*). Its volumes explore the lurid underbelly of Parisian high life, lay out the nefarious dealings of corrupt politicians and unscrupulous businessmen, and bluntly detail the labourer's existence. Despite pretensions to unflinching, 'scientific' truthfulness, Zola is an emotive writer whose prose is enlivened by coarse argot, ribald humour and poetic descriptiveness. His numerous essays on art call on painters to be true to nature, but above all true to themselves, as Zola defines art as 'nature seen through a temperament'. Zola's art-world novel, *L'Oeuvre* alienated him from painter friends (including Cézanne, whom he had known from childhood), but in 1898 Zola won admiration in the political realm: publication of 'J'accuse', a courageous defence of Army captain Alfred Dreyfus (an Alsatian Jew who had been wrongly accused of espionage and deported) led to the author's own year-long exile from France.

The Life and Art of Vincent van Gogh

A Context of Events

1853 Vincent van Gogh born in Zundert, Northern Brabant, The Netherlands, 30 March

1853 Crimean War begins (to 1856).
US Navy Commodore Matthew C Perry arrives in Japan, with fleet of armed ships, to open trade with the West. Treaty signed 1854.
Georges Haussmann begins rebuilding of Paris.
C H Spurgeon begins preaching in London

1854 Dickens, *Hard Times*

1855 Livingstone 'discovers' Victoria Falls

1856 Félix Bracquemond, one of the first proponents of *japonisme*, comes across Hokusai's *manga* in a Paris shop

1857 Millet paints *The Gleaners*

1859 Darwin, *On the Origin of Species*

1861 Civil War between northern and southern states begins in United States (to 1865)

1862 Bismarck becomes Prussian premier.
Two purveyors of *japonaiserie* open in Paris: Mme Desoye's shop and La Porte Chinoise.
Hugo, *Les Misérables*

1863 Salon des Refusés staged in Paris; Manet shows *Déjeuner sur l'herbe*.
Renan, *Vie de Jésus*.
Death of Delacroix

1864 Sent to boarding school at Zevenbergen (to 1866)

1864 Louis Pasteur invents process of pasteurization

1865 Abraham Lincoln assassinated.
Goncourt brothers, *Germinie Lacerteux* [131, 186]

1866 Secondary school at Tilburg, where he studies with Constantijn Huysmans (to 1868) [6, 7]

1866 Prussia defeats Austria at Battle of Sadowa.
Alfred Nobel invents dyamite.
Zola, *Mes Haines*

1867 Emperor Franz Joseph I becomes King of Hungary (Austro-Hungarian monarchy endures to 1916).
Mexican Revolution.
Canada becomes a dominion.
Universal Exposition in Paris features a display of Japanese prints.
Marx, *Das Kapital*, Volume 1.
Charles Blanc, *Grammaire des arts du dessin* [54].
Goncourt brothers, *Manette Salomon* [186]

1869 Moves to The Hague, where he joins Goupil & Co

1869 Opening of Suez Canal.
End of feudalism in Japan.
Daudet, *Lettres de mon moulin*.
Deaths of Berlioz and Thoré (Bürger)

1870 Franco-Prussian War begins.
Heinrich Schliemann starts to excavate Troy

1871 Wilhelm I proclaimed German Emperor.
Paris capitulates to Prussians; armistice signed.
Rise and fall of the Commune in Paris.
Stanley and Livingstone meet at Ujiji.
Zola, first volume of *Les Rougon-Macquart*.
Verdi, *Aida*

The Life and Art of Vincent van Gogh	A Context of Events
1872 Correspondence with Theo begins	**1872** D L Moody and I Sankey begin revivalist meetings in England. Thomas Edison perfects the telegraph. Remington company makes first successful typewriter. Dealer Paul Durand-Ruel stages first of four exhibits of Impressionist pictures in London (1872–5). Daudet, first volume of *Tartarin* trilogy
1873 Theo joins Goupil & Co, starting at the Brussels branch and transferring to The Hague once Vincent moves to the London office in May. In transit, Vincent makes first trip to Paris	**1873** Napoleon III dies in England. Six-year French economic depression begins with market crash in Paris
1874 Failed romance leaves Van Gogh despondent	**1874** First Impressionist exhibition [16]
1875 Transferred to Goupil's Paris office	**1875** Deaths of Millet and Corot. Edmond Duranty, *La Nouvelle Peinture*
1876 After his dismissal from Goupil in January, Van Gogh moves to England, where he works as a teacher and assists the Revd Thomas Slade-Jones in his ministry [17]. Van Gogh preaches his first sermon in November, then travels to Holland to spend Christmas with his family	**1876** Alexander Graham Bell patents the telephone. Thomas Edison invents the phonograph. Wagner's Bayreuth Festival Theatre opens, with first performance of *Der Ring des Nibelungen*. Gauguin exhibits at the Salon
1877 At his parents' insistence, Van Gogh relinquishes plans to return to England. After a few months in Dordrecht, where he works for a bookseller, he settles at an uncle's home in Amsterdam and prepares for university entrance exams	**1877** Britain annexes Transvaal as colony. Queen Victoria proclaimed Empress of India. Zola, *L'Assommoir*. Goncourt brothers, *La Fille Élisa* [79]
1878 Abandons preparatory studies in July, enrolling instead at an evangelists' training programme in Belgium. Unhappy there, he takes up a mission in the Borinage, a coal-mining district in southern Belgium [18], where he works as a minister's assistant	**1878** Bronzes and lacquers from collections of Philippe Burty and Siegfried Bing are among the multitude of works on display in the Japanese pavilion at the Universal Exposition in Paris. Death of Daubigny
1879 Relieved of his ministerial duties by Synodal Committee, which judges him devoted but ill-suited to preaching, Van Gogh despairs of his future	**1879** Thomas Edison invents the electric light. Transvaal Republic proclaimed
1880 Reads 'issue novels' by Beecher-Stowe [174], Dickens and Hugo. Enters a self-described 'moulting time', during which he decides to devote himself to art-making. In addition to drawing miners in the Borinage [19], Van Gogh works from Charles Bargue's drawing manuals, and copies figural works by Jean-François Millet [3, 20]. In the autumn, moves to Brussels, where he meets Anthon van Rappard. Theo, meantime, is promoted to Goupil's Paris organization (now run by Boussod and Valadon), and begins to contribute to his brother's financial support	**1880** Boers revolt against British in South Africa. Electric lights illuminate New York streets. First piano works by Claude Debussy. Tinned foodstuffs begin to be marketed
1881 Relocates to Holland, and lives with his parents in the village of Etten. Tackles Dutch landscape [22]; works with the visiting Van Rappard; and continues copy work from Bargue and Millet. Falls in love with a recently widowed cousin, who does not return his feelings. In September, visits The Hague, where he renews acquaintance with painters he had known as a dealer there, most notably Anton Mauve [23]. Returns to work with Mauve in November–December [29]. After quarrelling with his father on Christmas Day, Van Gogh returns to The Hague yet again, this time to remain for twenty months	**1881** Russia's Alexander II is assassinated. Siemans builds first electric tram in Berlin. Canadian Pacific Railway founded. Japanese women are permitted to act on the stage. Death of Carlyle

The Life and Art of Vincent van Gogh	A Context of Events

1882 In the first months of the year, Van Gogh works with Mauve and attends life-drawing classes at The Hague's Pulchri Studio. Meets and works with G H Breitner, and makes a suite of city views commissioned by his uncle Cor [30, 31]. Establishes a domestic partnership with Clasina (Sien) Maria Hoornik [32, 34, 35], which leads to his estrangement from Mauve and others. Makes his first oil paintings in autumn [44]

1883 Relationship with Hoornik deteriorates. In September, Van Gogh leaves The Hague for a painting expedition in Drenthe, a northeastern Dutch province [45]. In December, moves in with his parents – now living in Nuenen. He will spend the next two years there

1884 Makes a series of pictures of weavers [47, 49]. Takes on three students from a nearby town. Studies Charles Blanc's *Grammaire des arts du dessin* [54] and becomes interested in colour theory. Pursues a scandalous affair with a neighbour, which ends when she attempts suicide. Begins his series of 'peasant heads' [46, 56, 58]

1885 Death of his father. Paints *The Potato Eaters* [61], and breaks with Van Rappard, who dislikes the painting. Accused of impregnating an unmarried local who had posed for him, Van Gogh is condemned by village priests and shunned by former models; turns to still life in lieu of figural work [63, 64]. After a trip to Amsterdam longs for life in a vibrant arts community. Leaves Nuenen for Antwerp at year's end, to reside there for three months. Discovers Japanese prints

1886 Works at Antwerp Academy in January and February. Moves to Paris in March. Lives with Theo, who introduces him to Impressionism. Examines the Neo-Impressionism of Georges Seurat [73] and his disciples at the last Impressionist exhibition and the Salon des Indépendants. Works in the studio of Fernand Cormon [77], where he meets Louis Anquetin, Émile Bernard, John Russell and Henri de Toulouse-Lautrec [76]. Frequents Julien Tanguy's art supplies shop in Montmartre, a painters' hangout where Van Gogh meets Charles Angrand and Paul Signac. Paints floral still lives [74] and Montmartre views [68–71]

1887 Displays selections from his growing collection of Japanese prints at Le Tambourin, a Montmartre cafe [89]. Introduces Anquetin and Bernard to Siegfried Bing's emporium – Van Gogh's favourite source for *ukiyo-e*. Works with Paul Signac [81] in the spring, and flirts with pointillism [82–4], though Van Gogh reverts to broad brushstrokes after Signac departs Paris in late May [85]. Often paints with Anquetin and Bernard thereafter. All three explore *japonisme* [92, 108, 109]. Paints portraits, two of which are sold by Tanguy. Organizes the exhibition of his and his friends' recent paintings held at the Grand-Bouillon-Restaurant du Chalet in November. Meets Paul Gauguin (newly returned from Martinique); trades two of his own paintings for one of Gauguin's recent pictures [123]

1882 Italy joins Germany and Austria to form Triple Alliance.
Daimler builds petrol engine.
First hydroelectric plant opens (Appleton, Wisconsin).
The idea of a Channel Tunnel is first discussed in Britain; military authorities against it.
German bacteriologist Robert Koch discovers tuberculosis bacillus

1883 Paul Kruger becomes president of South African Republic.
Metropolitan Opera founded in New York.
First skyscraper (10 stories) built in Chicago.
Les Vingt founded in Brussels.
Zola, *Au Bonheur des dames* [79].
Deaths of Manet and Wagner

1884 Les Vingt mounts its first show.
Society of Independent Artists is founded in Paris and holds its first exhibition; Seurat shows *Bathers at Asnières*, his first major work.
Edmond de Goncourt, *Chérie*.
Zola, *La Joie de vivre* [64]

1885 Congo State established under Leopold II of Belgium, as his personal possession.
Germany annexes Tanganyika and Zanzibar.
Daimler improves internal combustion engine and Karl Benz builds single-cylinder engine for motorcar.
Die Nieuwe Gids founded by progressive Dutch poets in Amsterdam.
Zola, *Germinal*.
Maupassant, *Bel-Ami* [131]

1886 Britain annexes Upper Burma.
Rightwing general and hardline nationalist Georges Boulanger is appointed French minister of war.
Statue of Liberty erected in New York Harbor
Last Impressionist exhibition (the eighth); Seurat shows *Sunday Afternoon on the Island of La Grande Jatte*.
Zola, *L'Oeuvre*.
Loti, *Pêcheur d'Islande*.
Richepin, *Braves Gens* [79]

1887 Britain annexes Zululand and holds first Colonial Conference; British East Africa Company chartered.
Daimler builds four-wheeled car with petrol engine.
Heinrich Herz produces radio waves.
Construction of Eiffel Tower begins in Paris.
Bing organizes exhibition of Japanese art at Central Union of Decorative Arts, Paris.
Loti, *Mme Chrysanthème*

The Life and Art of Vincent van Gogh	A Context of Events

1888 Leaves Paris for Arles in February. Paints flowering orchards [115] and attempts to refine his drawing style under the influence of *ukiyo-e* [114, 119]. In May, rents the Yellow House [96], which encourages his thoughts of establishing an artists' commune at Arles (the 'studio of the South'). His new studio space also encourages portrait-making, which Van Gogh takes up in earnest, painting Zouave soldiers [132, 133, 140], women of Arles [129, 134], and types ranging from 'peasant' to 'poet' to 'postman' [135, 138, 139, 141]. Also paints his *Bedroom* [122], a series of *Sunflowers* [126], and *The Night Cafe* [152]. Gauguin joins him for several weeks, but competitiveness and artistic and personal differences cause tensions that flare in a violent quarrel on 23 December. In its aftermath, Van Gogh severs his left earlobe, and is hospitalized [151]. Gauguin retreats to Paris

1888 Wilhelm II becomes German Emperor.
Pasteur Institute founded in Paris.
George Eastman builds 'Kodak' box camera.
Bing begins publication of *Le Japon artistique*.
Gauguin, *Vision After the Sermon* (consigned to Theo van Gogh for sale) [125]

1889 Van Gogh spends the first months of the year alternately recuperating and relapsing, but manages to paint several versions of *La Berceuse* [154]. Theo marries Johanna Bonger in April. In May, Vincent voluntarily enters Saint-Paul-de-Mausole, an asylum in Saint-Rémy. Initially paints within its walls [161, 162], but soon ventures into surrounding fields and foothills [164]. Paints *Starry Night* [165] in June. Revisits Arles and has severe breakdown in July. In the autumn, Van Gogh's work is seen at the Salon des Indépendants; Les Vingt invites him to exhibit in Brussels in early 1890; and he writes impassioned letters on art-making to Bernard and Gauguin. Paints *Asylum Garden* [171], as well as oil 'translations' of favourite prints [169]. Falls ill once more at Christmas time

1889 Boulanger elected parliamentary deputy in Paris, but the government fears a *coup d'état* and issues a warrant for his arrest for treason. He flees to Brussels.
The just-completed Eiffel Tower is the centrepiece of the Universal Exposition in Paris. A celebration of the centenary of France's great revolution, the expo draws some 28 million visitors.
Constitutional monarchy established in Japan.
Moulin Rouge opens in Montmartre.
Edvard Munch's first trip to Paris

1890 In January, Van Gogh's *Red Vineyards* [193] is purchased by Anna Boch, a member of Les Vingt who sees it at that group's exhibition in Brussels. At the same time, Albert Aurier's enthusiastic essay on Van Gogh appears in *Mercure de France*. Theo's son is born 31 January; Vincent suffers a severe collapse shortly thereafter. As he struggles towards recovery at Saint-Rémy, ten of Van Gogh's paintings are shown at the Salon des Indépendants. Van Gogh leaves the asylum and in mid-May spends a few days in Paris before settling in Auvers-sur-Oise, where he is befriended by Dr Paul Gachet. Paints several portraits (including Gachet's) [183, 186] and numerous horizontal landscapes known as 'double squares' [182, 184, 189–91]. Theo's financial difficulties weigh on Vincent's mind after his day trip to Paris in early July. On 27 July, he shoots himself. Dies 29 July, with Theo beside him. Bernard helps organize the memorial exhibit held at Theo's Paris apartment in September

1890 Wilhelm II dismisses Bismarck.
Grand Duchy of Luxembourg separates from Netherlands on accession of Queen Wilhelmina.
First general elections in Japan.
First 'tube' railway passes beneath the Thames in London.
Pierre Puvis de Chavannes, Auguste Rodin and others form the Société Nationale des Beaux-Arts, with the aim of establishing a liberal alternative to the Salon; hold first Champs de Mars exhibition [181]

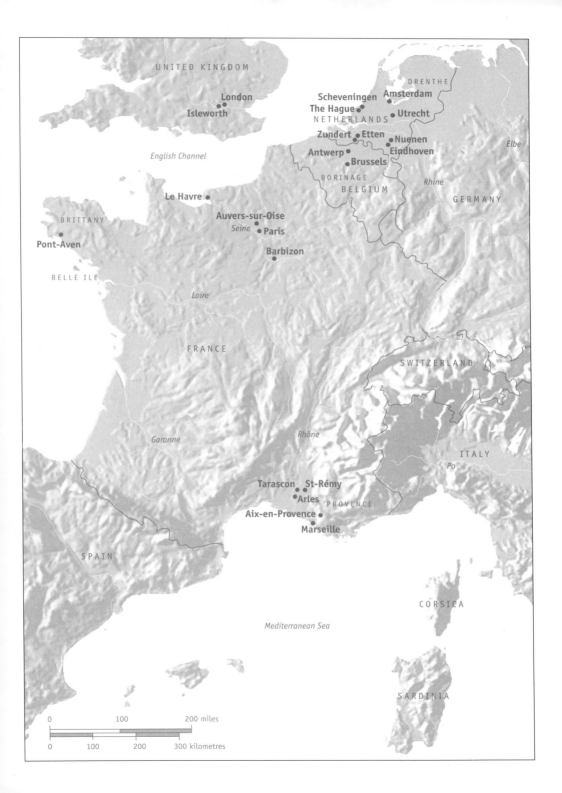

UNITED KINGDOM

London

Isleworth

English Channel

BRITTANY

Pont-Aven

BELLE ILE

Le Havre

Auvers-sur-Oise

Seine

Paris

Barbizon

Loire

FRANCE

Garonne

Rhône

Tarascon

St-Rémy

Arles

PROVENCE

Aix-en-Provence

Marseille

SPAIN

Mediterranean Sea

Scheveningen

Amsterdam

The Hague

DRENTHE

NETHERLANDS

Utrecht

Zundert

Etten

Nuenen

Antwerp

Eindhoven

Brussels

Elbe

BORINAGE

BELGIUM

Rhine

GERMANY

SWITZERLAND

ITALY

Po

CORSICA

SARDINIA

0 100 200 miles

0 100 200 300 kilometres

Further Reading

General

Douglas Druick and Peter Kort Zegers,
Van Gogh and Gauguin: The Studio of the South
(exh. cat., The Art Institute of Chicago;
Van Gogh Museum, Amsterdam, 2001)

Vincent van Gogh, *The Complete Letters of
Vincent van Gogh* (Boston, 2000)

Jan Hulsker, *Vincent and Theo van Gogh:
A Dual Biography* (Ann Arbor, MI, 1990)

—, *Vincent van Gogh: A Guide to His
Work and Letters* (Amsterdam, 1993)

—, *The New Complete van Gogh: Paintings,
Drawings, Sketches* (Amsterdam and
Philadelphia, 1996)

Sven Løvgren, *The Genesis of Modernism:
Seurat, Van Gogh, Gauguin and French
Symbolism in the 1880s* (Stockholm, 1959)

John Rewald, *Post Impressionism: From Van Gogh
to Gauguin* (New York, 1956)

Mark Roskill, *Van Gogh, Gauguin, and the
Impressionist Circle* (Greenwich, CT, 1970)

Meyer Schapiro, *Van Gogh* (New York, 1950)

Susan Alyson Stein, *Van Gogh: A Retrospective*
(New York, 1986)

Judy Sund, *True to Temperament: Van Gogh and
French Naturalist Literature* (New York, 1992)

David Sweetman, *The Love of Many Things:
A Life of Vincent van Gogh* (London, 1990)

Evert van Uitert and Michael Hoyle (eds), *The
Rijksmuseum Vincent van Gogh* (Amsterdam,
1987)

Evert van Uitert, Louis van Tilborgh and Sjraar
van Heugten, *Vincent van Gogh: Paintings* (exh.
cat., Rijksmuseum Kröller-Müller, Otterlo and
Rijksmuseum Vincent van Gogh, Amsterdam,
1990)

Bogomila Welsh-Ovcharov (ed.), *Van Gogh in
Perspective* (Englewood Cliffs, NJ, 1974)

Johannes van der Wolk, Ronald Pickvance and
E B F Pey, *Vincent van Gogh: Drawings* (exh.
cat., Rijksmuseum Kröller-Müller, Otterlo and
Rijksmuseum Vincent van Gogh, Amsterdam,
1990)

Chapter 1

Martin Bailey, *Van Gogh in England: Portrait of
the Artist as a Young Man* (exh. cat., Barbican
Art Gallery, London, 1992)

Elisabeth Jay, *The Religion of the Heart:
Anglican Evangelicalism and the Nineteenth-
Century Novel* (Oxford, 1979)

Frances Suzman Jowell, *Thoré-Bürger and the
Art of the Past* (New York, 1977)

Tsukasa Kōdera, *Vincent van Gogh: Christianity
versus Nature* (Amsterdam and Philadelphia,
1990)

John Silevis, Ronald de Leeuw and Charles
Dumas, *The Hague School: Dutch Masters of
the 19th Century* (exh. cat., Royal Academy of
Arts, London, 1983)

Louis van Tilborgh and Marie-Piere Salé, *Millet,
Van Gogh* (exh. cat., Musée d'Orsay, Paris, 1998)

Chapter 2

William J Burg, *The Visual Novel: Emile Zola and
the Art of his Times* (University Park, PA, 1992)

Griselda Pollock, 'Stark Encounters: Modern Life
and Urban Work in Van Gogh's Drawings of The
Hague 1881–1883', *Art History*, 6 (1983),
pp.330–58

Lauren Soth, 'Fantasy and Reality in The Hague
Drawings', in *Van Gogh Face to Face: The
Portraits* (exh. cat., Detroit Institute of Arts,
2000), pp.61–77

Carol Zemel, 'Sorrowing Women, Rescuing Men:
Images of Women and Family', in *Van Gogh's
Progress: Utopia, Modernity, and Late-
Nineteenth-Century Art* (Berkeley, CA, 1997),
pp.15–52

Chapter 3

Griselda Pollock, 'Van Gogh and The Poor Slaves:
Images of Rural Labour as Modern Art', *Art
History*, 11 (1988), pp.406–32

Frances S Jowell, 'The Rediscovery of Frans
Hals', in Seymour Slive (ed.), *Hals* (exh. cat.,
National Gallery of Art, Washington, DC; Royal
Academy of Arts, London; Frans Halsmuseum,
Haarlem, 1989), pp.61–86

Misook Song, *Art Theories of Charles Blanc,
1813–1882* (Ann Arbor, MI, 1984)

Louis van Tilborgh *et al.*, *The Potato Eaters
by Vincent van Gogh* (Zwolle, 1993)

Carol Zemel, 'The "Spook" in the Machine:
Pictures of the Weavers in Brabant', in *Van
Gogh's Progress: Utopia, Modernity, and Late-
Nineteenth-Century Art* (Berkeley, CA, 1997),
pp.55–85

Chapter 4

Wilfred Niels Arnold, 'Absinthe', in *Vincent
van Gogh: Chemicals, Crises, and Creativity*
(Boston, 1992), pp.101–37

Louis Emile Edmond Duranty, 'La nouvelle peinture', in Charles S Moffett (ed.), *The New Painting: Impressionism 1874–1886* (exh. cat., The Fine Arts Museums of San Francisco; National Gallery of Art, Washington, DC, 1986) pp.477–84

Linda Nochlin, 'Impressionist Portrait and the Construction of Modern Identity', in Colin B Bailey (ed.), *Renoir's Portraits: Impressions of an Age* (exh. cat., National Gallery of Canada, Ottawa; The Art Institute of Chicago; Kimbell Art Museum, Fort Worth, 1997), pp.53–75

John Rewald, 'Theo van Gogh, Goupil, and the Impressionists', *Gazette des beaux-arts*, 81 (1973), pp.1–108

Aaron Sheon, 'Monticelli and Van Gogh', in *Monticelli, His Contemporaries, His Influences* (exh. cat., Museum of Art, Carnegie Institute, Pittsburgh, 1978)

Richard Thomson, 'The Cultural Geography of the Petit Boulevard', in Cornelia Homburg (ed.), *Vincent van Gogh and the Painters of the Petit Boulevard* (St Louis, 2001), pp.65–108

Bogomila Welsh-Ovcharov, *Vincent van Gogh and the Birth of Cloisonnism* (exh. cat., Art Gallery of Ontario, Toronto; Rijksmuseum Vincent van Gogh, Amsterdam, 1981)

—, *Van Gogh à Paris* (exh. cat., Musée d'Orsay, Paris, 1988)

Chapter 5

Elisa Evett, *The Critical Reception of Japanese Art in Late Nineteenth Century Europe* (Ann Arbor, MI, 1982)

Tsukasa Kōdera, 'Van Gogh's Utopian Japonisme', in *Catalogue of the Van Gogh Museum's Collection of Japanese Prints* (Amsterdam, 1991), pp.11–53

Gerald Needham, 'Japanese Influence on French Painting 1854–1910', in Gabriel Weisberg (ed.), *Japonisme: Japanese Influences on French Art 1854-1910* (exh. cat., Cleveland Museum of Art, 1975), pp.115–31

Fred Orton, 'Van Gogh's interest in Japanese prints', *Vincent*, 1 (1971), pp.2–12

Ronald Pickvance, *Van Gogh in Arles* (exh. cat., Metropolitan Museum of Art, New York, 1984)

Mark Roskill, 'The Japanese print and French painting in the 1880s', in *Van Gogh, Gauguin, and the Impressionist Circle* (Greenwich, CT, 1970), pp.57–85

Debora Silverman, 'Self Portraits', in *Van Gogh and Gauguin: The Search for Sacred Art* (New York, 2000), pp.17–46

Carol Zemel, 'Brotherhoods: The Dealer, The Market, The Commune', in *Van Gogh's Progress: Utopia, Modernity, and Late-Nineteenth-Century Art* (Berkeley, CA, 1997), pp.171–205

Chapter 6

M H Abrams, 'Imitation and the Mirror' and 'Romantic Analogues of Art and Mind', in *The Mirror and the Lamp: Romantic Theory and the Critical Tradition* (Oxford, 1953), pp.30–69

Roland Dorn, 'The Arles Period: Symbolic Means, Decorative Ends', in *Van Gogh Face to Face: The Portraits* (exh. cat., Detroit Institute of Arts, 2000), pp.135–71

Vojtěch Jirat-Wasiutyński *et al.*, *Vincent van Gogh's Self-Portrait Dedicated to Paul Gauguin: Art Historical and Technical Study* (Cambridge, MA, 1984)

—, 'Van Gogh in the South: Antimodernism and Exoticism in the Arlesian Paintings', in Lynda Jessup (ed.), *Antimodernism and Artistic Experience: Policing the Boundaries of Modernity* (Toronto, 2001), pp.177–91

Marsha L Morton and Peter L Schmunk (eds), *The Arts Entwined: Music and Paintings in the Nineteenth Century* (New York, 2000)

Joanna Woodall, 'Facing the Subject', in Woodall (ed.), *Portraiture* (Manchester, 1997), pp.1–25

Chapter 7

H Arikawa, '*La Berceuse*: an Interpretation of Van Gogh's Portraits', *Annual Bulletin of the Museum of Western Art, Tokyo*, 1982, pp.31–75

A Boime, 'Van Gogh's *Starry Night*: A History of Matter and a Matter of History', *Arts Magazine*, 59 (1984), pp.86–103

Cornelia Homburg, *The Copy Turns Original: Vincent van Gogh and a New Approach to Traditional Art Practice* (Amsterdam and Philadelphia, 1996)

Vojtěch Jirat-Wasiutyński, 'Vincent van Gogh's Paintings of Olive Trees and Cypresses from St-Rémy', *Art Bulletin*, 75 (1993), pp.647–70

Ronald Pickvance, *Van Gogh in St-Rémy and Auvers* (exh. cat., Metropolitan Museum of Art, New York, 1986), pp.21–192

Debora Silverman, 'Gauguin's *Misères*' and 'Van Gogh's *Berceuse*', in *Van Gogh and Gauguin: The Search for Sacred Art* (New York, 2000), pp.267–369

Judy Sund, 'Favoured Fictions: Women and Books in the Art of Van Gogh', *Art History*, 11 (1988), pp.255–67

— 'Van Gogh's *Berceuse* and the Sanctity of the Secular', in Joseph D Masheck (ed.), *Van Gogh*, 100 (Westport, CT, 1996), pp.205–25

— 'Famine to Feast: Portrait-Making at St-Rémy and Auvers', in *Van Gogh Face to Face: The Portraits* (exh. cat., Detroit Institute of Arts, 2000), pp.183–209

Bogomila Welsh-Ovcharov, *Van Gogh in Provence and Auvers* (New York, 1999)

Chapter 8

Anne Distel and Susan Alyson Stein, *Cézanne to Van Gogh: The Collection of Doctor Gachet* (exh. cat., New York, 1999)

Ronald Pickvance, *Van Gogh in St-Rémy and Auvers* (exh. cat., Metropolitan Museum of Art, New York, 1986), pp.193–287

Aimée Brown Price, 'Two Portraits by Vincent van Gogh and Two Portraits by Pierre Puvis de Chavannes', *Burlington Magazine*, 1975, pp.714–18

Meyer Schapiro, 'On a Painting by Van Gogh', *Modern Art: 19th and 20th Centuries* (New York, 1977), pp.87–99

Carol Zemel, '"The Real Country": Utopian Decoration in Auvers', in *Van Gogh's Progress: Utopia, Modernity, and Late-Nineteenth-Century Art* (Berkeley, CA, 1997), pp.207–45

Chapter 9

Albert Aurier, 'The Isolated Ones: Vincent van Gogh' (trans. and annotated by Ronald Pickvance), in *Van Gogh in St-Rémy and Auvers* (exh. cat., Metropolitan Museum of Art, New York, 1986), pp.310–15

Ronald Dorn *et al.*, *Vincent van Gogh and Early Modern Art, 1890–1914* (exh. cat., Museum Folkwang, Essen; Rijksmuseum Vincent van Gogh, Amsterdam, 1990)

A M Hammacher, 'Van Gogh and the Words', in J B de la Faille *et al.*, *The Works of Vincent van Gogh – His Paintings and Drawings* (Amsterdam, 1970), pp.9–37

Tsukasa Kōdera (ed.), *The Mythology of Van Gogh* (Amsterdam, 1993)

Russell Lynes, *Good Old Modern: an intimate portrait of the Museum of Modern Art* (New York, 1973)

Debra N Mankoff, *Sunflowers* (New York, 2001)

Griselda Pollock, 'Artists' Mythologies and Media: Genius, Madness, and Art History', *Screen*, 21 (1980), pp.57–96

Rudolf and Margot Wittkower, *Born Under Saturn, the character and conduct of artists: a documentary history from Antiquity to the French Revolution* (New York, 1963)

Carol Zemel, *The Formation of a Legend: Van Gogh Criticism, 1890–1920* (Ann Arbor, MI, 1980)

Index

Numbers in **bold** refer to illustrations

Acknowledgements

I am ever grateful to Ted Reff, who taught me
how to look at pictures and piqued my interest
in Van Gogh. For their help on this particular
project, I am especially grateful to Colin B Bailey,
Martin Bailey, Pat Barylski, Elizabeth C Childs,
Julia MacKenzie and Carol Tognieri. Special
thanks go to Leovigilda Sierra for her unstinting
day-in, day-out support. My deepest gratitude
is reserved for Scott Gilbert, whose great and
wide-ranging generosity makes my writing
(and all else) possible.

J S

For Scott, Gabriel and the two Harrys

Photographic Credits

Aberdeen Art Gallery and Museums: 60; AKG, London: 107, 166, Wadsworth Atheneum, Hartford, Connecticut 108; Amsterdam University Library: (ms X111 C 13a) 5; The Art Institute of Chicago: Helen Birch Bartlett Memorial Collection (1926.202) 68, (1926.224) 73, gift of Mr and Mrs Maurice E Culberg (1951.19) 198, gift of Mr and Mrs Gaylord Donnelly (1969.696) 160; Bildarchiv Preussischer Kulturbesitz, Staatliche Museen zu Berlin: 52, Nationalgalerie (B86a), photo Jorg P Anders 199; Bridgeman Art Library, London: Arts Council Collection, London 192, Jean Loup Charmet 16, Chester Beatty Library and Gallery, Dublin 106, Gemeentemuseum, The Hague 30, 195, Private collection 117, Towneley Hall Art Gallery and Museum, Burnley 57; British Library, London: 158; © British Museum, London: 100, 116; © Christie's Images Ltd 2002: 110, 186; Chrysler Museum of Art, Norfolk, Virginia: gift of Walter P Chrysler Jr 157; Courtauld Institute Galleries, London: 86; Dallas Museum of Art, Wendy and Emery Reves Collection: 190; Flowers East, London: 202; Foundation E G Bührle Collection, Zurich: 51; Freer Gallery of Art, Smithsonian Institution, Washington, DC: purchase (F1957.7) 90; Gemeentemuseum, The Hague: 8, 26; J Paul Getty Museum, Los Angeles: 137, 161; Ian Bavington Jones: 15; Koninklijk Museum voor Schone Kunsten, Antwerp: 155; Koninklijke Bibliotheek, The Hague: 7; Kröller-Müller Museum, Otterlo: 19, 21, 22, 33, 34, 35, 36, 41, 43, 63, 70, 84, 127, 131, 136, 140, 154, 163; © Kunsthaus, Zurich: 74, 162; Royal Cabinet of Paintings, Mauritshuis, The Hague: 10, 67; Metropolitan Museum of Art, New York: bequest of Sam A Lewisohn, 1951 (51.112.3), photo © 1979 Metropolitan Museum of Art 129, bequest of Mary Livingston Willard, 1926 (26.186.1), photo © 1996 Metropolitan Museum of Art 118; Mountain High Maps © 1995 Digital Wisdom Inc: p.341; Museum of Art, Rhode Island School of Design, Providence: gift of Mrs Murray S Danforth, photo Cathy Carver 119; Musées Royaux des Beaux-Arts de Belgique, Brussels: 48, 144; Museum Boymans-van Beuningen, Rotterdam: 49; Museum of Fine Arts, Boston: bequest of Anna Perkins Rogers (21.1329) 105, gift of Quincy Adams Shaw through Quincy A Shaw Jr and Mrs Marian Shaw Haughton (17.1485) 20, 1951 Purchase Fund, 104; Museum Folkwang, Essen: 62, 171; Digital Image © The Museum of Modern Art, New York/Scala, Florence: 164, 165; Museum für Ostasiatische Kunst, Cologne: (inv. no. R 54,14) photo Rheinisches Bildarchiv, Cologne 103; National Gallery, London: 126, 149; National Gallery of Art, Washington, DC, photos © 2002 Board of Trustees: Chester Dale Collection 134, Ailsa Mellon Bruce Collection 120, Collection of Mr and Mrs Paul Mellon 91, Widener Collection 66; National Museums and Galleries of Wales, Cardiff: 72; Norton Simon Art Foundation, Pasadena: 135; Panorama Mesdag, The Hague: photo Ed Brandon 24; Photothèque des Musées de la Ville de Paris: 78; Private collection 87; Rijksmuseum, Amsterdam: 65; RMN, Paris: photo G Blot 94, 142, 167, 180, photo H Lewandowski 2, 85, 92, 97, 139, 185, photo F Raux 197, photo Peter Willi 201; Scala, Florence: 101; State Hermitage Museum, St Petersburg: 88; Stedelijk Museum, Amsterdam: 80; © Tate, London 2002: 99, 182; Toledo Museum of Art, Ohio: gift of Arthur J Secor (1922.22) 23; Van Gogh Museum, Amsterdam (Vincent van Gogh Foundation): 1, 3, 6, 9, 11, 12, 17, 18, 29, 37, 38, 40, 42, 44, 45, 46, 47, 50, 55, 56, 58, 59, 61, 64, 69, 71, 75, 76, 77, 79, 82, 83, 89, 95, 96, 98, 111, 114, 121, 122, 123, 128, 132, 143, 146, 148, 150, 156, 169, 175, 176, 177, 178, 184, 189, 191, 194; Von der Heydt Museum, Wuppertal: 53; Wadsworth Atheneum, Hartford, Connecticut: bequest of Anne Parrish Titzell 147; Walsall Museum and Art Gallery: 32; Witt Library, Courtauld Institute of Art, London: 4, 14

Phaidon Press Limited
Regent's Wharf
All Saints Street
London N1 9PA

Phaidon Press Inc.
180 Varick Street
New York, NY 10014

www.phaidon.com

First published 2002
© 2002 Phaidon Press Limited

ISBN 0 7148 4084 X

A CIP catalogue record for this book is available
from the British Library.

All rights reserved. No part of this publication
may be reproduced, stored in a retrieval system
or transmitted, in any form or by any means,
electronic, mechanical, photocopying, recording
or otherwise, without the written permission of
Phaidon Press Limited.

Typeset in Officina

Printed in Singapore

Cover illustration Detail from *Van Gogh's Chair*,
1888 (see p.230)